RESERVES *of* STRENGTH

Pennsylvania's Natural Landscape

MICHAEL P. GADOMSKI

Schiffer Publishing Ltd

4880 Lower Valley Road • Atglen, PA 19310

Designed by Danielle D. Farmer
Type set in Chambord/Cataneo Lt BT/Gotham

ISBN: 978-0-7643-4422-0
Printed in China

Published by Schiffer Publishing, Ltd.
4880 Lower Valley Road
Atglen, PA 19310
Phone: (610) 593-1777; Fax: (610) 593-2002
E-mail: Info@schifferbooks.com

For our complete selection of fine books on this and related subjects, please visit our website at **www.schifferbooks.com.** You may also write for a free catalog.

This book may be purchased from the publisher. Please try your bookstore first.

We are always looking for people to write books on new and related subjects. If you have an idea for a book, please contact us at **proposals@schifferbooks.com**

Schiffer Publishing's titles are available at special discounts for bulk purchases for sales promotions or premiums. Special editions, including personalized covers, corporate imprints, and excerpts can be created in large quantities for special needs. For more information, contact the publisher.

In Europe, Schiffer books are distributed by
Bushwood Books
6 Marksbury Ave.
Kew Gardens
Surrey TW9 4JF England
Phone: 44 (0) 20 8392 8585; Fax: 44 (0) 20 8392 9876
E-mail: info@bushwoodbooks.co.uk
Website: www.bushwoodbooks.co.uk

OTHER SCHIFFER BOOKS ON RELATED SUBJECTS:

Faces of the Susquehanna:
A Photographic Study of Natural Reflections,
978-0-7643-3931-8, $29.99

To Smitty: This one is for you.
—MPG

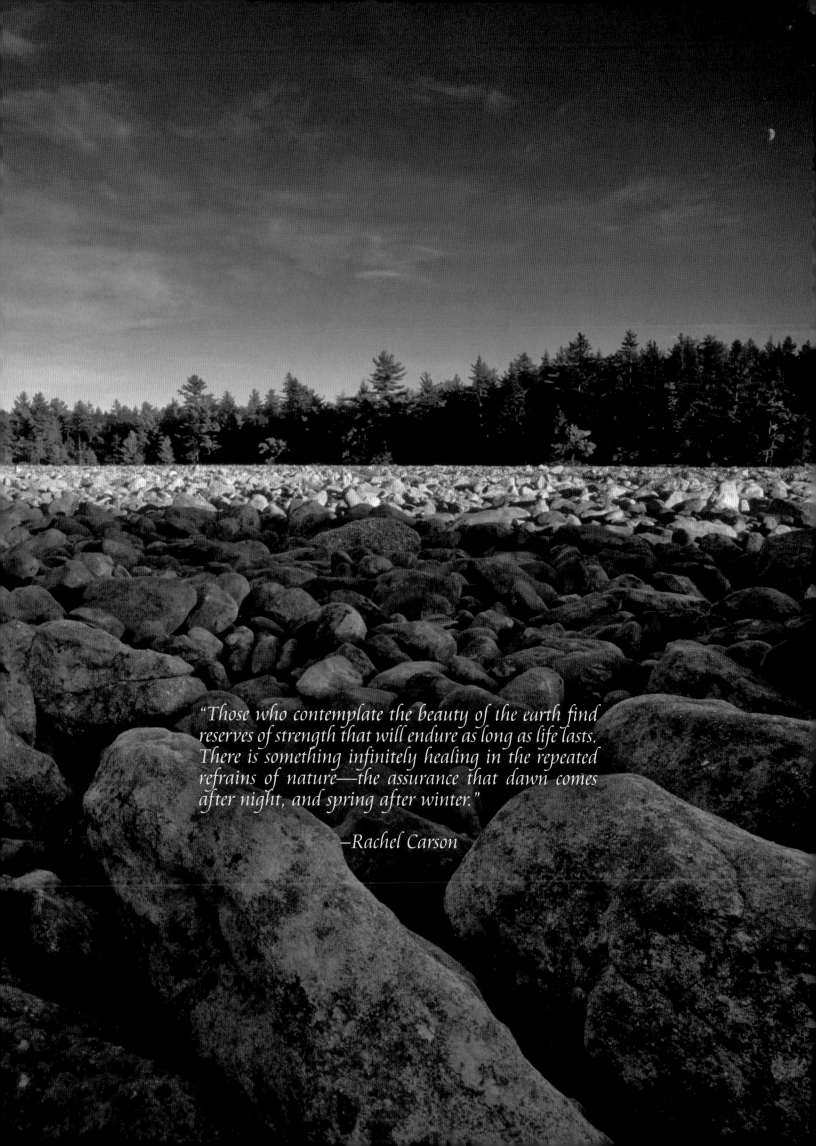

"Those who contemplate the beauty of the earth find reserves of strength that will endure as long as life lasts. There is something infinitely healing in the repeated refrains of nature—the assurance that dawn comes after night, and spring after winter."

—Rachel Carson

CHAPTER 1

CHAPTER 2

CHAF

CHAPTER 5

CHAPTER 6

CHAPTER 4

CONTENTS

Introduction

"Don't go there. It's nothing but a garbage dump." I was told. But I was curious and I wanted to see it for myself. So, one afternoon in early September, I launched my one-person, Old Town Loon kayak from the riverbank at Governor Printz Park located in Essington, Delaware County. I started paddling across the tidewater on the broad Delaware River to Little Tinicum Island, a state forest natural area sitting nearly a half-mile away.

I was used to kayaking on the lakes and wetlands of the Poconos and had even done some modest whitewater kayaking on the Upper Delaware River. But this was different. The Lower Delaware is a major commercial shipping route. Across the river, sprawling oil storage facilities and refineries lined the New Jersey shore. Every several minutes jet airlines passed a few hundred feet overhead after taking off from the nearby Philadelphia International Airport. The roar from their jet engines deafened any other sounds in the vicinity.

As an oil tanker passed, on its way up the river, it left behind a three-foot high wake. My tiny kayak rose up, then down, then up again as I navigated the almost ocean-like waves caused by the passing tanker. I was on big water now and thought, "Wow this is kind of fun and more exciting than the flat water I'm used to."

Safely reaching the northwestern shore of 2 1/4-mile long Little Tinicum Island, I came upon a wonderful marsh, a tidal marsh no less, which is very rare in Pennsylvania and only occurs in a few places along the Lower Delaware River. I was in an estuary, a transition zone between river and ocean environments, where salt water from the Atlantic is forced up the river by the tides and mixes with the fresh water flowing down the river. This mixing of waters provides a high level of nutrients, making estuaries among the most productive natural habitats in the world. And here I was right in the middle of this unique natural environment yet surrounded by industrial development, oil tankers, and a major international airport.

After exploring the marsh for some time from my kayak, I paddled around to the southeast side of the island, as the light seemed better there for photographs. Here I found a beautiful beach of reddish-colored sand and gravel. I pulled my kayak on shore and started to explore the beach on foot. Waves from distant passing ships washed the sand, gravel, and scattered shells on the beach. I noticed raccoon tracks in the moist sand showing where the animal had walked along the beach in search of food. Driftwood of all kinds was lodged along the shore. Sure, there was some trash and a few tires that also had floated down river and had become stranded, but in comparison to the surrounding shores, this was truly a natural area and worth every penny of the $100,000 the Commonwealth paid for its 200-plus acres in 1982. Not only was it worth the less-than $500 per acre to protect this extremely rare and unique natural area from eventual commercial development, but this island and the riverbank at Governor Printz Park, where I had launched, has the distinction of being the first permanent European settlement in what is now Pennsylvania by Swedish Colonists in 1643.

A bright orange sun was beginning to set, reflecting a golden glow in the waves hitting the beach. The tide was coming in and narrowing the beach's width as I started to paddle across the river back to Essington. As I paddled I thought, "I have been all over Pennsylvania, from Lake Erie, the Allegheny Plateau, the Appalachian Ridges, the Great Valley, and many other places, but this tiny island typifies Pennsylvania more than any other place I've been." Often thought of as a highly industrialized, agricultural, and commercialized state, and by some as part of the "rust-belt," many people forget or do not know that Pennsylvania has some of the most exceptional and diverse natural and wild areas in the eastern United States.

Along with of the rest of the New World, Pennsylvania has changed since October 12, 1492. There are no areas left exactly as they were in pre-Columbian Pennsylvania. Native species have been exterminated or become extinct, while new species from the Old World have become established and made this their new home, just as many of us have. As humans have changed the land to meet their own needs, species have expanded or reduced their home range. With each slight change, an addition or elimination of a species, there is a chain reaction that affects the entire natural community and all its organisms in some way and ultimately our own lives.

Additionally, the climate of the world and local areas is constantly changing through both natural events and human intervention. At times the change occurs very slowly and at other times rather dramatically, such as after a major volcanic eruption, which sends volcanic ash into the atmosphere to circle the earth for a few years, dimming sunlight reaching the earth.

At other times major catastrophic events changed the landscape. It is widely believed that the great white pine forests that spread across northern Pennsylvania, the reason for the great logging boom of the late nineteenth century, was the result of massive forest fires in the early 1600s, which created a favorable seed bed for the white pine seedlings to become established on the charred soil.

Change in the natural world is not only inevitable but also the only factor that is constant. The only thing that never changes is change itself.

MAP 13

PHYSIOGRAPHIC PROVINCES OF PENNSYLVANIA

COMMONWEALTH OF PENNSYLVANIA
DEPARTMENT OF
CONSERVATION AND NATURAL RESOURCES
BUREAU OF TOPOGRAPHIC AND GEOLOGIC SURVEY
www.dcnrstate.pa.us/topogeo

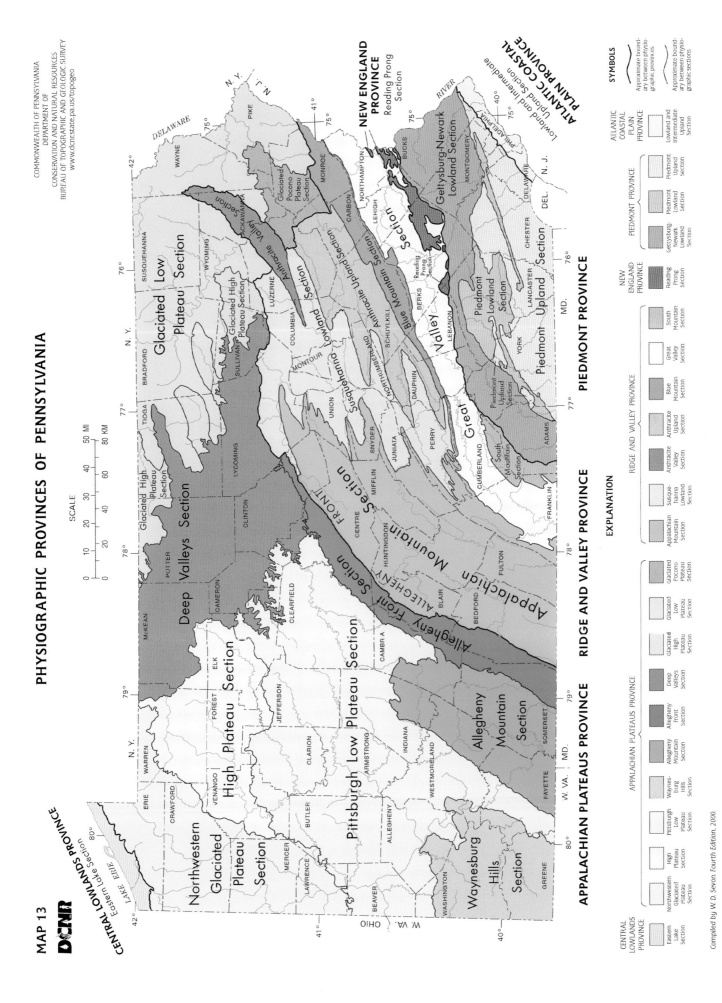

SCALE

0 10 20 30 40 50 MI

0 20 40 60 80 KM

EXPLANATION

CENTRAL LOWLANDS PROVINCE
- Eastern Lake Section

APPALACHIAN PLATEAUS PROVINCE
- Northwestern Glaciated Plateau Section
- High Plateau Section
- Pittsburgh Low Plateau Section
- Waynesburg Hills Section
- Allegheny Mountain Section
- Allegheny Front Section
- Deep Valleys Section
- Glaciated High Plateau Section
- Glaciated Low Plateau Section
- Glaciated Pocono Plateau Section

RIDGE AND VALLEY PROVINCE
- Appalachian Mountain Section
- Susquehanna Lowland Section
- Anthracite Valley Section
- Anthracite Upland Section
- Blue Mountain Section
- Great Valley Section
- South Mountain Section

NEW ENGLAND PROVINCE
- Reading Prong Section

PIEDMONT PROVINCE
- Gettysburg-Newark Lowland Section
- Piedmont Lowland Section
- Piedmont Upland Section

ATLANTIC COASTAL PLAIN PROVINCE
- Lowland and Intermediate Upland Section

SYMBOLS

- Approximate boundary between physiographic provinces
- Approximate boundary between physiographic sections

Compiled by W. D. Sevon.

Sevon, W. D., compiler, 2000, Physiographic provinces of Pennsylvania (4th ed.): Pennsylvania Geological Survey, 4th ser., Map 13, scale 1:2,000,000.

So then, what is the meaning of "natural?" Many people would say, "untouched or not influenced by humans or civilization." But with this definition, human beings are separated from and not connected to nature. Yet, as humans, we must drink the same water, breathe the same air, and consume the products of nature even if the products are cultivated. If we see a beaver colony dam a stream to create a pond and then construct a beaver lodge, we say this is a natural event. However, when a human builds a dam to create a lake or constructs a home, we say this is unnatural. Additionally, scientists discovered human-produced air pollution particles in remote unpopulated Antarctica ice many years ago. Probably nowhere on earth is left untouched by the influence of humans.

Probably a better definition of "natural" would be, "something occurring as close as possible to conforming to the original order of the laws and relationships of nature while taking into account inevitable change."

Rachel Carson said it beautifully in her quote found at the beginning of this chapter, "There is something infinitely healing in the repeated refrains of nature—the assurance that dawn comes after night, and spring after winter." As humans, we are connected and a part of nature and its repeated refrains. Our human spirit, either consciously or subconsciously, recognizes that we are part of this natural order of the laws and relationships of nature, and from this it takes comfort. Our modern industrialized and highly technically advanced culture often brings us stress and anxiety while not providing that *infinitely healing* process Ms. Carson mentions. Psychologists know this. All we have to do is look at the paintings or photographs hanging on the walls of hospitals, nursing homes, or hospices. The images are usually not of our modern lifestyle but more often *the repeated refrains of nature* from which our spirit and bodies can *find reserves of strength.*

It is not just the human spirit that finds *reserves of strength* in nature. Human materialism is dependent on nature's *infinitely healing* aspects. There is an old expression, "nature heals all." Because of the power of nature, there is a lot of truth to this, but we must care for nature for it to take care of us.

Several times since pre-Columbian days it appeared that the natural landscape of Pennsylvania could be lost forever. In the early nineteenth century, every possible piece of arable land was cleared for farms and agriculture. The original forest was gone and the cleared land faced dramatic shifts in seasonal weather. Forest animals and plants left or were exterminated while animals and plants of the grasslands flourished or moved into the new habitat. But starting after the Civil War, many of the marginal farms on poor soils were abandoned as settlers moved to new lands in the western United States. Almost immediately, nature started to reclaim these abandoned farms through the process of succession. Although very few areas obtained their original natural diversity, the strength of nature was at work to reclaim what had been altered from the original order of the laws and relationships.

Starting around the mid-eighteenth century, forestlands unsuitable for agriculture and near iron deposits were clear-cut to make charcoal to be used in iron smelting. Some forests were cut not once but several times, as even small saplings could be used for charcoal production. The forest never had a

chance to fully recover before it was cut again. This continued until the late nineteenth century, when large iron fields in the upper Midwest replaced the small local ones in Pennsylvania. But during this period, it is estimated 3.5 million acres of Pennsylvania's forest were cut for charcoal.

Around the time of the Civil War, the vast timber reserves in the primeval forests of northern and central Pennsylvania were being viewed as a great economic resource. Lumbering had been occurring since the settlement of the state, but never on the scale that was about to happen. Timber was in great demand as railroads expanded, cities grew, underground coal mining was beginning to boom, and the industrial revolution gained momentum. Europe, which had depleted its forest reserves centuries before, was paying a premium for timber imports. Railroads and skid roads were built through the forest to haul logs. Splash dams were built to provide water to create flash floods during the log drives on the rivers. The most valuable trees were sent to the mills while those of lesser value were left to pile up on the forest floor. Hemlock bark was stripped from the logs to use for tanning. Railroad cars filled with bison and cattle hides were shipped from the west to be tanned in Pennsylvania. Fortunes were made. Timber barons built grand Victorian mansions in Williamsport, Emporium, Wellsboro, and other towns. In 1860, Williamsport was the country's leading center of lumber production. Thousands of men, many immigrants, were employed in the logging camps and sawmills. Businesses flourished to fill the needs and desires of the workers and the industry. Affluence was everywhere. Just like the great forest, it seemed like prosperity would go on forever and there would be no end. But it did end and it ended rather suddenly. By the early 1900s, virtually the entire state had been clear-cut, with only tiny remnant pockets of the original forest left. Counties were loosing population as the jobs disappeared. Timber companies were abandoning the land with their taxes unpaid. The slash left on the forest floor dried and started to burn. Massive brush fires took place throughout the state. In places, the fires were so intense that they burned the organic topsoil that took thousands of years to form and build up. And when the rains came, the exposed soil eroded off the mountain slopes to clog the creeks and rivers with sediment. Without the forest to absorb the runoff, flooding and silting became a normal occurrence.

In nineteenth-century Pennsylvania, coal was king. Bituminous was mined mainly in the western counties and anthracite in the northeast, leaving scars on the land still seen today. The drainage from abandoned mines left many streams and rivers nearly lifeless with high concentrations of sulfuric acid.

In 1859, Edward Drake struck oil in northwestern Pennsylvania and liquid black gold changed not only Pennsylvania but also the world. Oil boomtowns and thousands of drilling derricks, denuding and polluting the landscape, sprang up almost overnight throughout the region, yet some just as quickly died. In 1865, due to nearby oil discoveries, people started swarming into what would become Pithole City in Venango County. At its peak, it had a population of more than 20,000 people, 54 hotels, 3 churches, numerous bars, a newspaper, railroad, a red-light district, a 1,100-seat theater, and the third largest post office in Pennsylvania. A year later, oil production started to slow, and by 1877, Pithole was a

ghost town. Today, visitors to the site walk through a grassy meadow with scattered black cherry trees. Mowed paths designate the former streets where they pass the occasional stone foundation and modern interpretive signs with diagrams and photographs of the town's short-lived glory.

During the late nineteenth century, people were becoming alarmed by all the destruction to the forest, wildlife, land, air, and water quality. They also saw how this was affecting people's health and the state's long-term economy. Progressive leaders, such as Gifford Pinchot, Dr. Joseph T. Rothrock, J. Horace McFarland, and several others, began to influence legislation and educate the public. The Department of Forestry, Game Commission, Fish Commission, and other state agencies were established to protect and manage the state's natural resources. Early environmental and game laws were passed and signed into law. Forest fire suppression became a priority. It was rough and slow going at first, as there was great opposition to what some people considered a loss of their freedom. The lands abandoned by the timber companies were sold at county tax sales for pennies an acre to the Commonwealth. Although seemingly nothing but a wasteland at the time, these lands would become priceless in the future. Management policies were enacted and, while well-intended, some were misguided, such as the planting of certain exotic species, which later became invasive pests, and the bounty system on predators. But this was a brand new science, and as with any groundbreaking endeavor, mistakes are almost certainly made.

As the forest started to recover, the Department of Forestry initiated forest-fire suppression policies and techniques. Game protectors and fish wardens were hired to control poaching and other unlawful activities. Money received from the sales of hunting licenses was used to purchase state game lands, which were managed specifically for wildlife. White-tailed deer, which were nearly exterminated, were starting to recover with the abundance of browse from the hardwood seedlings establishing themselves on the cut-over, former pine and hemlock, forests. Beaver and elk were reintroduced from western states, and soon beavers were showing up in many parts of the state. Elk did well for a few years, but their numbers dropped to a small herd confined to a few counties in north central Pennsylvania. Still missing from the state were bison, wolves, mountain lions, pine martins, and fishers, all of which had been exterminated. The river otter was exterminated from most of the state except for a remote population in the Poconos. The passenger pigeon, once the most common bird in eastern North America, was extinct, and soon to be followed by the heath hen. There is no way to know how many lesser species, which were never truly studied, became extinct or were exterminated.

As the forest was starting to recover, chestnut blight fungus, accidentally introduced to North America, virtually exterminated this very common and valuable tree from Pennsylvania's landscape in a few short years. Epidemics of white pine weevil deformed millions of recovering white pine saplings.

In 1929, the Great Depression fell upon the country. Millions of able-bodied men were unemployed and unable to find work. In March of 1933, President Franklin D. Roosevelt proposed a plan before Congress called The Emergency Conservation Work Act, commonly known as the Civilian Conservation Corps (CCC). Within less than a month, the first enrollees were inducted and Pennsylvania had some of the first camps in the nation. During the nine-year period of the CCC, 160,000 Pennsylvania men were hired to suppress forest fires, plant trees, build roads, dams, fire towers, and perform a multitude of other task to restore and protect the state's natural resources. The CCC built many of Pennsylvania's first state park facilities.

With the start of World War II, most of the CCC men were either drafted or joined the military, as were many state forestry and conservation agency employees. The CCC camps were closed. Timber resources were extremely vital to the war effort, and the recovering Pennsylvania State Forests lands took a strong leading role in supplying the Allied Forces. With the labor shortage, several former CCC camps were reopened as prisoner of war camps, and the prisoners were employed in the woods to harvest timber. At the end of the war, the prisoners were sent home, and this time the CCC camps closed for good.

Following World War II, the middle class became more affluent, as union workers gained a five-day, 40-hour, workweek and two or more weeks of paid vacation a year. The automobile brought workers and their families from the urban factories to Pennsylvania's State Parks, Forests, and Game Lands. Wives would often camp with their children at a state park all week, to be joined by the working fathers on weekends. Escalating pressure was placed on the facilities and resources, especially on weekends and holidays, when camping and picnic areas were filled beyond capacity as the demand for outdoor recreation increased.

In 1955, Governor George M. Leader appointed Maurice K. Goddard as the Secretary of the Pennsylvania Department of Forests and Waters, which later became the Pennsylvania Department of Conservation and Natural Resources. Secretary Goddard set a goal to establish a state park within 25 miles of every citizen of the Commonwealth. During his tenure, which lasted until 1979, through six administrations, 45 new state parks were created and 130,000 acres were added to the system. This was accomplished through two major bond issues: Project 500, mainly to acquire land, and Project 70, to develop the facilities on these newly acquired lands. Additionally, the General Assembly created the Oil and Gas Lease Fund, which mandated revenues from oil and gas leases on state land to be used for additional parks and forestry land acquisition and infrastructure.

With additional foresight, several areas on State Forests and State Parks were set aside as natural and wild areas, where only a minimal amount of necessary human development was allowed, to preserve these unique areas in as much a natural condition as possible for future generations.

Historically, politics or political pressure from special interests would often determine conservation and environmental practices. In 1972, Ralph Abele was appointed executive director of the Pennsylvania Fish Commission and put forth the philosophy of "Resource First." He believed that protecting Pennsylvania's lakes, streams, and aquatic life from pollution should be the primary goal. The "Straight Talk" columns that he wrote for *Pennsylvania Angler* magazine won him admiration from supporters and attacks from those who disagreed.

During the twentieth century, the federal government also took an active role in restoring and preserving Pennsylvania's

wild resources. During the Great Depression, the Resettlement Administration, part of President Franklin D. Roosevelt's New Deal, offered to purchase land from struggling farmers on marginal farmland so the owners could move to urban areas or purchase better farmland elsewhere. Much of this land was later transferred to the state.

In 1923, the Allegheny National Forest, Pennsylvania's only national forest, was established and now covers 513,175 acres.

It has often been said that the modern environmental movement began in September of 1962, with the publication of the book *Silent Spring* by Rachel Carson, who was born in Springdale, Pennsylvania, near Pittsburgh. The book documented the harmful effects of the unregulated use of pesticides on the environment. Not only was there a major backlash against the book by the chemical industry, but also there were many personal attacks against Ms. Carson's character and expertise, even as she was dying from cancer. Because of the controversy, President John F. Kennedy directed his Science Advisory Committee to investigate Ms. Carson's claims. In May of 1963, after months of testimony and investigation, the committee backed the claims and research of Ms. Carson. Less than a year later, Rachel Carson lost her other major battle, this time with cancer.

The Erie National Wildlife Refuge was established in 1959 in Crawford County, and in 1972, the Tinicum National Environmental Center, now named the John Heinz National Wildlife Refuge at Tinicum, was established in Philadelphia and Delaware Counties. In 2008, Cherry Valley National Wildlife Refuge, in northeastern Pennsylvania, came into reality through a strong coalition of community and conservation interests working together for eight years. Eventually, this refuge will encompass 20,000 acres in an area of rapid residential and commercial growth, within a two-hour drive of millions of people.

When the extremely controversial Tocks Island Dam project was disapproved by a majority vote of the Delaware River Basin Commission in 1975, the nearly 70,000 acres, originally purchased by the federal government for the reservoir, were transferred to the National Park Service to become the Delaware Water Gap National Recreation Area, which is now the tenth most visited area in the National Park System. In 1978, the Upper Delaware Scenic & Recreational River was authorized by Congress, to preserve and protect 73.4 miles of the longest, undammed, free-flowing river in the Northeast United States.

In the meantime, the private sector was not sitting idle, waiting for the government to act. In 1951, The Nature Conservancy was incorporated as a nonprofit organization with a mission to conserve the lands and waters on which all life depends. A few years later, a Pennsylvania chapter was formed. In addition to owning and preserving rare and threatened habitat preserves, The Nature Conservancy, through creative financial procedures, is able to purchase at-risk lands and hold title until the state can obtain the funding to transfer the deeds into public ownership. Additionally, many regional conservancies formed throughout the state, including the Western Pennsylvania Conservancy and the Wildlands Conservancy, among several others. Besides acquiring unique natural lands for protection, these various conservancies purchase voluntary conservation easements from private landowners to protect their land from unwanted development.

The National Audubon Society, along with its local chapters and local governments, established nature centers to educate and expose the ever-increasing urban population to nature. Private organizations, including the Rocky Mountain Elk Foundation, Ruffed Grouse Society, Ducks Unlimited, National Wild Turkey Federation, and many others contributed to the conservation efforts in the state.

By 2012, Pennsylvania had 120 state parks on 300,000 acres and 2.2 million acres of State Forest lands. The Pennsylvania Game Commission had acquired more than 1.4 million acres of State Game Lands, scattered throughout the Commonwealth, purchased through the sale of hunting licenses, timber sales, and the Oil and Gas Lease Fund. The Pennsylvania Boat and Fish Commission had more than fifty lakes, reservoirs, and dams owned and/or managed by the Commission for sport fishing, recreational boating, and preserving priceless aquatic habitats.

Today, in spite of continuing dangers, such as exotic pests, an unnatural white-tailed deer population, and continuing urban sprawl, Pennsylvania's forests are again generally healthy and the state is the nation's largest producer of hardwood lumber. Forests cover about 60% of the state—75% of this forestland is in private ownership by corporations and families and provides 80% of Pennsylvania's timber products. Timber harvests are done in a more sustainable manner than they were 100 years ago.

Many farmers, whose marginal farms are no longer profitable for traditional farming, are turning to other opportunities to keep their land, rather than selling it for commercial development. Some are growing only hay, which is sold to other farms, suburban horse stables, or mulch hay for Pennsylvania's famous mushroom farms. These hay fields help to provide some relief to the state's shrinking grassland habitat. Other farmers have turned to Christmas tree farms, which, in addition to growing a recyclable and renewable product, provide a scarce young conifer successional habitat for some species of birds and mammals.

Several species of wildlife, that were exterminated or in danger of becoming extinct, are now doing well and even thriving. Fishers and river otters have now been restored in the state. Elk and bobcats are increasing in both numbers and range. White-tailed deer and snow geese, which were rare a 100 years ago in Pennsylvania, may now be over-populated and exceeding their carrying capacity. As recently as thirty years ago, some experts felt that it would only be a matter of time until the bald eagle, osprey, and peregrine falcon would be extinct in the state. Today, they are nesting throughout the state and increasing their numbers yearly, thanks to the ban of DDT and regulated use of pesticides.

The abandoned coal strip mines, that have been scarring Pennsylvania's landscape and leaching their poisonous acid into our waters, are now being restored into important grassland habitats by the Pennsylvania Department of Environmental Protection and the Game Commission. The acid mine drainage from these mines is being treated, using natural methods to purify the water.

After centuries of abuse and neglect, the natural landscape of Pennsylvania has shown its *reserves of strength* and will endure, with our help and wise management, hopefully for countless generations of Pennsylvanians yet to come.

The Wisconsinan glaciers, which covered northwest Pennsylvania 17,000–22,000 years ago, left us many gifts. It gave us the largest natural lake in Pennsylvania, 934-acre Conneaut Lake, as well as numerous eskers, kames, kettles, and moraines. It gave us the picturesque rolling terrain, gentle rounded hills, and commercial deposits of sand and gravel. But possibly the greatest gifts, it gave Pennsylvania were wetlands consisting of swamps and marshes.

Quality wetlands are uncommon in many parts of the state, but in the northwestern counties they are common. The majority of Pennsylvania's marshes are found here. These wetlands provide vital habitat for several unique plants and many animal species, including many breeding and migrant birds. For many years, when the bald eagle was on the verge of extinction and nearly gone from Pennsylvania, Pymatuning Lake had the only breeding pair in the entire state. The region is Pennsylvania's "duck factory," as many waterfowl species breed here. Some species even have nested here outside of their normal breeding range.

Home of the Mound Builders, Shawnee, Iroquois, and later the Lenape tribes of Native America, the area has evidence of human habitation going back to the end of the last Ice Age. The land, lakes, and wetlands provided them with food. It was a good land.

The area and its local weather are often dominated by Lake Erie, one of the five Great Lakes, and another gift of the last Ice Age. Although Pennsylvania's shoreline on Lake Erie is only 51 miles long, it shortness does not diminish its quality. The land above Lake Erie is one of the finest grape growing regions in the country, with vineyards providing fruit for wine, juice, and jelly. In addition, some streams feeding the lake are becoming famous for their steelhead salmon runs in autumn.

Yet the most famous and visited natural area along Pennsylvania's Lake Erie shoreline is Presque Isle State Park, which has up to 4 million visitors a year. While most visitors come to enjoy the pristine beaches, fish, or boating, many people come to discover and explore the park's unique and diverse natural features. The 3,112-acre arching sandy peninsula, which makes up the park, contains seven different ecological zones. This diversity has resulted in more than 320 bird species being recorded here, over a third of the total number of species in the entire United States. Additionally, 45 of these bird species are listed as "endangered" or "threatened." Its no wonder *Birder's World* magazine has rated this Pennsylvania state park as one of the best places in the United States for bird watching.

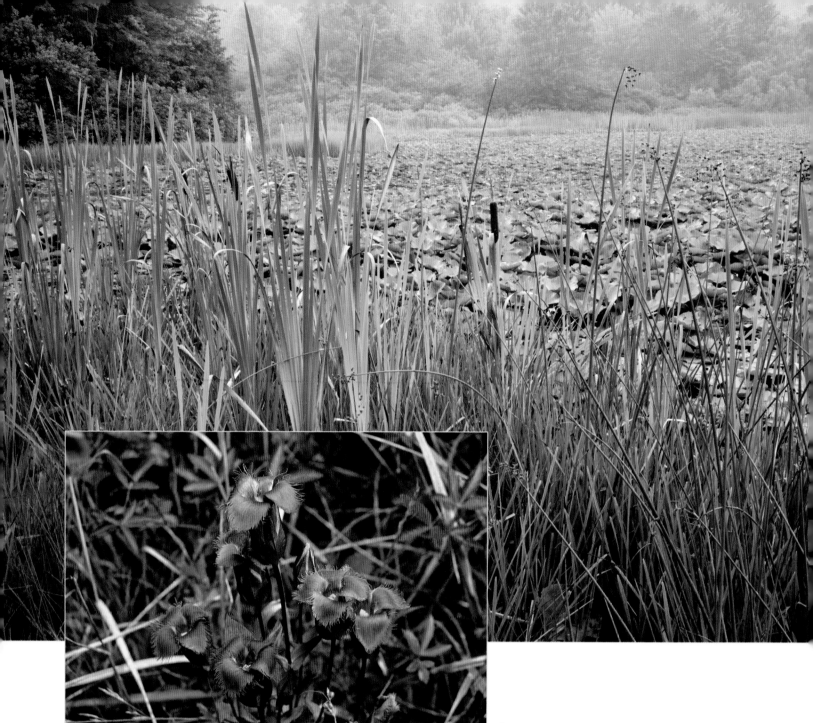

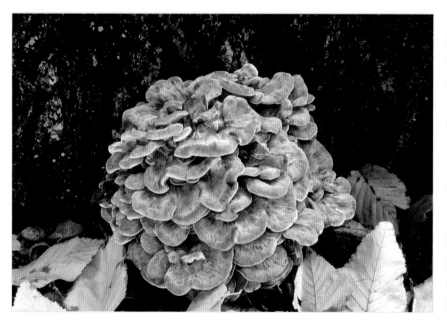

top

Fringed gentian, *Gentianopsis crinita*, grows in very scattered locations throughout the state. Blooming in late summer, it was historically common in moist meadows, but with agricultural practices it is now uncommon. The Western Pennsylvania Conservancy owns and manages a small fen in Lawrence County for the protection of this species.

bottom

Grifolia frondosus is a mushroom that goes by many common names, including hen-of-the woods, ram's head, and sheep's head. It grows in clusters at the base of hardwood trees, particularly oaks, in autumn. Considered an epicurean delight, early research is showing it might be a cancer inhibitor and diabetic aid.

opposite

3,225-acre Lake Arthur, the centerpiece of Moraine State Park, is located in Butler County. The 16,725-acre park was developed on restored strip coal mines and is now classified as an Important Bird Area by the National Audubon Society because it provides essential habitat for one or more species of birds.

top

The American bittern, *Botaurus lentiginosus*, is a medium-size heron that prefers large wetlands. To avoid detection it extends its body upward, blending with the surrounding vegetation. In Pennsylvania it is listed as "state endangered," primarily due to a 50% loss of wetlands in the state over the past two centuries.

bottom

The beautiful 20-mile long Neshannock Creek in Lawrence County is classified as a high quality freestone stream. A freestone stream is one whose source is rainwater and snowfall that seeps through the soil and rocks to develop springs.

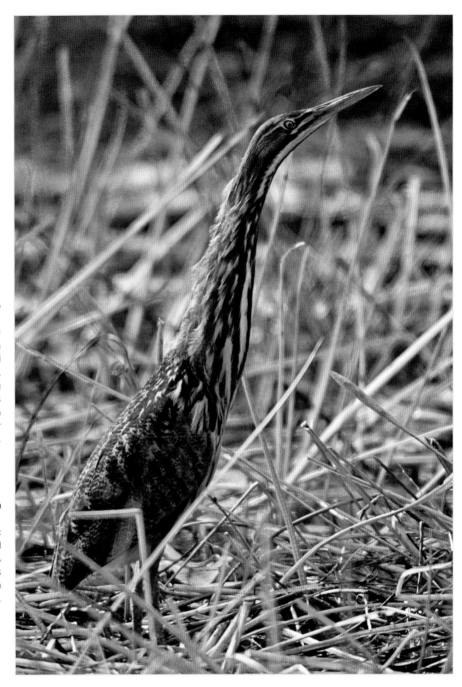

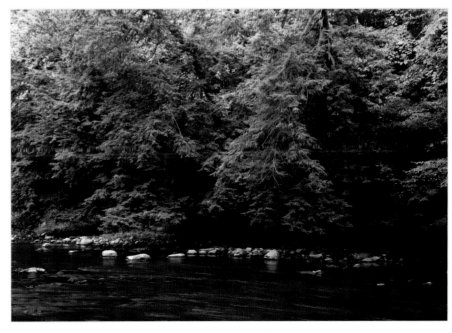

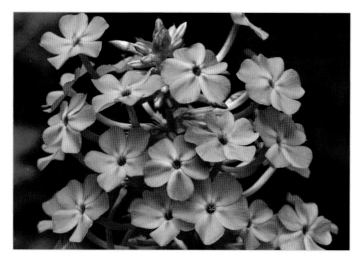

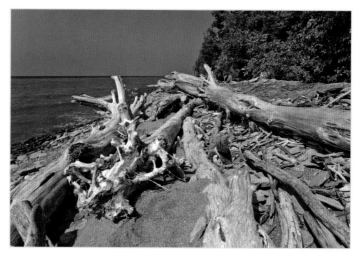

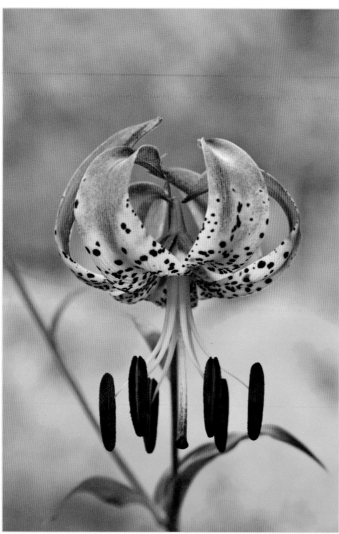

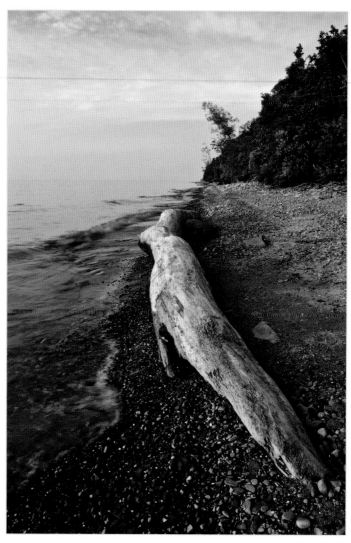

top left

Wild sweet William, *Phlox maculate*, grows along the banks of Neshannock Creek in Lawrence County and many other Pennsylvania locations. The 2- to 3-foot-tall native wildflower prefers to grow in moist meadows and along riverbanks. Its nectar is used as food by butterflies and the ruby-throated hummingbirds.

bottom left

The very stylish 5- to 8-foot-tall native Turk's-cap lily, *Lilium superbum*, grows in moist, rich soil in many locations throughout Pennsylvania. The reflexed shaped of the flowers, which bloom in July and August, resemble a type of hat worn by early Turkish people and gave the wildflower its common name.

top right

Driftwood that may have come all the way from Canada or Michigan is piled up on the shore of Lake Erie on State Game Lands 314 at the David M. Roderick Wildlife Reserve in Erie County.

bottom right

Established in 2004, Erie Bluffs State Park is Pennsylvania's newest state park. The park contains 587 acres and in addition to the Lake Erie shoreline, the park contains species of special concern found in its uncommon oak savannah sand barren ecosystem and forest wetlands.

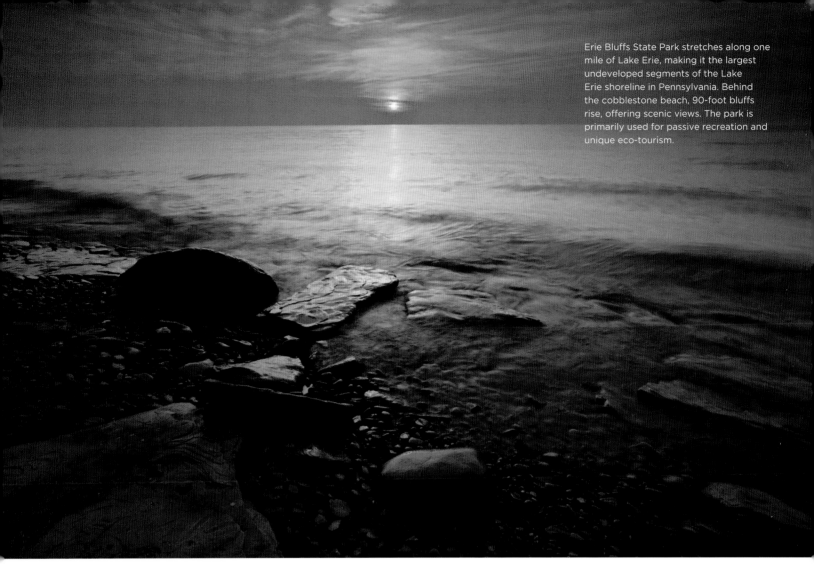

Erie Bluffs State Park stretches along one mile of Lake Erie, making it the largest undeveloped segments of the Lake Erie shoreline in Pennsylvania. Behind the cobblestone beach, 90-foot bluffs rise, offering scenic views. The park is primarily used for passive recreation and unique eco-tourism.

Falling Run Trail in Maurice K. Goddard State Park is a 0.7-mile long self-guiding nature trail that follows old logging roads that lead into the cool hemlock forest ravine of Falling Run, where cascades, a small waterfall, and the remains of a pioneer settlement can be seen.

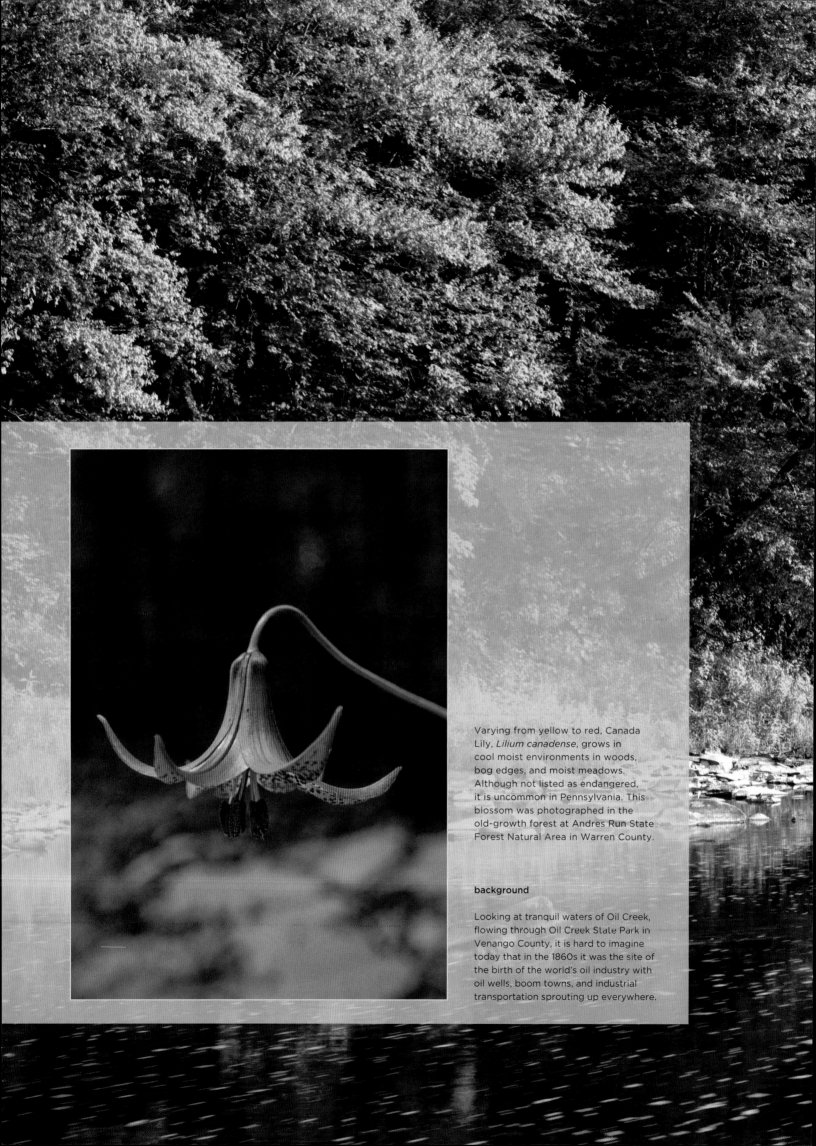

Varying from yellow to red, Canada Lily, *Lilium canadense*, grows in cool moist environments in woods, bog edges, and moist meadows. Although not listed as endangered, it is uncommon in Pennsylvania. This blossom was photographed in the old-growth forest at Andres Run State Forest Natural Area in Warren County.

background

Looking at tranquil waters of Oil Creek, flowing through Oil Creek State Park in Venango County, it is hard to imagine today that in the 1860s it was the site of the birth of the world's oil industry with oil wells, boom towns, and industrial transportation sprouting up everywhere.

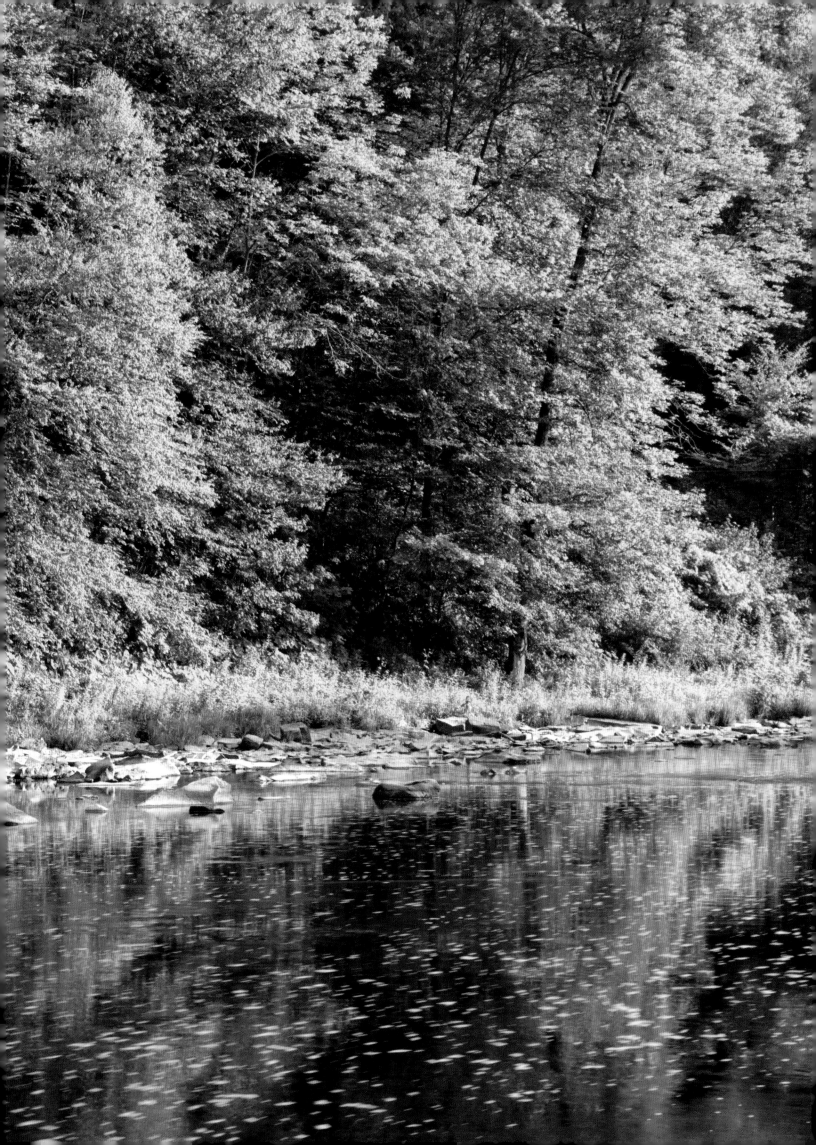

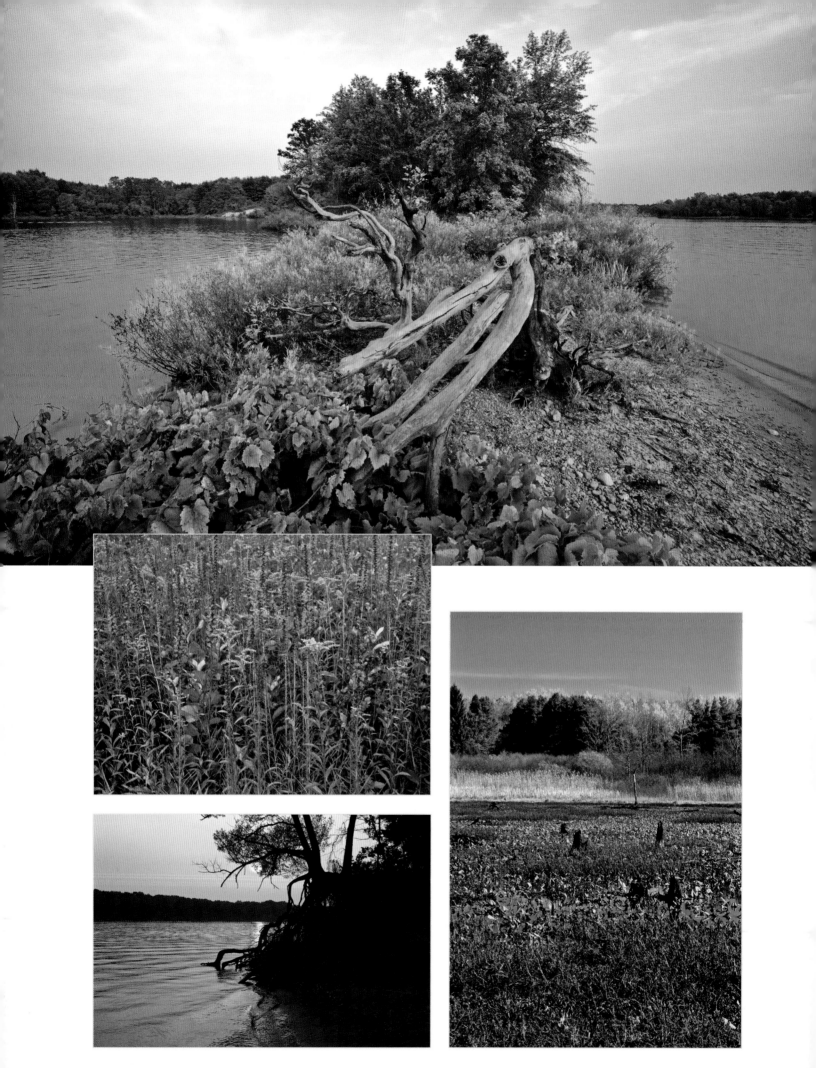

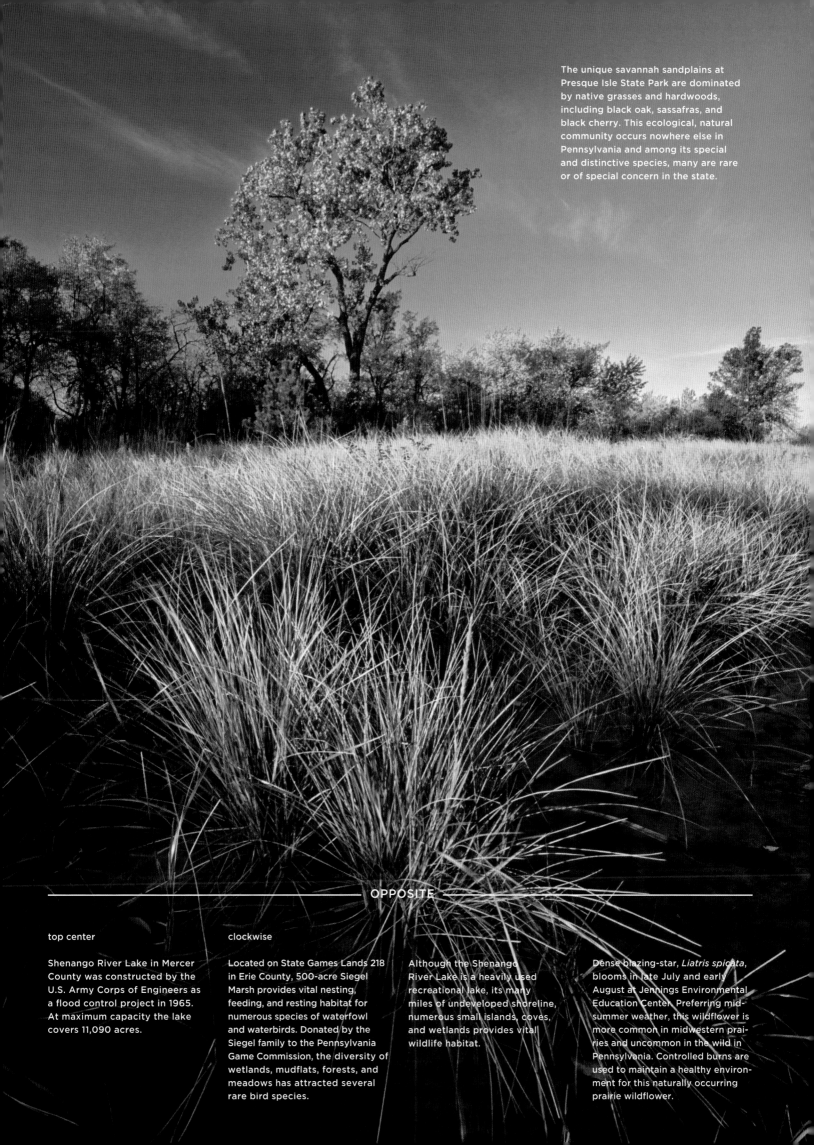

The unique savannah sandplains at Presque Isle State Park are dominated by native grasses and hardwoods, including black oak, sassafras, and black cherry. This ecological, natural community occurs nowhere else in Pennsylvania and among its special and distinctive species, many are rare or of special concern in the state.

OPPOSITE

top center

Shenango River Lake in Mercer County was constructed by the U.S. Army Corps of Engineers as a flood control project in 1965. At maximum capacity the lake covers 11,090 acres.

clockwise

Located on State Games Lands 218 in Erie County, 500-acre Siegel Marsh provides vital nesting, feeding, and resting habitat for numerous species of waterfowl and waterbirds. Donated by the Siegel family to the Pennsylvania Game Commission, the diversity of wetlands, mudflats, forests, and meadows has attracted several rare bird species.

Although the Shenango River Lake is a heavily used recreational lake, its many miles of undeveloped shoreline, numerous small islands, coves, and wetlands provides vital wildlife habitat.

Dense blazing-star, *Liatris spicata*, blooms in late July and early August at Jennings Environmental Education Center. Preferring mid-summer weather, this wildflower is more common in midwestern prairies and uncommon in the wild in Pennsylvania. Controlled burns are used to maintain a healthy environment for this naturally occurring prairie wildflower.

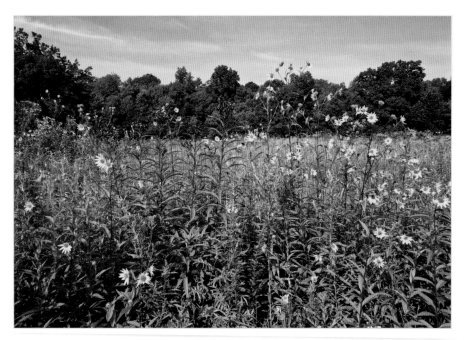

top

Famous for the spectacular prairie wildflower, the blazing star, many other species of prairie wildflowers grow on the rare 20-acre eastern relict prairie ecosystem at Jennings Environmental Education Center. This Pennsylvania State Park in Lawrence County also provides vital habitat for the endangered massasauga rattlesnake.

bottom left

Containing a mixture of locally frozen water and ice that has floated in by wave action, the Lake Erie ice pack, that forms every winter off Presque Isle, creates an artic-like landscape. Some of this ice might have formed along the Canadian shoreline eventually becoming beached in Pennsylvania.

bottom right

While the primary objective at Erie National Wildlife Refuge is to provide nesting, brooding, feeding, and resting habitat for wildlife, the management practices of prescribed burning, removing invasive plants, and native plant regeneration has also resulted in diverse and healthy late summer meadow wildflower habitats, which also benefits wildlife.

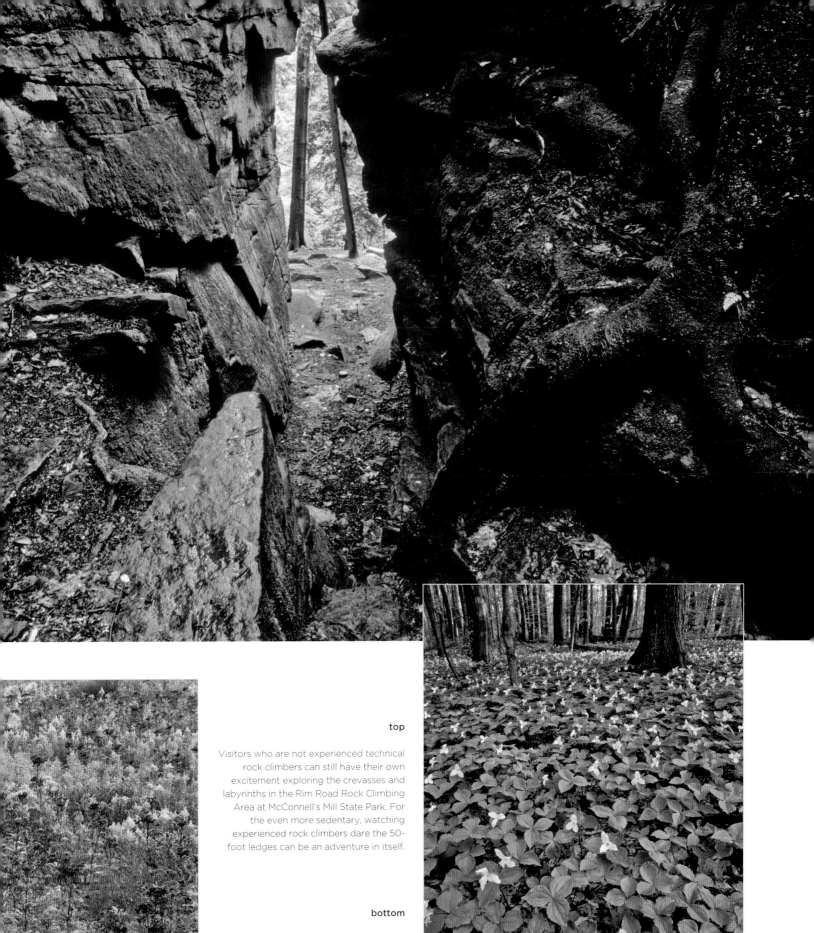

top

Visitors who are not experienced technical rock climbers can still have their own excitement exploring the crevasses and labyrinths in the Rim Road Rock Climbing Area at McConnell's Mill State Park. For the even more sedentary, watching experienced rock climbers dare the 50-foot ledges can be an adventure in itself.

bottom

Between 1979 and 1982, the Western Pennsylvania Conservancy acquired Wolf Creek Narrows Natural Area in Butler County, famous for its outstanding display of spring wildflowers. In addition to large-flowered trillium seen here, the 115-acre preserve also harbors Virginia bluebells, trout lily, walking fern, and in mid-summer Turk's-cap lily.

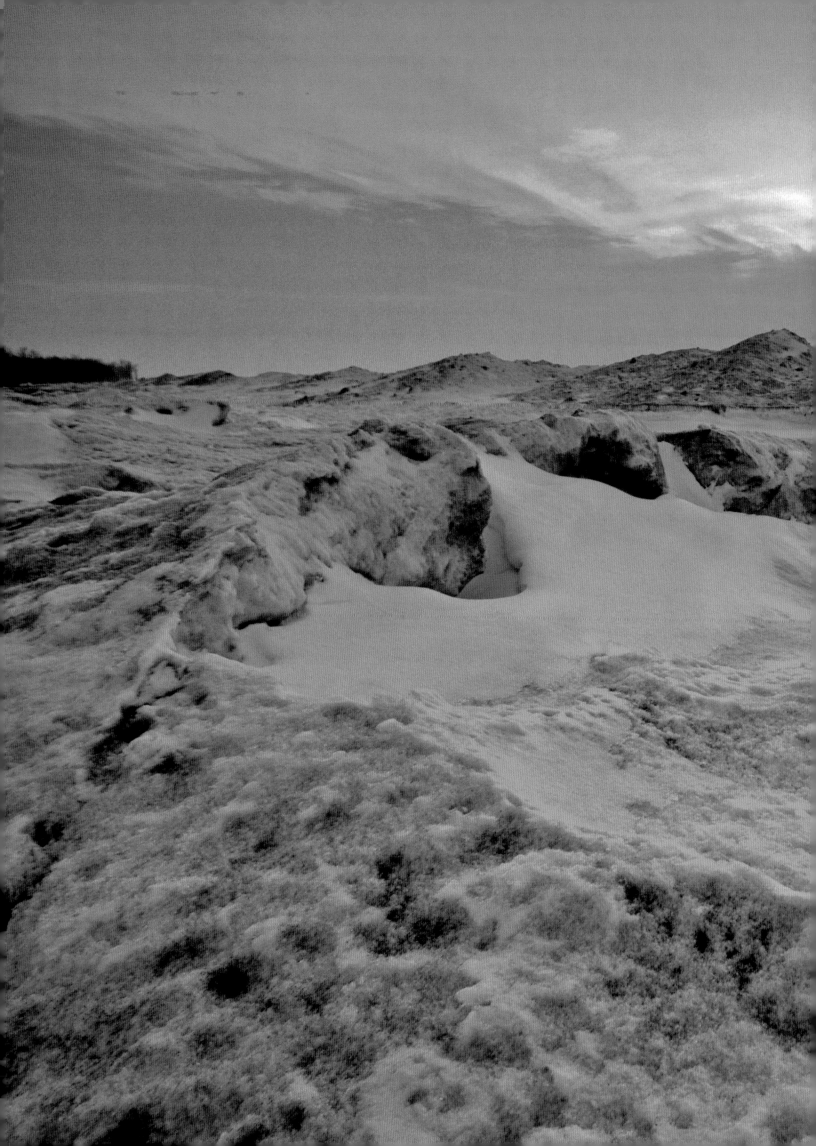

top

A riparian floodplain forest grows along French Creek on State Game Lands 277 in Crawford County. Riparian zones are important natural biofilters protecting the adjacent aquatic environment. Because of its biodiversity, The Nature Conservancy lists French Creek as one of the thirty most important freshwater bodies in the United States.

center

During winter, hoar frost often forms on the plants lying dormant in the sandplains at Presque Isle State Park. This fernlike, ice-crystal frost grows as relatively warmer moist air flows off nearby Lake Erie and settles on the colder surface of plants found a few yards inland.

bottom

Sunlight filtering through the late summer leaves on hardwood trees, above Shull Run in Venango County, creates a dappled palette of gold, yellow, and green in the stream waiting to ignite the creative imagination of poets.

background

Six-foot-high ice dunes form in winter along the beach at Presque Isle State Park. Sometimes called an ice ridge or ice foot, this formation is found on artic beaches and the shoreline of the Great Lakes. Ice dunes are inherently weak and walking on them can be exceedingly dangerous.

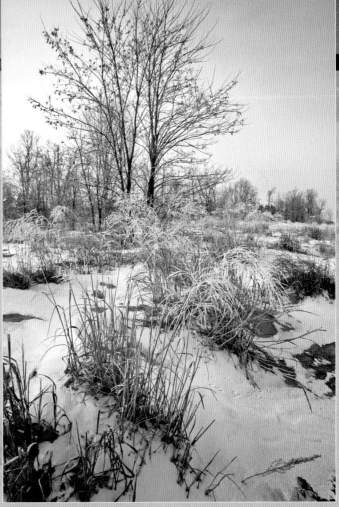

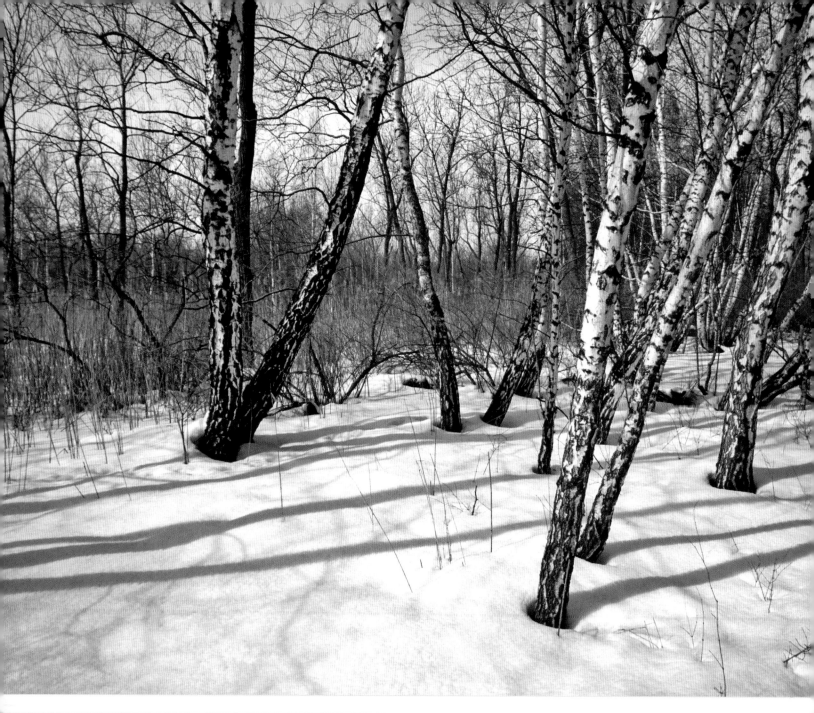

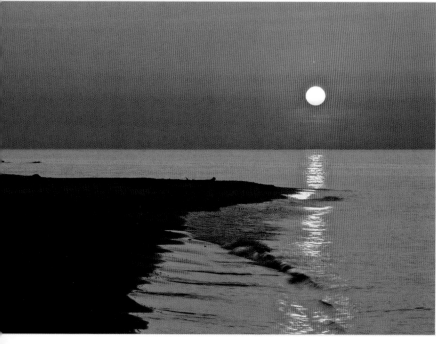

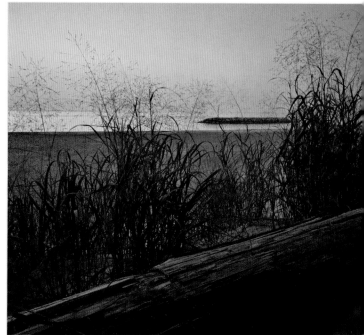

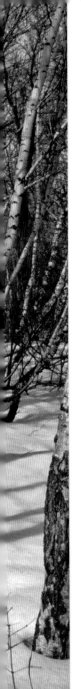

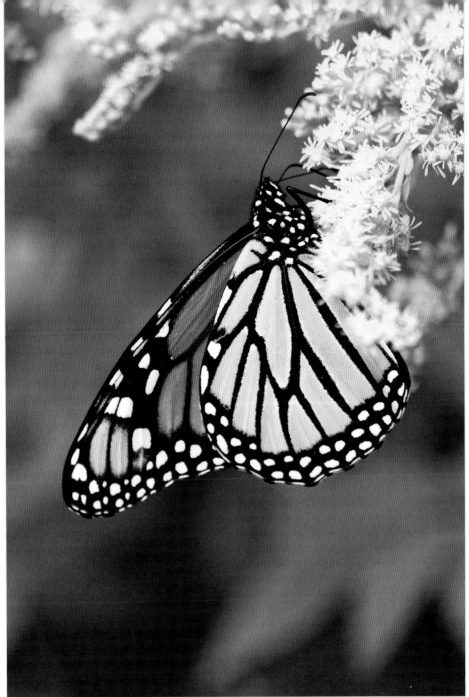

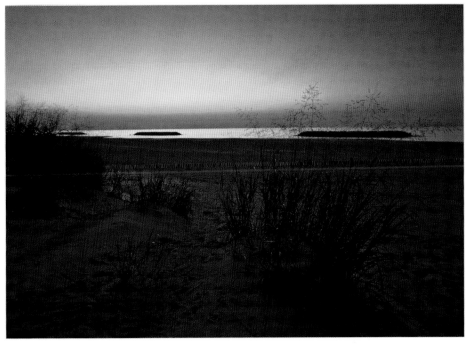

top left

European weeping, or silver birch, *Betula pendula*, native to Europe and Asia Minor, is frequently planted as a landscape tree in Pennsylvania. At Presque Isle State Park it has become naturalized throughout the peninsula. A grove of these trees is in a winter landscape.

top right

An adult monarch butterfly is seen feeding on the nectar of goldenrod. Found throughout Pennsylvania, particularly in meadows that contain milkweed plants, the species has a complex life history that spans several generations a year. The monarchs we see in Pennsylvania will fly several thousand miles to overwinter in Mexico.

bottom left

The beach at Presque Isle State Park on Lake Erie in Erie County is said to have some of the best sunsets in all of Pennsylvania. *Presque Isle* is a French phrase meaning, "almost island."

bottom center

A National Natural Landmark, Presque Isle State Park has many unique natural habitats. The Pennsylvania Bureau of State Parks says the park, "contains a greater number of the state's endangered, threatened and rare species than any other area of comparable size in Pennsylvania."

bottom right

The 3,200-acre sandy peninsula, which arches into Lake Erie and forms Presque Isle State Park, is often referred to as Pennsylvania's only "seashore." Even though the visitors get the feeling of being at the sea, the water is fresh from the Great Lakes and not ocean salt water.

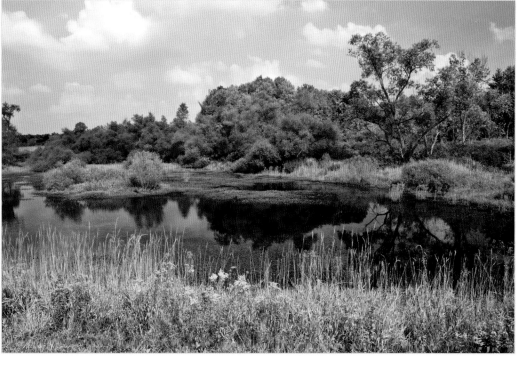

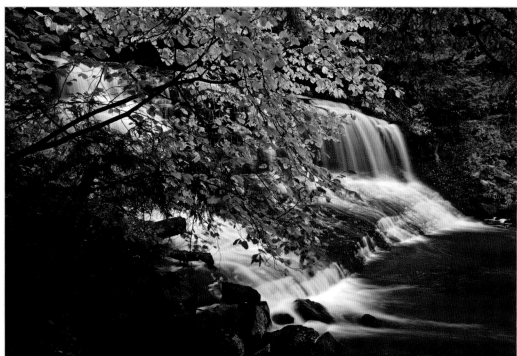
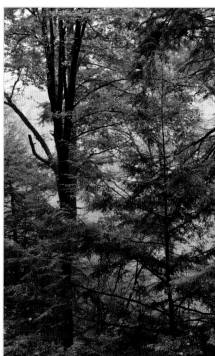

top left

Erie National Wildlife Refuge in Crawford County contains many shallow-water ponds that were constructed for the feeding, resting, and nesting of wildlife.

bottom left

Barely reaching 13 feet in height and 60 feet in width, Springfield Falls in Mercer County on State Game Lands 284 makes up in exceptional charm what it may lack in size.

top center

The sand dunes at Presque Isle State Park formed when beach sand transported by wind and waves is trapped by vegetation. As the dunes grow, and are stabilized by grasses, other types of vegetation follow in succession. These dunes provide a unique natural habitat that is very rare in Pennsylvania.

bottom center

Because of the high humidity that is often trapped in the 2,546 acres of the deep, spectacular Slippery Rock Creek Gorge at McConnell's Mill State Park, morning fog can linger for several hours, creating a mystical feel in the forest.

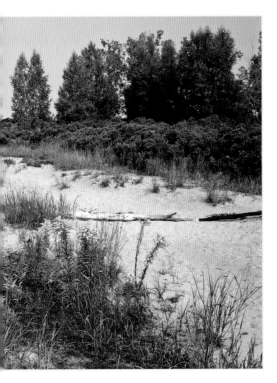

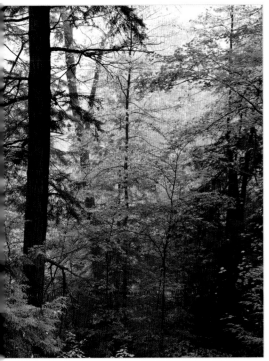

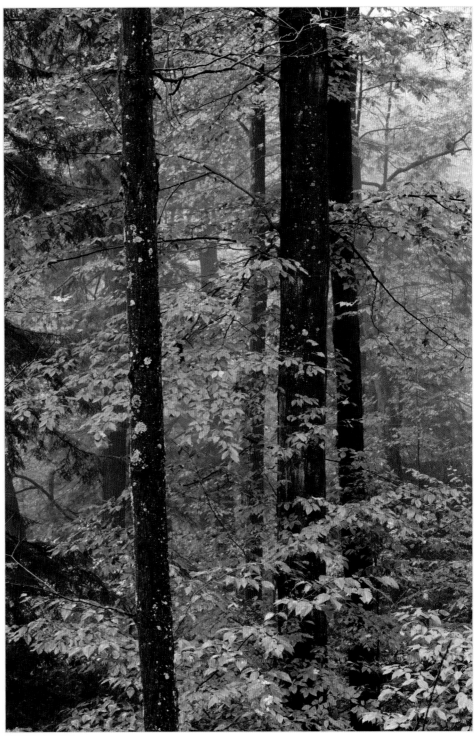

right

The forest at McConnell's Mill
State Park in Lawrence County
is what ecologists classify as the
Appalachian mixed mesophytic
forest, an ecoregion west of the
Appalachians that extends in a
somewhat narrow band from
southwestern Pennsylvania south
into northwest Alabama.

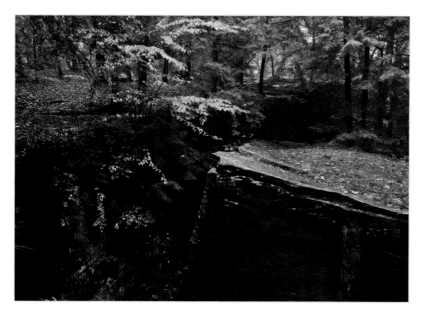

top

The Homewood sandstone found at the Rim Road Climbing Area in McConnell's Mill State Park was formed around 300 million years ago. Over thousands of years, large blocks have separated from the main outcrop. Through the force of gravity, these blocks are very slowly slumping downhill.

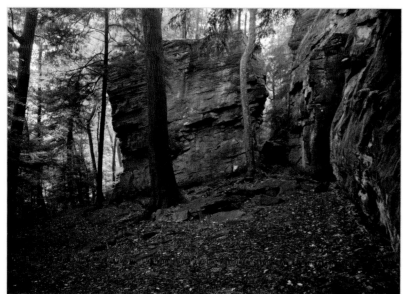

center

Disjointed along vertical cracks, the slumping sandstone blocks at the Rim Road Climbing Area in McConnell's Mill State Park have created a spectacular "rock city" with walkways, grottoes, and labyrinths that invite exploration by people of all ages.

bottom

At McConnell's Mill State Park, Slippery Rock Creek flows through a spectacular steep-sided gorge that was formed at the end of the last Ice Age when glacial lakes to the north quickly drained and swept through the area, creating the rugged landscape we see today.

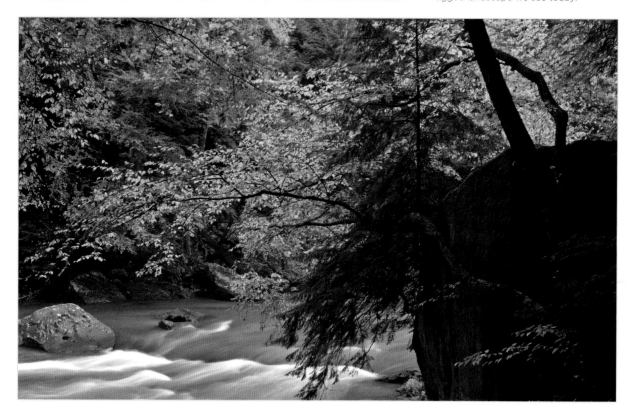

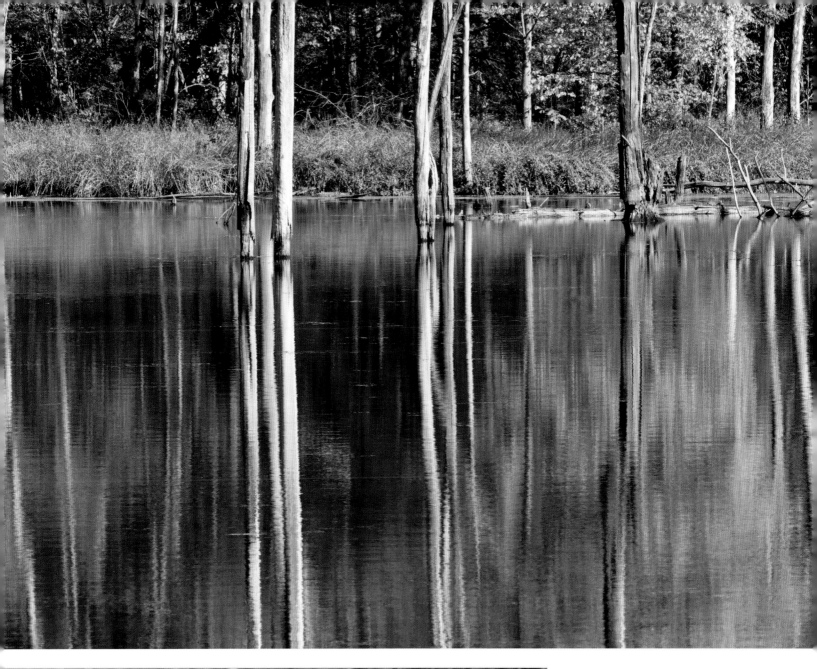

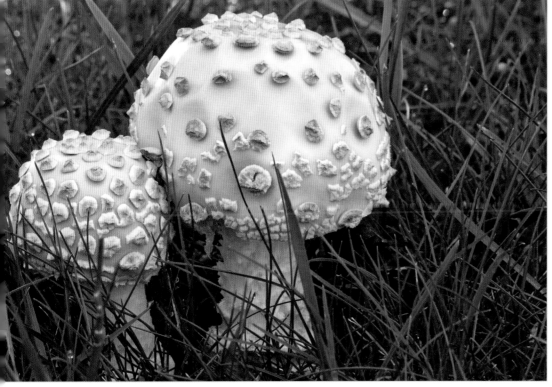

top

On a still autumn day, the reflections of dead tree trunks and autumn foliage created an abstract picture at the Waterfowl Observation Area in Maurice K. Goddard State Park.

bottom

While considered to be poisonous, these colorful fly agaric mushrooms, *Amanita muscaria*, found growing at Maurice K. Goddard State Park, are consumed in some parts of the world after the poison is removed by parboiling. This practice is highly risky and definitely not recommended!

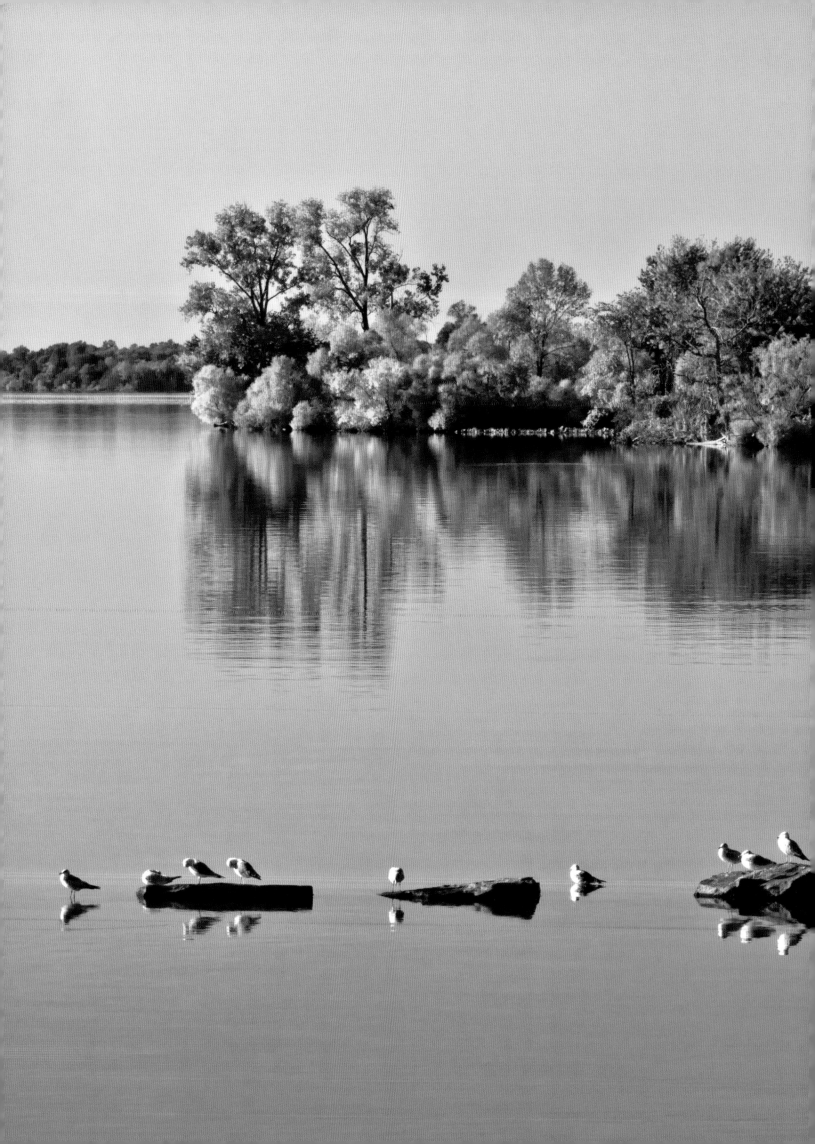

top

In nature everything is connected. At Maurice K. Goddard State Park, a beaver a chews down a tree to use for food and lodge building. Here a great blue heron finds a good roost to rest or hunt for the fish and amphibians that find shelter under the downed tree.

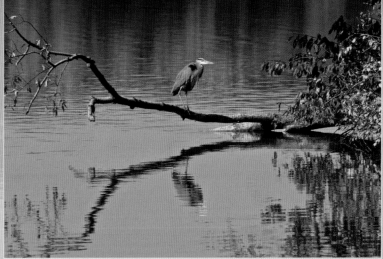

bottom

The Pymatuning Reservoir was created in 1934 by damming the Shenango River. The reservoir extends across the border into Ohio and contains numerous unnamed small islands like the one seen here near the larger Ford Island.

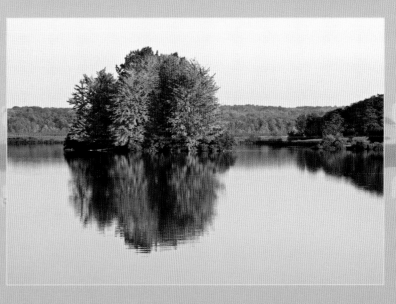

background

On a calm, warm, autumn afternoon, a flock of ring-billed gulls takes a restful break along the shore of the 17,088-acre Pymatuning Reservoir in Crawford County; Pennsylvania's largest lake.

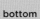

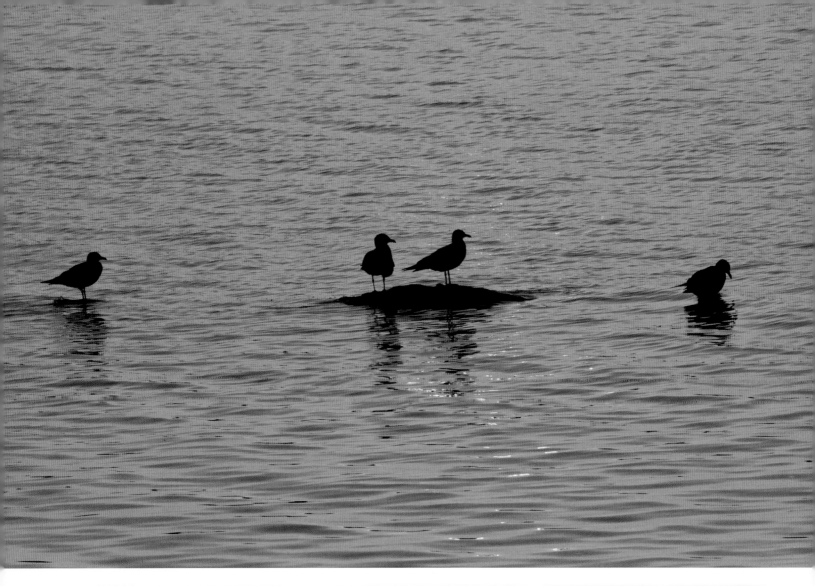

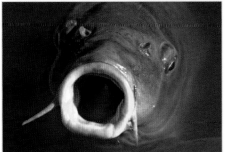

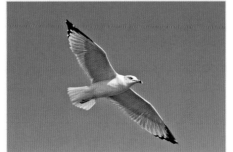

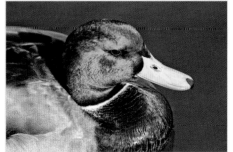

top center

These ring-billed gulls seem to be enjoying a Pymatuning Reservoir sunset near the Linesville Causeway just as the thousands of humans who come to the area every year do.

bottom left

For decades, people have been feeding the numerous ducks and carp fish that congregate along the Linesville Spillway on Pymatuning Reservoir. As the carp see people approach, they rise to the surface, begging for food with an open mouth, creating a very bizarre sight.

bottom center

After the Pymatuning Reservoir was created, the newly formed aquatic habitat became a mecca for many species of birds like this ring-billed gull. Often called "sea gulls," the ring-billed gull, *Larus delawarensis*, is an inland species and many individuals never see the ocean during their lifetime.

bottom right

The most common duck species in Pennsylvania's northwest wetlands, and throughout the state, is the mallard. As the mallard population increased, due to a change in the natural landscape, it hybridized with the closely related black duck, causing a decline in the genetic purity of black ducks.

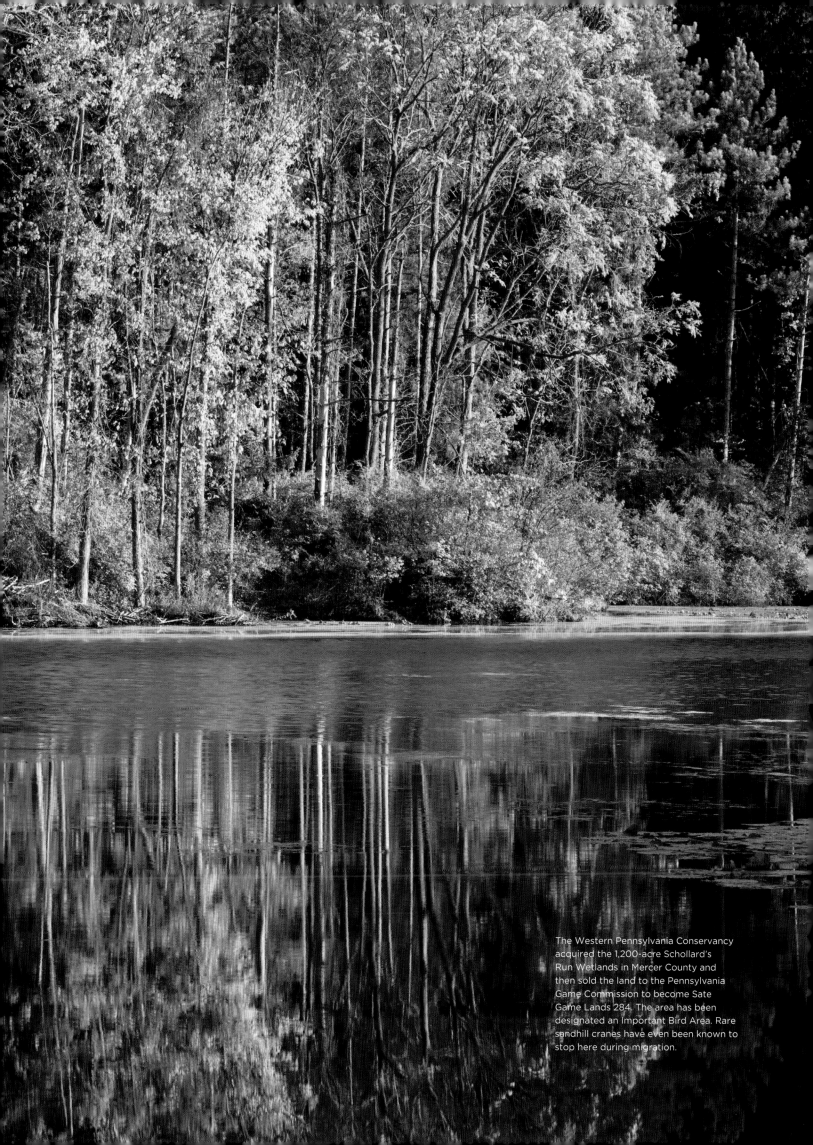

The Western Pennsylvania Conservancy acquired the 1,200-acre Schollard's Run Wetlands in Mercer County and then sold the land to the Pennsylvania Game Commission to become Sate Game Lands 284. The area has been designated an Important Bird Area. Rare sandhill cranes have even been known to stop here during migration.

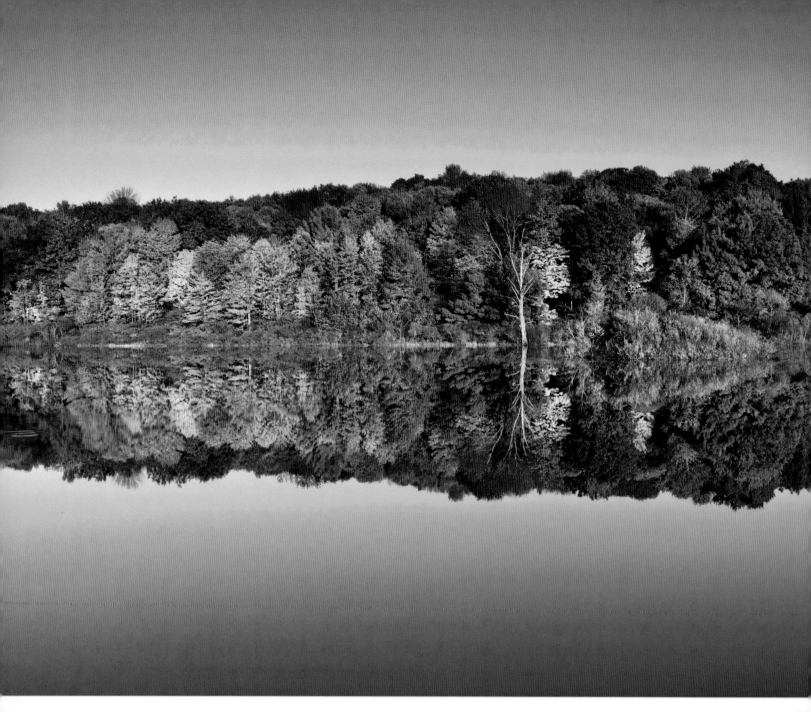

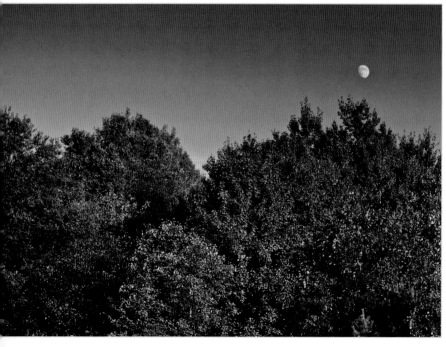

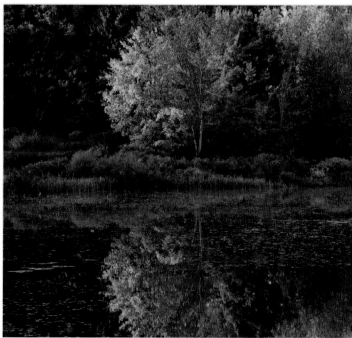

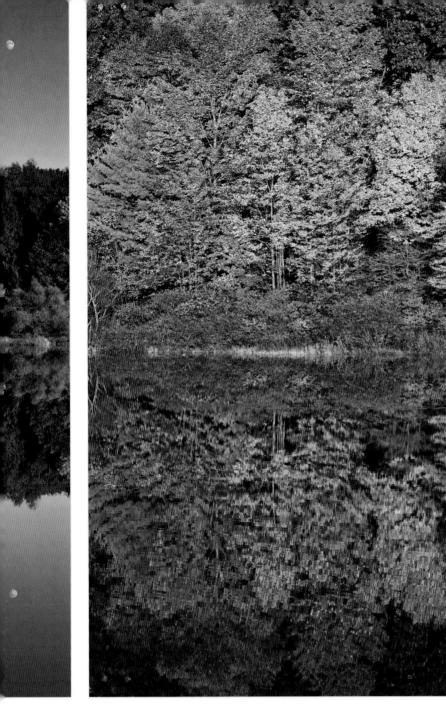

top left

Pool K in Erie National Wildlife Refuge in Crawford County is part of the 2,500 acres of wetlands and impoundments on the refuge managed as wildlife habitat.

top right

The autumn forest at its peak color is perfectly reflected at sunset in the calm waters of Pool K at the Erie National Wildlife Refuge.

bottom left

A Hunter's Moon rises over the autumn forest at Erie National Wildlife Refuge. It is believed that the name Hunter's Moon came from the Native Americans who tracked and killed prey by moonlight to stockpile food for the coming winter months.

bottom center

The 8,777-acre Erie National Wildlife Refuge was established in 1959 and is one of three national wildlife refuges in Pennsylvania and one of more than 500 in the United States. Its diverse habitat attracts more than 237 species of birds, 47 species of mammals, and 37 species of amphibians and reptiles.

bottom right

The lake sand dunes at Presque Isle State Park is one of the few locations in Pennsylvania where eastern cottonwood, *Populus deltoides*, is abundant. Closely related to aspens, eastern cottonwood trees can grow to well over 100 feet in height.

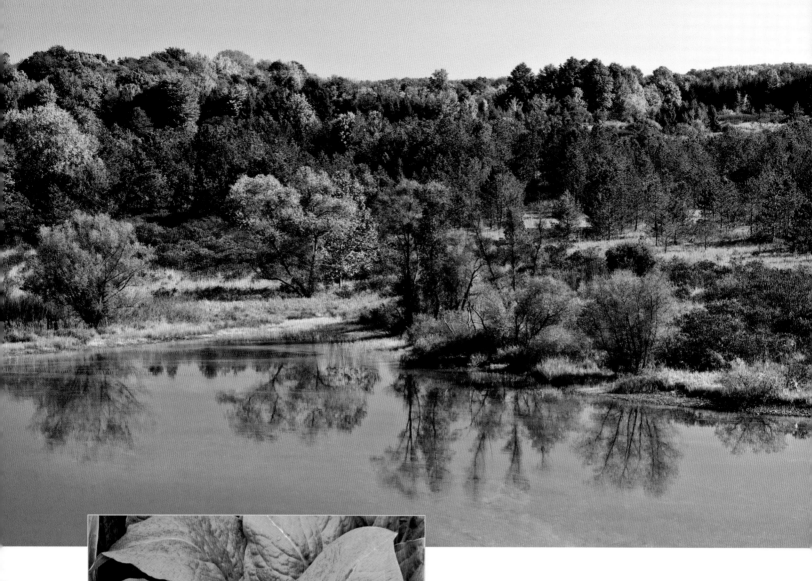

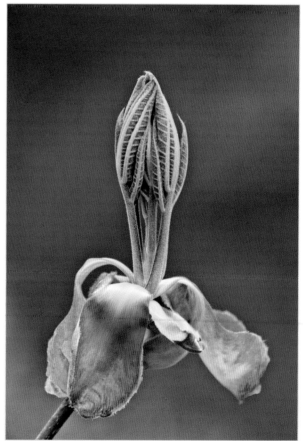

The eastern red-spotted newt, *Notophthalmus viridescen*, has a complex life history. Born as aquatic larva, they metamorphose into the juvenile terrestrial red eft as seen here. After 3 to 7 years they return to the water as aquatic adults and can often be seen swimming in winter under the ice.

— OPPOSITE —

top center

Woodcock Creek Lake in Crawford County is a U.S. Army Corp of Engineers flood control project on French Creek. At maximum capacity, the lake covers 775 acres. Because of its diverse shoreline, the area provides habitat for wildlife. Several bird species rare to Pennsylvania have been observed here.

clockwise

In April, the buds on shagbark hickory open, presenting the tiny immature curled leaves inside. Some people think the folded leaves resemble hands clasped in prayer. Shagbark hickory, *Carya ovata*, is found throughout Pennsylvania and gets its common name from the tree's distinguishable shaggy gray bark.

Double-crested Cormorants, *Phalacrocorax auritus,* migrating in autumn over Lake Erie at Presque Isle State Park. These fish-eating birds declined in the 1960s due to the effects of DDT. Since the ban on DDT, the species has rebounded in such great numbers that now population control is sometimes necessary.

Broad spreading leaves of skunk cabbage, *Symplocarpus foetidus*, are a familiar springtime sight in wet places throughout Pennsylvania. The plant gets its name from the pungent odor of the broken leaves, which were used for medical purposes by some Native Americans and pioneers. It is the first flowering plant in the spring.

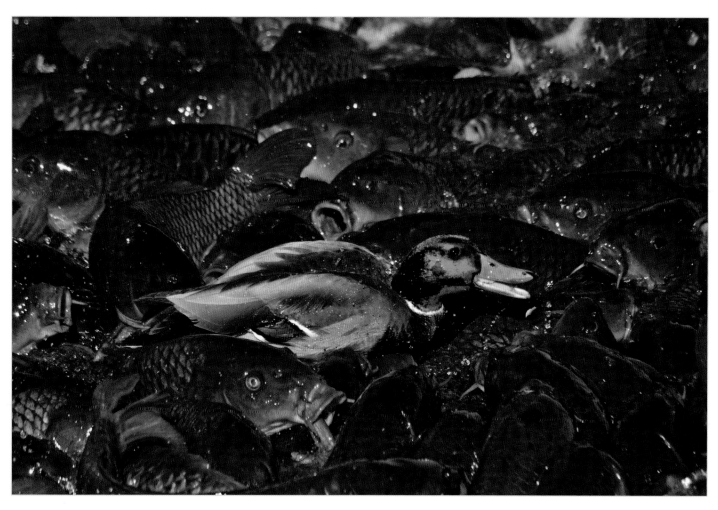

Chaos breaks out when people come
to feed the fish and ducks that gather
at the Linesville Spillway. As pieces of
bread are tossed in the water, the tightly
concentrated carp and ducks frantically
compete for every morsel—eventually the
ducks walk on the backs of the fish.

It's early autumn and the morning sun is just beginning to brighten the mist-shrouded land. On a nearby mountain meadow the whistle-like bugling call of a rutting 1,000-pound bull wapiti echoes across the landscape shortly followed by the primitive, raspy *"cr-r-ruck"* call of a raven flying overhead. For many people who come to this area every year, this is a once-in-a-lifetime experience never to be forgotten. Welcome to Pennsylvania Wilds and the Allegheny Plateau that extends across nearly three-fourths of northern Pennsylvania.

The northern Allegheny Plateau is the most sparsely populated area of the state, yet it contains the greatest amount of protected wild lands in the state. In addition to the 512,998-acre Allegheny National Forest, there are nearly 1.4 million acres of state forest, 34 state parks, hundreds of thousands of state game land acres, and other protected parcels across the region.

Trees make up this region, maybe a billion trees or more. During the late nineteenth and early twentieth century, this magnificent forest attracted timber barons and soon nearly the entire region's forests were clear-cut. Then it got worse. The remaining timbering slash started to burn, often in fires so intense that the organic matter in the topsoil actually burned and was destroyed. A barren wasteland was left and abandoned by the logging companies. Some referred to it as the Pennsylvania Desert. In 1897, the Commonwealth enacted legislation creating the Forest Reserve Commission for the purpose of purchasing "unseated" lands at tax sales. Large parcels were purchased at bargain prices. The original forest was gone, but newly acquired lands would now serve many generations of Pennsylvanians yet to come.

But timber wasn't the only boom to scar the area. Oil was discovered and successfully drilled in the western section in 1859 and oil boomtowns sprung up overnight throughout the area. Some of these boomtowns are now just crumbling stone foundations being reclaimed by nature.

And, of course, there was coal, mostly bituminous in the western counties, which is still being strip-mined today.

The booms to exploit the natural resources of this region are not just something for the history books, as it's happening right now and maybe the biggest energy resource boom across the nation. Large amounts of natural gas, known for years to exist a mile or more underground in the Marcellus Shale Formation, are now being exploited through a new and controversial process called hydrofracting, or fracking. Beside the concerns of natural land disturbance by large drilling sites, heavy equipment, infrastructure, and pipelines, there are also some very serious concerns about the chemicals used in the fracking process and maintaining healthy safe aquifers.

Progressive Pennsylvanian leaders of the past helped save and restore the land from previous negligent practices. We now enjoy and prize these lands. As the two-term, Republican Governor of Pennsylvania, Gifford Pinchot, said: "The vast possibilities of our great future will become realities only if we make ourselves, in a sense, responsible for that future."

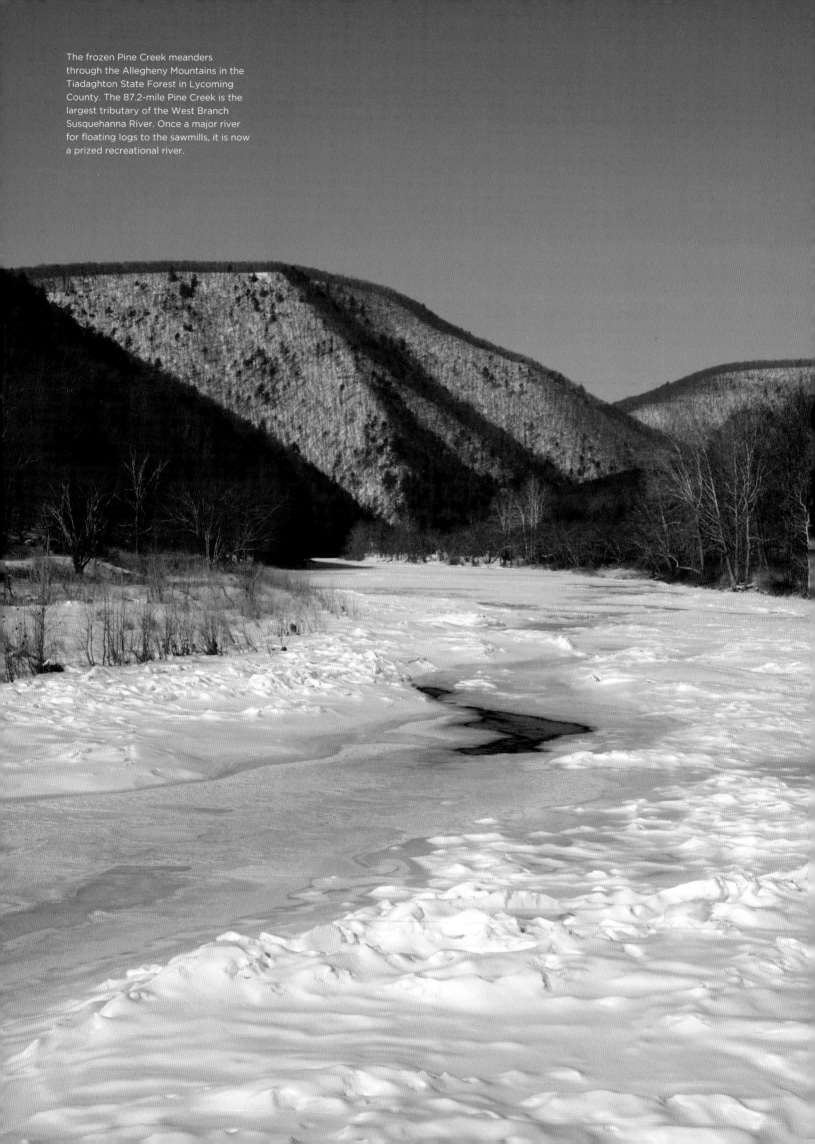

The frozen Pine Creek meanders through the Allegheny Mountains in the Tiadaghton State Forest in Lycoming County. The 87.2-mile Pine Creek is the largest tributary of the West Branch Susquehanna River. Once a major river for floating logs to the sawmills, it is now a prized recreational river.

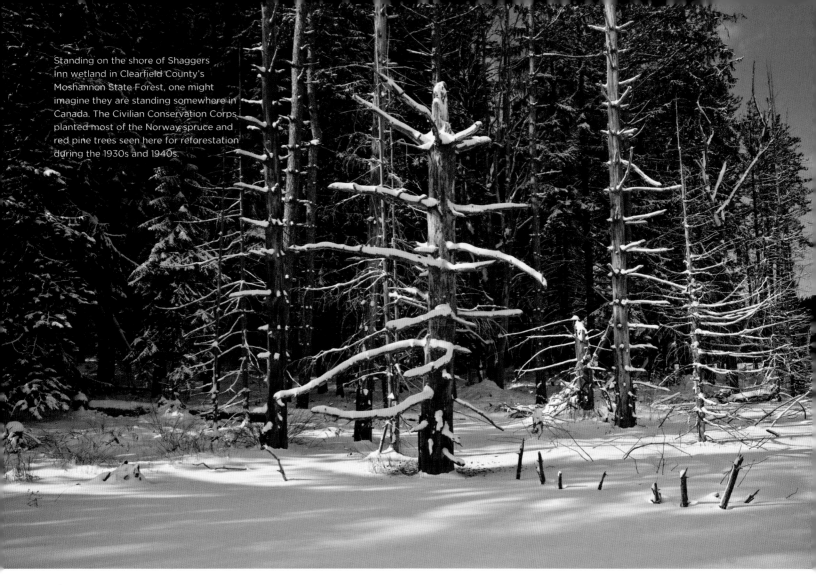

Standing on the shore of Shaggers Inn wetland in Clearfield County's Moshannon State Forest, one might imagine they are standing somewhere in Canada. The Civilian Conservation Corps planted most of the Norway spruce and red pine trees seen here for reforestation during the 1930s and 1940s.

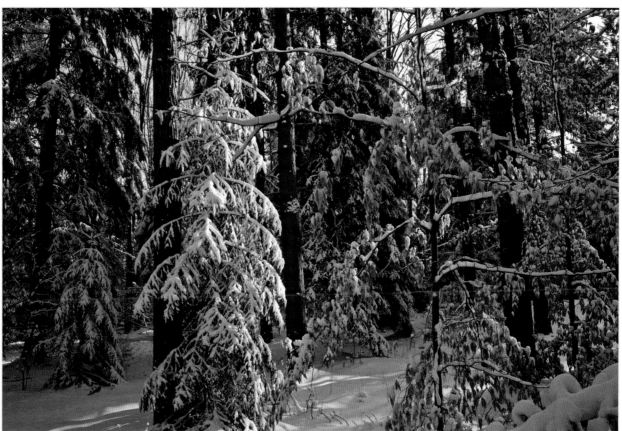

Fresh snow blankets the Moshannon State Forest in Clearfield County. Some parts of Clearfield County receive up to an average of 70 inches of snow every year due to its high elevation and lake effect snowstorms.

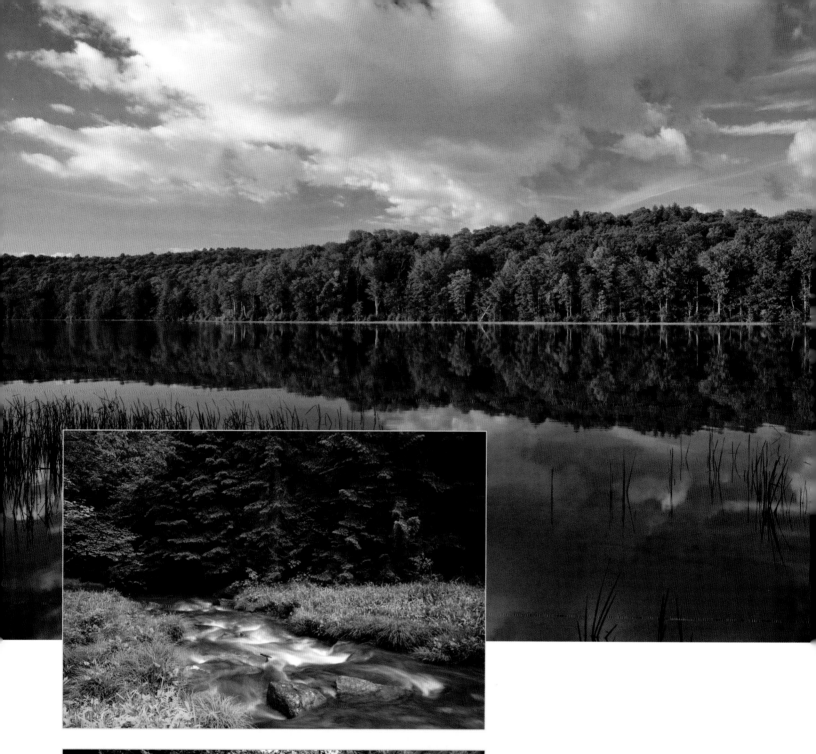

top

Clear Creek in Jefferson County's Clear Creek State Park flows through a lush evergreen forest planted by the Civilian Conservation Corps between 1933 and 1937 on land that was once totally clear cut of all trees.

bottom

Dame's rocket flowers, *Hesperis matronalis*, grace the banks of the Clarion River in Cook Forest State Park during late May and early June. This European naturalized garden plant has flower petals in purple, pink, or white.

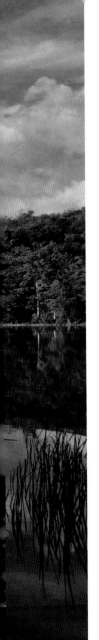

opposite

Located in the Endless Mountains of Sullivan County, 117-acre Hunters Lake lies at an elevation of 1,617 feet. Owned and managed by the Pennsylvania Fish and Boat Commission, the lake and surrounding 2,000 acres are popular for fishing, bird watching, and kayaking.

top

Kitchen Creek in Ricketts Glen State Park has cut its course through the red sandstone, forming smooth-sided potholes at Adams Falls. This waterfall was used as a background for several scenes in the independent film *The Fay*, a story based on ancient Celtic myth and medieval Arthurian romance.

bottom

Hidden on State Game Lands 13 in Sullivan County and surrounded by a steep vertical rock ledge, dramatic Big Falls drops 25 feet into the cold waters of Heberly Run.

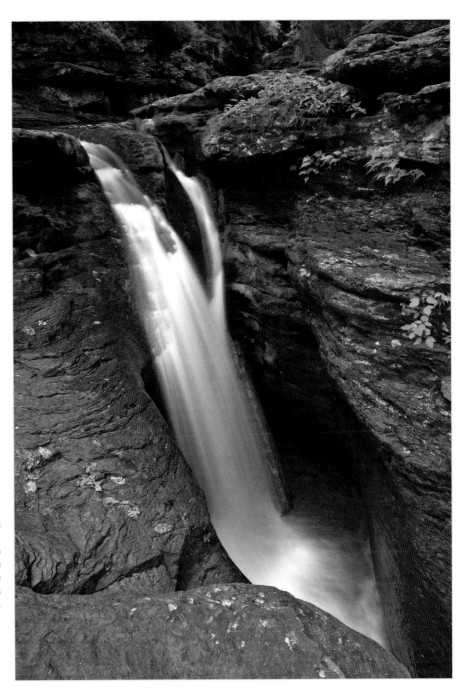

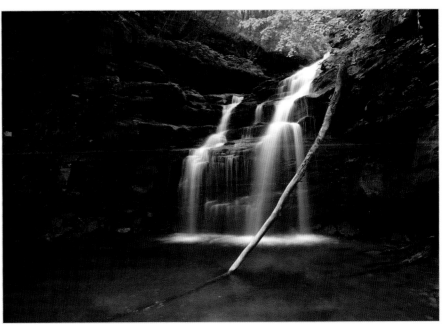

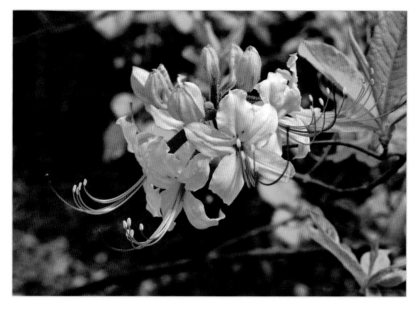

top

Pink azalea or pinxter-flower, *Rhododendron periclymenoides*, is a familiar and welcome sight along mountain streams and in the damp forests of Pennsylvania. This wild, native deciduous shrub, whose flowers appear before the leaves, has been used in gardens and was introduced in England as early as 1734.

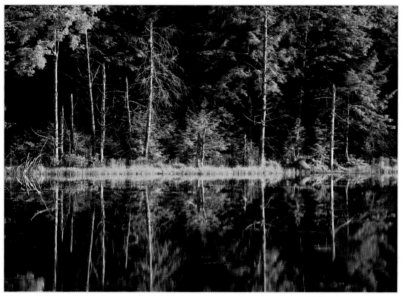

center

A woodland pond on Noon Branch of the Loyalsock Creek in the Loyalsock State Forest provides vital wetland habitat for many species of wildlife, including several species of amphibians and waterfowl. According to the Pennsylvania Department of Conservation and Natural Resources, the state loses 1,200 acres of wetlands per year.

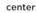

bottom

A vista along Hillsgrove Road in the 115,000-acre Loyalsock State Forest dramatically illustrates the dissected plateau features of northeastern Pennsylvania's Endless Mountains Region, which is characterized by high plateaus and ridges cut with numerous deep stream valleys.

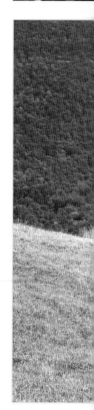

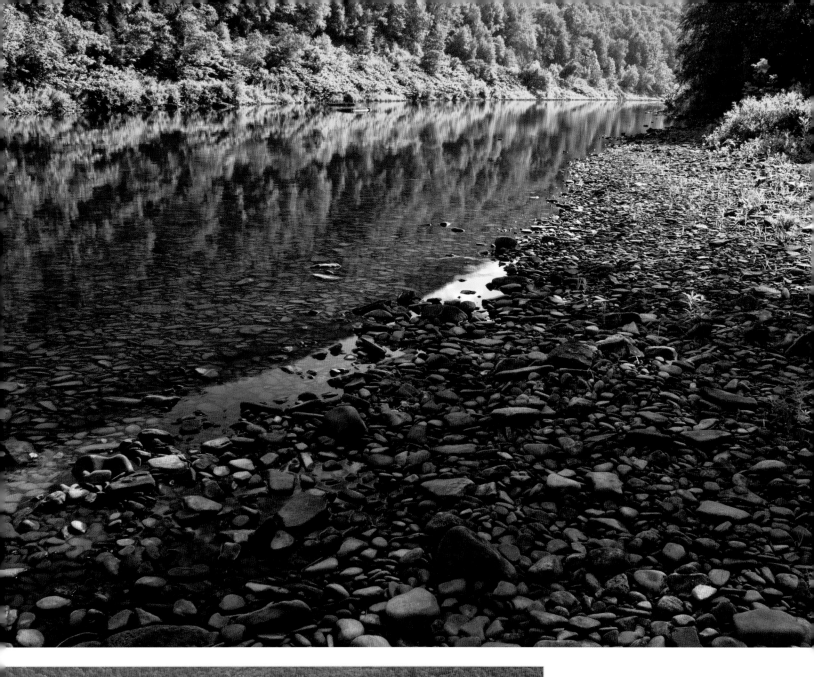

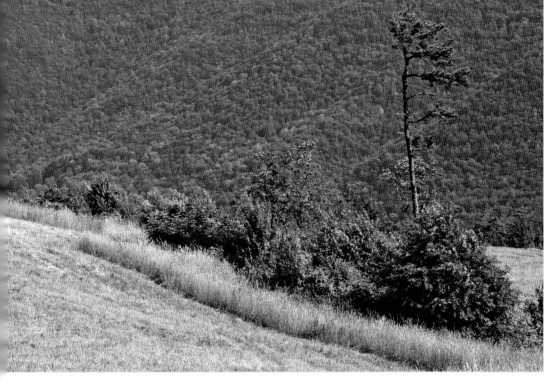

top

The West Branch Susquehanna River in Cameron County flows through a section of the scenic, 75-mile long, Bucktail State Park Natural Area. This natural area stretches along PA 120 from Emporium, through Renovo, to Lock Haven.

bottom

At an elevation of 2,092 feet, the 367-acre clearing at Boyer Run Vista on Mason Hill in Elk State Forest provides summer grazing for Pennsylvania's elk herd. It is the only location in Elk State Forest with a panoramic view.

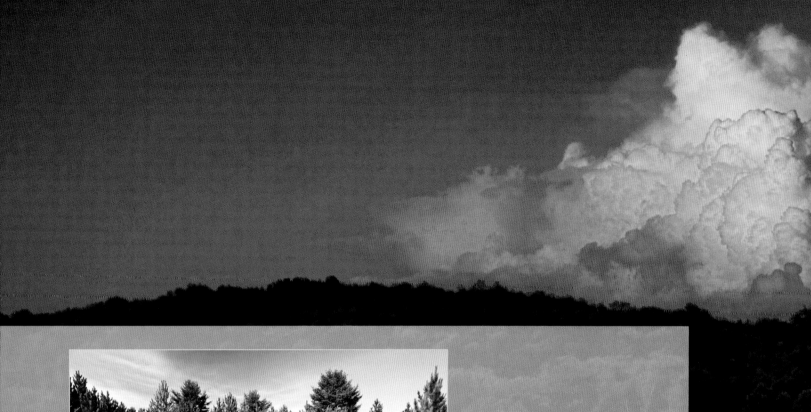

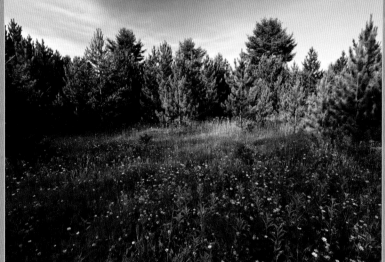

top

A healthy young forest is returning after a fearsome tornado in May of 1985 leveled several acres of forest in Parker Dam State Park. Tornado-damaged areas of the park have not been replanted to demonstrate how forests will regrow if left untouched after a tornado.

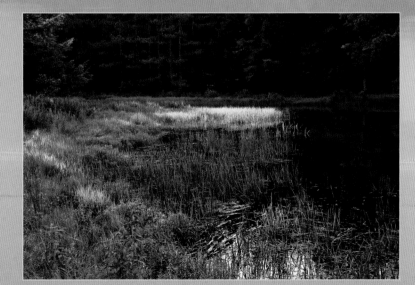

bottom

The 2.3-mile Beaver Dam Trail at Parker Dam State Park leads hikers through a diversity of natural environments consisting of wetlands, forest, and meadows, including active beaver colonies.

background

An awesome anvil-shaped cumulonimbus cloud forming over Lake Lackawanna at Lackawanna State Park on a summer evening. Formed at an altitude of about 500 to 13,000 feet, cumulonimbus clouds produce thunderstorms and other inclement weather.

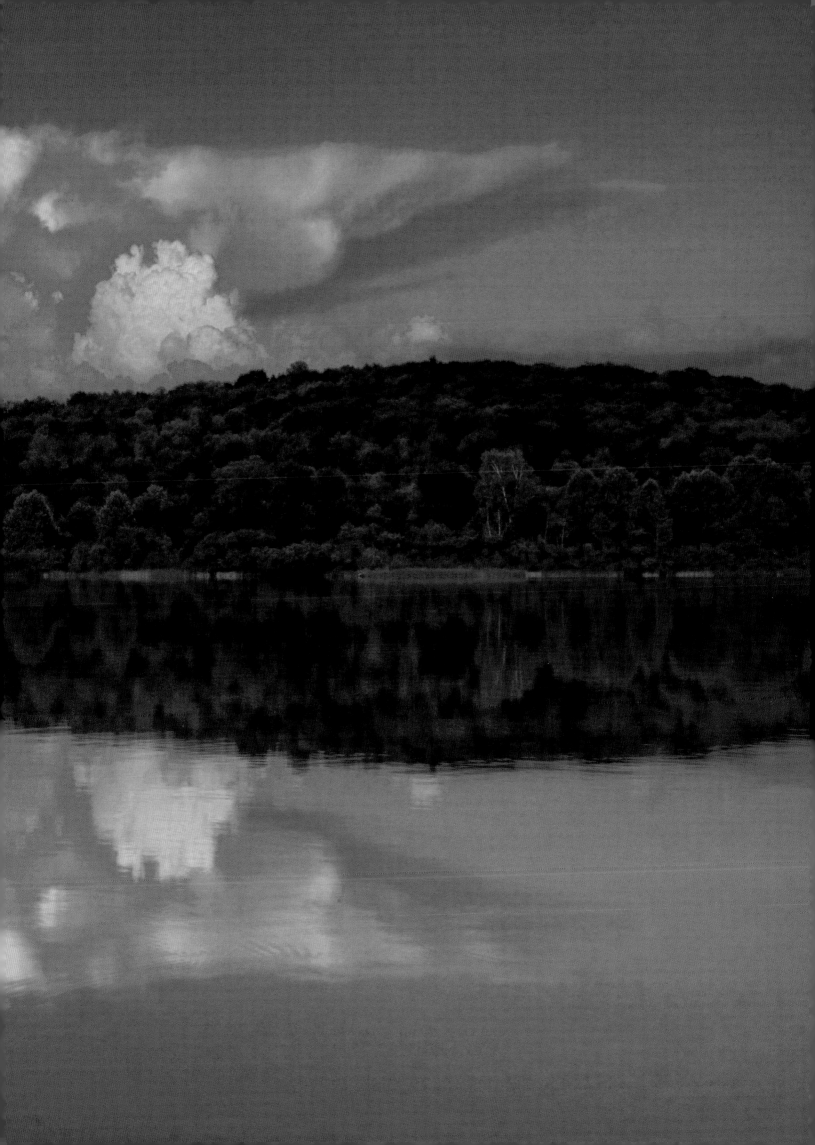

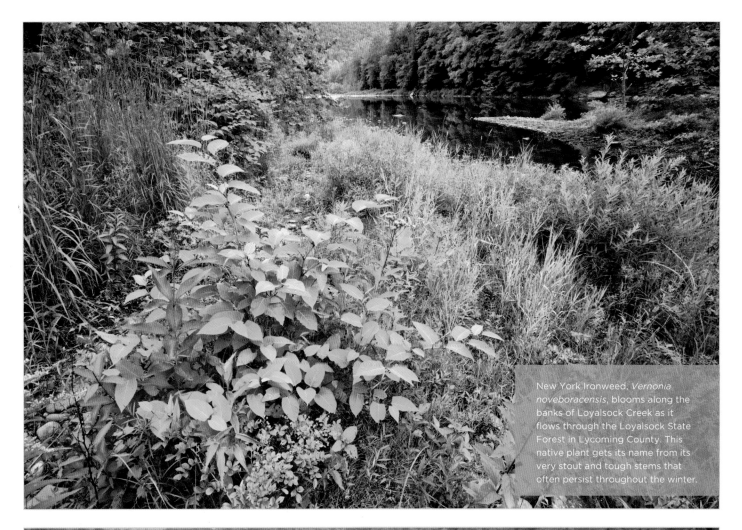

New York Ironweed, *Vernonia noveboracensis,* blooms along the banks of Loyalsock Creek as it flows through the Loyalsock State Forest in Lycoming County. This native plant gets its name from its very stout and tough stems that often persist throughout the winter.

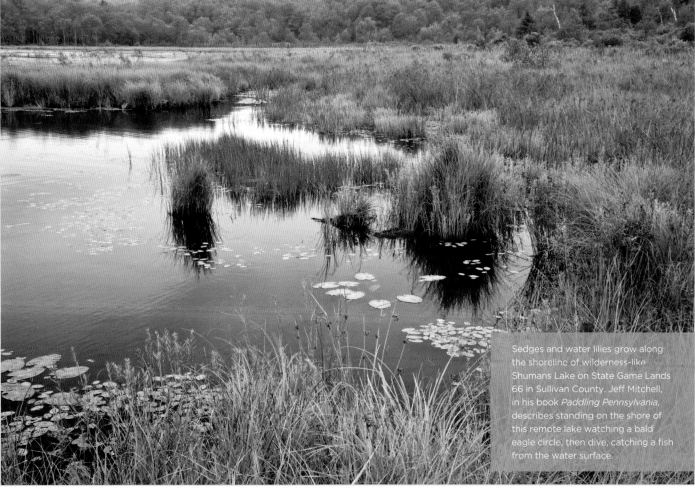

Sedges and water lilies grow along the shoreline of wilderness-like Shumans Lake on State Game Lands 66 in Sullivan County. Jeff Mitchell, in his book *Paddling Pennsylvania,* describes standing on the shore of this remote lake watching a bald eagle circle, then dive, catching a fish from the water surface.

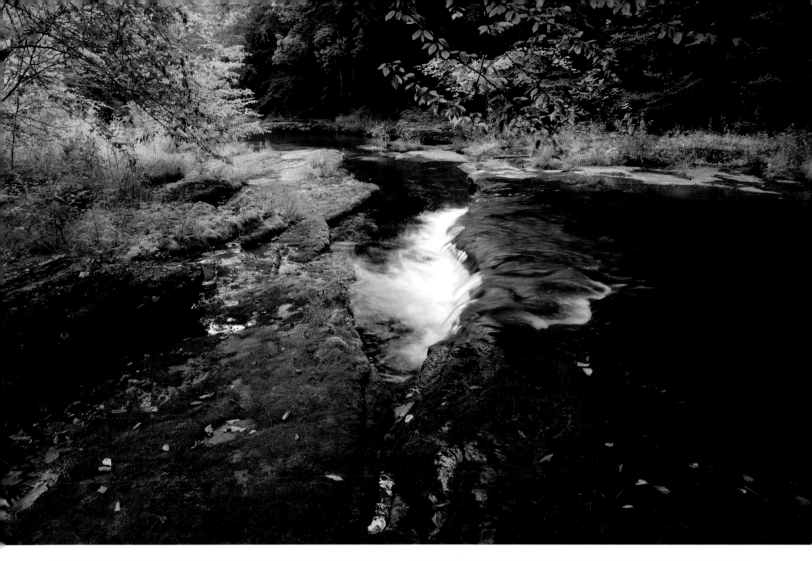

top center

Cedar Run in the Tioga State Forest is one of the most pristine, unpolluted streams in Pennsylvania. A popular trout stream supporting excellent populations of wild brook and brown trout, Cedar Run meets the criteria of a Class A wild trout stream by the Pennsylvania Fish and Boat Commission.

bottom left

Near Shumans Lake in Sullivan County, a very mature forest of eastern hemlock grows. This forest is well on its way to becoming an old-growth forest to be cherished by future generations of nature enthusiasts, ecologists, and botanists.

bottom right

Next to the Algerine Swamp State Forest Natural Area, located in the Tiadaghton State Forest, a beautiful mature forest of planted Norway spruce and native white and red pines provides healthy diversity to the extensive hardwood forest of the area.

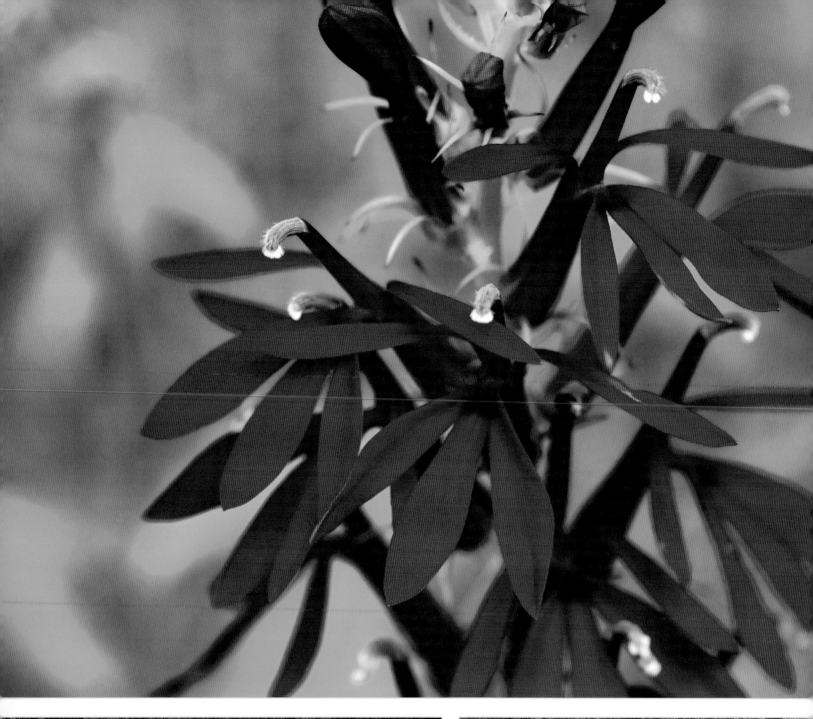

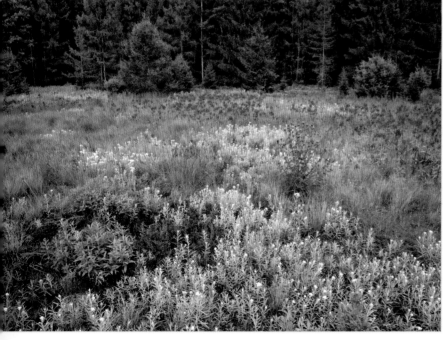

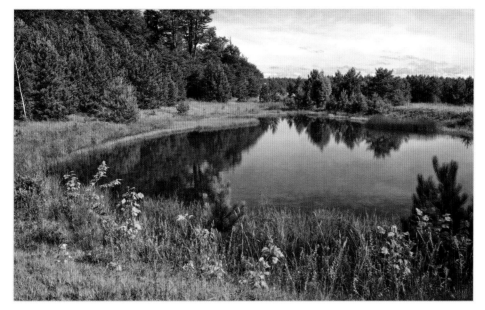

clockwise

The nectar from the brilliant red blossoms of Cardinal flower, *Lobelia cardinalis*, like these blooming along Sinnemahoning Creek in Sinnemahoning State Park, is a favorite food of butterflies and ruby-throated hummingbirds, *Archilochus colubris*, which pollinate the plant while feeding on the nectar.

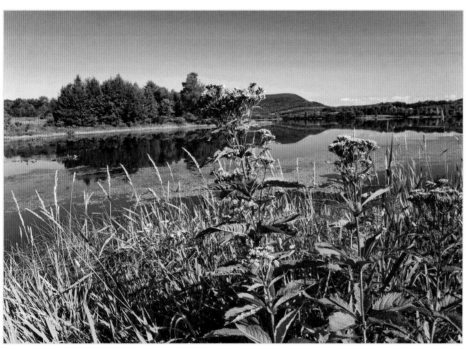

Land that was once blighted for decades with abandoned coal strip mines have now been reclaimed with a rich diversity of environments, including grasslands, tree plantations, and ponds within the Tioga State Forest near Blossburg in Tioga County.

Flowering Sweet Joe-Pye weed, *Eupatorium purpurem*, and goldenrod, *Solidago spp.*, grace the meadows in summer along the shore of the George B. Stevenson Reservoir in Sinnemahoning State Park.

Owned by the Commonwealth of Pennsylvania, Rose Valley Lake in Lycoming County covers 389 acres and is managed by the Pennsylvania Fish and Boat Commission for public fishing and boating. This area is under threat of encroachment due to increased private housing development on surrounding private lands.

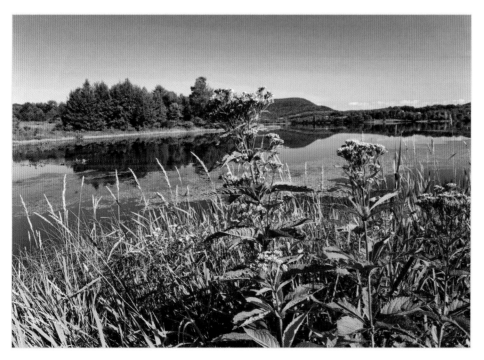

Blue vervain finds favorable growing conditions in the wetlands of Fahneystock Run in the Tioga State Forest. The plant was made into a tea and used by Native Americans and some nineteenth-century physicians to treat ailments such as colds, coughs, and dysentery. It was also used as a "female tonic."

What was once a dam site and small lake on the headwaters of Fahneystock Run in the Tioga State Forest is now a beautiful wetland meadow supporting wildflowers like these blue vervain and pearly everlasting.

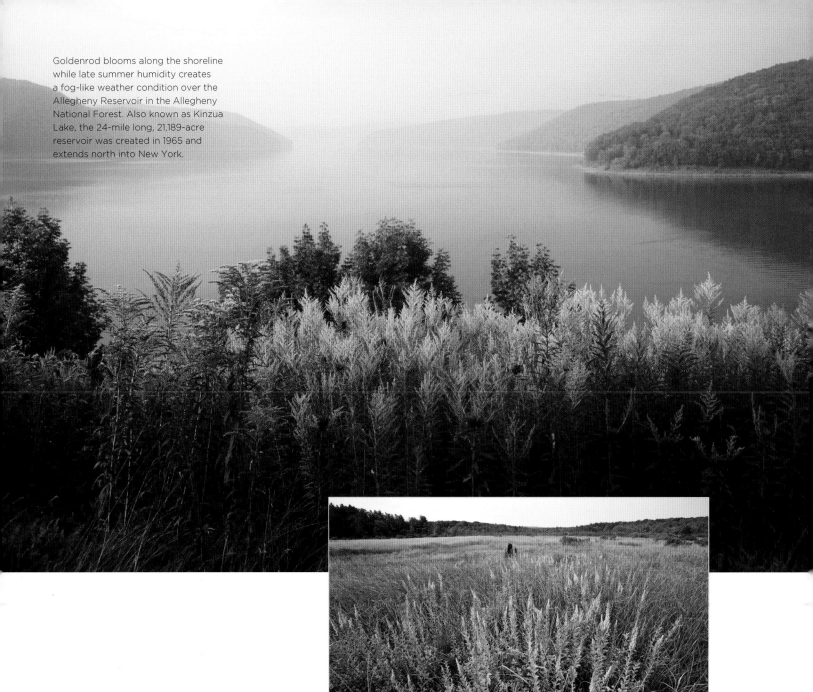

Goldenrod blooms along the shoreline while late summer humidity creates a fog-like weather condition over the Allegheny Reservoir in the Allegheny National Forest. Also known as Kinzua Lake, the 24-mile long, 21,189-acre reservoir was created in 1965 and extends north into New York.

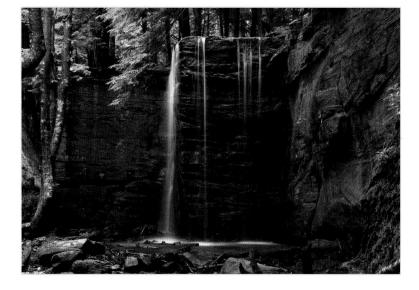

top

Generations of beaver activity and nineteenth-century logging have created large wetland meadows along Black Moshannon Creek in the Moshannon State Forest, making a favorable growing environment for the rose-colored stee-plebush, a species of *spirea*.

bottom

The unique Hector Falls in Pennsylvania's Allegheny National Forest drops 22 feet over massive sandstone blocks, which were exposed in a periglacial environment during the last Ice Age. Located on a small stream, the falls is sometimes dry in late summer.

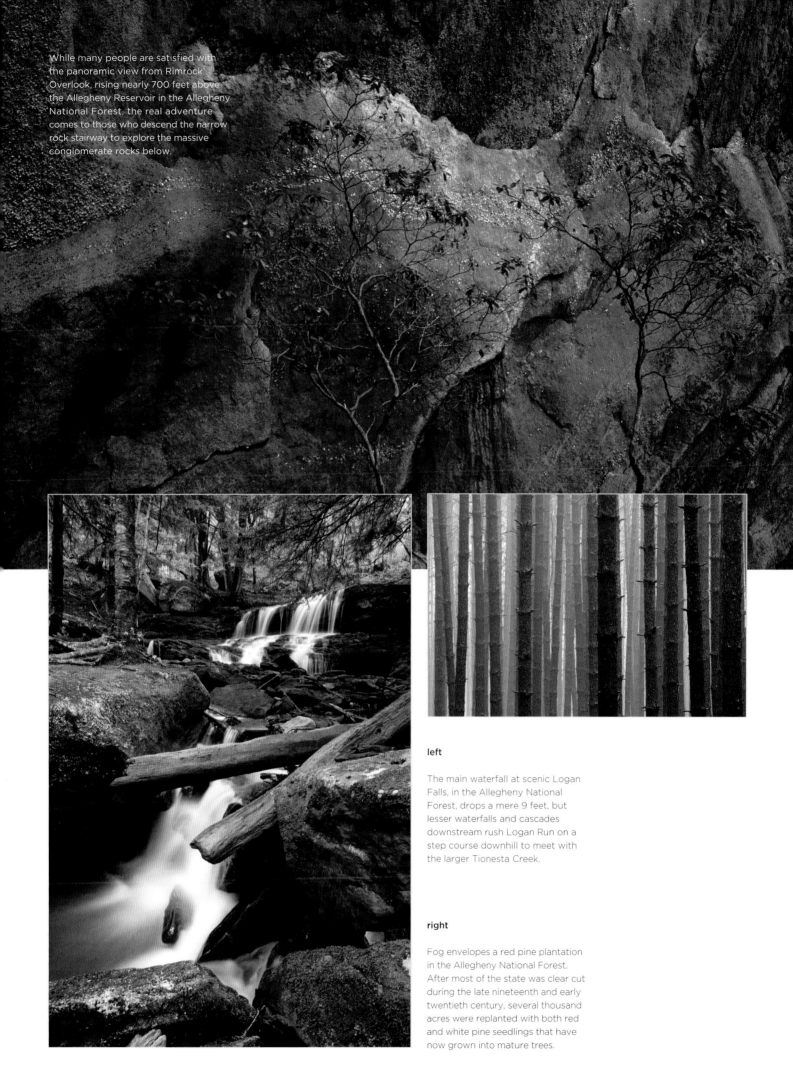

While many people are satisfied with the panoramic view from Rimrock Overlook, rising nearly 700 feet above the Allegheny Reservoir in the Allegheny National Forest, the real adventure comes to those who descend the narrow rock stairway to explore the massive conglomerate rocks below.

left

The main waterfall at scenic Logan Falls, in the Allegheny National Forest, drops a mere 9 feet, but lesser waterfalls and cascades downstream rush Logan Run on a step course downhill to meet with the larger Tionesta Creek.

right

Fog envelopes a red pine plantation in the Allegheny National Forest. After most of the state was clear cut during the late nineteenth and early twentieth century, several thousand acres were replanted with both red and white pine seedlings that have now grown into mature trees.

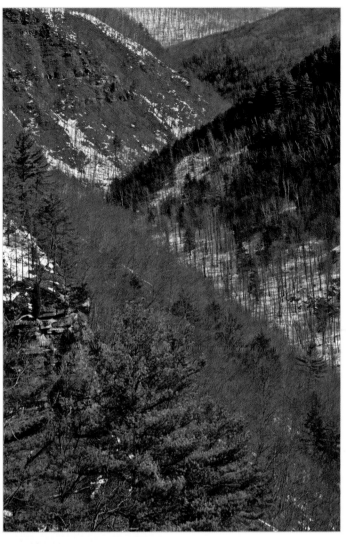

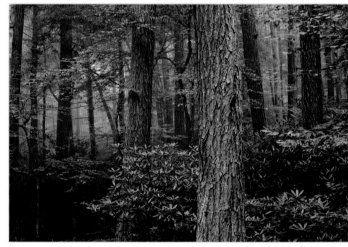

top left

From Colton Point State Park, along the Pine Creek Gorge in Tioga County, there are several overlooks into the Grand Canyon of Pennsylvania. At this location, the gorge is nearly 800 feet deep and 4,000 feet across. Colton Point is listed as one of the "Twenty Must-See Pennsylvania State Parks."

bottom left

A winter snowfall adds to the charm and silence in the old-growth forest at Cook Forest State Park. The park has nine old-growth areas, totaling more than 2,200 acres, and has been called the gem of the Northeast's old-growth woodlands. The "Forest Cathedral" area is designated as a National Natural Landmark.

top right

Fructose lichens grow among lowbush blueberry plants near the Bartlett Mountain balds on State Game Lands 57, Wyoming County. This extraordinarily unique trailless area is only accessible through bushwhacking. Jeff Mitchell has said, "(this is) one of the most memorable places I ever explored. It was absolutely amazing."

bottom right

Cook Forest State Park in Forest and Clarion Counties contains a 1,500-acre old-growth forest of 250- to 400-year-old white pine and eastern hemlock trees. Some trees reach more than 180 feet high and are 48 inches in diameter. Anthony W. Cook donated the land to the Commonwealth in 1928.

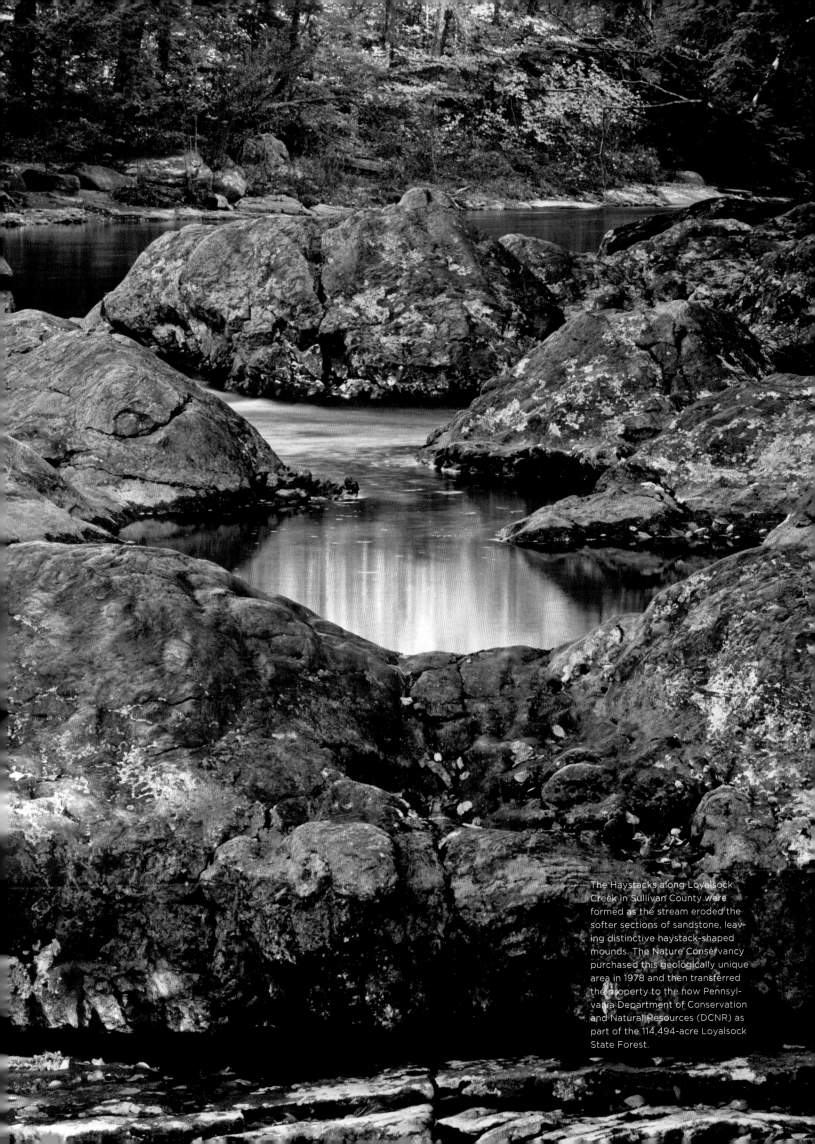

The Haystacks along Loyalsock Creek in Sullivan County were formed as the stream eroded the softer sections of sandstone, leaving distinctive haystack-shaped mounds. The Nature Conservancy purchased this geologically unique area in 1978 and then transferred the property to the now Pennsylvania Department of Conservation and Natural Resources (DCNR) as part of the 114,494-acre Loyalsock State Forest.

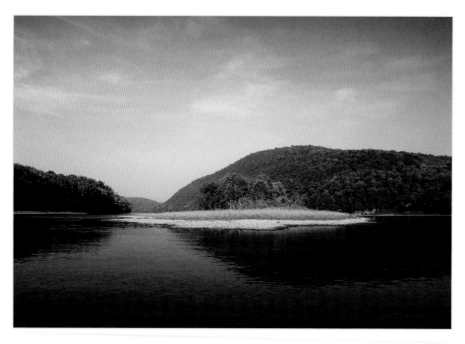

top

The North Branch Susquehanna River, flowing through Pennsylvania's Endless Mountains in Bradford County. Many islands dot the 464-mile long Susquehanna, which ranks as the 16th largest river in the United States and is a major water source of Chesapeake Bay.

bottom left

The 25 feet high, 13.5 feet wide, Standing Stone, a natural monolith in the North Branch Susquehanna River in Bradford County, was formed by a landslide that occurred on a slope above the river. Geologists believe the stone has been standing in this position between 8,000 to 10,000 years.

bottom right

Many people consider Rock Run to be the most beautiful stream in Pennsylvania, due in part to its isolated, forested location and because it has cut its course through solid rock. Since it doesn't have designated trails and does have often-steep, slippery conditions, it is a place reserved for the experienced hiker.

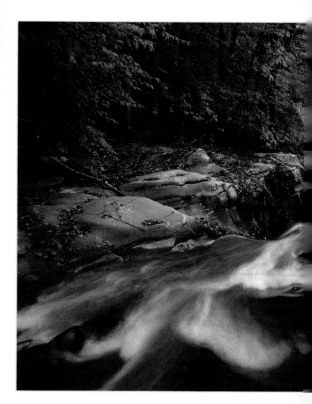

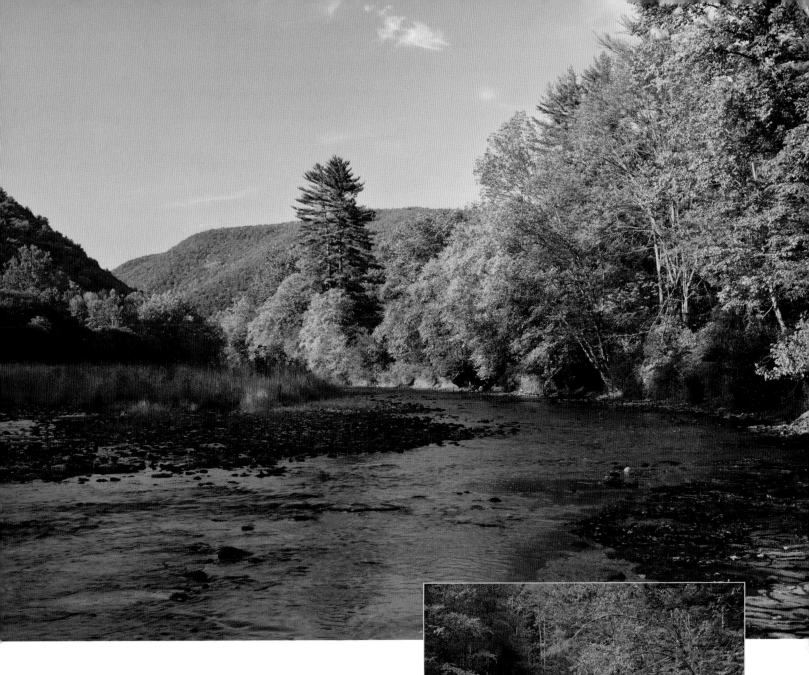

top

The splendor of autumn is reflected in Kettle Creek as it flows through Kettle Creek State Park in Clinton County. Beginning in Tioga County, the 43-mile creek is a tributary of the West Branch Susquehanna River. Ninety percent of the creek's watershed is located on state forest and state park lands.

bottom

Backpacker magazine voted Rock Run in the Loyalsock State Forest as one of the best swimming holes in the United States, although it is for the very brave of heart, as the chilly waters of the pristine stream never warm, even during mid-summer.

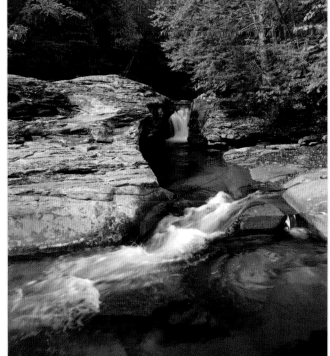

top

During late summer and early autumn, as cool air sinks into the steep valleys of north central Pennsylvania, mist will form over night, then evaporate in the morning sun, as seen here in Little Pine Creek Valley in the Tiadaghton State Forest.

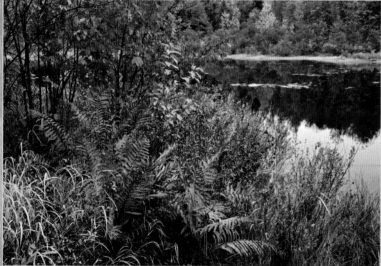

center

Beavers have created a wetland wildlife habitat haven along Fiddle Lake Creek on State Game Lands 236 in Susquehanna County. Many species of birds, amphibians, mammals, and fish will now find a suitable habitat, while other species that require swift flowing streams will be displaced.

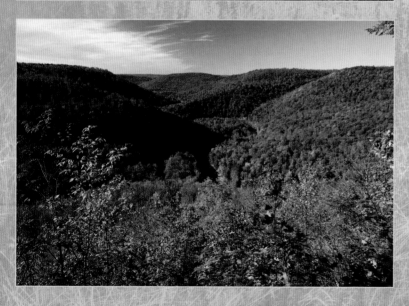

bottom

Canyon Vista, with its 270-degree view in the Loyalsock State Forest above Worlds End State Park, is one of the most famous vistas in Pennsylvania. A major outdoor clothing manufacturer has even used it as a background for a fashion photo shoot.

background

The 144-acre Cranberry Swamp State Forest Natural Area, preserved in the Sproul State Forest in Clinton County, has remained virtually unchanged since 1915, when the large trees that grew here were logged from the wetland.

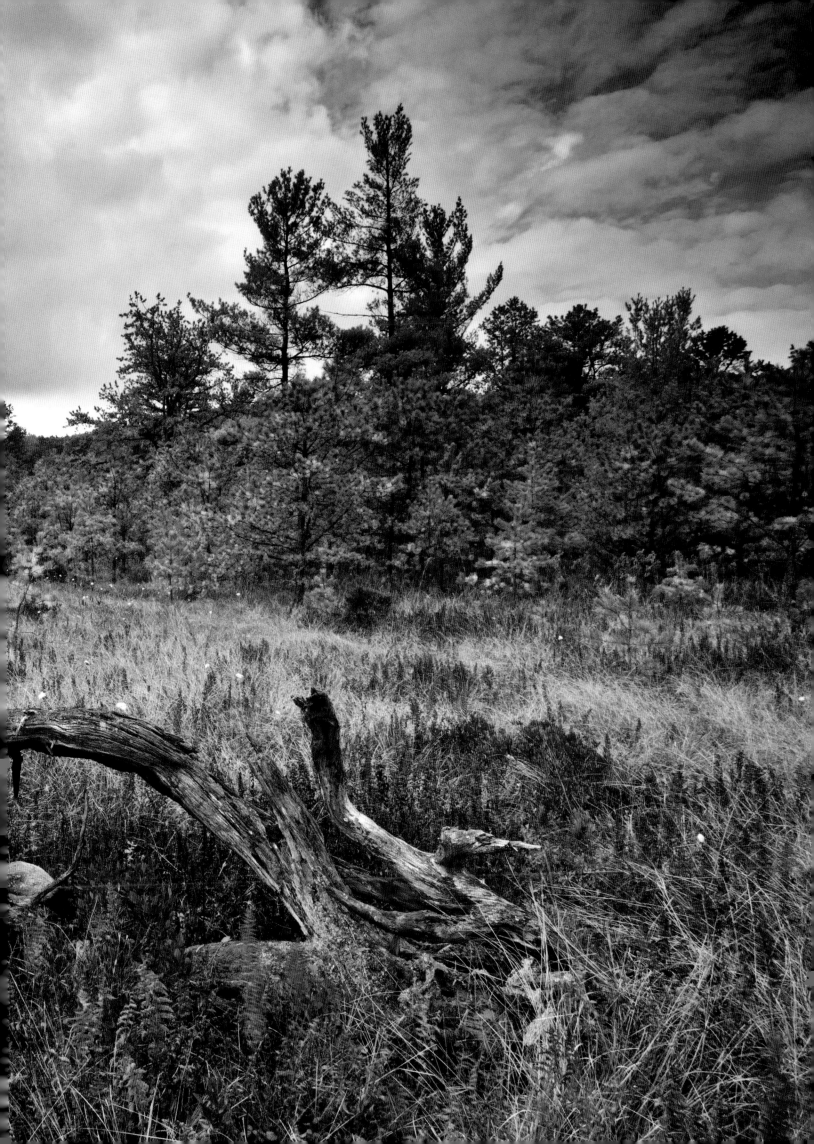

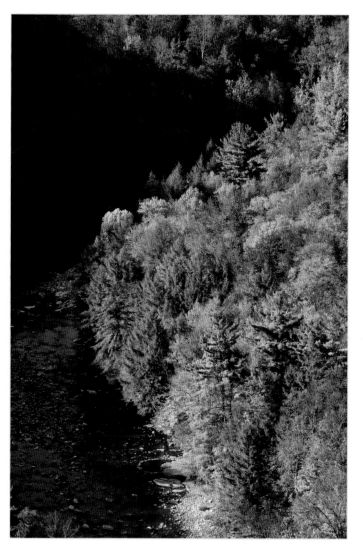

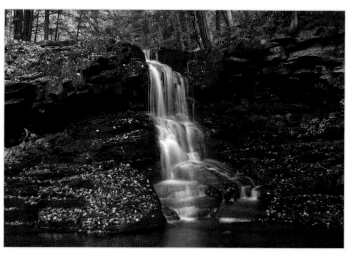

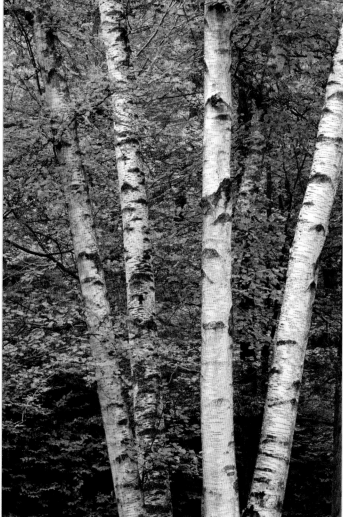

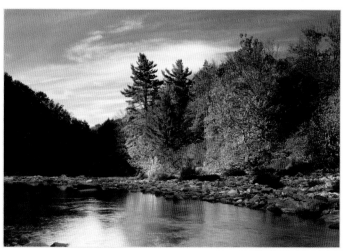

top left

From an elevation of 1,750 feet above sea level, an observer standing at Canyon Vista can look down 530 feet to the Loyalsock Creek below, as it cuts its course through the Appalachian Plateau of Pennsylvania's Endless Mountains in Sullivan County.

bottom left

A portion of the 64-mile long Loyalsock Creek runs through Worlds End State Park in Sullivan County. The name Loyalsock is believed to be a Native American phrase, *Lawi-sahquick*, meaning "middle-creek."

top right

The highly picturesque, 14 feet high, Dry Run Waterfalls, in the Loyalsock State Forest, is easily accessible just a few feet off a state forest road and next to a small picnic area. During dry summers, the falls may be reduced to only a trickle of water.

bottom right

Paper birch trees, *Betula papyrifera*, are generally associated with a northern type forest and are common in the Tioga State Forest. Rarely growing more than 70 feet high in Pennsylvania, the short-lived tree has more picturesque value than it has timber value.

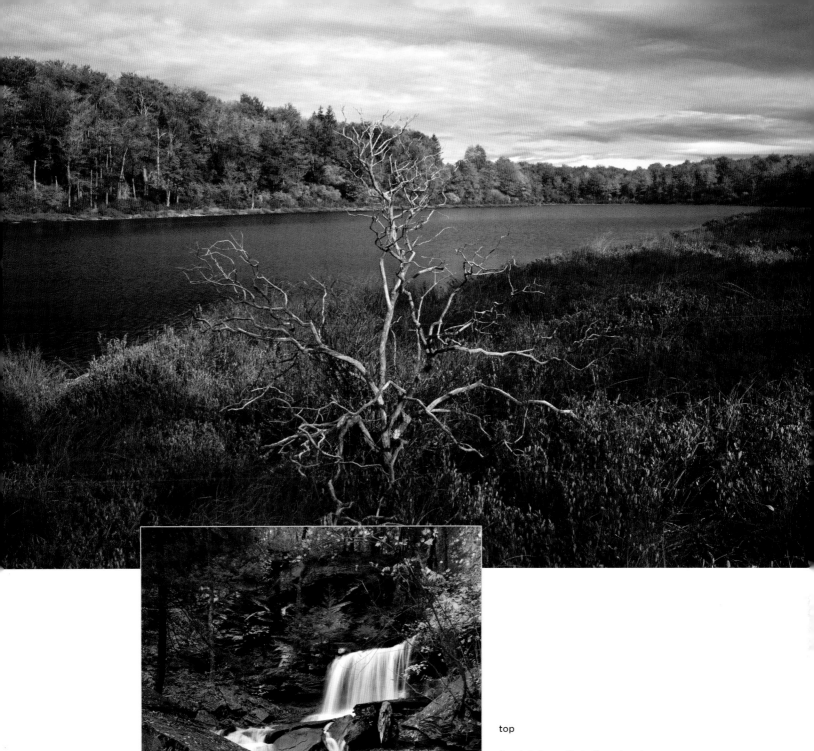

top

Beach Lake on State Game Lands 57 in Luzerne County is a small natural lake of approximately 20 acres in size. Because of its high elevation in a cool environment, ice was commercially cut and harvested here for refrigeration during the late nineteenth and early twentieth centuries.

bottom

Many people feel that the 40 feet high, B. Reynolds Falls along Leigh Glen in Ricketts Glen State Park, may be the most picturesque of the 22 named waterfalls found in the park. For others, it is an impossible task to choose the single most scenic falls, as all would qualify.

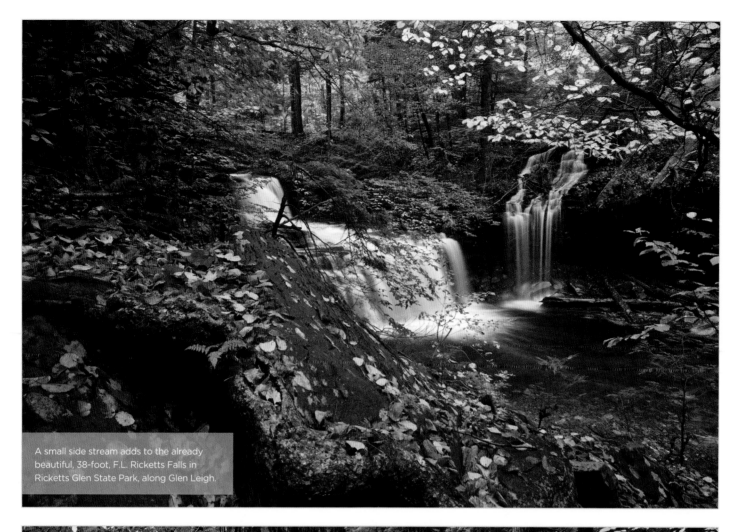

A small side stream adds to the already beautiful, 38-foot, F.L. Ricketts Falls in Ricketts Glen State Park, along Glen Leigh.

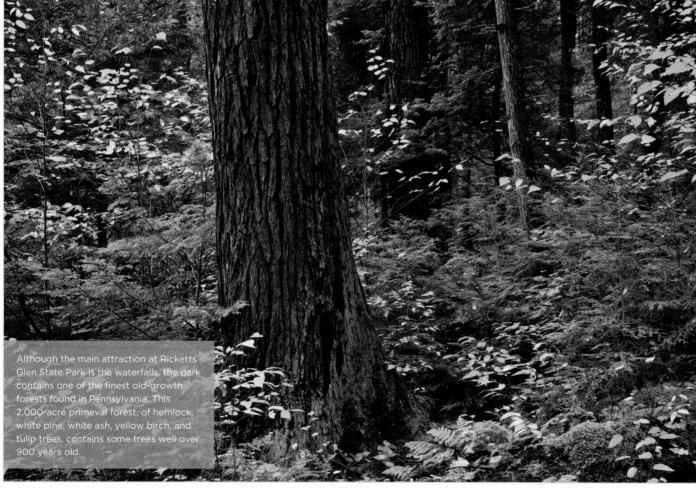

Although the main attraction at Ricketts Glen State Park is the waterfalls, the park contains one of the finest old-growth forests found in Pennsylvania. This 2,000-acre primeval forest, of hemlock, white pine, white ash, yellow birch, and tulip trees, contains some trees well over 900 years old.

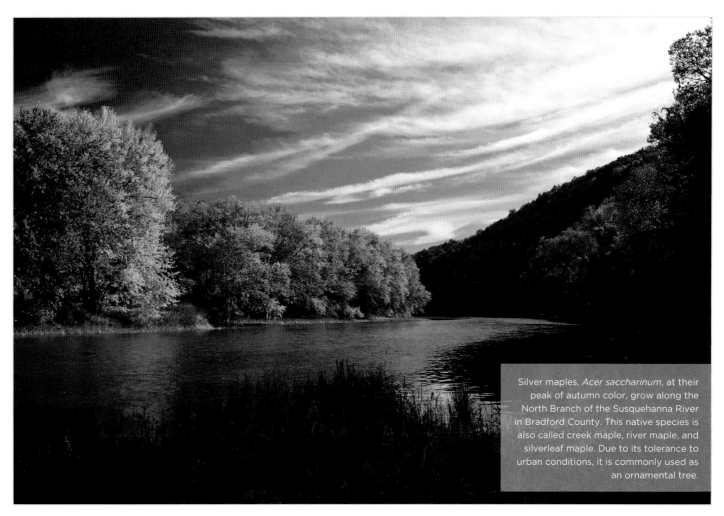

Silver maples, *Acer saccharinum*, at their peak of autumn color, grow along the North Branch of the Susquehanna River in Bradford County. This native species is also called creek maple, river maple, and silverleaf maple. Due to its tolerance to urban conditions, it is commonly used as an ornamental tree.

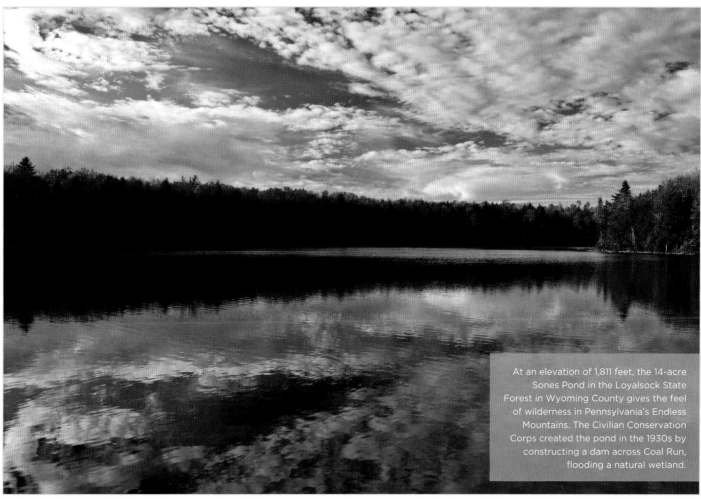

At an elevation of 1,811 feet, the 14-acre Sones Pond in the Loyalsock State Forest in Wyoming County gives the feel of wilderness in Pennsylvania's Endless Mountains. The Civilian Conservation Corps created the pond in the 1930s by constructing a dam across Coal Run, flooding a natural wetland.

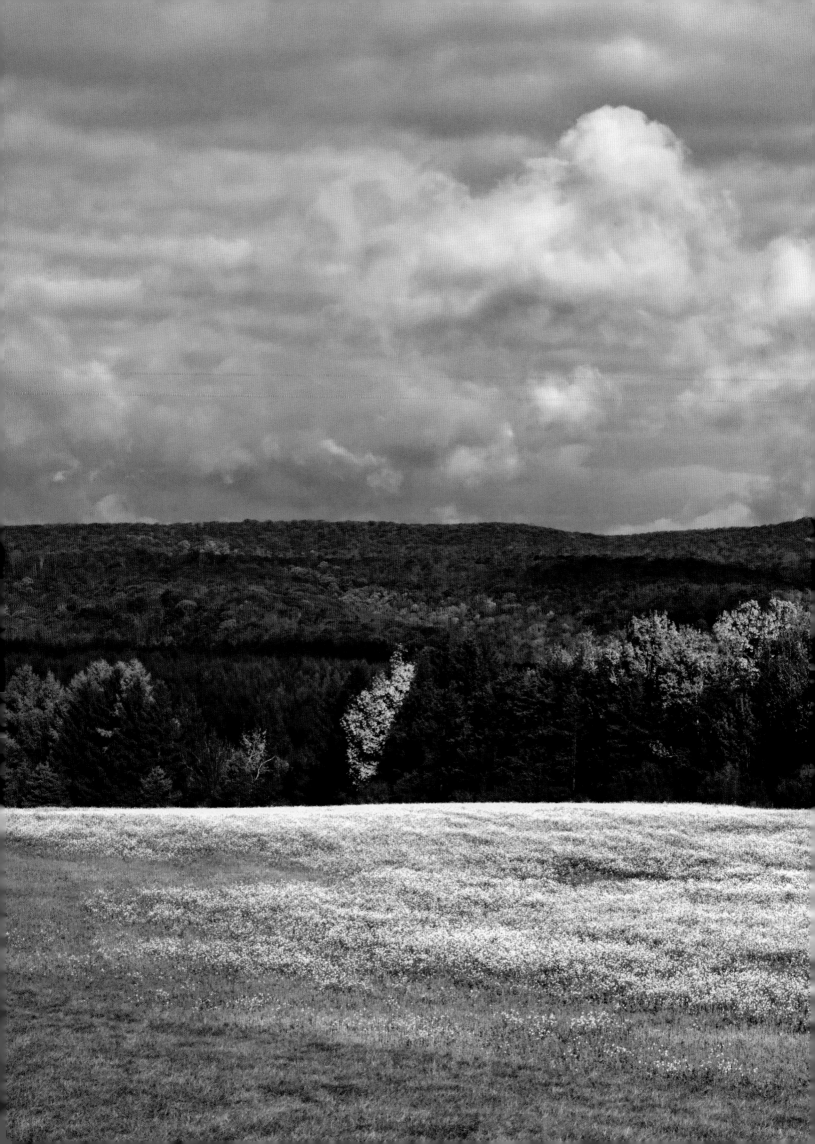

top

In late summer and early fall, visitors, arriving early to Hyner View State Park in Clinton County to catch the morning sunrise, may have to wait for the morning mist to clear. Some days mist lingers for hours, while other days it evaporates in minutes, right before the visitor's eyes.

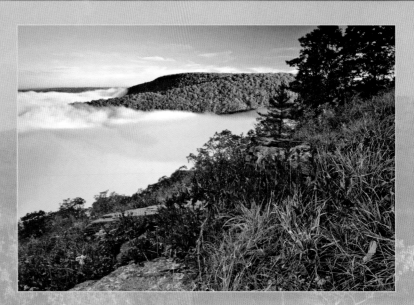

bottom

When fog settles in the West Branch Susquehanna River Valley and then climbs the slope of Hyner Mountain in Clinton County, it provides a rich palette that inspires artists in all the disciplines.

background

The elk habitat management area, on Winslow Hill on State Game Lands 311 in Elk County, offers not only exceptional elk viewing but also some incredible natural scenery. Elk viewing brings thousands of people to this area every year to see one of the largest elk herds in the East.

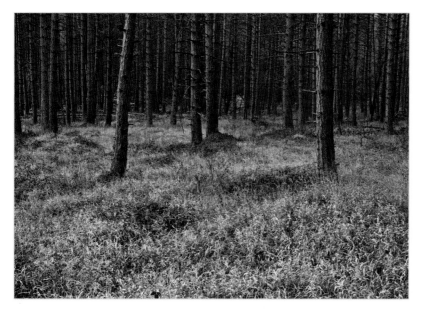

top

An unusual grassy savannah has formed in the red pine plantation in the Allegheny National Forest near Loleta.

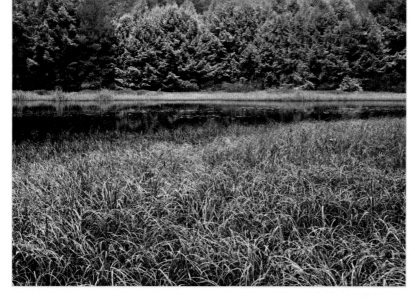

center

An early winter snow squall falls on the marsh at Black Moshannon Lake in Black Moshannon State Park, Centre County. With 1,592 acres of wetlands, this is the largest reconstituted bog/wetland complex in Pennsylvania. It was designated as the "Black Moshannon Bog Natural Area" in 1994, for its "unique scenic, geologic or ecological value."

bottom

Wind-blown snow from a November squall streaks across the newly frozen ice on Black Moshannon Lake at Black Moshannon State Park. The 250-acre lake has an elevation of 1,900 feet and was formed when the original Civilian Conservation Corps-built dam was replaced in the early 1950s.

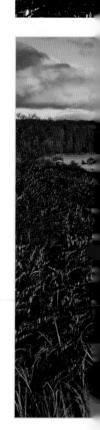

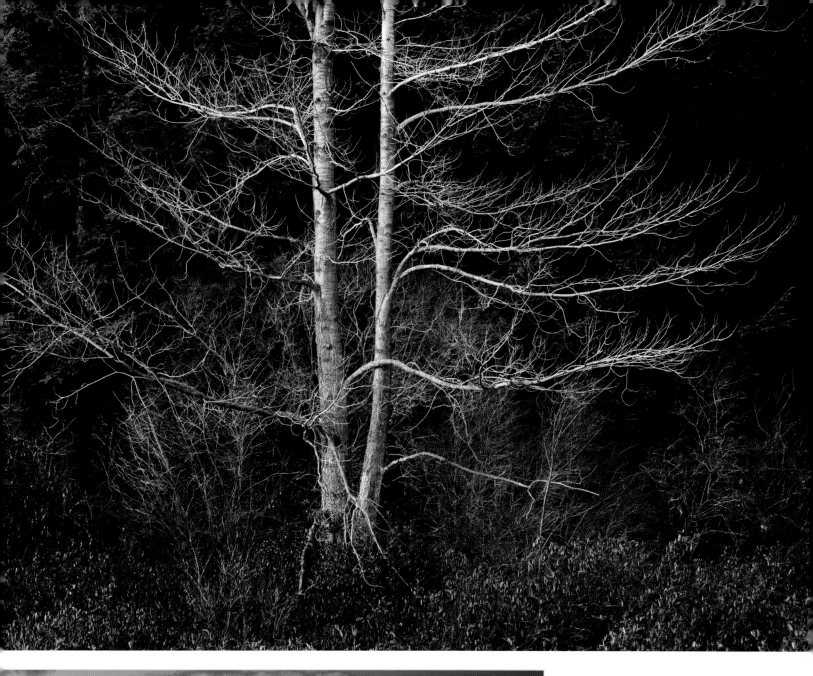

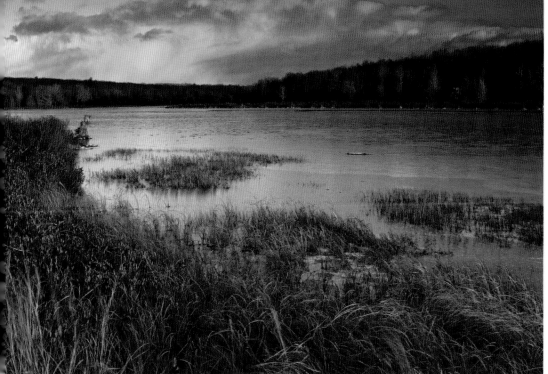

top

A red maple tree, *Acer rubrum*, in the Black Moshannon Bog at Black Moshannon State Park, waits out winter until the warming April sun forces its dormant flower buds to burst open, signaling one of the first sure signs of spring.

bottom

Passing snow squall clouds reflect the warm setting sun to create a juxtaposition of colors over newly frozen Black Moshannon Bog at Black Moshannon State Park. The bog and nearby state forest and game lands are part of a 45,667-acre, designated Important Bird Area, in which 175 species have been recorded.

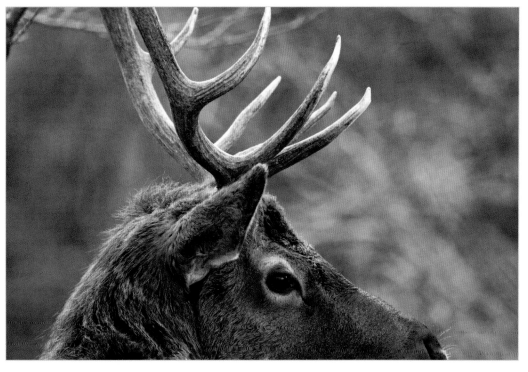

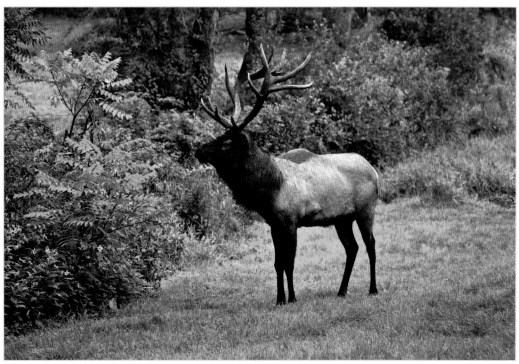

top left

Native to Pennsylvania, elk were exterminated by 1867 through unregulated hunting. In the early twentieth century, elk were reintroduced from the Rocky Mountains and now, with proper management by the Pennsylvania Game Commission, they have increased in population to even allow for a limited hunting season.

bottom left

A handsome bull elk in his prime during the autumn rutting season in Elk County. Each year the bulls grow a new set of antlers, which can reach 4 to 5 feet in length. Their antlers are shed in late winter or early spring.

top center

American sycamores growing in Sinnemahoning State Park. These white-bark trees are found along watercourses throughout the state and can obtain a large size, reaching more than 130 feet in height and a trunk diameter greater than 60 inches. The hollow trunks occurring on old trees provide nesting cavities for wood ducks.

bottom center

The Sinnemahoning Creek in the Bucktail State Park Natural Area cuts its course through the Deep Valleys Section of the Appalachian Plateaus Province in Clinton County. The area was named to commemorate the Bucktail Regiment, Pennsylvania Reserves from Cameron County, who fought for the Union in the Civil War.

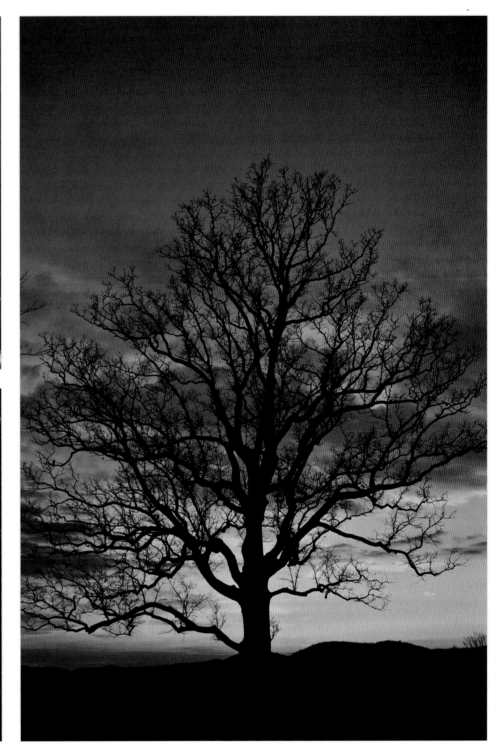

right

A stately old white oak tree,
Quercus alba, is silhouetted in a
winter's sunset on the shore of
Foster Joseph Sayers Lake at Bald
Eagle State Park in Centre County.
One of the longest living eastern
trees, some white oak trees have
been documented to be more than
400 years old.

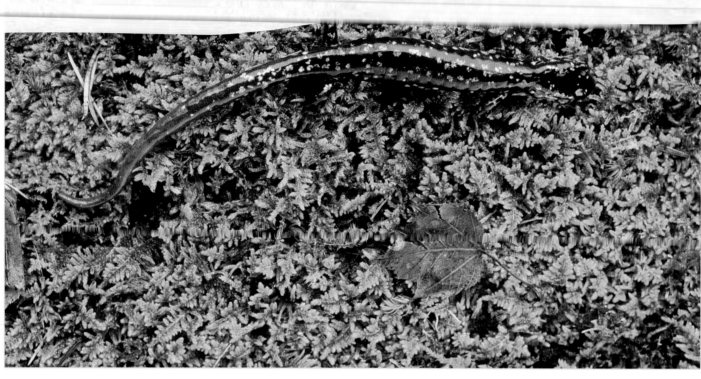

Found in scattered locations throughout Pennsylvania, the 6-inch northern slimy salamander, *Plethodon glutinosus*, prefers dense forested ravines and hillsides. Harmless to humans, this salamander has a distinctive defense mechanism: its skin secretes a large amount of sticky glue-like fluid that compromises a predator's ability to chew.

Located in northern Monroe County, in the heart of Pennsylvania's Pocono Mountains, is an attractive village named Canadensis. Some people wonder, "why such a strange name," but those who know Latin realize that it means "of Canada." And this is a well-chosen name, for nowhere else in Pennsylvania is there such a variety and concentration of landforms, plants, and animals representative of Canada than here in the Poconos.

Geologically part of the Appalachian Plateau province and an extension of New York's Catskill Mountains, the Poconos are not really mountainous; rather the area is a high plateau with elevations up to 2,300 feet. But the Poconos were glaciated at least three times in the last several million years, leaving behind hundreds of natural wetlands, bogs, lakes, and ponds; the greatest concentration in the state. These wetlands, along with the high elevation, and its often-severe, cold weather, resulted in a cool and moist environment, not unlike Canada. Many northern species, that retreated north with the warming climate and receding glaciers at the end of the last Ice Age, found a suitable habitat in the Poconos and stayed.

Boreal tree species, such as red and black spruce, tamarack, and balsam fir, can be found in other parts of the state in isolated populations, but in the Poconos they are common. Rhodora and bog laurel reach their most southern point in the Poconos. The snowshoe hare also stayed to forage around the bogs. The Poconos were also the last refuge for the river otter, before it was reintroduced in other parts of the state.

But it's not all wet and boggy. There is a natural ecological community called the mesic till barrens complex found only on the Pocono Plateau. This natural community occurs nowhere else in the world. It is a mixture of wet and xeric soil conditions and is said to contain at least 30 regionally rare and 10 globally rare species.

Actually, there are two Poconos: the Pocono Plateau on the northwest and the Glaciated Low Plateau, with a nearly 1,300-foot escarpment dividing the two. Along the edge of this escarpment, at least 50 named waterfalls are located along with numerous unnamed falls. Yet the biggest surprise to many people is the desert-like conditions found on the shale ledges in Pike County, above the Delaware River, where native prickly-pear cactus, more typical of the American Southwest, has found a fitting home, sometimes within a few hundred yards of a boreal, Canadian-like bog.

CHAPTER 3

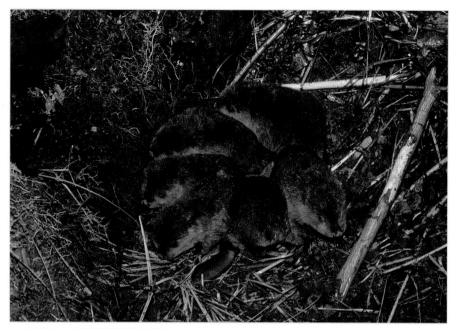

top

Beaver kits are generally born inside a secure, well-protected lodge. Here, however, a female beaver, probably displaced from her lodge, gave birth inside a hollow tree trunk along the East Branch Wallenpaupack Creek in Pike County. She also had a large litter of 6 kits, with 4 being the average.

bottom left

Found growing in damp meadows and swamp edges throughout Pennsylvania, the uncommon and strikingly beautiful greater purple fringed orchid, *Platanthera grandifolia*, blooms in June and July. It has evolved a unique cross-pollination method involving moths to carry the pollen from one flower to another.

bottom right

Gray birch trees, *Betula populifolia*, bend from the weight of an ice storm at Tobyhanna State Park. The trunk of the gray birch is so uniquely flexible that as the ice melts, the tress will straighten without any lasting damage.

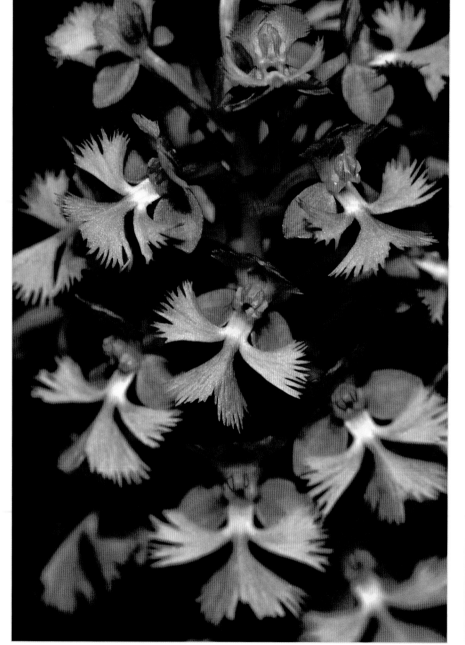

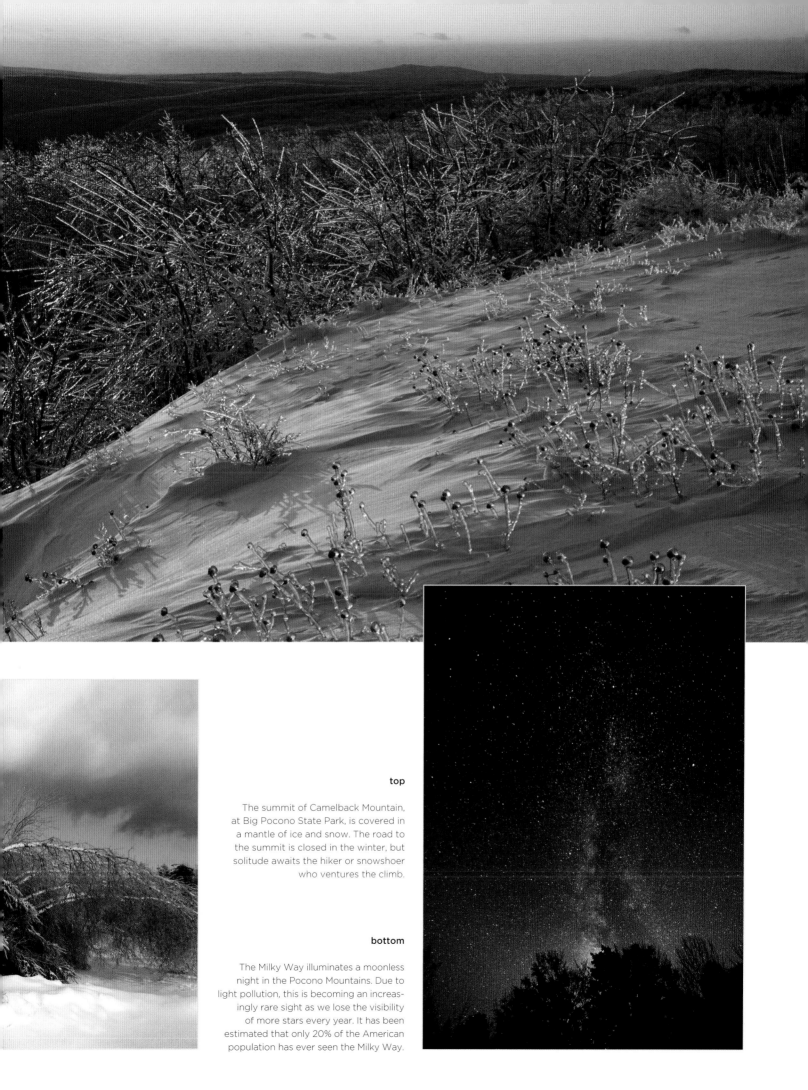

top

The summit of Camelback Mountain, at Big Pocono State Park, is covered in a mantle of ice and snow. The road to the summit is closed in the winter, but solitude awaits the hiker or snowshoer who ventures the climb.

bottom

The Milky Way illuminates a moonless night in the Pocono Mountains. Due to light pollution, this is becoming an increasingly rare sight as we lose the visibility of more stars every year. It has been estimated that only 20% of the American population has ever seen the Milky Way.

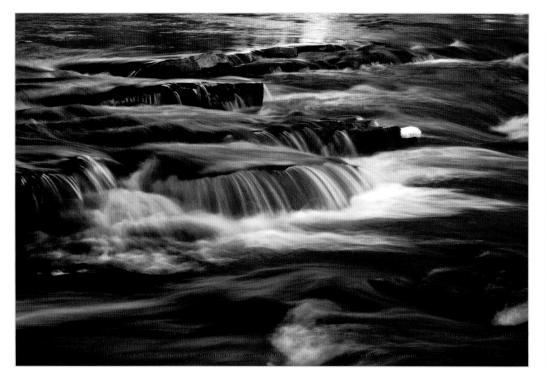

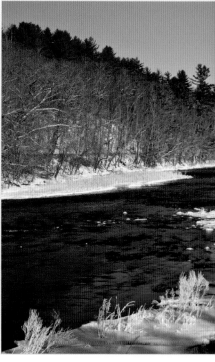

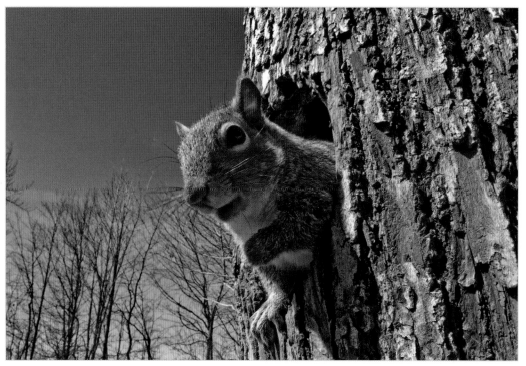

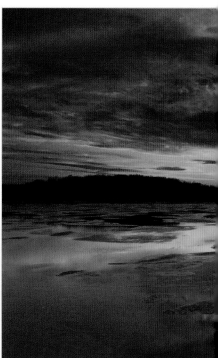

top left

The upper reaches of the 109-mile Lehigh River, on the border of Lackawanna and Monroe counties, reflects the orange color of winter's clinging beech leaves.

bottom left

An eastern gray squirrel, *Sciurus carolinensis*, peaks out from a tree cavity made by a pileated woodpecker to survey his territory in southern Wayne County.

top center

Hoar frost has formed on the vegetation growing on some small islands in the Lackawaxen River flowing through Pike County. The lower reach of the river, between Lake Wallenpaupack and the confluence with the Upper Delaware River, is an important wintering area for bald eagles.

bottom center

Mid-March brings the ice break-up to the numerous lakes in the Pocono Mountains. Here, on Lower Lake at Promised Land State Park, the late winter sun is melting the top layer of ice.

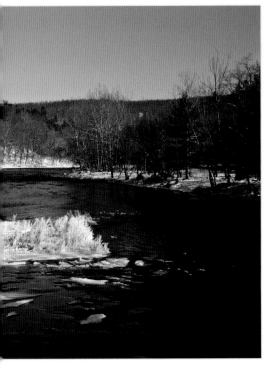

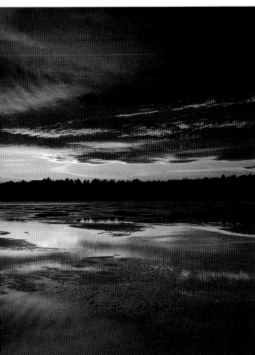

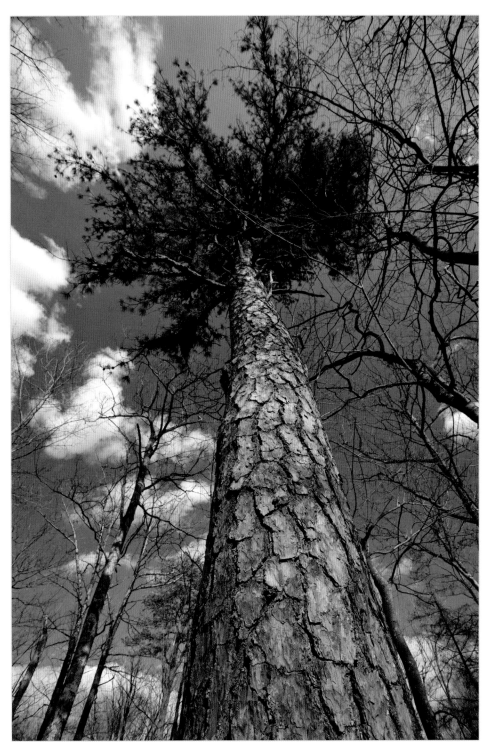

right

A large pitch pine, *Pinus rigida*, is found growing in the Delaware State Forest in eastern Pike County. Ranging from southern Canada to northern Georgia, the species is known to make its best growth in Pike County, Pennsylvania.

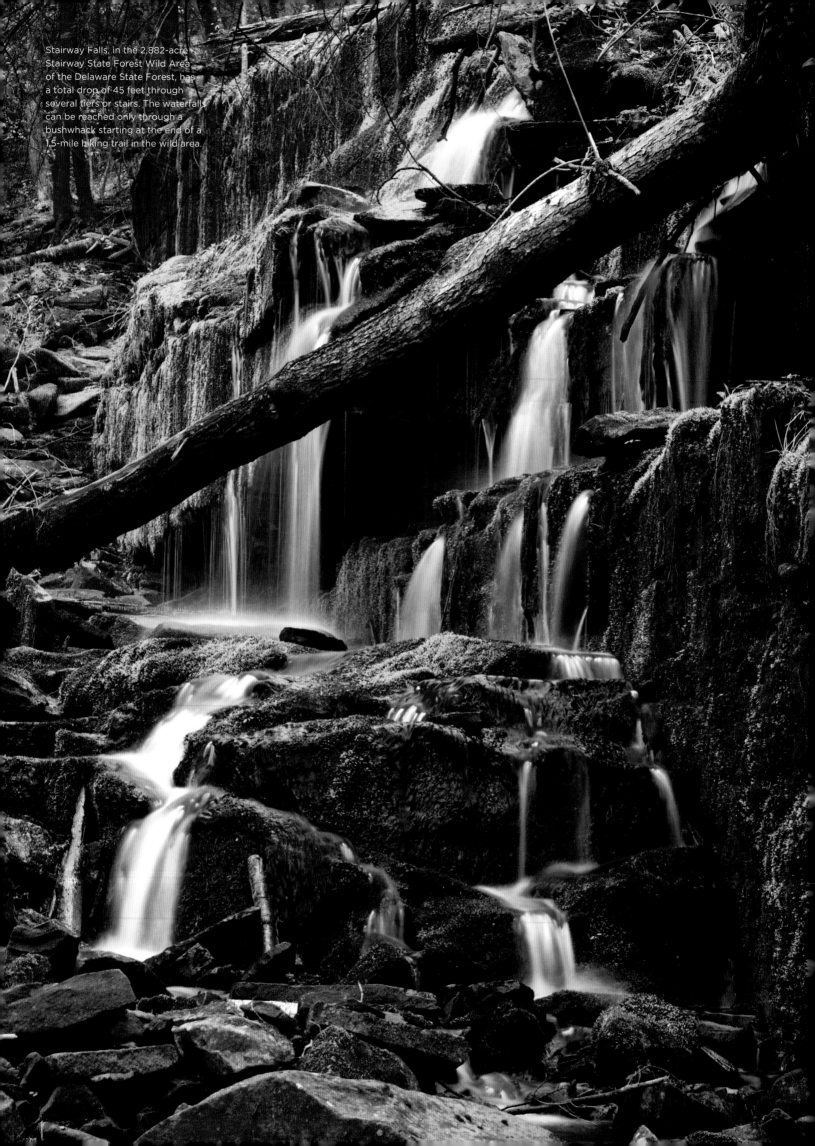

Stairway Falls, in the 2,882-acre Stairway State Forest Wild Area of the Delaware State Forest, has a total drop of 45 feet through several tiers or stairs. The waterfalls can be reached only through a bushwhack starting at the end of a 1.5-mile hiking trail in the wild area.

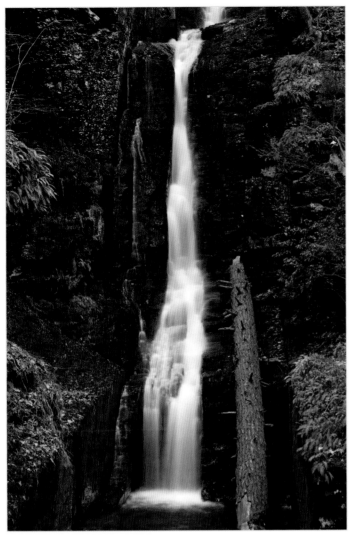

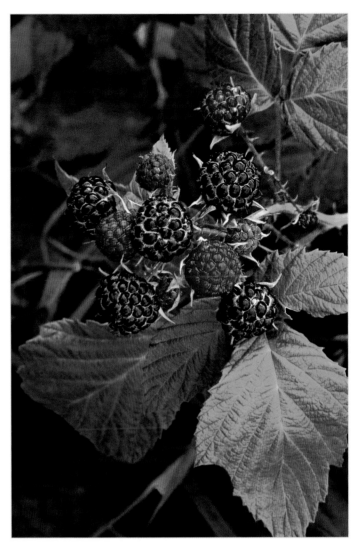

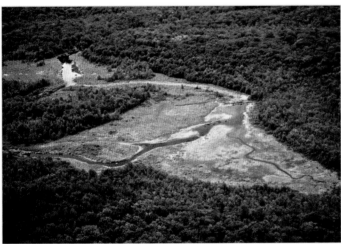

top left

The remarkably scenic Silverthread Falls, in the Delaware Water Gap National Recreation Area, drops a total of 80 feet through a narrow rock fracture. In winter the frozen falls is a popular ice-climbing site for those trained and experienced in the highly technical sport.

bottom left

The dam upstream from Warnertown Falls, built in the nineteenth century to create a lake for ice harvesting, was breached by the floodwaters of Hurricane Diane in 1955. Today, more than 50 years later, the former lakebed is reverting back to wetlands and providing habitat for beavers, otters, and mink.

top right

Also called black caps, black raspberry, *Rubus occidentalis*, grows in woodland openings in the state's mountainous regions. Besides being a tasty treat for humans and wildlife alike, the berries have an extremely high concentration of anthocyanins, which is offering promising research results in inhibiting certain forms of cancer.

bottom right

At 2,265 feet, the summit of Pine Hill, in Lackawanna State Forest, contains a heath barren on the thin rocky soil. Heath barrens are primarily composed of drought-resistant plants, such as blueberries, sheep laurel, pitch pine, and scrub oak.

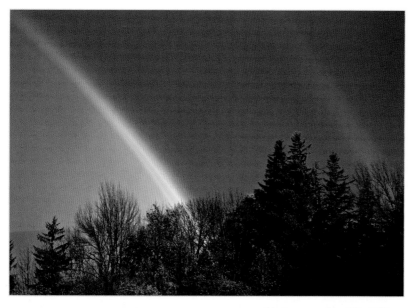

top

Rainbows, like this double rainbow in the northern Poconos of southern Wayne County, have been inspiring humans since before the start of recorded time.

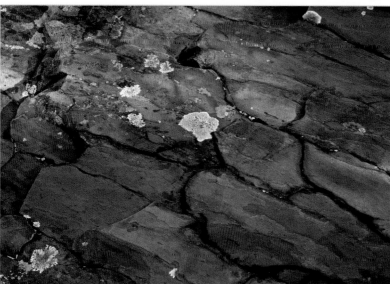

center

The lichen-covered, fractured sandstone bedrock in the Austin T. Blakeslee Natural Area of Monroe County displays natural form, color, and lines to create an abstract composition.

bottom

Looking upward, into the tall straight trunks of a red pine plantation in the Austin T. Blakeslee Natural Area, gives a different perspective to an otherwise common scene.

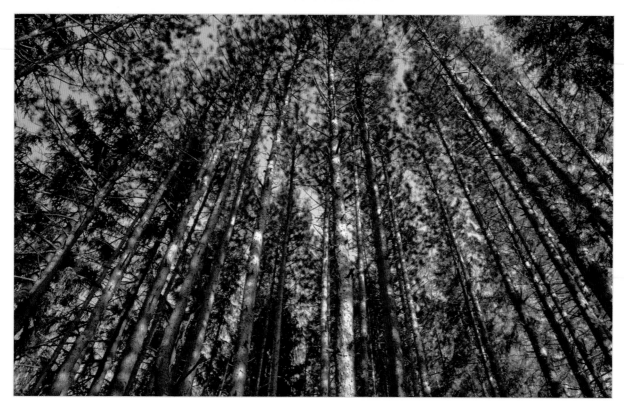

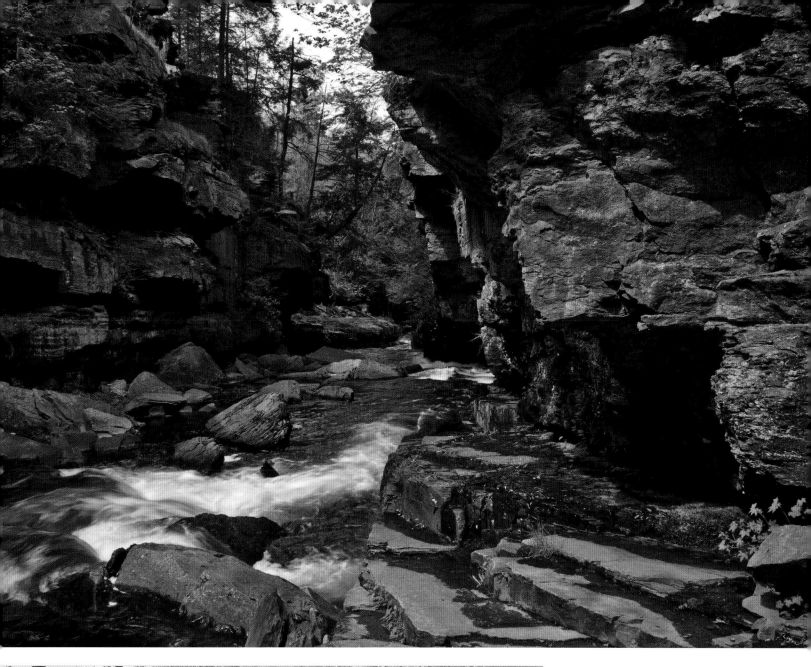

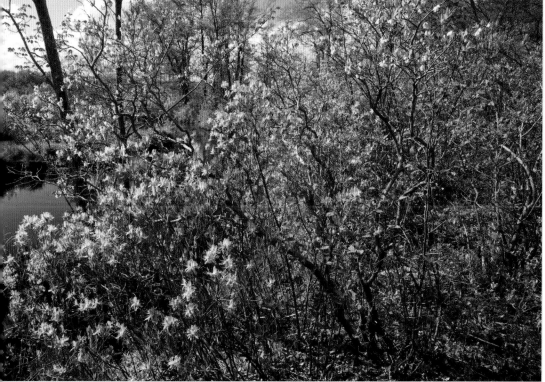

top

The Shohola Creek Gorge, on State Game Lands 180 in Pike County, runs approximately 1,800 feet through a scenic, geologically unusual, 80-foot-deep vertical rock fracture in the Devonian age Catskill Formation rock.

bottom

The extensive wetlands at Gouldsboro State Park in Monroe County harbor many unique species, like this blooming rhodora, *Rhododendron canadense*, a northern species of azalea that grows naturally in Pennsylvania, but only in the Poconos and on Moosic Mountain.

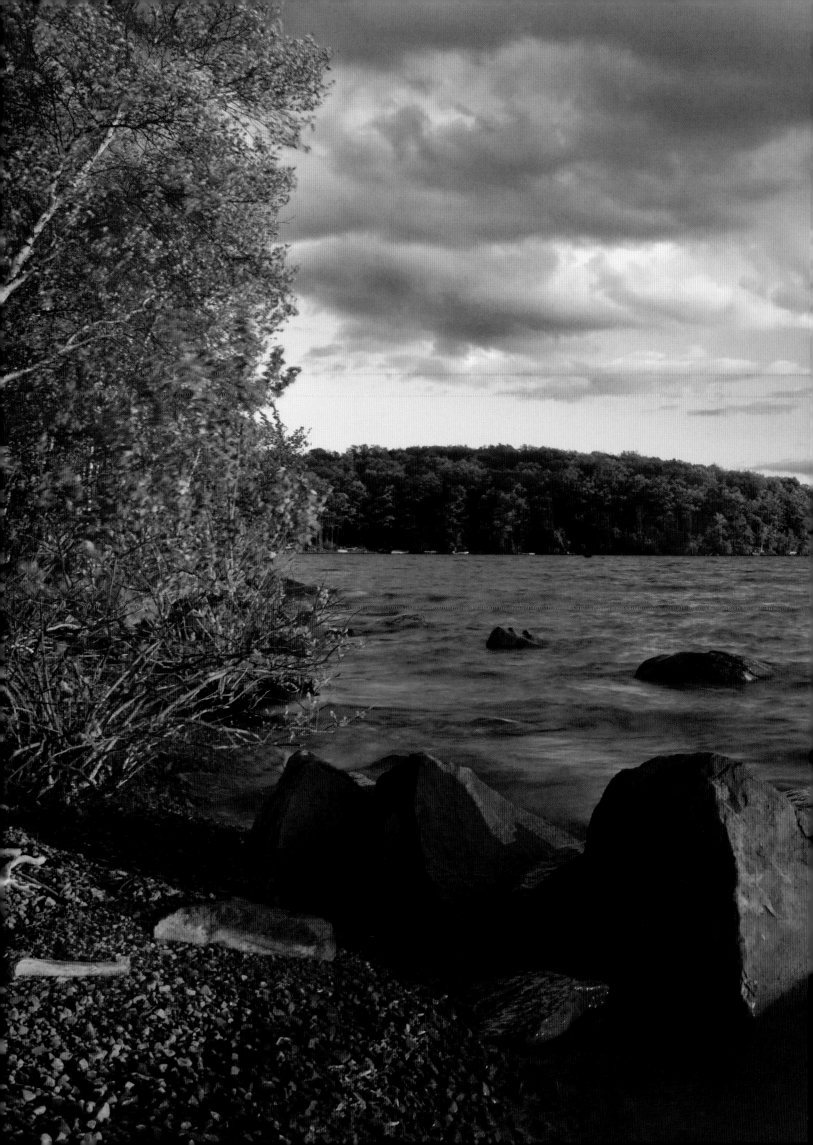

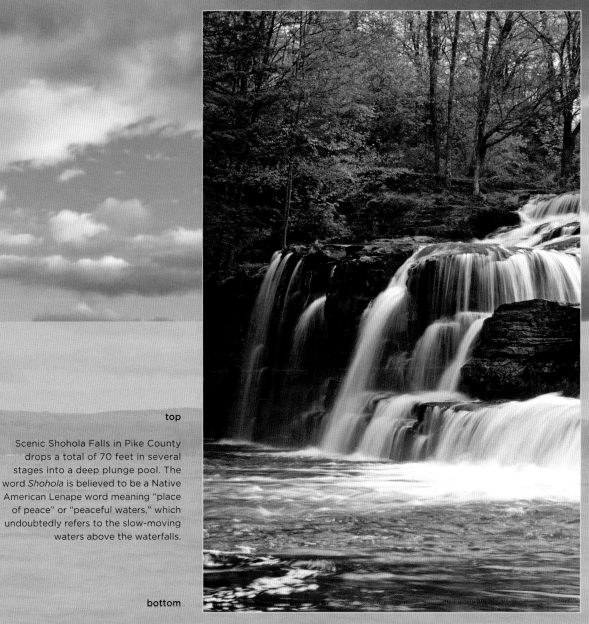

top

Scenic Shohola Falls in Pike County drops a total of 70 feet in several stages into a deep plunge pool. The word *Shohola* is believed to be a Native American Lenape word meaning "place of peace" or "peaceful waters," which undoubtedly refers to the slow-moving waters above the waterfalls.

bottom

Mud Pond in eastern Luzerne County is a small glacial lake. It made archaeological history in 1935 when a group of boys discovered a dugout canoe, estimated to have been made around 1250 AD, in the lake. The canoe is on exhibit at The State Museum of Pennsylvania in Harrisburg.

background

Lake Wallenpaupack, on the Wayne and Pike County border, was created in 1926 by the PPL Corporation for hydroelectricity. Covering 5,700 acres, it is one of the largest lakes in Pennsylvania. There are a few peaceful natural locations to enjoy on this busy recreational lake with numerous vacation homes.

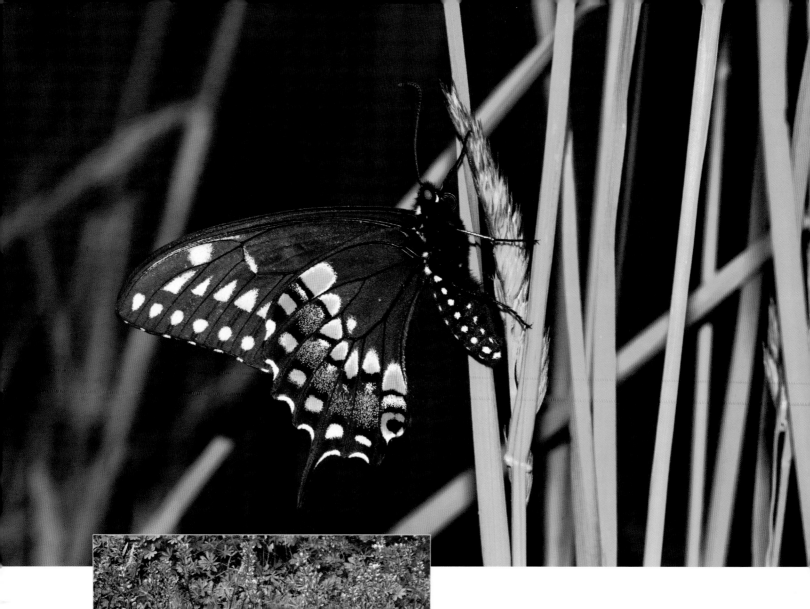

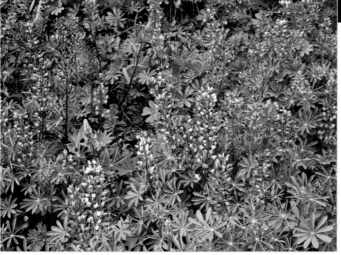

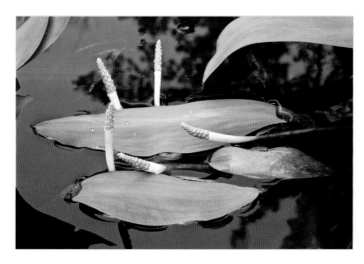

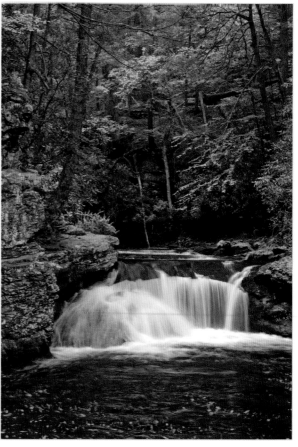

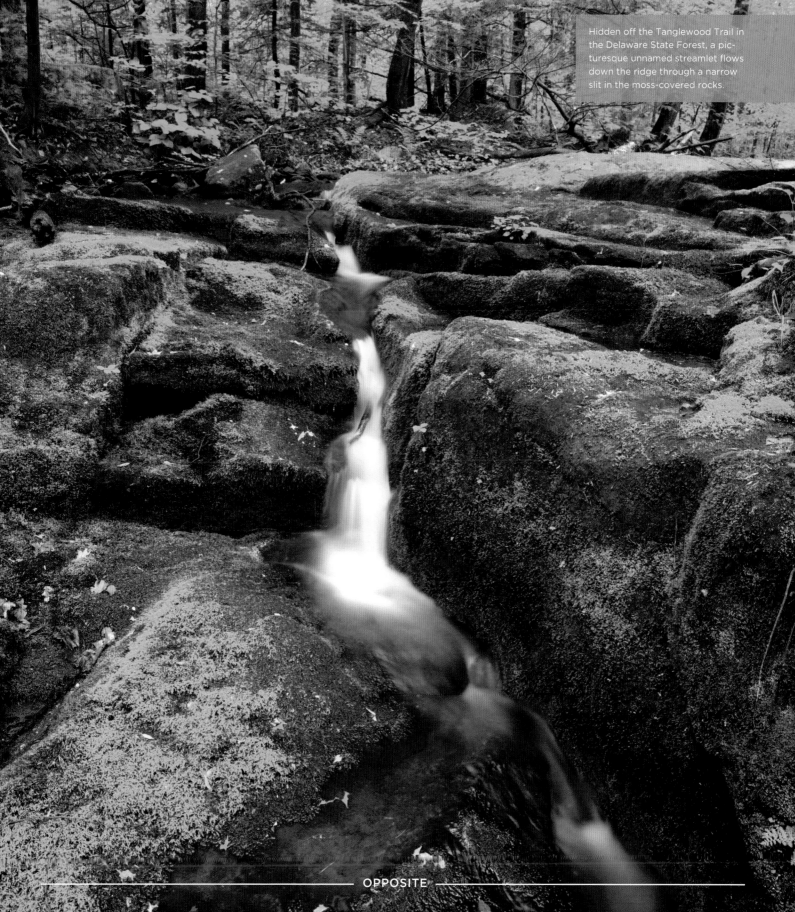

Hidden off the Tanglewood Trail in the Delaware State Forest, a picturesque unnamed streamlet flows down the ridge through a narrow slit in the moss-covered rocks.

—————————————— OPPOSITE ——————————————

top center

An eastern black swallowtail butterfly, *Papilio polyxenes*, at rest in the Pocono Mountains. Ranging from southern Canada to the Gulf of Mexico, this butterfly is common in meadows east of the Rocky Mountains.

clockwise

In addition to the famous Raymondskill Falls, Pennsylvania's tallest at 180 feet, there are several other lesser waterfalls along the Raymondskill Creek in Pike County. However, to reach these falls a difficult and sometimes dangerous bushwhack is required.

Golden club, *Orontium acquaticum*, is classified as rare in Pennsylvania by the U.S. Department of Agriculture. It can be found in a few locations across the state, including the upper reaches of the Lehigh River near its source in southern Wayne County.

Native wild lupine, *Lupinus perennis*, grows on sandy soils mainly in eastern and central Pennsylvania. Many people confuse wild lupine with large-leaf lupine, *Lupinus polyphyllus*, a native of western North America that has been cultivated and is now naturalizing abundantly in the northeast, especially in New England and Canada.

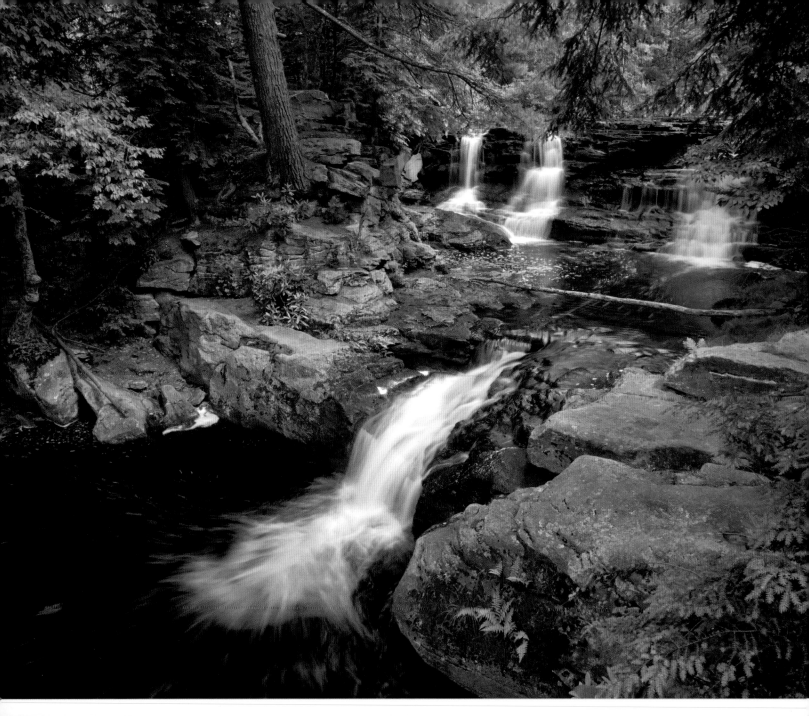

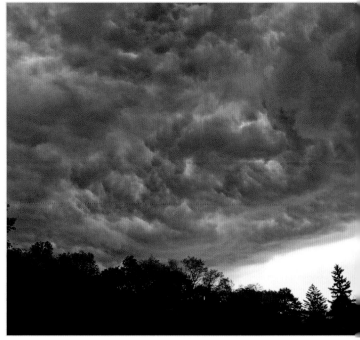

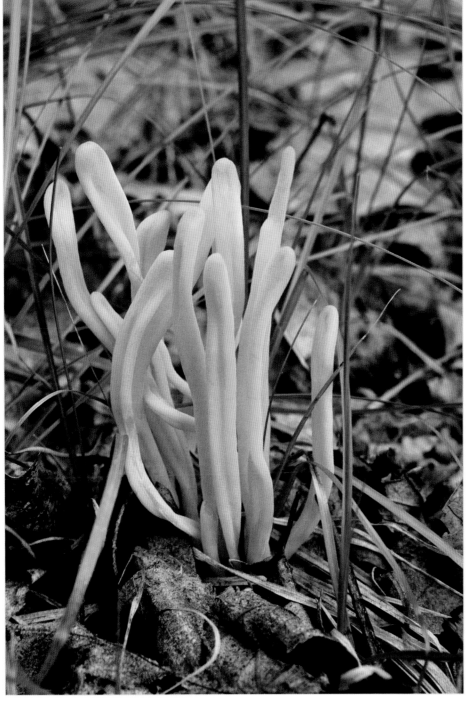

top left

Thanks to the efforts of local and state government agencies, and private conservation organizations, including the Wildlands Conservancy of Emmaus, Pennsylvania, 40-foot Choke Creek Falls, along with 2,650 additional acres, which were slated for development, are now preserved in the Lackawanna State Forest for future generations to enjoy.

top right

Appearing in grassy woods in late summer and autumn, *Clavulinopsis fusiformis*, or spindle-shaped yellow coral fungus, grows in tight clusters up to 6 inches high. Considered edible by some, few people seem to consume it, although it is not considered poisonous. An extract from the fungus inhibits cancers in mice.

bottom left

Red spruce, *Picea rubens*, is a conifer of Canada, New England, and the high Appalachians. It can be found naturally in a few locations in northern and central Pennsylvania. However, in the Poconos, red spruce is common due to the region's favorable cool moist habitat.

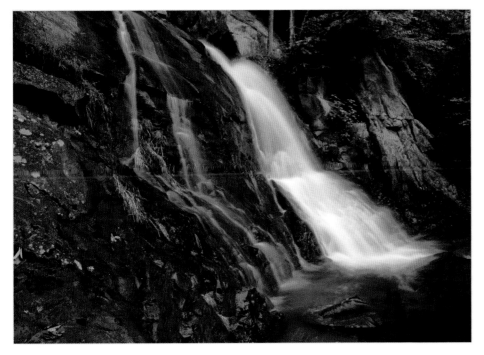

bottom center

Threatening cumulonimbus mammatus clouds are forming prior to a storm in northeastern Pennsylvania. This cloud formation sometimes develops on the leading edge of a cold front passing over warmer air and often produces severe thunderstorms or even tornadoes.

bottom right

The 60-foot-high Butter Milk Falls in Lehigh Gorge State Park is one of three waterfalls in the park. Butter Milk Falls is accessible by a short and easy 1/4-mile hike from the Rockport access area.

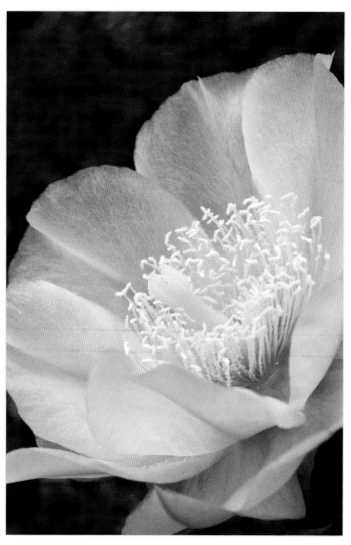

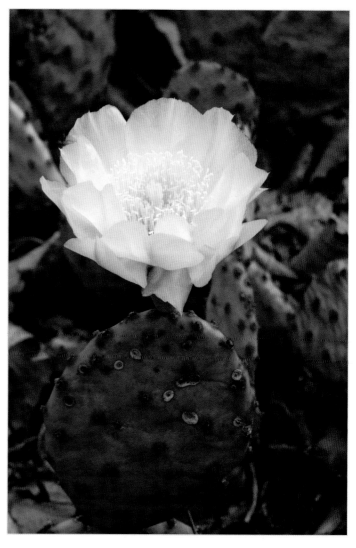

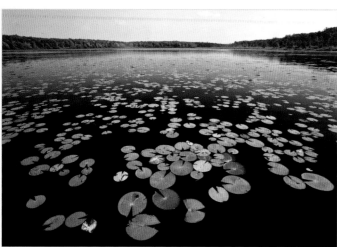

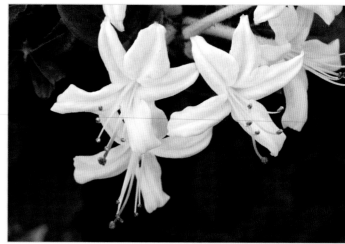

top left

The insect-pollinated flowers of prickly pear cactus, *Opuntia humifusa*, are waxy and sometimes have a red center. They are about 1.5 to 2.5 inches wide and appear in late June.

bottom left

Bruce Lake is a 56-acre, completely spring-fed glacial lake in the 2,845-acre Bruce Lake Natural Area of the Delaware State Forest. The secluded lake can only be reached by a nearly 3-mile hike. The west shoreline harbors a unique boreal bog with northern plants rare to Pennsylvania.

top right

A special feature of the Poconos is the natural diversity found in small areas. A person can be in a boreal bog, typical of Canada, then walk a few hundred yards to the shale barrens above the Delaware River and find native prickly pear cactus, more typical of the American southwest..

bottom right

White swamp azalea, *Rhododendron viscosum,* blooms in late June and is particularly common in the abundant wetlands that were created in the Poconos during the last Ice Age. This species was the first North American azalea to be grown in England from seeds collected in 1680.

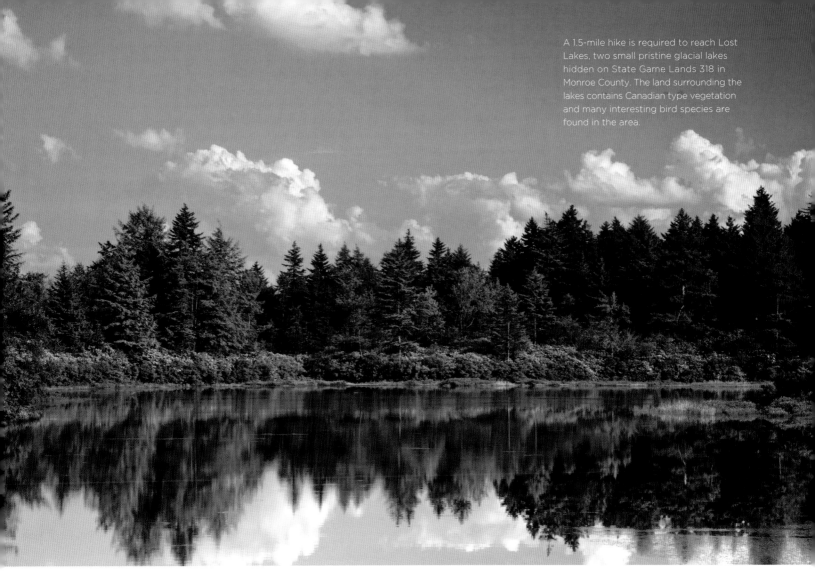

A 1.5-mile hike is required to reach Lost Lakes, two small pristine glacial lakes hidden on State Game Lands 318 in Monroe County. The land surrounding the lakes contains Canadian type vegetation and many interesting bird species are found in the area.

An underwater view of the floating leaves and stems of fragrant water-lily, *Nymphaea odorata*, and plankton growing in Bruce Lake. These underwater gardens provide vital feeding and hiding areas for many aquatic animals.

top

Hay-scented fern, *Dennstaedtia punctilobula*, which has the scent of newly mowed hay when crushed, is abundant in the Poconos and other parts of the state. However beautiful, an abundance of the fern indicates an overpopulation of white-tailed deer, as this is one native plant they will not eat.

bottom left

In mid-October, the season's first ice covers a wetland in the Delaware State Forest. In some years the wetland may be covered with ice until mid-March. Beneath the frozen surface, insects and some cold-blooded animals remain active and muskrats leave their dens to forage for submerged vegetation under the ice.

bottom right

Thawing and refreezing of Lower Lake at Promised Land State Park has created different thicknesses of ice. Although a beaver lodge, seen along the far shore, is encased in ice, its inhabitants stored an underwater supply of food in autumn before the freeze up.

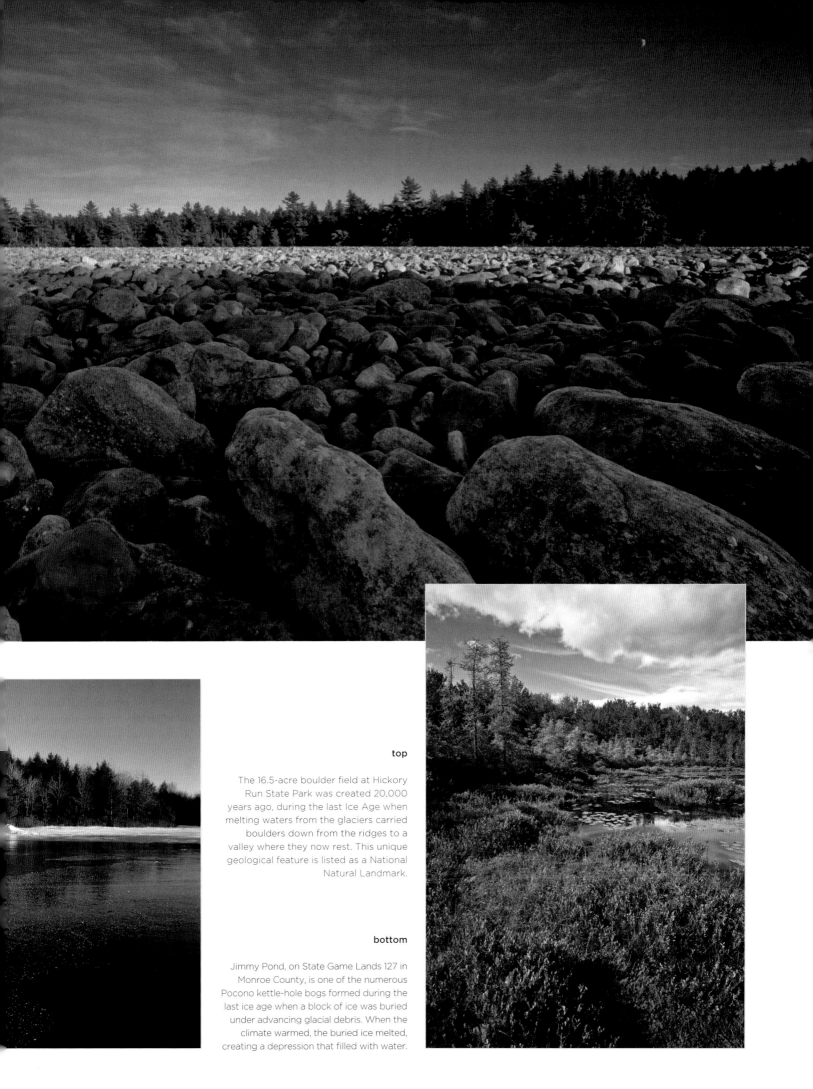

top

The 16.5-acre boulder field at Hickory Run State Park was created 20,000 years ago, during the last Ice Age when melting waters from the glaciers carried boulders down from the ridges to a valley where they now rest. This unique geological feature is listed as a National Natural Landmark.

bottom

Jimmy Pond, on State Game Lands 127 in Monroe County, is one of the numerous Pocono kettle-hole bogs formed during the last ice age when a block of ice was buried under advancing glacial debris. When the climate warmed, the buried ice melted, creating a depression that filled with water.

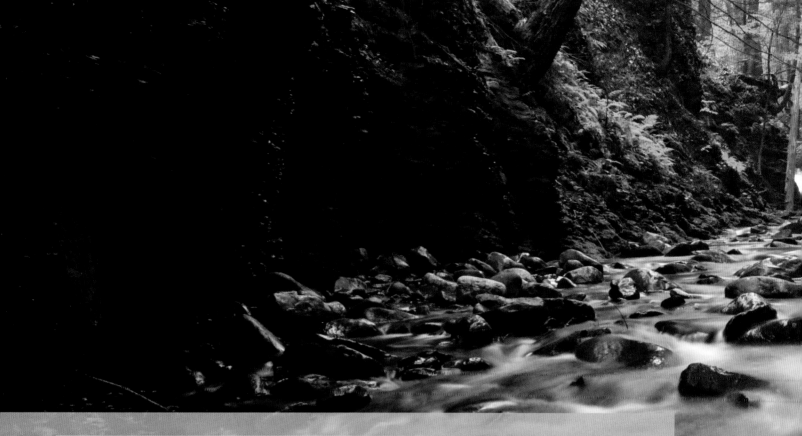

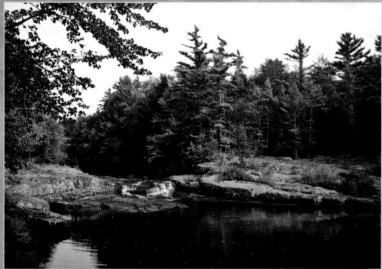

top

Although Tobyhanna Falls, at the Austin T. Blakeslee Natural Area in Monroe County, drops a mere 10 feet over the grayish-red sandstone, the beauty of the area has qualified it to be listed as one of the Outstanding Scenic Geological Features of Pennsylvania by the Pennsylvania Geological Survey.

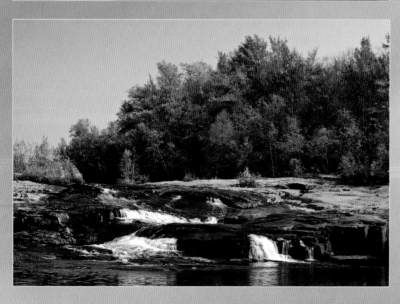

bottom

Warnertown Falls can be reached after a 1-mile hike on State Game Lands 127. Upstream are remains of an old dam that formed a lake upon which ice was harvested during the winter and then transported to New York City for refrigeration. This ice harvest industry lasted into the early 1950s.

background

Adams Creek in the Delaware Water Gap National Recreation Area flows through one of the several beautiful and ecologically sensitive hemlock ravine forests found in the park.

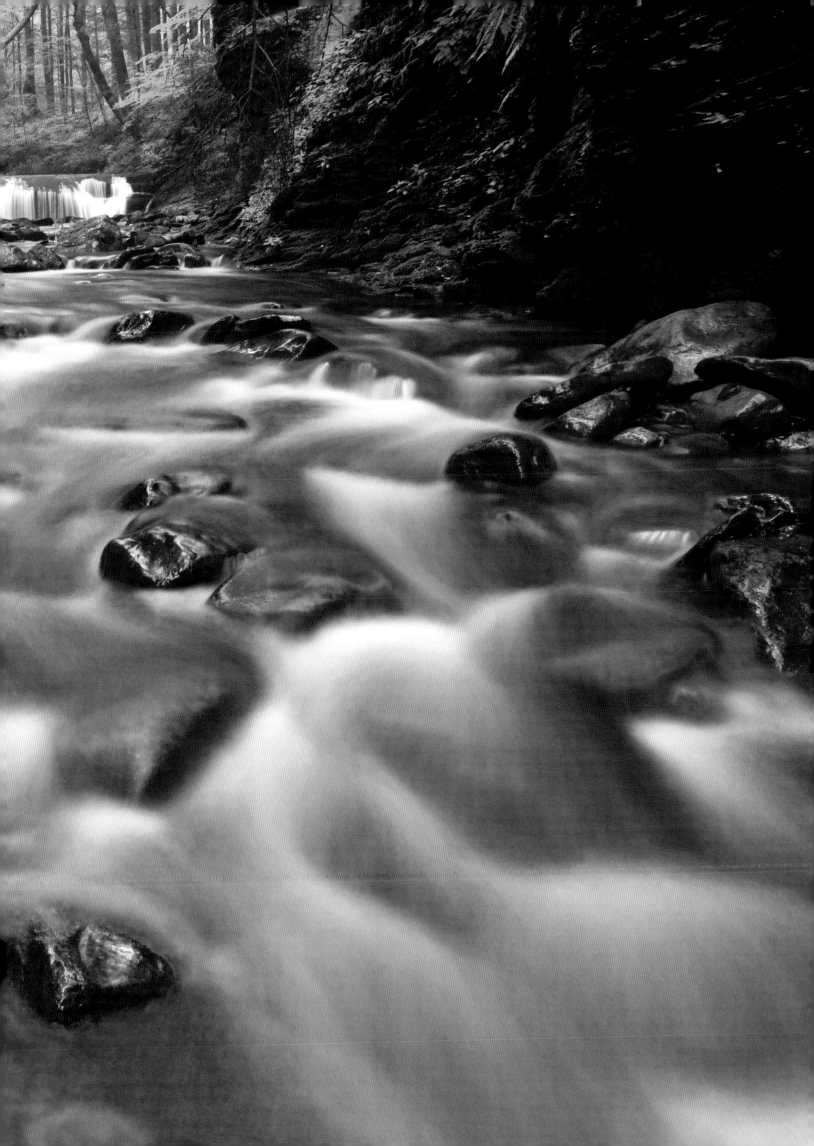

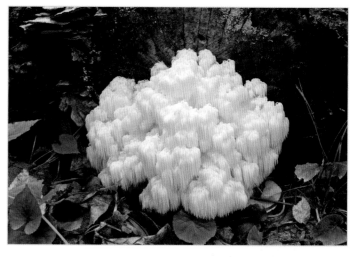

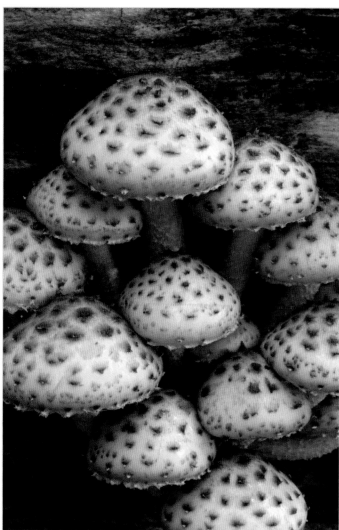

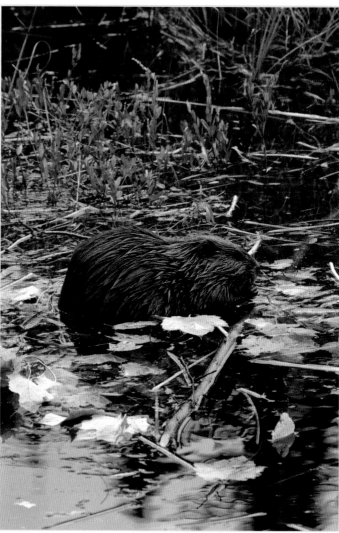

top left

Established in 2008, Cherry Valley National Wildlife Refuge, in Monroe County, will eventually encompass 20,000 acres and protect unique habitats, including limestone, spring-fed wetlands called fens. The refuge will also protect part of the Kittatinny Ridge and the valley's cultural and historical heritage.

bottom left

Goldskin scalecap mushroom, *Pholiota aurivella*, is seen here growing in the Pocono Mountains. Typically found on either dead or living deciduous wood in autumn, it is consumed by some people, although most experts agree it is not edible as it is reported to cause gastric upset after eating.

top right

Resembling a frozen water spray, coral hedgehog fungus, *Hericium coralloides*, as seen here in Wayne County, grows on dead or dying wood in late summer and early autumn. It is reportedly a very tasty fungus and is also being used in medical research for its cytotoxic effects on cancer cells.

bottom right

Probably no other animal was more significant in the exploration of North America than the beaver, *Castor Canadensis*, as its fur was highly prized in eighteenth-century Europe, nearly causing its extinction. Additionally, no other animal is more important for creating valuable wetlands for wildlife habitat, flood control, and water conservation.

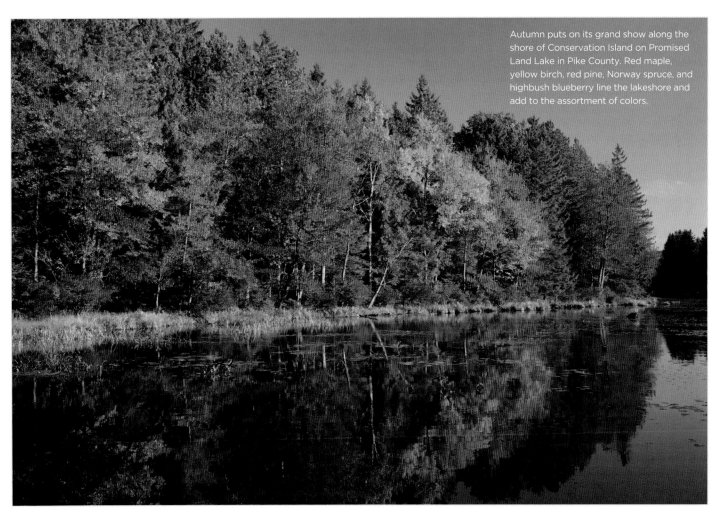

Autumn puts on its grand show along the shore of Conservation Island on Promised Land Lake in Pike County. Red maple, yellow birch, red pine, Norway spruce, and highbush blueberry line the lakeshore and add to the assortment of colors.

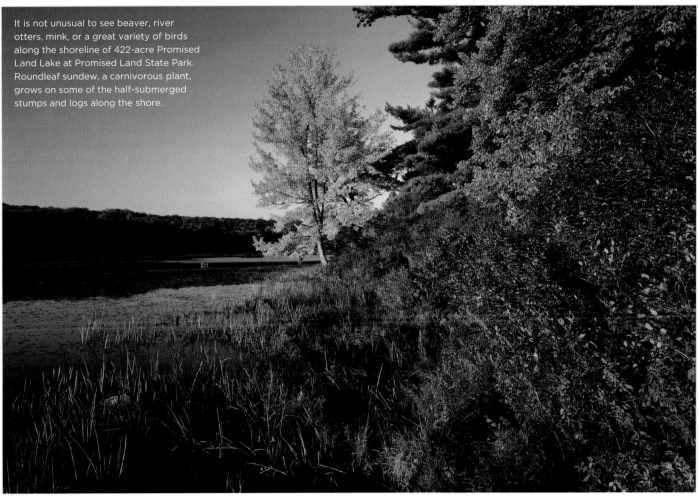

It is not unusual to see beaver, river otters, mink, or a great variety of birds along the shoreline of 422-acre Promised Land Lake at Promised Land State Park. Roundleaf sundew, a carnivorous plant, grows on some of the half-submerged stumps and logs along the shore.

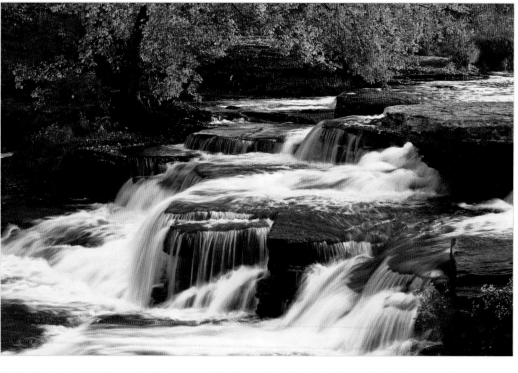

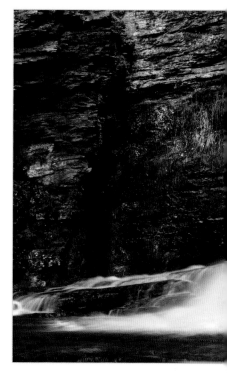

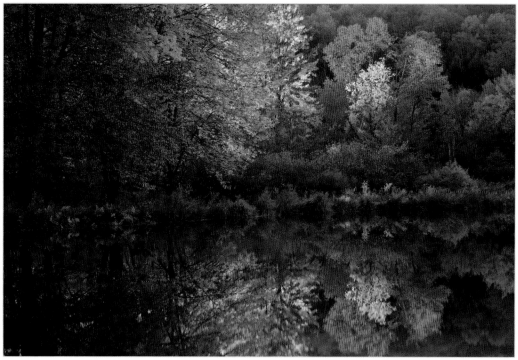

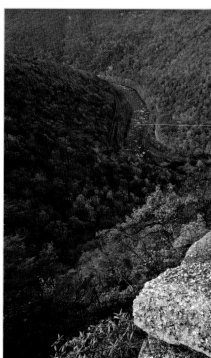

top left

The upper section of Shohola Falls flows over a series of sandstone terraces before the final 20-foot drop into the main plunge pool. In autumn, many photographers, artists, and ecotourists flock to the falls to cherish its beauty.

bottom left

In 2001, Dr. Mead Shaffer generously donated 430 acres of his family homestead in Wayne County to the Pennsylvania Bureau of State Parks to become the Varden Conservation Area and be used for, "present and future generations to observe and study the diverse ecology found in the Varden Conservation Area."

top center

Deer Leap Falls funnels through a narrow rock chute before plunging 30 feet back into Dingmans Creek in the Delaware Water Gap National Recreation Area. Deer Leap is one of three waterfalls found in the George W. Childs Recreation Site located near Dignman's Ferry in Pike County.

bottom center

From high atop Scrub Mountain on State Game Lands 141, the hiker is rewarded with a breathtaking view down to the Lehigh River cutting through Lehigh Gorge State Park.

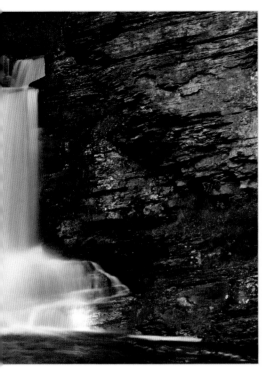

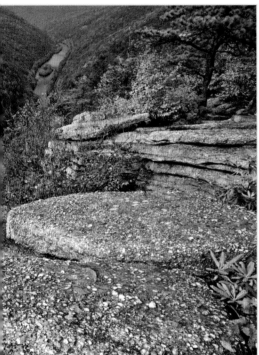

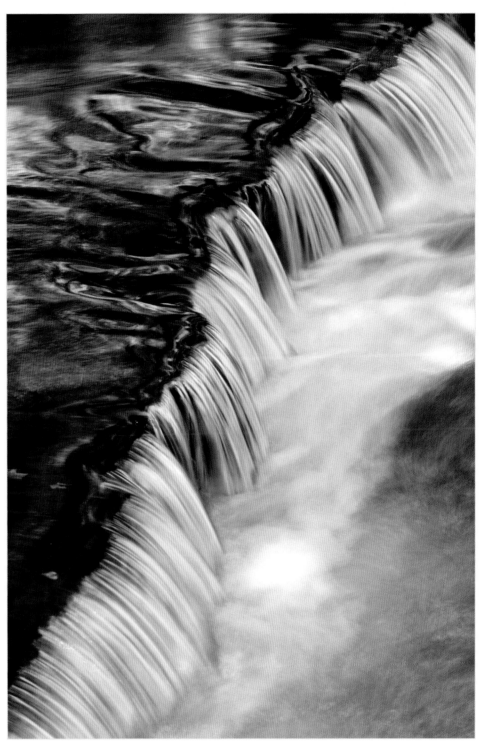

right

Autumn colors reflect in Dingmans
Creek, flowing through George
W. Childs Recreation Site. The
site is named for George William
Childs, a Philadelphia newspaper
publisher, whose widow deeded
the land to the Commonwealth in
1912 as a state park. Later it was
incorporated in the Delaware Water
Gap National Recreation Area.

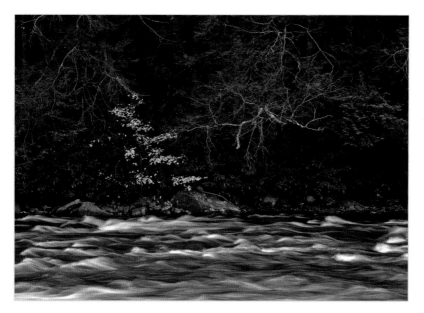

top

The Lehigh River flows through the Lehigh Gorge State Park in Carbon County. In 1829, the legendary naturalist, painter, and Pennsylvania resident, John James Audubon, visited the gorge and spent more than a month there studying and painting the birds in the area.

center

Morning frost collecting on tussock sedge, *Carex stricta*, growing along Kleinhans Creek in the Delaware State Forest. Tussocks develop over time. As old sedge leaves die they build up around the living plant to form mounds. These tussocks provide breeding cover for amphibians and nesting sites for some bird species.

bottom

An early snowfall contrasts with the changing colors in an autumn forest at Promised Land State Park. In the Pocono Mountains it is not at all uncommon to have snowstorms anytime from October through April.

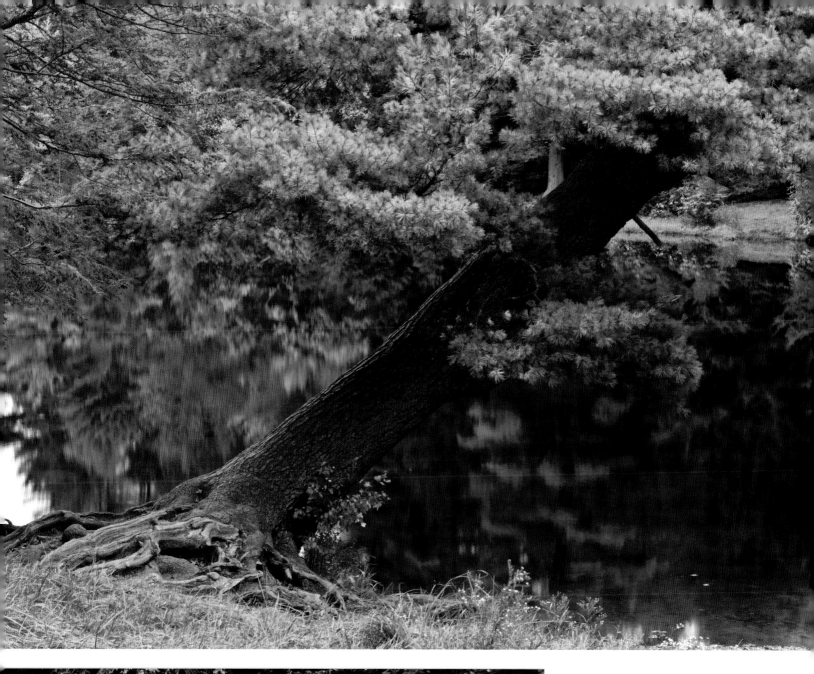

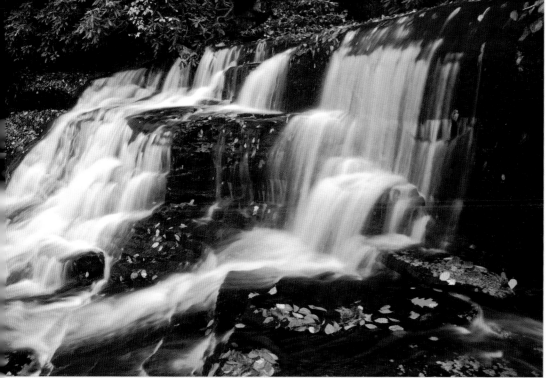

top

Only three acres in size, Hickory Run Lake, in the expansive 15,990-acre Hickory Run State Park, is one of the more scenic bodies of water in the Pocono Mountains. Although covered by glaciers during the last Ice Age, Hickory Run Lake was man-made by damming the stream of the same name.

bottom

Several small waterfalls and cascades are found along the pristine Devils Hole Creek on State Game Lands 221 located in Monroe County. Without official designated trails, hiking in the area requires some bushwhacking and several bridgeless stream crossings. During Prohibition, a "speakeasy" was hidden in the deep ravine.

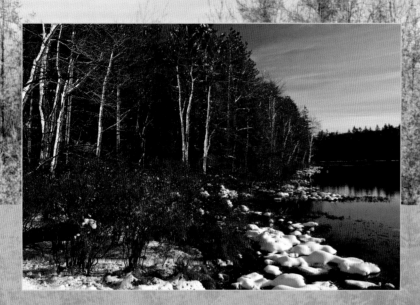

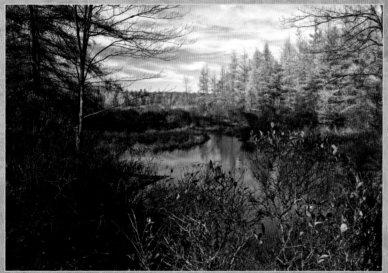

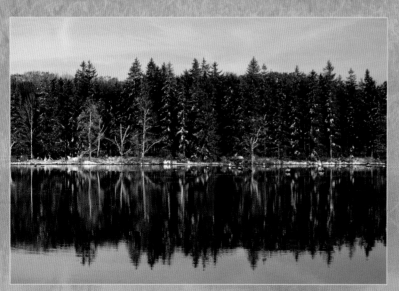

top

An early snowfall along the shore of Promised Land Lake adds to the color palette of the blue water and crimson autumn leaves of highbush blueberry, *Vaccinium corymbosum*, which finds excellent growing conditions in the moist, acidic soil occurring in the Poconos.

center

The Pocono Mountain region is noted for its excellent wetlands. Here, beavers have expanded a section of Wagners Run on State Game Lands 127 in Monroe County. The resulting pond provides excellent wildlife habitat and a wild picturesque setting.

bottom

The thousands of Norway spruce trees, *Picea abies*, planted along the shore of Promised Land Lake by the Civilian Conservation Corps in the 1930s and 1940s, offers a priceless visual reward for park visitors today.

background

Tamarack or American larch, *Larix laricina*, is common in the wetlands of the Poconos. A boreal tree, It grows to the northern limit of tree growth in the Artic. Tamarack is a deciduous conifer that sheds its needles every winter. Here it is displaying its autumn foliage along Wagner's Run.

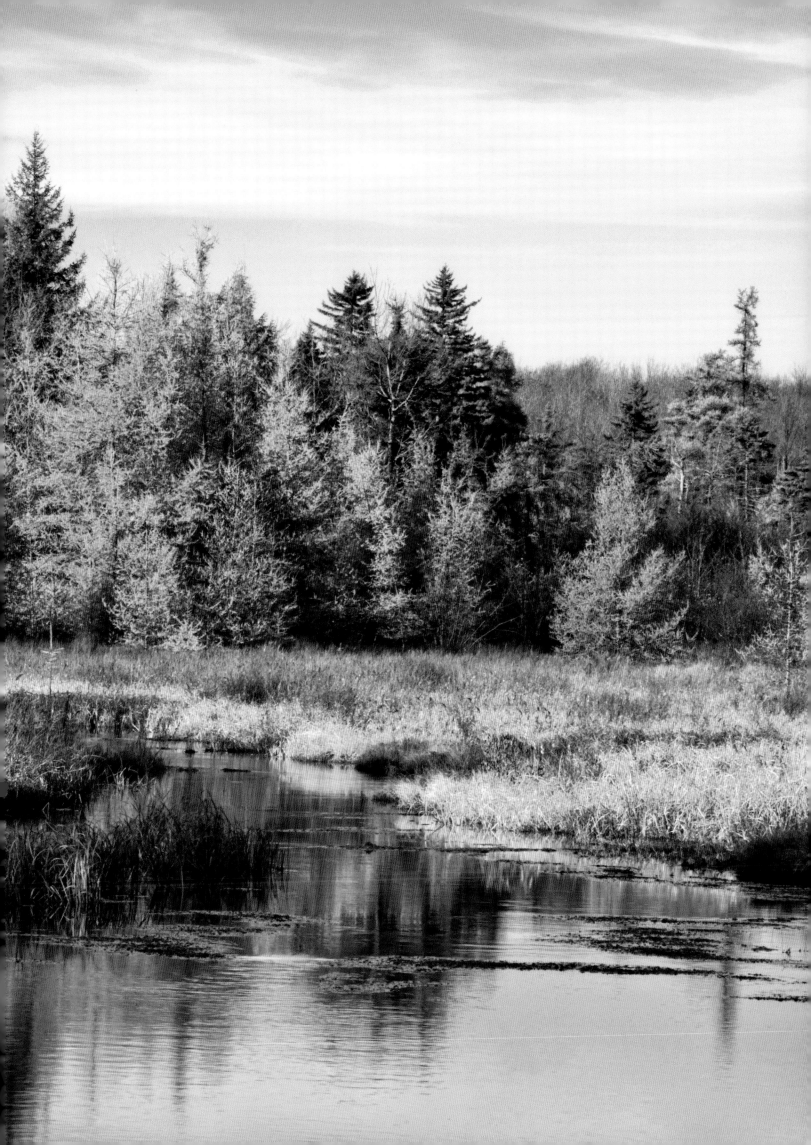

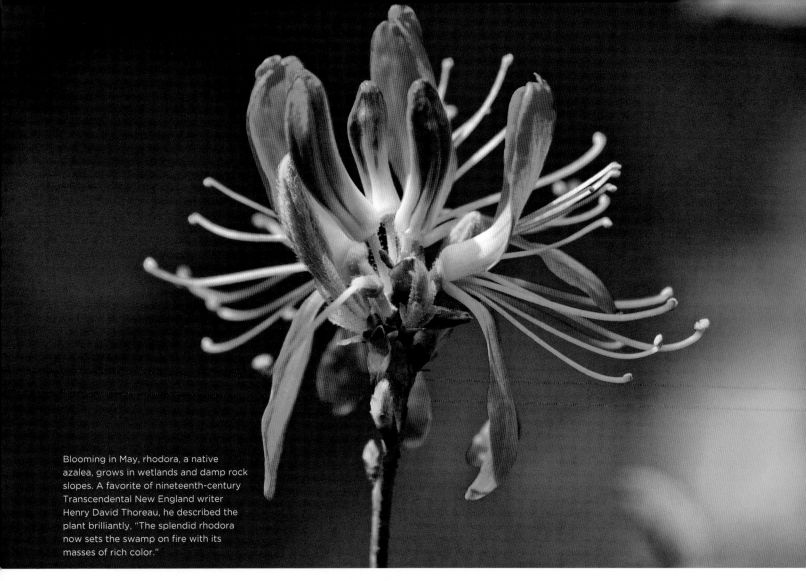

Blooming in May, rhodora, a native azalea, grows in wetlands and damp rock slopes. A favorite of nineteenth-century Transcendental New England writer Henry David Thoreau, he described the plant brilliantly, "The splendid rhodora now sets the swamp on fire with its masses of rich color."

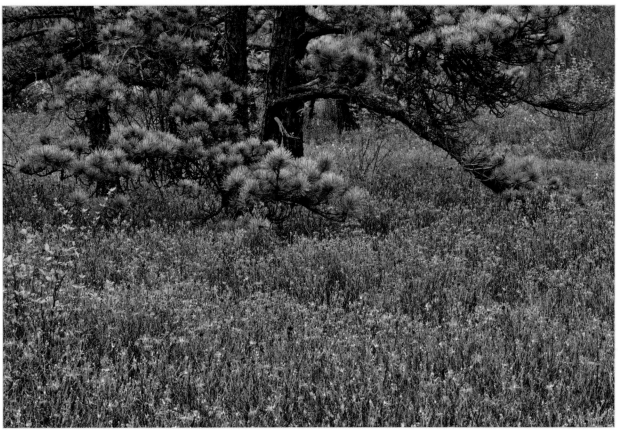

Rhodora, *Rhododendron canadense*, blooms on the mesic till barrens at Long Pond in Monroe County. The Nature Conservancy says these barrens are "the only natural community of its kind in the world" and harbor "a greater concentration of rare terrestrial species than any other place in Pennsylvania."

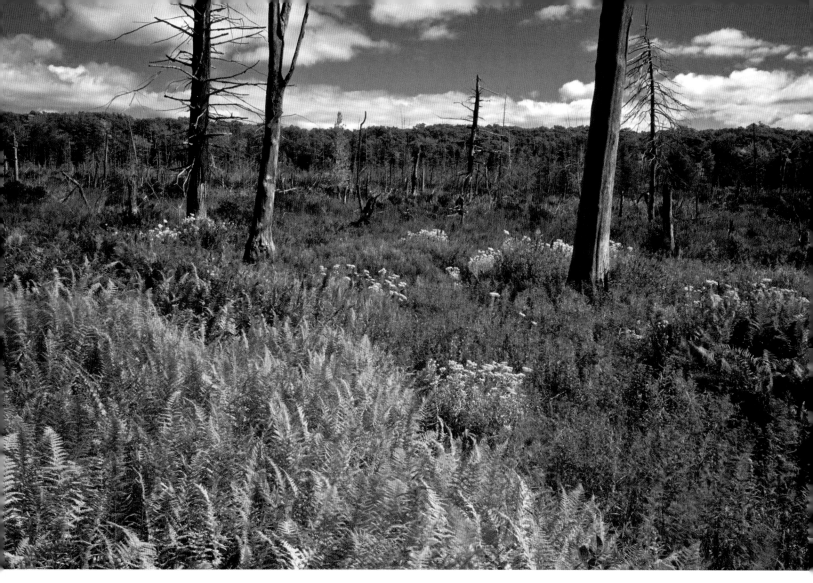

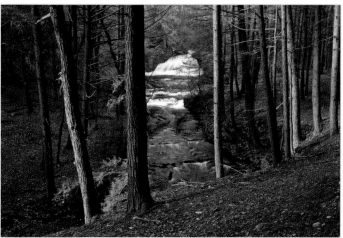

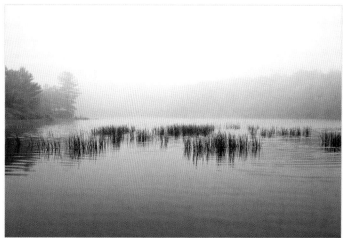

top center

Nature is never static and always changing. Panther Swamp, in the Bruce Lake State Forest Natural Area, was forested before beavers dammed a small brook in the 1970s, creating a wetland. When the beavers left the area, the pond drained and succession started forming a meadow and forest again.

bottom left

The trail to Hackers Falls, in the Delaware Water Gap National Recreation Area is a 2.2-mile round trip hike. Hidden in a dense grove of hemlock trees, this low waterfall along Raymondskill Creek has been described as resembling a "giant faucet...with gushing water."

bottom right

In 1935, the Civilian Conservation Corps constructed 48-acre Egypt Meadows Lake in what is now the Bruce Lake State Forest Natural Area. Before the area was inundated, acres of marsh grass flourished here. The grass was harvested to safely pack the world-renowned Dorflinger Glass, milled in nearby White Mills, for transport.

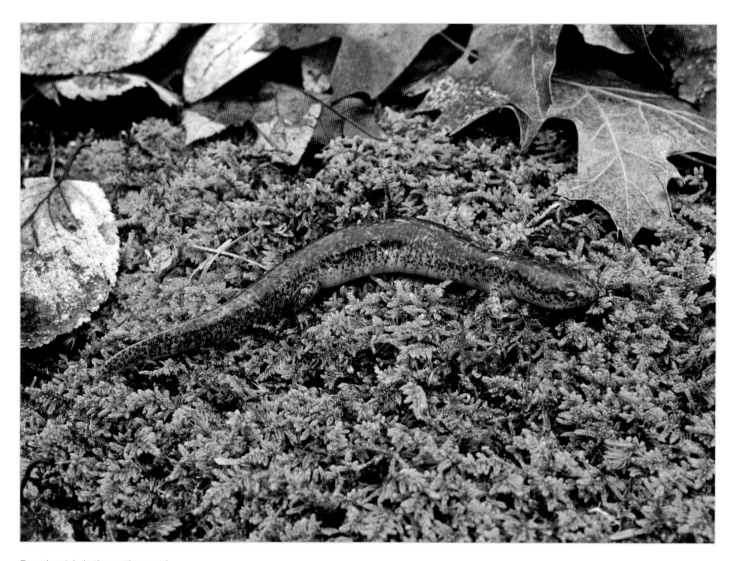

Found mainly in the northern and mountainous regions of the state, the 4- to 6-inch-long northern red salamander, *Pseudotriton ruber*, prefers cool forests with streams and spring seeps. Varying in color from pinkish to red with distinctive black spots, the spots are less distinctive in older adults, as seen here.

Locals in the Poconos have an expression that says: "It's always different south of the Blue." The "Blue" they are referring to is the Blue Mountain, also called the Kittatinney Ridge, which begins in Pennsylvania at the Delaware Water Gap and, following a rough-shaped arch, extends to south central Pennsylvania. To the southeast of this mountain are the fertile lands of the Great Valley, Piedmont, and coastal plain. Someone traveling from the north, across the "Blue" may pass from winter to spring, autumn back to summer, or from a rural area to suburbia.

Pennsylvania began in the southeast corner. History goes back here as far as the history of the settlement of the New World. With centuries of agriculture, shipping, manufacturing, commerce, and government, it has become the most densely populated region of the state.

Even today the sprawl continues as irreplaceable rural lands are transformed into housing developments, industrial parks, strip malls, and their supporting super highways. Yet in spite of what may seem to some as chaotic and sporadic development, the areas still supports and preserves some of the most wondrous and unique natural parcels in Pennsylvania. And with the tireless work of several nongovernmental organizations, such as The Nature Conservancy, Wildlands Conservancy, and many others working along side state and federal agencies, more vital natural areas are being protected each year for future generations to enjoy and study.

The southeast presents us with a paradox that results in a symbiotic relationship—development and natural preservation must be in balance to maintain a healthy environment. Preserving healthy natural lands helps to purify the air, water, and stress of urban areas. When clean, prosperous urban areas, with high-quality infrastructures, help preserve natural lands, there is less pressure to develop outside the urban area.

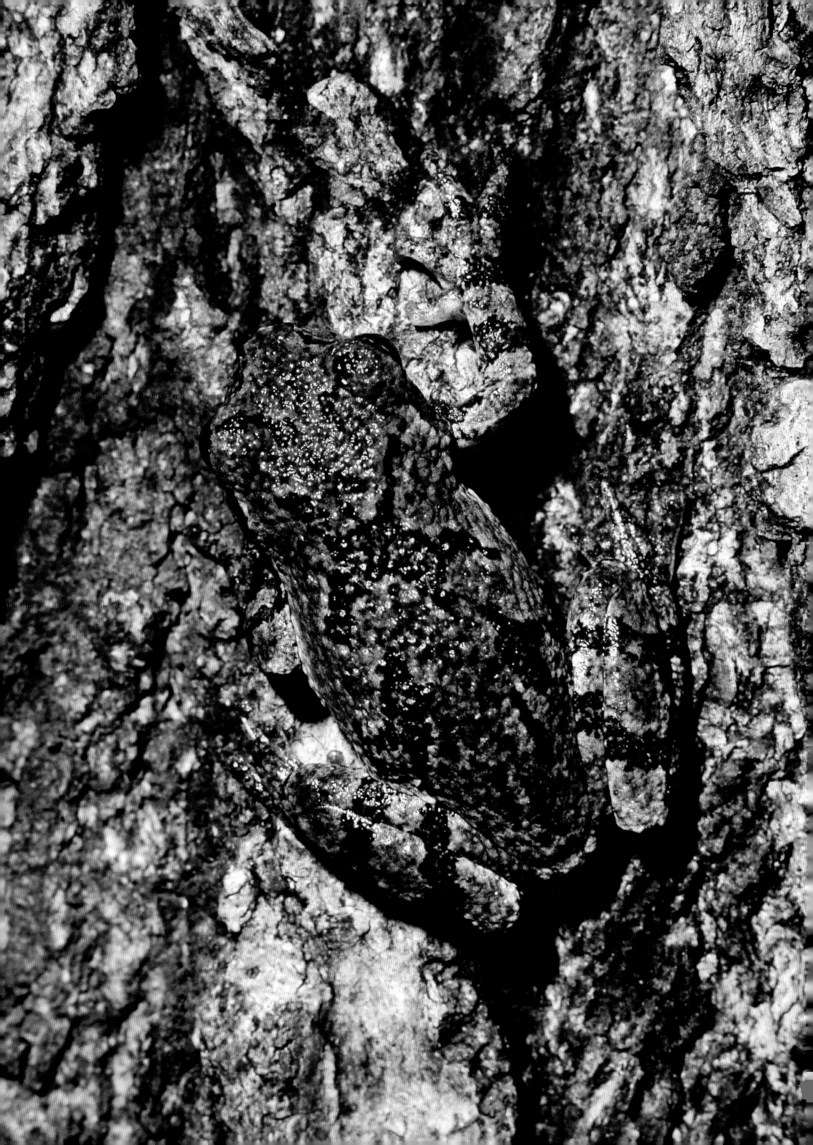

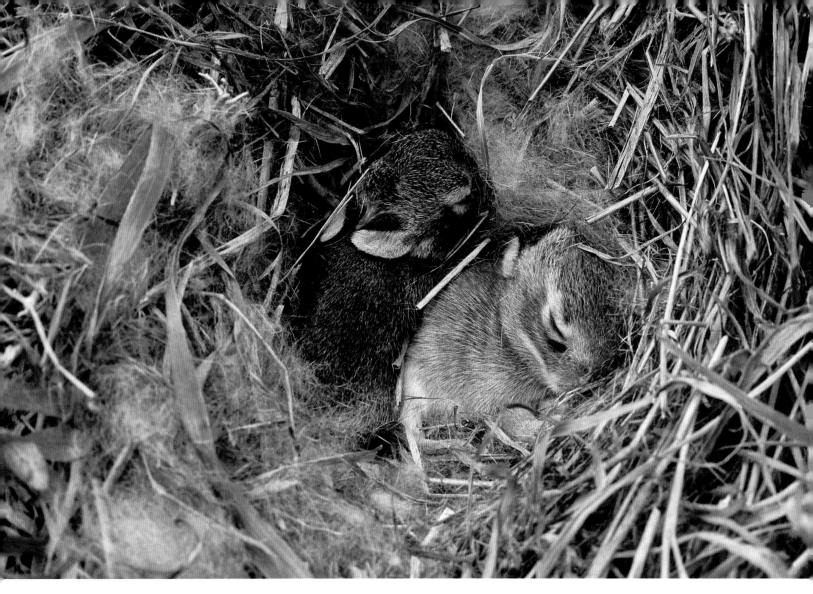

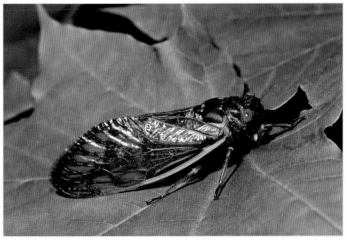

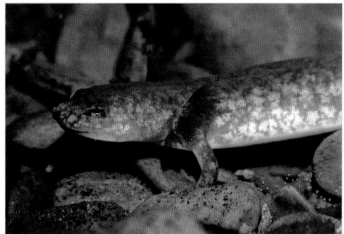

opposite

Found throughout Pennsylvania, the 1.5- to 2-inch-long gray treefrog, *Hyla versicolor*, is a master at camouflage. Varying from gray to green, they are able to change their color to match their perch. Spending most of their time in treetops, they rarely descend, except to mate and hibernate.

top center

The female eastern cottontail rabbit builds a nest, lined with her own fur and dry grass, in a small depression which she excavates in tall grass or shrubbery. Here she will give birth to litters ranging from three to eight young, which she will wean for up to five weeks.

bottom left

Commonly called 17-year locust, periodical cicadas spend 13 or 17 years underground before emerging as millions of adults in June. Immediately, the males start "singing" to attract females. As adults they do not eat or sting. Living only 3 to 4 weeks, they provide a feast for many forest animals.

bottom right

In vernal breeding pools, spotted salamanders may lay up to 100 eggs in round, clear, jelly-like clumps, clinging to underwater vegetation. Depending on water temperature, the gill-bearing larvae hatch in 1 to 2 months, vigorously feeding on tiny aquatic invertebrates for 2-4 months until they leave the water as adults.

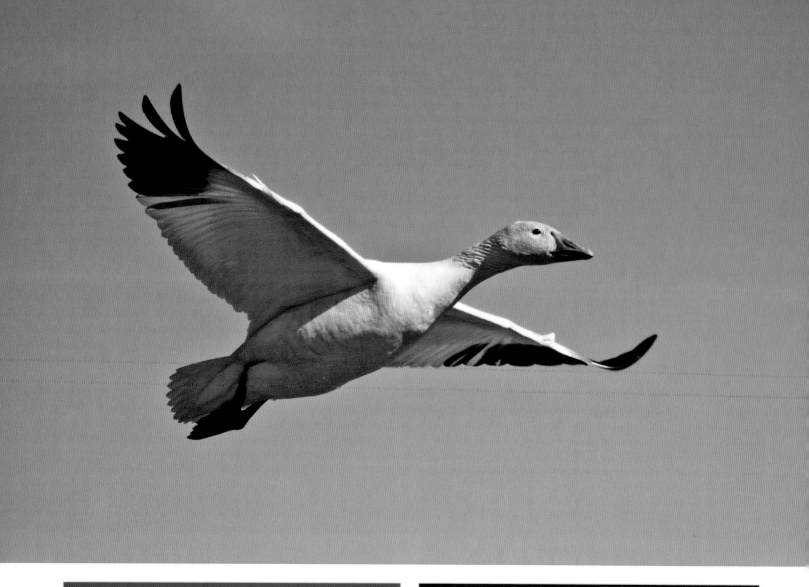

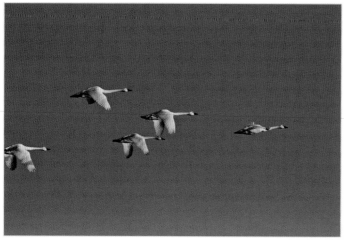
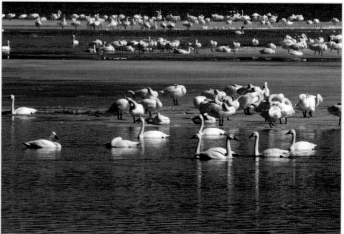

top center

Breeding in the Artic region of Greenland, Canada, Alaska, and the northeastern tip of Siberia, the greater snow goose, *Chen caerulescens*, has been using southeastern Pennsylvania not only as a migration corridor but also as an important wintering area. Traditionally wintering in coastal marshes, these birds now favor agriculture fields.

bottom left

Unlike the familiar, non-native mute swan, *Cygnus olor*, that are introduced and seen at city parks, tundra swans are birds of the wild. Several thousand migrate through Pennsylvania every spring and fall. To add to the gracefulness of their flight, they call with their soft, high-pitched *hoo-oo-hoo*.

bottom right

Once known as "whistling swans" the species is now more appropriately called the tundra swan, *Cygnus Columbianus*, referring to its breeding grounds in the far north. Although their main wintering area in the east centers around the Chesapeake Bay, several thousand winter in southeast Pennsylvania, including Middle Creek Wildlife Management Area.

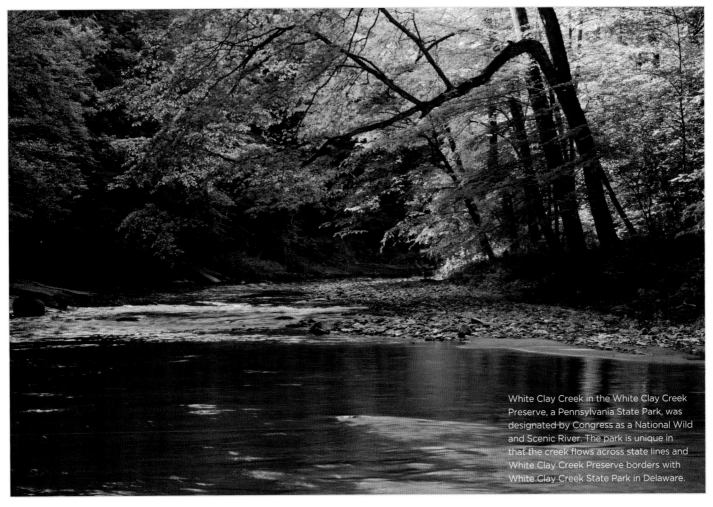

White Clay Creek in the White Clay Creek Preserve, a Pennsylvania State Park, was designated by Congress as a National Wild and Scenic River. The park is unique in that the creek flows across state lines and White Clay Creek Preserve borders with White Clay Creek State Park in Delaware.

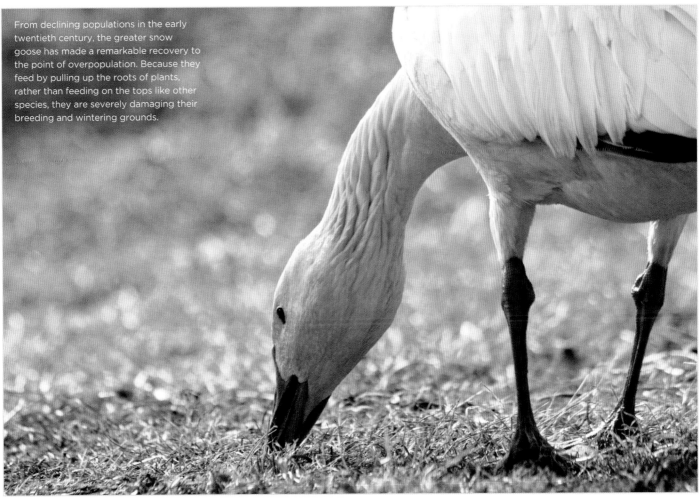

From declining populations in the early twentieth century, the greater snow goose has made a remarkable recovery to the point of overpopulation. Because they feed by pulling up the roots of plants, rather than feeding on the tops like other species, they are severely damaging their breeding and wintering grounds.

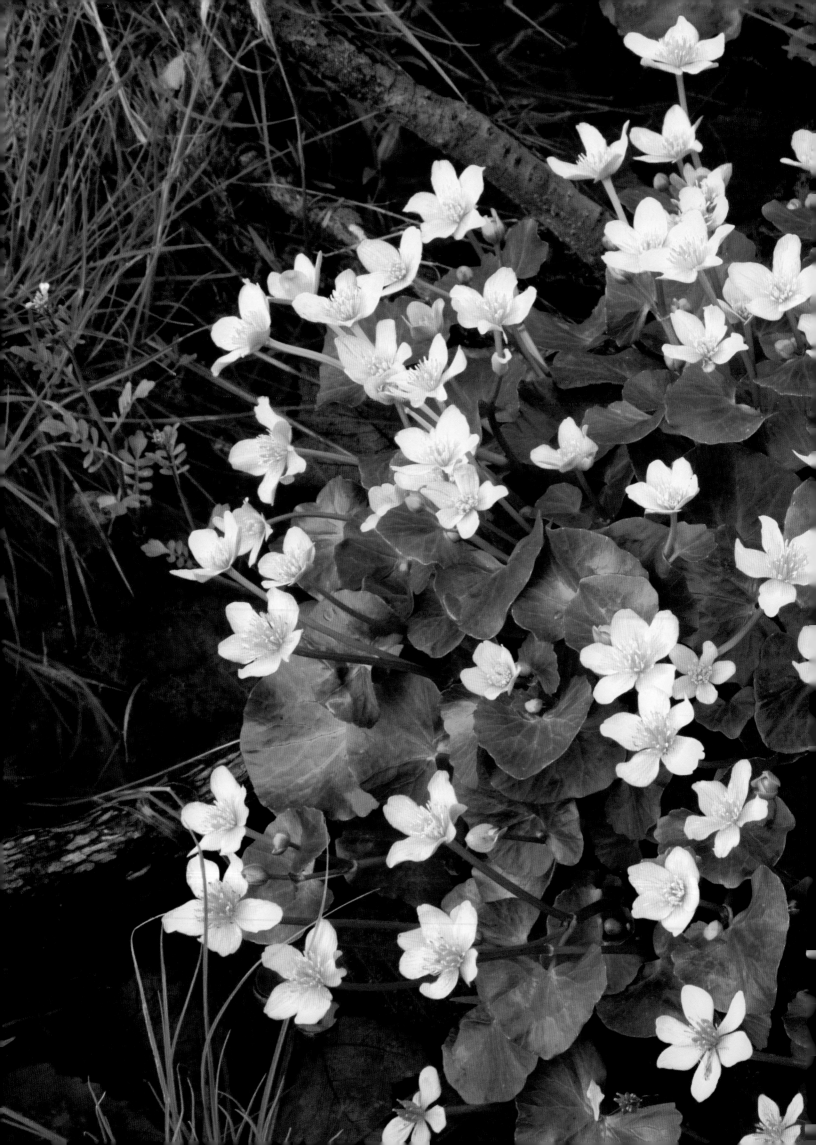

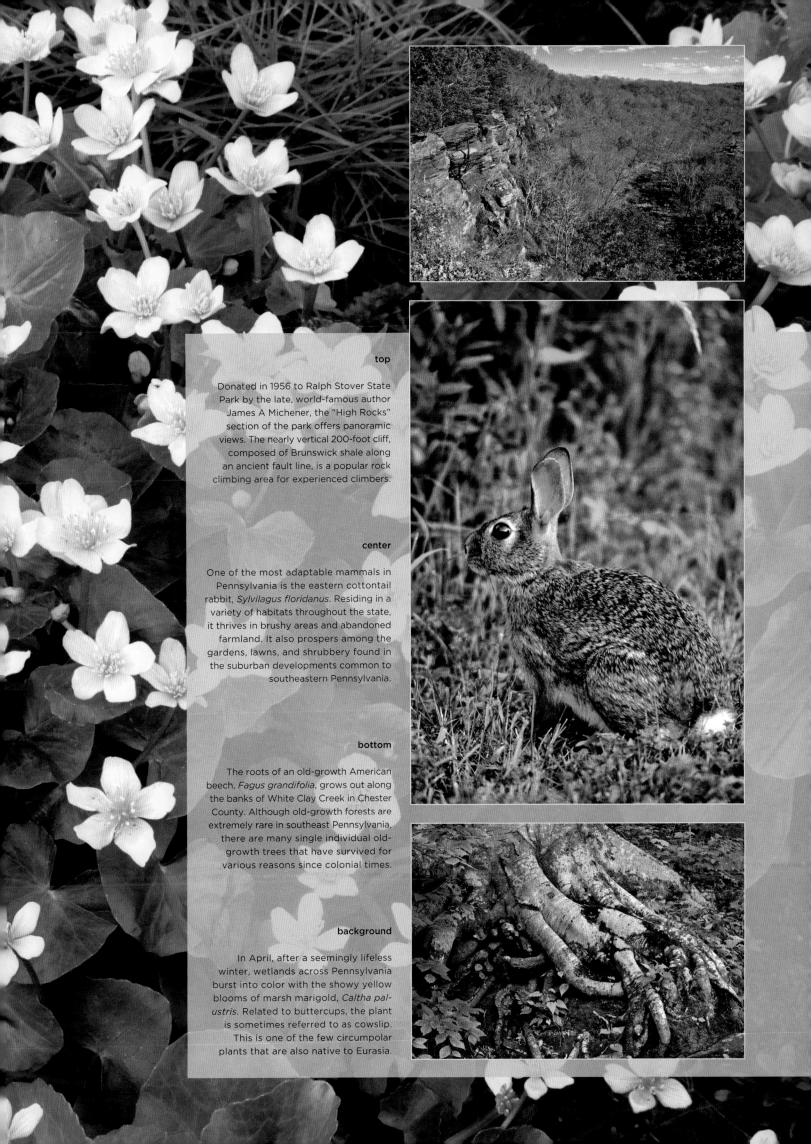

top

Donated in 1956 to Ralph Stover State Park by the late, world-famous author James A Michener, the "High Rocks" section of the park offers panoramic views. The nearly vertical 200-foot cliff, composed of Brunswick shale along an ancient fault line, is a popular rock climbing area for experienced climbers.

center

One of the most adaptable mammals in Pennsylvania is the eastern cottontail rabbit, *Sylvilagus floridanus*. Residing in a variety of habitats throughout the state, it thrives in brushy areas and abandoned farmland. It also prospers among the gardens, lawns, and shrubbery found in the suburban developments common to southeastern Pennsylvania.

bottom

The roots of an old-growth American beech, *Fagus grandifolia*, grows out along the banks of White Clay Creek in Chester County. Although old-growth forests are extremely rare in southeast Pennsylvania, there are many single individual old-growth trees that have survived for various reasons since colonial times.

background

In April, after a seemingly lifeless winter, wetlands across Pennsylvania burst into color with the showy yellow blooms of marsh marigold, *Caltha palustris*. Related to buttercups, the plant is sometimes referred to as cowslip. This is one of the few circumpolar plants that are also native to Eurasia.

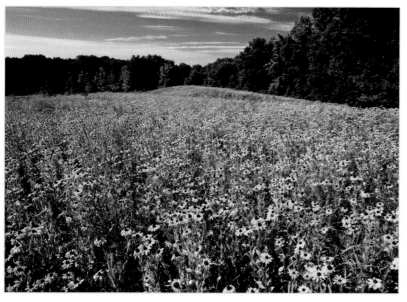

top

In Adams County, a mid-summer meadow at Gettysburg National Military Park is almost completely covered with black-eyed Susan. A perennial native to the eastern United States, black-eyed Susan, *Rudbeckia hirta*, has become established throughout much of North America and is used as a garden plant.

center

Blue violets and spring-beauty bloom in the 33-acre deciduous forest at Ruth Zimmerman State Forest Natural Area in Berks County. Part of the William Penn State Forest, the land was donated to the Commonwealth in 1989 by Mrs. Zimmerman and provides critical open space in an area teeming with development.

bottom

A stunning view of the Lower Susquehanna River and surrounding countryside is offered from 885-foot-high Mt. Pisgah at Samuel S. Lewis State Park in York County. The park was named to honor the Secretary of the Pennsylvania Department of Forest and Waters from 1951–1954.

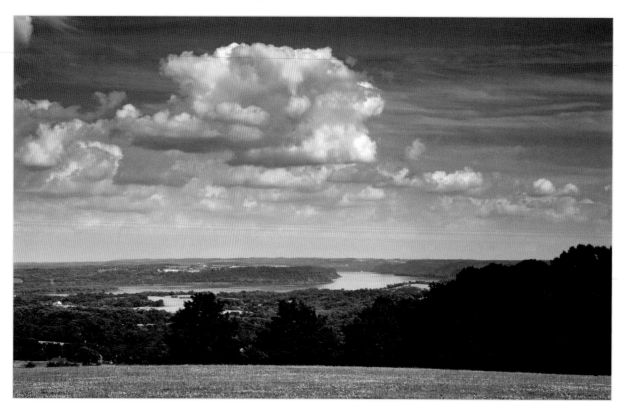

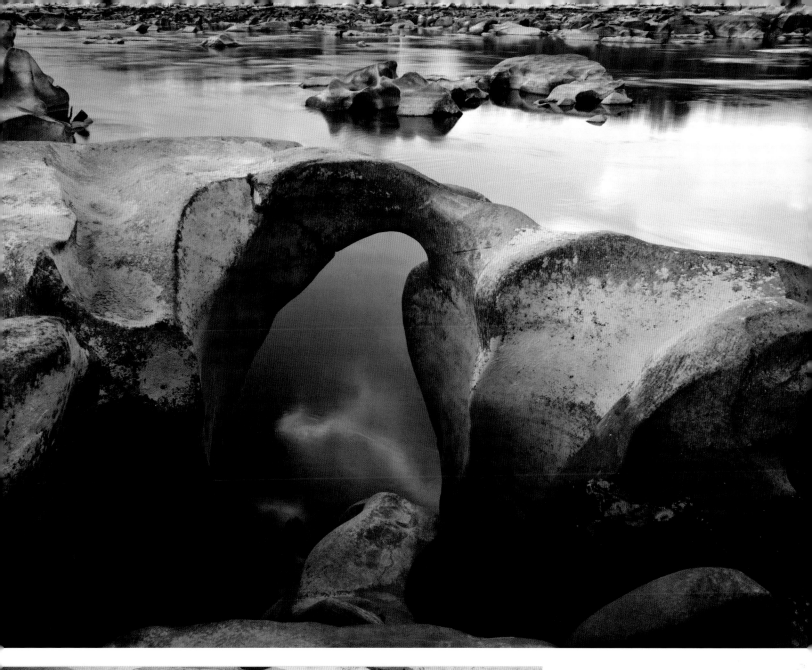

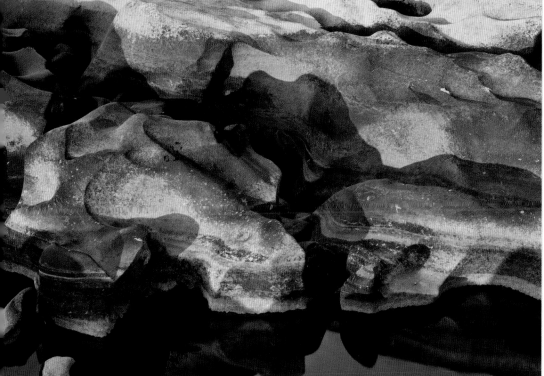

top

During periods of low river flow, the rocks at Conewago Falls are exposed and can be explored by foot or by boat. No two rocks are exactly alike and it would take years to explore them all. There are some that even form a perfect natural arch.

bottom

The beautiful, naturally sculptured rocks at Conewago Falls, on the Lower Susquehanna River, are believed to be from the Triassic Period and 250 to 200 million years old. Through thousand of years of erosion, grinding, and polishing, the rocks contain numerous potholes, some large enough to hide a human.

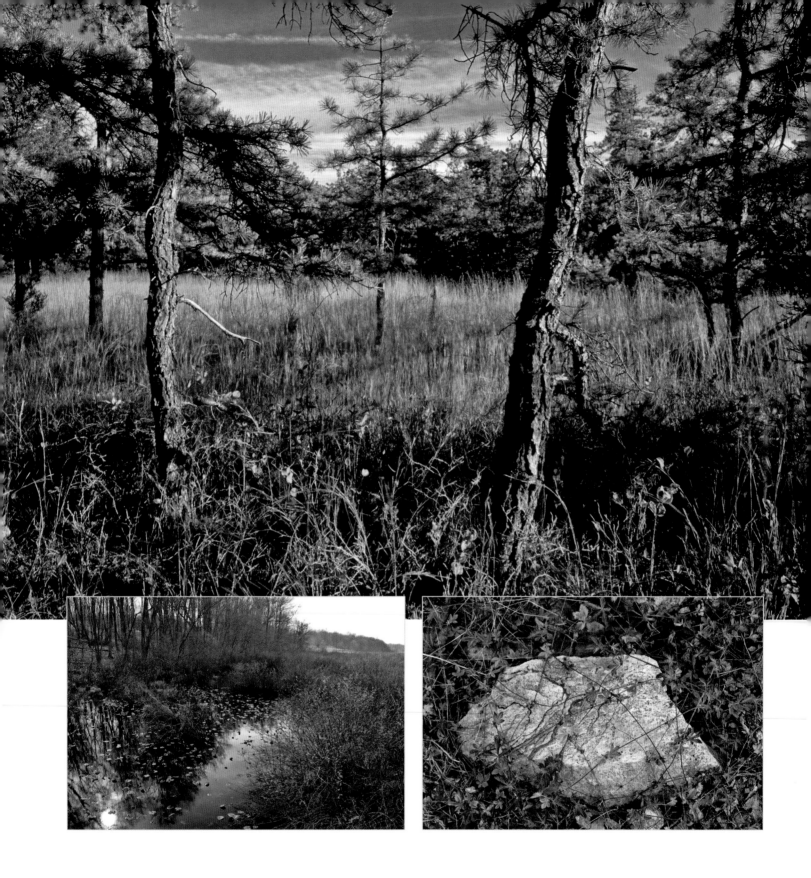

top center

Pitch pines grow in a savannah-like environment at The Goat Hill Wild Plant Sanctuary, Chester County. This 602-acre tract, owned by the Pennsylvania DCNR, is one of six sites that make up the State Line Serpentine Barrens, a globally rare and state imperiled ecosystem.

bottom left

In highly developed Chester County, just feet from the busy Pennsylvania Turnpike, lies the 3,400-acre Great Marsh, said to be the "largest, most biologically rich inland freshwater marsh in eastern Pennsylvania." More than 155 bird species have been recorded here, including several species that are state endangered or of special concern.

bottom right

The greenish-colored serpentine rock found almost exclusively in the serpentine barrens is low in plant nutrients and high in toxic metals, including magnesium, chromium, and nickel. These elements, which actually slightly poison the soil, influencing the plant life growing on the barrens, create a dramatically unusual plant community.

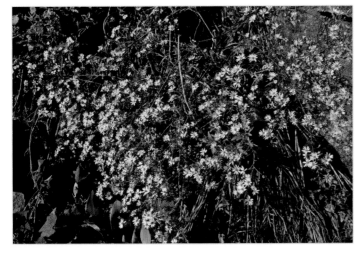

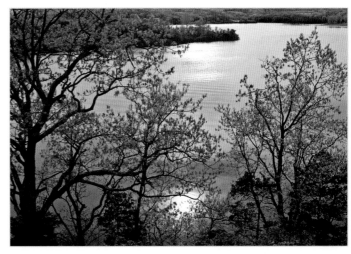

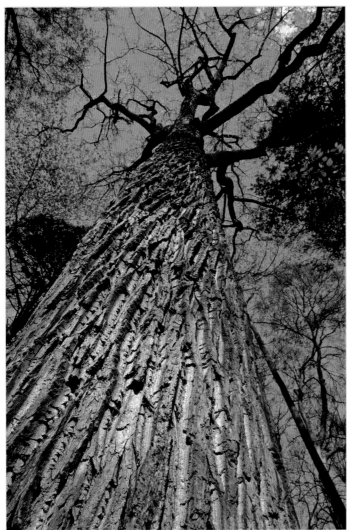

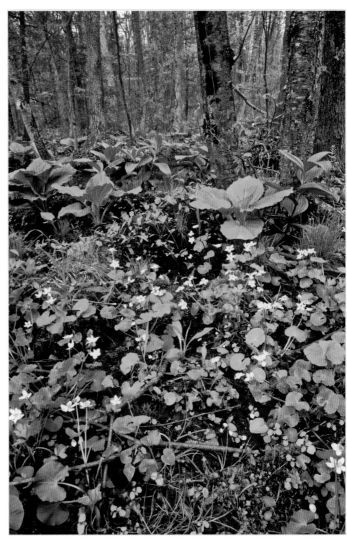

top left

Serpentine aster, *Symphyotrichum depauperatum (Syn. Aster depauperatus)*, has been called a "flagship" species for serpentine barrens. Blooming in September, it occurs on only 20 of the 26 serpentine barrens in the eastern United States, including Goat Hill. It is classified as a threatened species in Pennsylvania due to its limited range.

bottom left

An old-growth tulip tree grows in the forest canopy at Wissahickon Gorge in northwest Philadelphia. The site of eighteenth-century mills, in 1868, Wissahickon became the first publicly owned U.S. land to be preserved because of its scenic attributes. Surprisingly, it harbors a 120- to 200-year-old forest within Philadelphia city limits.

top right

Spring comes to the forest surrounding 1,150-acre Blue Marsh Lake. By damming Tulpehocken Creek, the lake was constructed in 1979 by the U.S. Army Corps of Engineers as a flood control project. Blue Marsh Lake area and adjacent State Game Lands 280 have been designated as an Important Bird Area.

bottom right

Located near Minsi Lake in Upper Mount Bethel Township, Northampton County, 262-acre Bear Swamp is a spring-fed, calcareous wetland. In spring, plants such as marsh marigold, skunk cabbage, and Indian poke grow here. The swamp is also a birding hot spot. A trail and boardwalk make the swamp accessible for visitors.

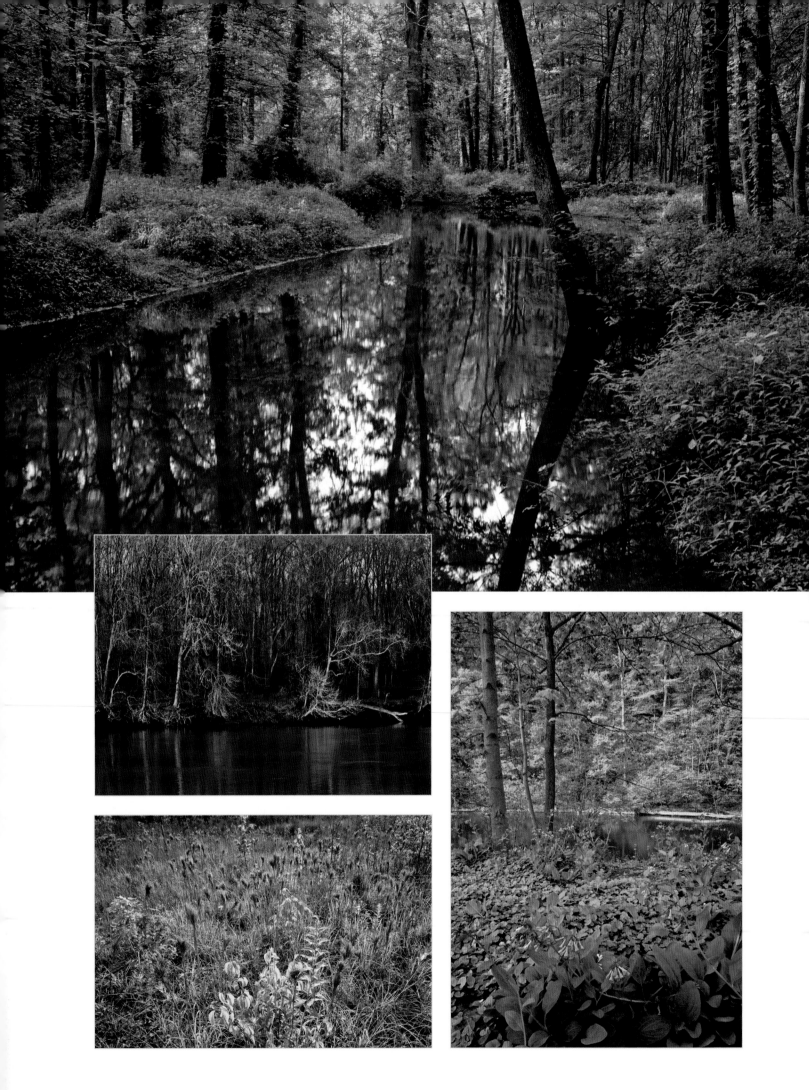

Little Tinicum Island State Forest Natural Area, 12 miles south of Philadelphia in the Delaware River Estuary, is around 2.25 miles long and 200 yards wide. Located in a heavy industrialized area, it nevertheless contains numerous uncommon Pennsylvania species. In 1643 it was the first permanent European settlement in Pennsylvania.

— OPPOSITE —

top center

French Creek flows through the Natural Land Trust's Crow's Nest Preserve in Chester County. The 612-acre preserve is composed of forest, meadows, agriculture fields, and riparian habitat along French Creek. It is also part of the 73,000-acre Hopewell Big Woods, one of the largest parcels of protected land in the region.

clockwise

Virginia bluebells, *Mertensia virginica*, bloom in spring on the floodplain along Tulpehocken Creek in Berks County. The 26-mile-long creek is an important trout stream and a branch of the Schuylkill River. Tulpehocken comes from the Native American Lenape word *Tulpewikaki*, meaning "land of turtles."

Sliver Lake Nature Center protects some unique habitats for Pennsylvania, including the best example of a coastal plain forest, an unglaciated bog, and wet meadows, as seen here. Owned and operated by the Bucks County Department of Parks and Recreation, the 235-acre preserve possesses 43 Pennsylvania Species of Special Concern.

A late afternoon sun offers a warm glow along the Schuylkill River at Valley Forge National Historic Park. On the bluffs overlooking this site, General George Washington and his tattered and tired army spent the winter of 1777–78, making it one of the most iconic events in United States history.

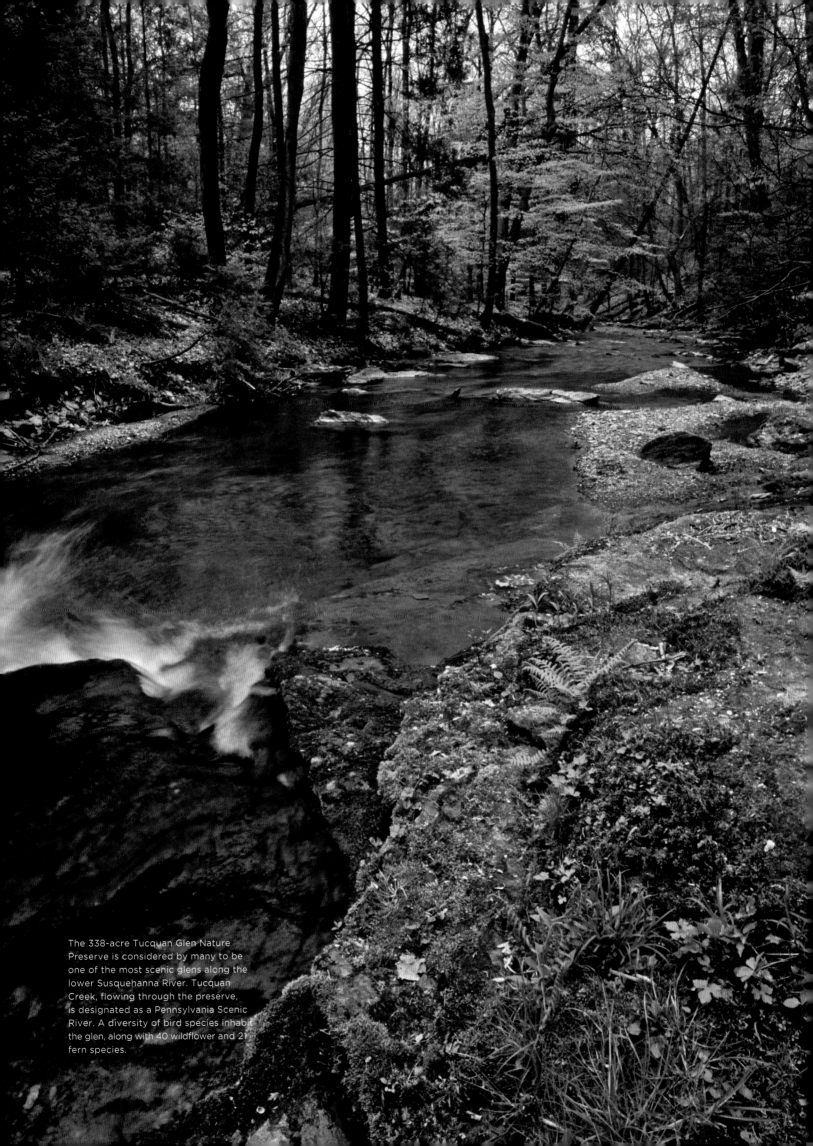

The 338-acre Tucquan Glen Nature Preserve is considered by many to be one of the most scenic glens along the lower Susquehanna River. Tucquan Creek, flowing through the preserve, is designated as a Pennsylvania Scenic River. A diversity of bird species inhabit the glen, along with 40 wildflower and 21 fern species.

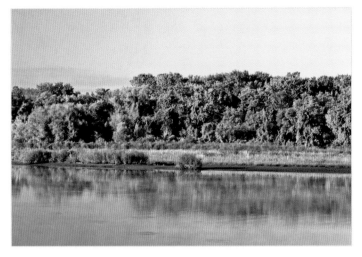

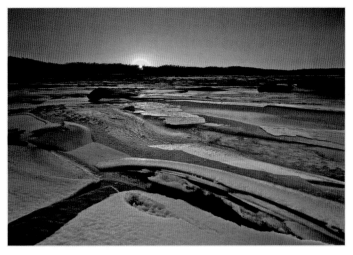

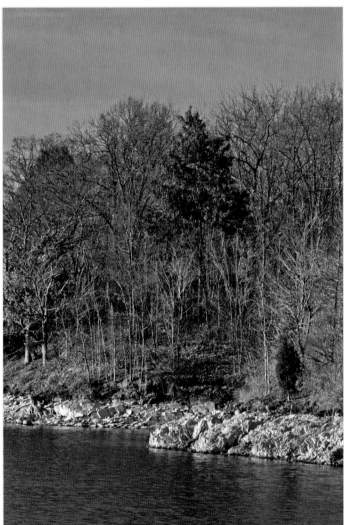

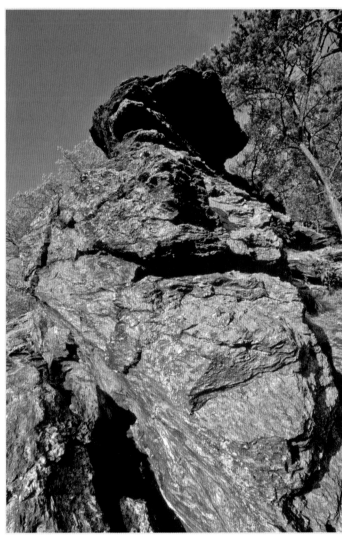

top left

Morning mist rises from the Susquehanna River at Conejohela Flats in Lancaster County. Prior to the early-1900s construction of hydroelectric dams downstream, the area was a marshy floodplain forest. Now a group of brushy islands and mudflats, the area attracts more than 30 species of shorebirds during migration.

bottom left

At normal pool elevation, 8-mile-long Blue Marsh Lake has approximately 35 miles of shoreline and a maximum depth of 53 feet. Studies by the Pennsylvania Fish and Boat Commission have determined the lake has a self-supporting warm water fish community with 37 species captured during surveys by Commission biologists.

top right

A winter sun sets over the ice-covered Susquehanna at Conewago Falls. Under certain conditions, river ice can form ice dams, inundating the adjacent low-lying land, a naturally and positive ecological condition. However, with unregulated development in floodplain areas, severe loss of property, economy, and human life can occur.

bottom right

Geologists describe the rock type forming Pinnacle Rock as Wissahickon schist, a metamorphic rock formed under intense heat and pressure from sedimentary rock. The Precambrian Wissahickon Formation is estimated to be more than 500 million years old. At that time, the land that is now Pennsylvania was south of the Equator.

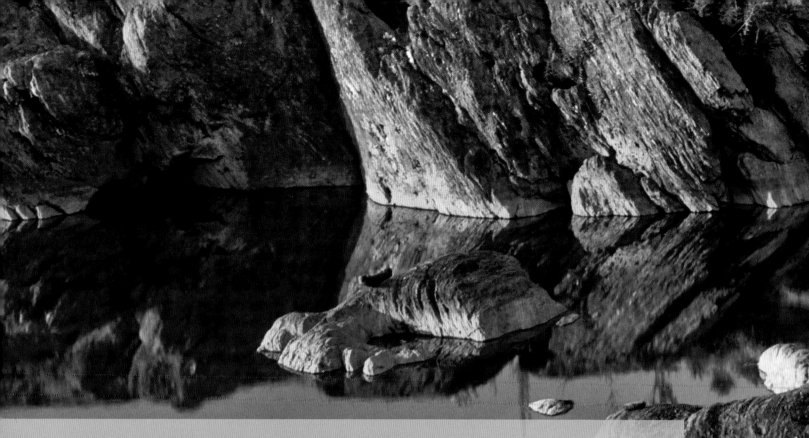

top

The beautiful 1,275-acre Lake Marburg at Codorus State Park in York County is a one-of-a-kind for Pennsylvania. Created in 1966 as a joint effort between the Commonwealth and Glatfelter Paper Company, the lake provides water for a private industry, the town of Spring Grove, and a public recreation area.

bottom

Flowering dogwood and eastern redbud show off their spring blossoms at Gifford Pinchot State Park in York County. The park is named in honor of Gifford Pinchot (1865–1946), a progressive Republican who served two terms as governor of Pennsylvania and as first chief of the United States Forest Service under President Theodore Roosevelt.

background

Once viewed only as a barrier to commercial transportation on the Lower Susquehanna River, the Conowingo Islands are now seen as an important natural, scenic, and recreational resource. There is nowhere else in Pennsylvania quite like this landscape and artists and photographers are just discovering its scenic treasures.

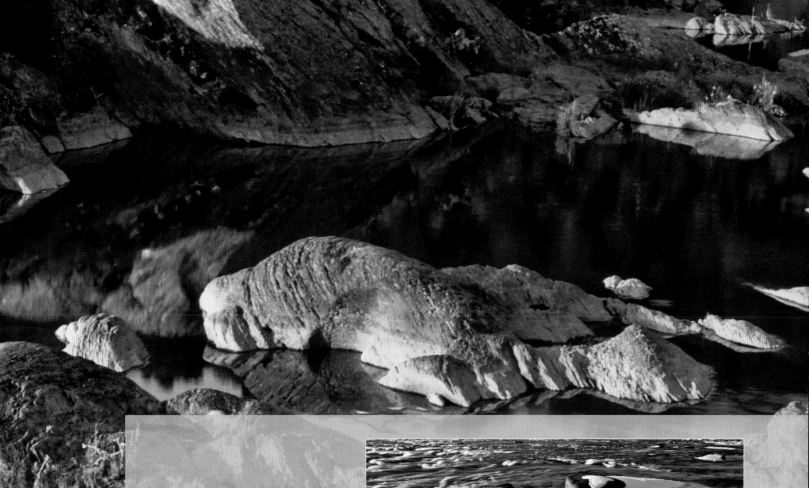

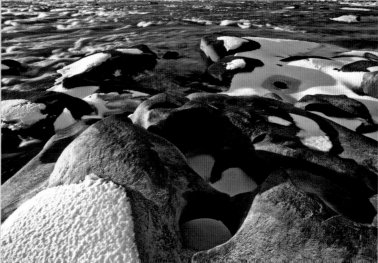

top

Snow and ice only seem to enhance the natural, gracefully carved river potholes at Conewago Falls. This feature has been interpreted by many historians, in particular in the writings of Captain John Smith, who explored the area in 1608. He discovered a Native American Susquehannock village near this site that he called "Sasquesahanough."

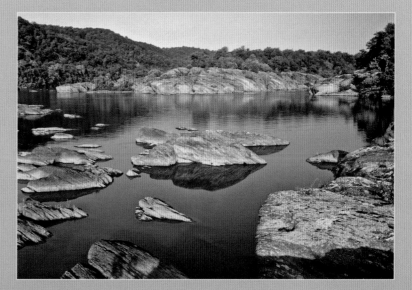

bottom

The Conowingo Islands are considered by The Nature Conservancy as highly significant for maintaining biological diversity in Pennsylvania due to the state-endangered, threatened, and rare species that inhabit the Riverside Cliff/Outcrop natural community that exists here. The islands also provide a nesting and roosting site for bald eagles and osprey.

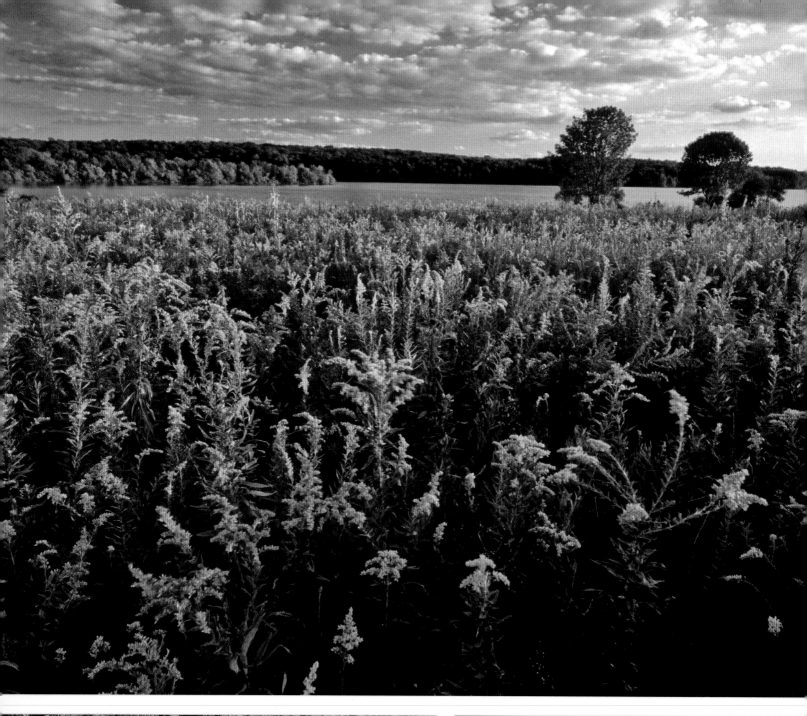

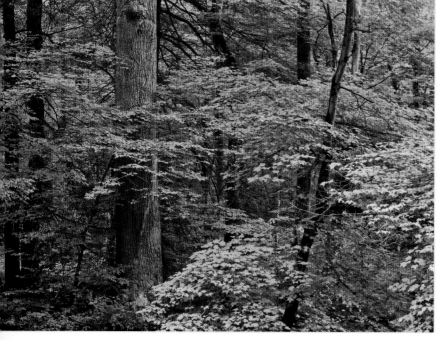

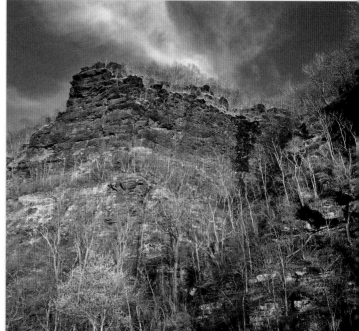

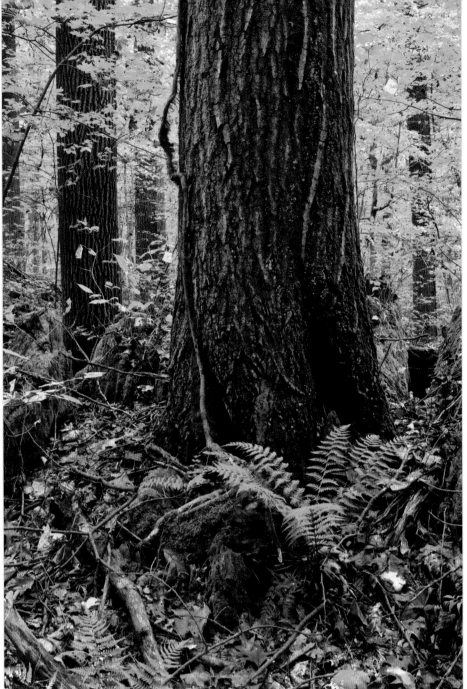

top left

In summer, acres of goldenrod bloom in wild meadows along the shore of Lake Nockamixon at Nockamixon State Park. There are numerous goldenrod species native to Pennsylvania and identification can be difficult at times. Goldenrod does not cause hay fever, rather its sticky pollen makes a high quality honey.

top right

One of the last remaining old-growth forests in Northampton County is located in the 750-acre Martins Creek Environmental Preserve, owned by PPL Corporation. This 15-acre deciduous forest, growing next to the Delaware River, is composed mostly of tulip tree, various oaks, and hickories. Several hiking trails traverse the preserve.

bottom left

Henry's Woods is an old-growth forest at Jacobsburg Environmental Education Center in Northampton County. Protected as a Pennsylvania State Park, the 40-acre grove, located along scenic Bushkill Creek, includes eastern hemlock, white pine, and several hardwood species. The trees are estimated to be between 180–350 years old.

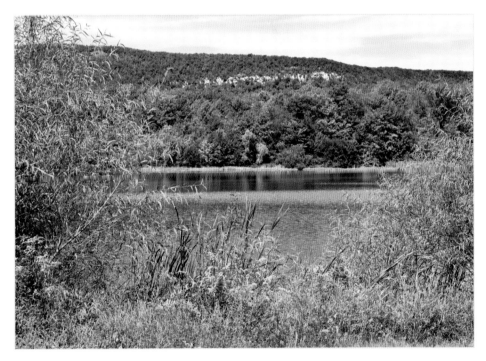

bottom center

Spectacular Nockamixon Cliffs at Delaware Canal State Park have been designated a State Park Natural Area. The nearly vertical cliffs rise 300 feet above the Delaware River in Bucks County. Composed of shales, siltstones, and sandstones of the Brunswick Formation, they have faced eons of erosion by the Delaware River.

bottom right

Located in Northampton County and lying at the base of the Kittatinny Mountain, Minsi Lake is a 117-acre impoundment within Northampton County's Minsi Lake Wilderness Area, a 300-acre county park reserve with hiking trails, wilderness, and wetlands.

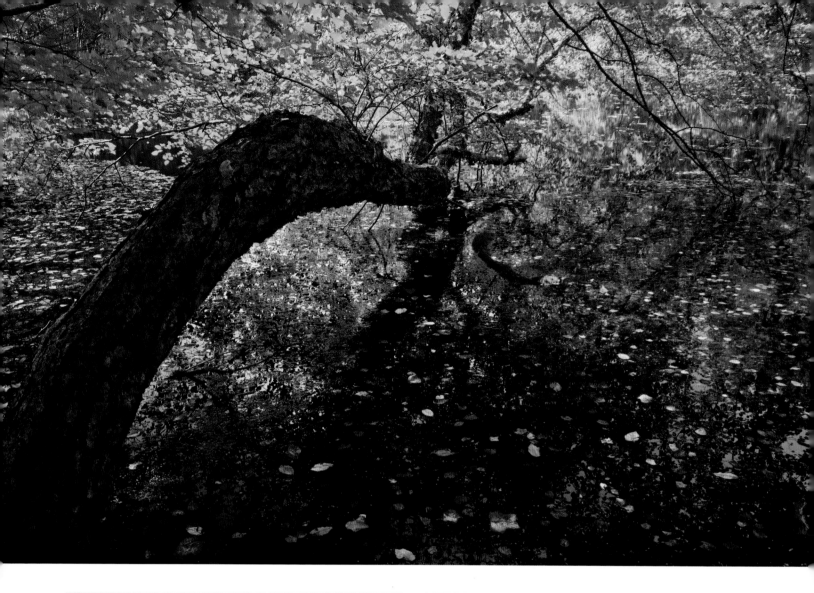

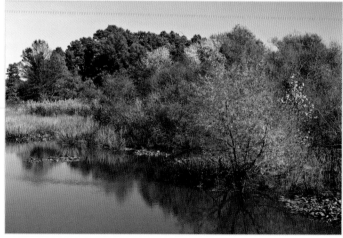

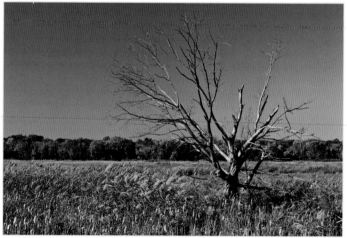

top center

A river birch, *Betula nigra*, finds a favorable growing location along the shore of a pond near Slatford Farm at Delaware Water Gap National Recreation Area in Northampton County. Small ponds, and especially seasonal ponds, are vital habitat and breeding locations for many amphibians.

bottom left

John Heinz National Wildlife Refuge, in Philadelphia and Delaware counties, has recorded more than 280 species of birds, 19 species of reptiles and amphibians, and several species of mammals inhabiting its varied wetland and forest habitats. Establishment in 1972, the refuge has served as an important outdoor classroom for environmental education.

bottom right

It is estimated that at the time of European settlement in 1634, more than 5,700 acres of tidal marsh occurred in the southeast corner of Pennsylvania. Through centuries of draining, diking, and urbanization, today only around 350 acres are left. Most are protected at the John Heinz National Wildlife Refuge.

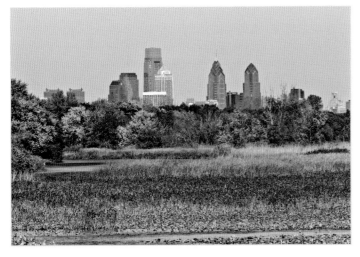

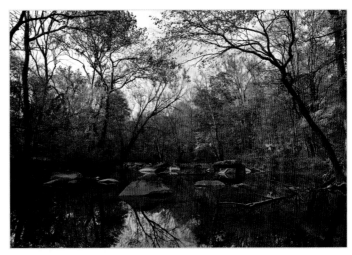

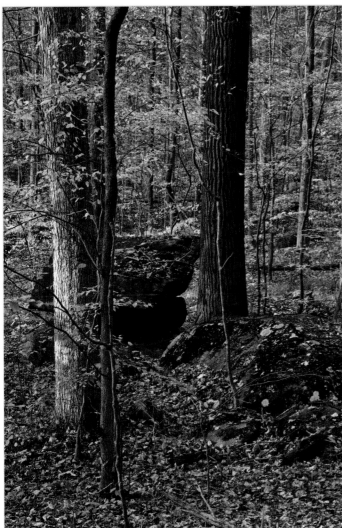

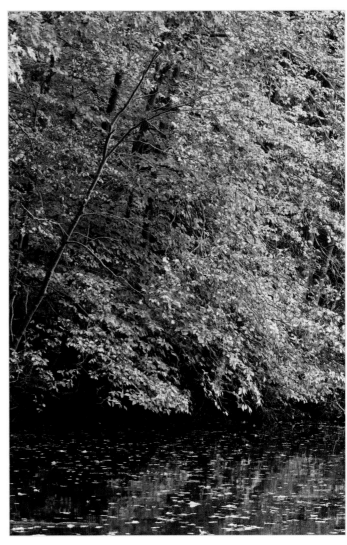

top left

Located just outside the city of Philadelphia, a metropolitan area of nearly 6 million people, John Heinz National Wildlife Refuge at Tinicum is said to be the "most urbanized area in the National Wildlife Refuge System" and has 130,000 visitors annually, providing vital exposure to nature for the urban dweller.

bottom left

A beautiful, mature deciduous forest grows along the upper reaches of Tohickon Creek at Nockamixon State Park in Bucks County. Forest such as these are uncommon in southeast Pennsylvania and if protected may well ultimately develop into an old-growth forest in a few generations.

top right

A section of the 29.5-mile-long Tohickon Creek flows through Nockamixon State Park where it is dammed, forming Lake Nockamixon. It is the longest waterway located entirely in Bucks County. *Tohickon* is a Native American Lenape name, which means "Deer-Bone Creek." The area today contains several historic Native American archaeology sites.

bottom right

The diverse habitat at Montgomery County's 3,400-acre Green Lane Park has attracted more than 270 different species of birds, resulting in Audubon Pennsylvania designating it an Important Bird Area. Numerous species of songbirds, shorebirds, wading birds, waterfowl, and even bald eagles use the water and forest areas of the park.

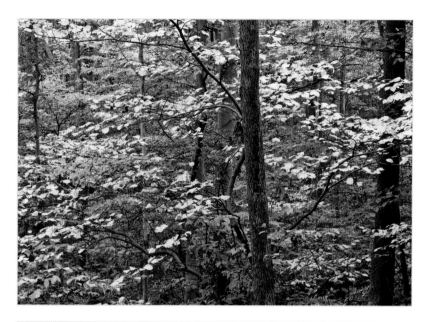

top

Two major forest types are found at Green Lane Park in Montgomery County. Extensive eastern red-cedar barrens dominate the drier sites while on the fertile moist sites a mixed mesophytic forest consisting of various oaks, hickories, tulip tree, and American beech, along with other species, grows.

center

Most people are familiar with flowering dogwood, *Cornus florida*. In spring, the tree displays its 4-inch-wide, bright white flowers. But in autumn the tree gives us more delights as it shows off some of reddest autumn foliage in the forest, as seen here at Green Lane Park.

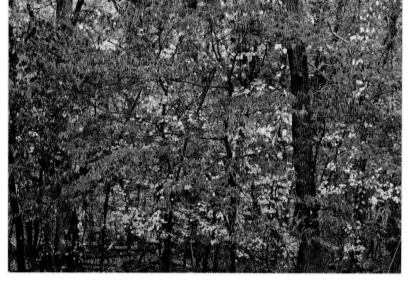

bottom

Montgomery County's 814-acre Green Lane Reservoir was formed in 1957 when Perkiomen Creek was dammed to provide a water source for Philadelphia. Prior to this, a smaller artificial lake was present on the site. This nineteenth-century lake provided ice for refrigeration, which was cut from the frozen lake.

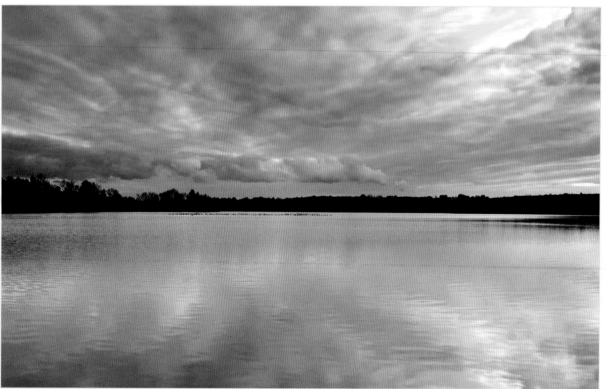

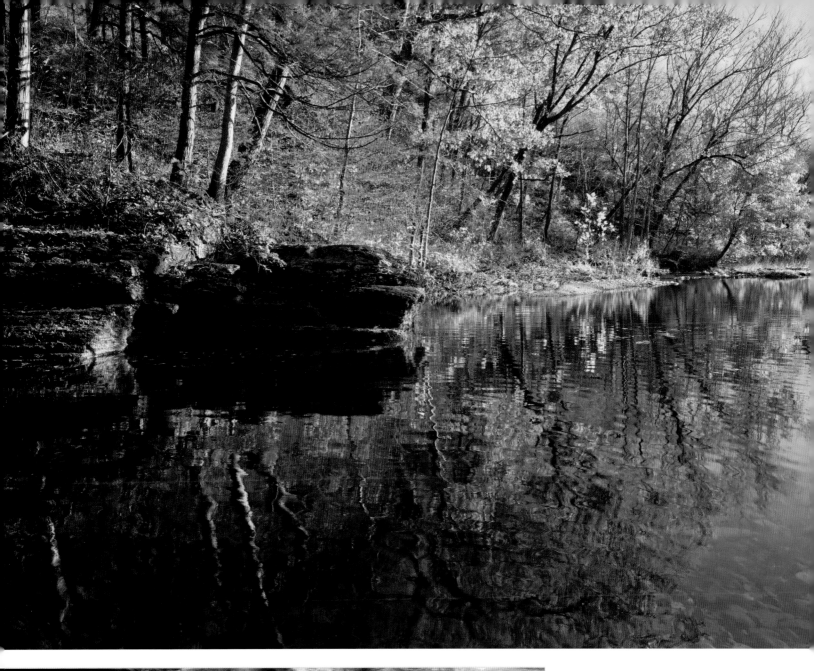

top

Autumn puts on an impressive show along Bushkill Creek in 1,168-acre Jacobsburg Environmental Education Center, a Pennsylvania State Park in Northampton County. *Bushkill* is a Dutch word meaning "bushy" or "forest creek." About 2.5 miles of the creek flow through the park.

bottom

Autumn reflections in Bushkill Creek at Jacobsburg Environmental Education Center form an abstract design reminiscent of the painting movement popular in the early and mid-twentieth century. With each minor change in water current or slight change of wind direction, a new abstract pattern is formed.

125

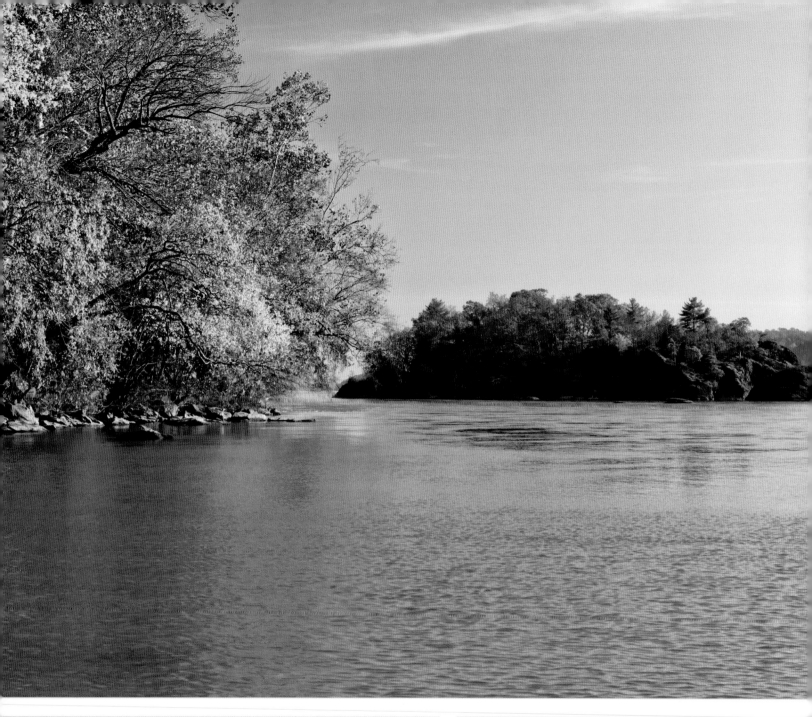

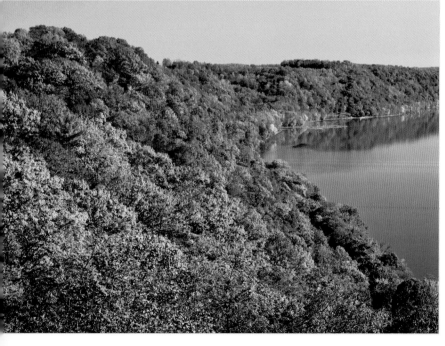

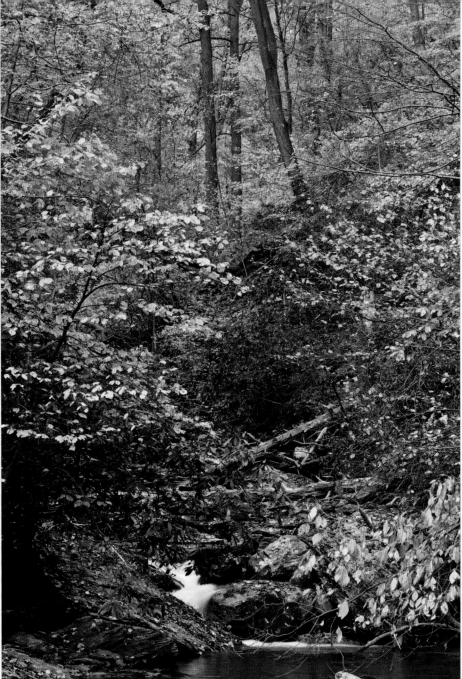

top left

While most islands in the Susquehanna River are alluvial, formed from sediment flowing in the river, the scenic Conowingo Islands in the lower Susquehanna, south of Holtwood, are erosional remnants of metamorphic bedrock. More than sixty islands make up the archipelago, including Sicily Island seen here from Muddy Run.

top right

The very picturesque Kelly's Run, at PPL's Holtwood Environmental Preserve in Lancaster County, cuts its channel down the mountainside through 500-million-old metamorphic Wissahichon schist. Bordering the stream, a rare old-growth forest, containing 300-year-old eastern hemlocks and tulip trees, towers over a dense understory of rhododendron.

bottom left

A view of the lower Susquehanna River's "river hills" is seen from 400-foot-high Hawk Point Overlook at Susquehannock State Park in Lancaster County. This is an excellent location to see bald eagles. Two and a half miles down river is Mt. Johnson Island, dedicated in 1945 as the world's first bald eagle sanctuary.

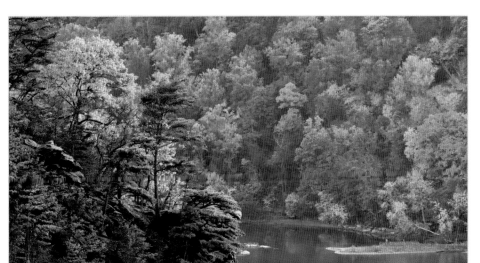

bottom center

Old-growth tulip trees and American sycamores grow along the lower Susquehanna River in Lancaster County. These trees form a vital habitat for the many bird species found along the river, including osprey and bald eagles, which use them as a perch while hunting for fish in the river.

bottom right

The rugged rock bluffs and ledges overlooking the Susquehanna River at the Pinnacle in Lancaster County contrasts with the pastoral Amish farmland found over much of the county and for which the area is well-known.

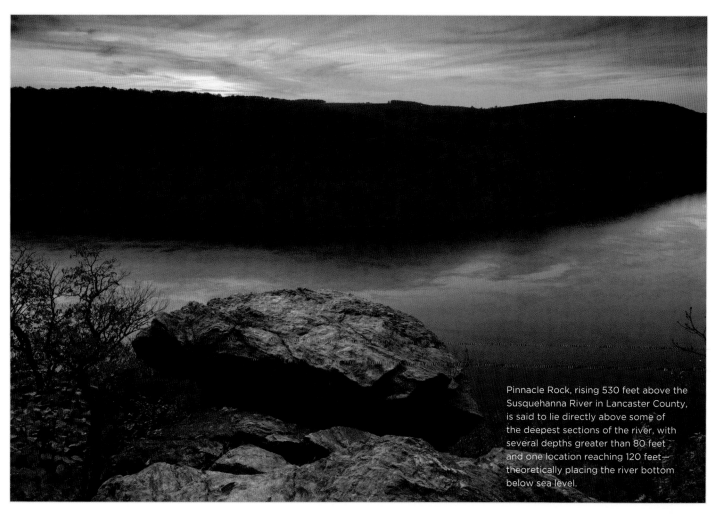

Pinnacle Rock, rising 530 feet above the Susquehanna River in Lancaster County, is said to lie directly above some of the deepest sections of the river, with several depths greater than 80 feet and one location reaching 120 feet—theoretically placing the river bottom below sea level.

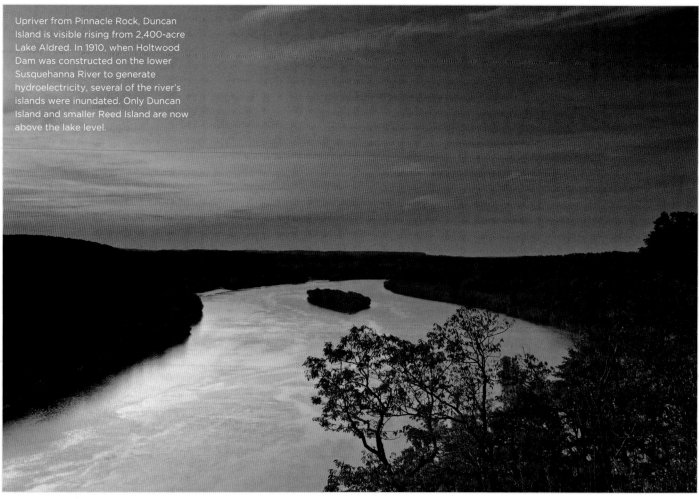

Upriver from Pinnacle Rock, Duncan Island is visible rising from 2,400-acre Lake Aldred. In 1910, when Holtwood Dam was constructed on the lower Susquehanna River to generate hydroelectricity, several of the river's islands were inundated. Only Duncan Island and smaller Reed Island are now above the lake level.

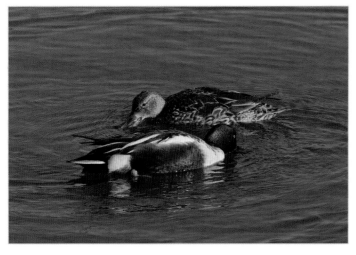

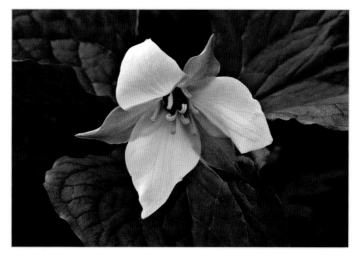

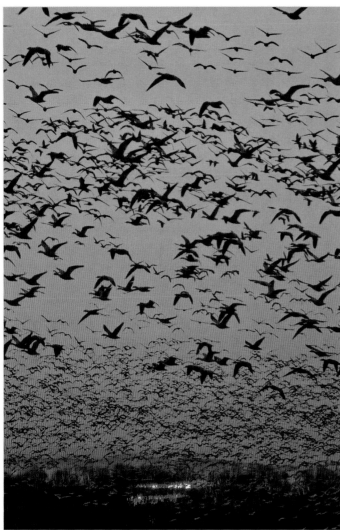

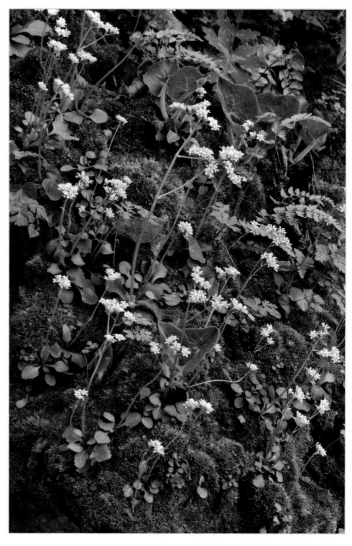

top left

Common during winter and migration at the John Heinz National Wildlife Refuge, the northern shoveler, *Anas clypeate*, is one of the few birds found in both North America and Eurasia. During courtship, the couple swims slowly in a circle, one behind the other, with water running through their bills.

bottom left

At the Pennsylvania Game Commission's Middle Creek Wildlife Management Area in Lancaster and Lebanon Counties, greater snow geese stage during the spring migration, waiting for the northern lakes to become ice-free. In some years up to 170,000 snow geese have been present on the management area during the spring migration.

top right

One of the main attractions at Shenk's Ferry Wildflower Preserve is the rare, white variety of red trillium, *Trillium erectum var. album*. Usually bearing blossoms of a deep red color, almost all the red trilliums growing at the preserve are the white variety.

bottom right

Early saxifrage, *Saxifraga virginiensis*, and wild ginger, *Asarum canadense*, have found a favorable growing location on the side of a moss-covered boulder at Shenk's Ferry Wildflower Preserve. Both plants and animals live in locations that not only fulfill their growing needs but also lessen competition from other similar organisms.

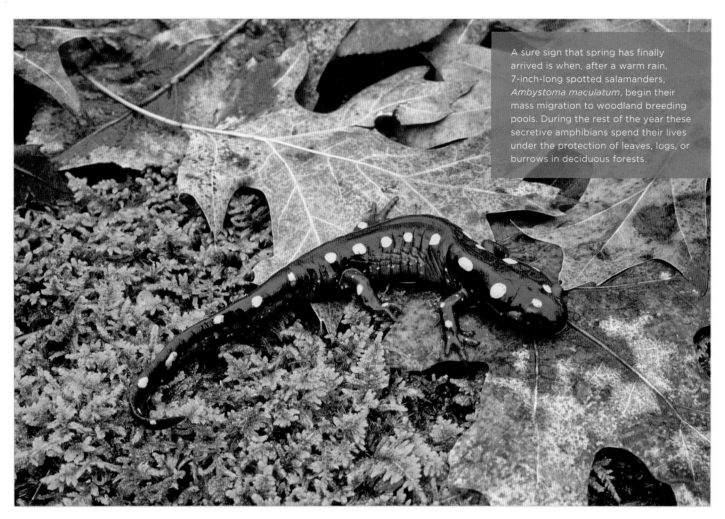

A sure sign that spring has finally arrived is when, after a warm rain, 7-inch-long spotted salamanders, *Ambystoma maculatum*, begin their mass migration to woodland breeding pools. During the rest of the year these secretive amphibians spend their lives under the protection of leaves, logs, or burrows in deciduous forests.

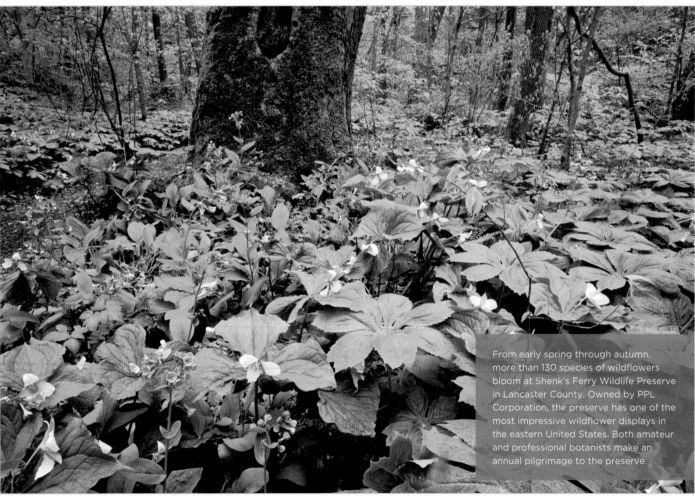

From early spring through autumn, more than 130 species of wildflowers bloom at Shenk's Ferry Wildlife Preserve in Lancaster County. Owned by PPL Corporation, the preserve has one of the most impressive wildflower displays in the eastern United States. Both amateur and professional botanists make an annual pilgrimage to the preserve.

Mountains as high as the Himalayas stretched in a broad band across Pennsylvania from the northeast corner to the south central section. Hard to believe, but geologists say its true. The only problem is that it occurred more than 260 million years ago. The Appalachian Mountains we see now in central Pennsylvania are the eroded remnant roots of Himalayan-sized ridges composed of arcs and tectonic plates folded under pressure during a collision of the Africa and North America continents.

These parallel mountain ridges presently rise just a little more than 2,000 feet in elevation above the valleys 1,600 below and comprise an area known as the Ridge and Valley Province. This is one of the most studied geological areas in the world by students of geology and nature's forces. Famous for it corduroy-like ridges, it also is renowned for its classic water gaps and wind gaps, which strikingly display the geological forces of uplift and erosion.

While the valleys contain some of the state's richest agriculture land, the mountaintops harbor some of the wildest natural areas in Pennsylvania. Extending from southeast New York to northeast Alabama, these ridges running through Pennsylvania act as ecological highways. Besides their fame as a migratory route for raptors and monarch butterflies, to name just a few, there are species found only on these ridges from north to south, such as table mountain pine and the Allegheny wood rat. Humans also traverse these ridges, hiking the approximately 229 miles of the world-famous Appalachian Trail that runs through Pennsylvania along the Blue and South Mountain.

Yet, while celebrated for its geological and ecological riches, the province has not escaped human abuse for economic greed. In some places, the mining scars from iron, coal, and other minerals are still visible today. This is in addition to the economic burden on taxpayers who have to pay to restore the lands left abandoned by the mining companies. Most of the magnificent primeval forests were clear-cut, not only for timber, but also for charcoal production to fuel the iron smelting industry of the eighteenth and nineteenth centuries.

But all was not lost. Under the progressive, forward-thinking leadership of men like Gifford Pinchot, Joseph Rothrock, and others, conservation polices introduced nearly one hundred years ago helped this land recover from the abusive practices of the past. It can never be restored to pre-Columbian times, but today this most distinctive Pennsylvania landscape is known and valued by people the world over for its natural riches.

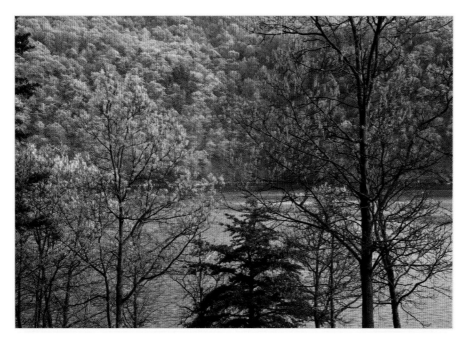

top

In mid-April the various species of oak trees on the shore of Raystown Lake in Huntingdon County start to add color to the landscape as their flower buds open, exposing catkins that will disperse pollen in the spring breezes.

bottom left

Growing in rich, moist soil on wooded hillsides throughout Pennsylvania, Dutchman's breeches, *Dicentra cucullaria*, blooms in early spring. The flowers, which resemble the trousers of early Dutch settlers, produce seeds that are spread by ants through a process called myrmecochory. This beautiful cluster was photographed near the Delaware Water Gap.

bottom right

Before the leaves appear on the American sycamore trees growing along the Raystown Branch of the Juniata River, oaks and eastern redbud are flowering on the shale cliffs at Warriors Path State Park in Bedford County.

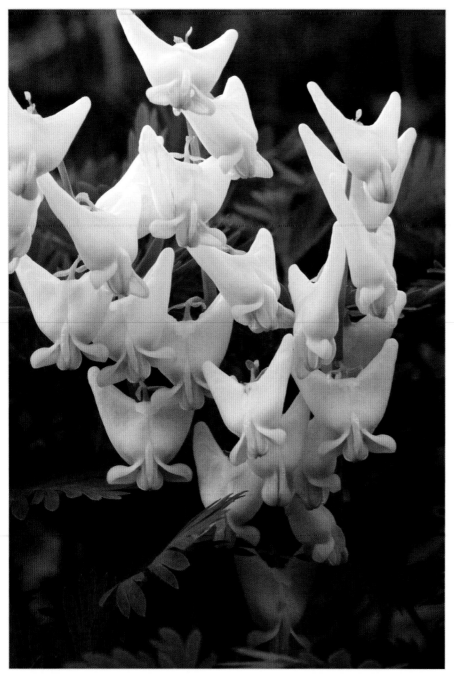

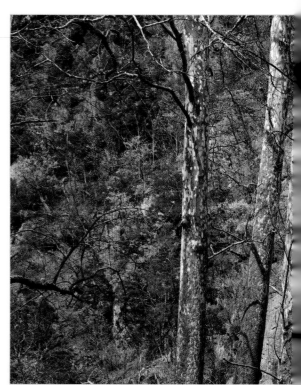

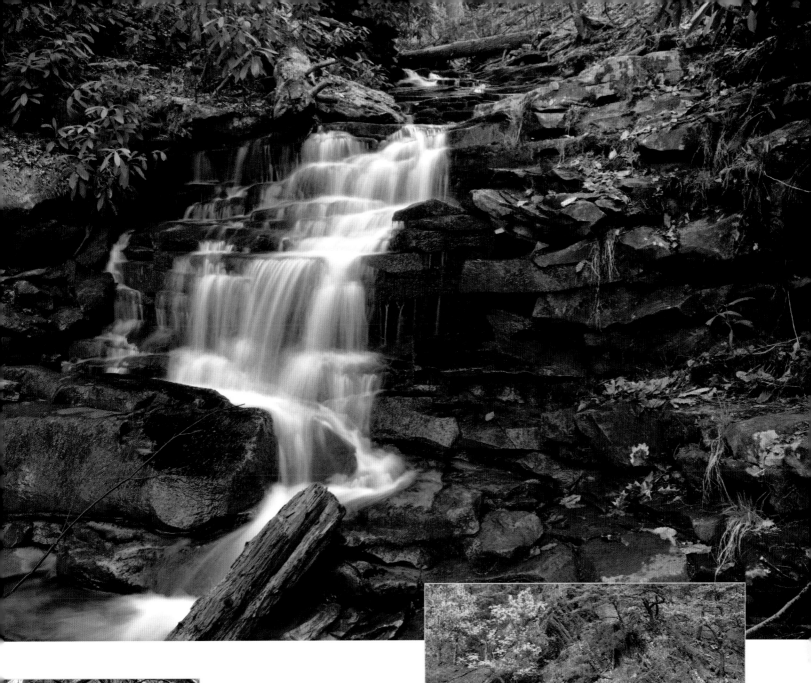

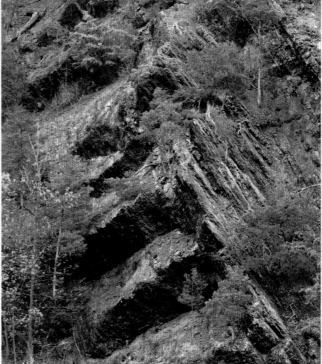

top

In addition to the Ice Mine, Balanced Rock, and Copperas Rocks, the 18-foot-high Rainbow Falls along Abbot Run in Trough Creek State Park, Huntingdon County, is just one of the interesting geological features found in the 554-acre park.

bottom

Warriors Path Shale Barrens Biological Diversity Area has been given an "exceptional" ranking by the Western Pennsylvania Conservancy due to being a location where four plant species of special concern are found, two of which are restricted to shale barrens, in addition to one animal species of special concern.

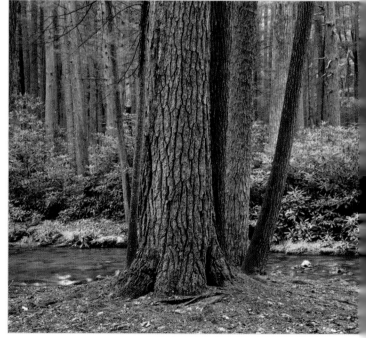

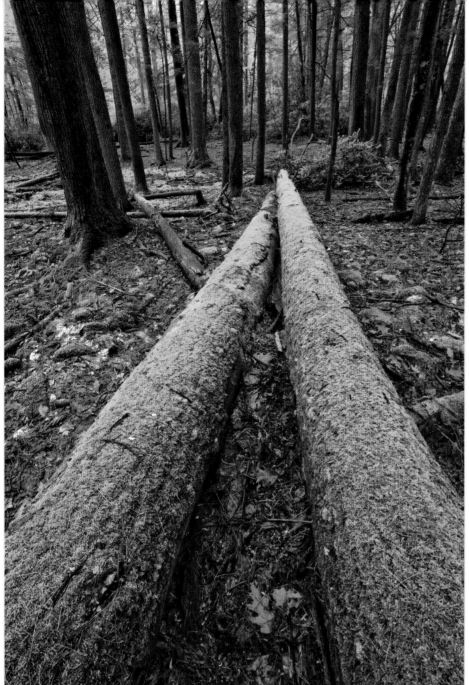

top left

Although eastern redbud, *Cercis Canadensis*, is widely grown as an ornamental, it's a native that grows wild throughout southern and central Pennsylvania, as seen here in Bedford County. The brilliant purplish-pink flowers appear in early spring before the leaves. Redbud is one of the state's earliest flowering trees.

top right

Two moss-covered, wind-thrown eastern hemlock logs coincidentally point toward the old-growth forest in the 390-acre Alan Seeger State Forest Natural Area in Huntingdon County.

bottom left

The prominent botanist, ecologist, and expert on the forests of the eastern United States, E. Lucy Braun, said the Alan Seeger State Forest Natural Area is, "a perfect example of a hemlock forest." The area was named in 1921 for a World War 1 solider and poet killed in France.

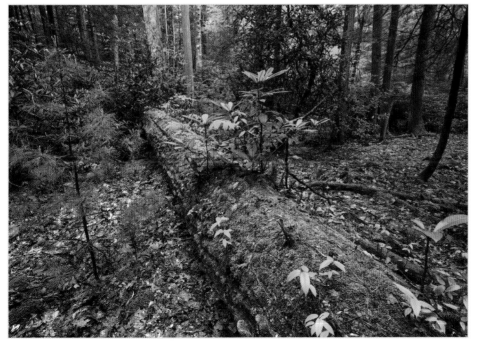

bottom center

Old-growth forest composed of towering eastern white pine and eastern hemlock, like the one preserved here along Standing Stone Creek in the Alan Seeger State Forest Natural Area, were once common throughout northern and central Pennsylvania before the massive clear-cutting during the late nineteenth and early twentieth centuries.

bottom right

At the Alan Seeger State Forest Natural Area in the Rothrock State Forest, rhododendron and birch seedlings find a favorable growing location on a nurse log of a decaying old-growth eastern hemlock tree. After the log decays, the trees will appear to be growing on stilts.

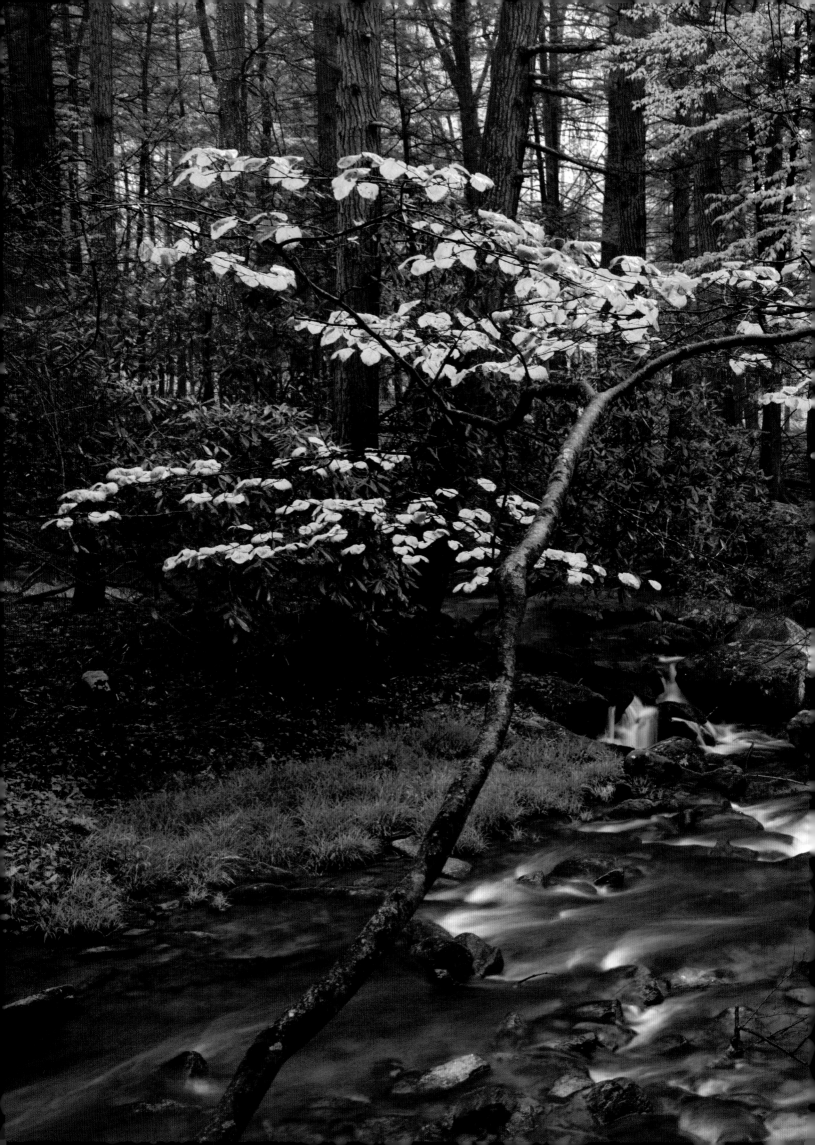

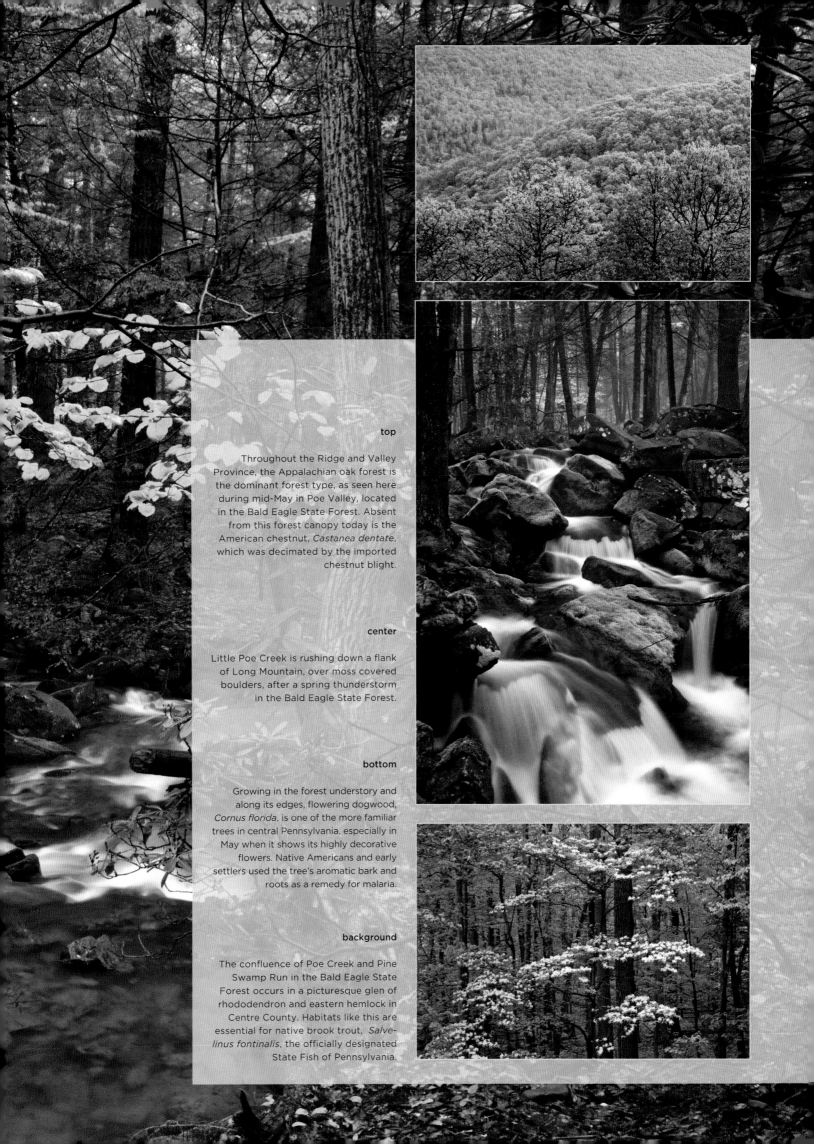

top

Throughout the Ridge and Valley Province, the Appalachian oak forest is the dominant forest type, as seen here during mid-May in Poe Valley, located in the Bald Eagle State Forest. Absent from this forest canopy today is the American chestnut, *Castanea dentate*, which was decimated by the imported chestnut blight.

center

Little Poe Creek is rushing down a flank of Long Mountain, over moss covered boulders, after a spring thunderstorm in the Bald Eagle State Forest.

bottom

Growing in the forest understory and along its edges, flowering dogwood, *Cornus florida*, is one of the more familiar trees in central Pennsylvania, especially in May when it shows its highly decorative flowers. Native Americans and early settlers used the tree's aromatic bark and roots as a remedy for malaria.

background

The confluence of Poe Creek and Pine Swamp Run in the Bald Eagle State Forest occurs in a picturesque glen of rhododendron and eastern hemlock in Centre County. Habitats like this are essential for native brook trout, *Salvelinus fontinalis*, the officially designated State Fish of Pennsylvania.

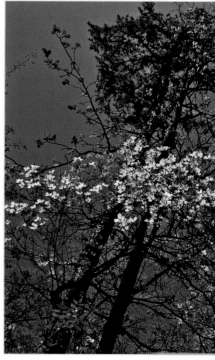

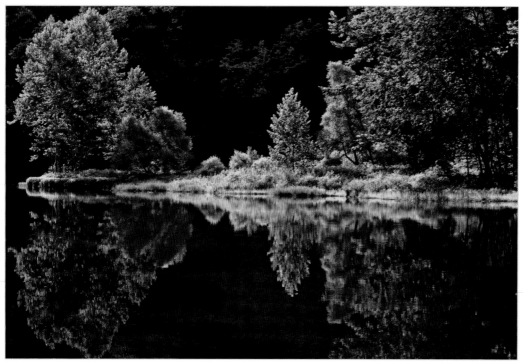

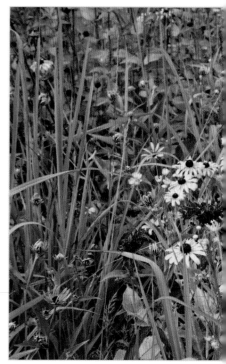

top left

Most people are familiar with creeping phlox or moss-pink, *Phlox subulata*, as a spring garden flower. However, this wild native species, now common in cultivation, grows on sandy or rocky locations in many parts of the state. Rarely reaching 6 inches in height, it can form mats 5 feet wide.

bottom left

Summer morning sunlight creates a mirror-like image of the willows, American sycamores, and silver maple trees growing on an island in the Raystown Branch Juniata River in Huntingdon County.

top center

Flowering dogwood blooms beneath Virginia pines at Meeting of the Pines State Forest Natural Area in Franklin County. This extraordinary, 611-acre natural area is the only place in Pennsylvania where five of the six native species of pines grow together: Virginia, shortleaf, white, pitch, and table-mountain.

bottom center

The old fields, at the Joseph F Ibberson Conservation Area in Dauphin County, are being managed as diverse natural wild meadows by the Pennsylvania Bureau of State Parks. Some of the summer meadow wildflowers growing here include purple coneflower, black-eyed Susan, and bee balm.

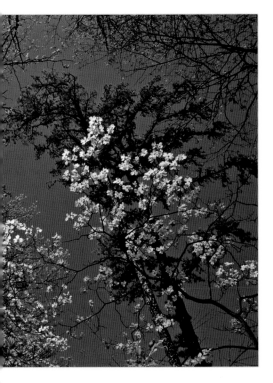

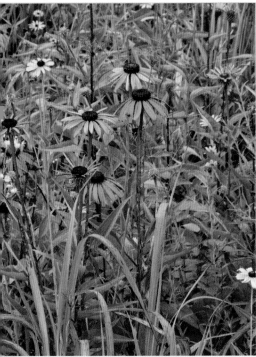

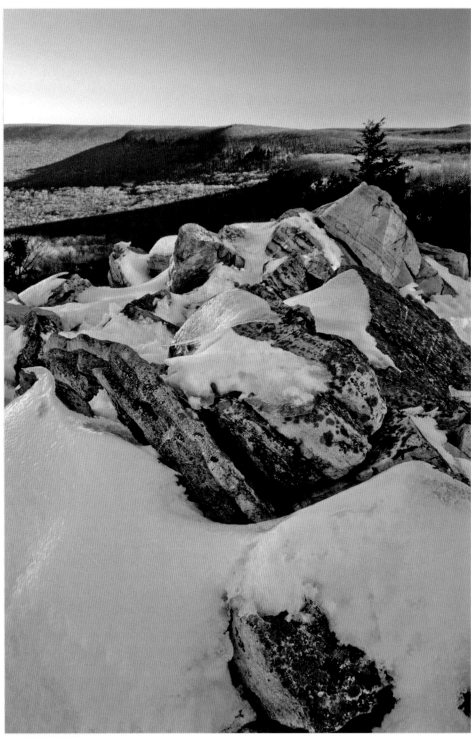

right

When the autumn raptor migration over the North Lookout at Hawk Mountain Sanctuary is no longer inundated with thousands of birdwatchers who climb to witness this world-famous natural event, this tranquil winter view to the east along Blue Mountain might be similar to what Native American Lenapes beheld.

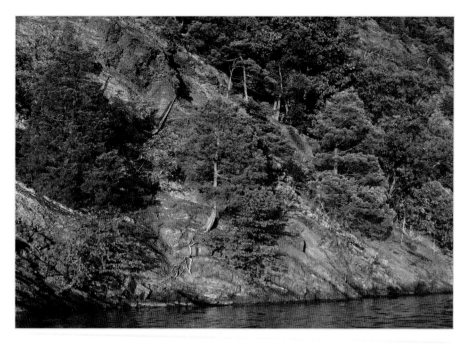

top

The spectacular, south-facing shale barrens, rising from the waters of Raystown Lake, create a desert-like environment with many red cedars and other drought-tolerant species. This ecologically unique niche harbors endemic plants and rare animals and is listed as a special protected area by the U.S. Army Corps of Engineers.

bottom left

Weathering Knob, on the Carbon/Northampton County border, rises to an elevation that is 1,400 feet above Little Gap on top of Blue Mountain. The massive quartzite boulders are a result of intense weathering under periglacial conditions. Located along the Appalachian Trail, hikers must sometimes use handholds to reach the summit.

bottom right

A summer sunset colors the evening sky over South Mountain in the Michaux State Forest, Cumberland County. As the northern section of the Blue Ridge Mountains that extend south to northern Georgia, South Mountain is separated from the main Ridge and Valley Province by the fertile, agriculturally rich Great Valley.

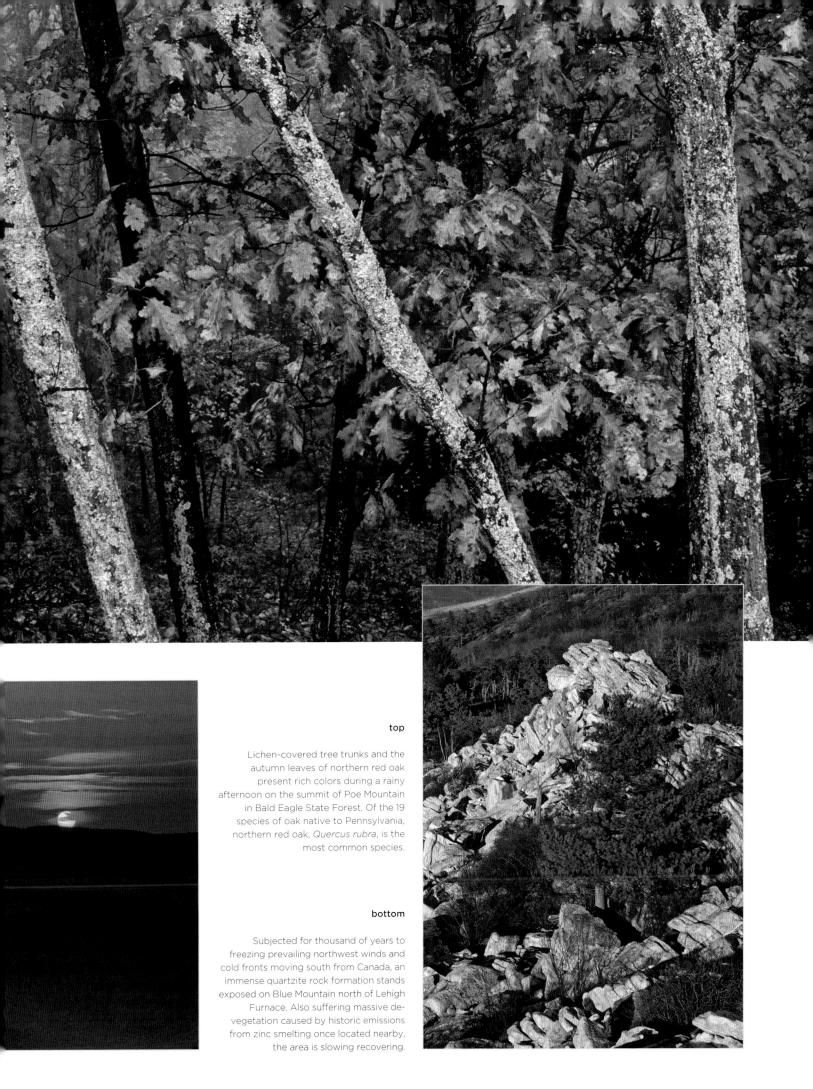

top

Lichen-covered tree trunks and the autumn leaves of northern red oak present rich colors during a rainy afternoon on the summit of Poe Mountain in Bald Eagle State Forest. Of the 19 species of oak native to Pennsylvania, northern red oak, *Quercus rubra*, is the most common species.

bottom

Subjected for thousand of years to freezing prevailing northwest winds and cold fronts moving south from Canada, an immense quartzite rock formation stands exposed on Blue Mountain north of Lehigh Furnace. Also suffering massive de-vegetation caused by historic emissions from zinc smelting once located nearby, the area is slowing recovering.

141

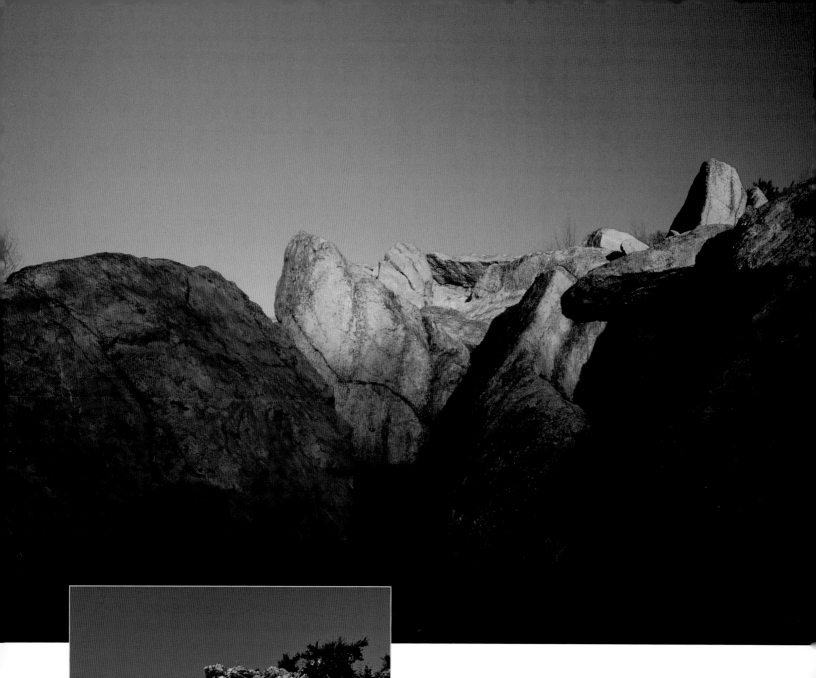

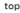

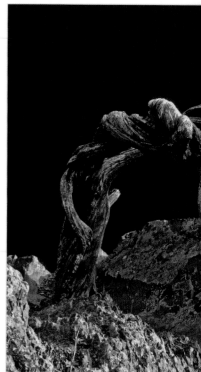

top

The last of the day's sunlight strikes a rock outcropping near Lehigh Furnace Gap on the Kittatinny Ridge along the Appalachian Trail. This ridge is also known as Blue or First Mountain and is the most easterly ridge in the Appalachian Section of the Ridge and Valley Province.

bottom

Hiking a 1/2-mile side trail off the Appalachian Trail, or 3/4-mile from Pine Grove Furnace State Park, a rewarding view of South Mountain is found atop Pole Steeple, a quartzite rock pillar outcropping in Michaux State Forest. Formed by fractures, faults, and erosion, the cliffs contain numerous worm tube fossils.

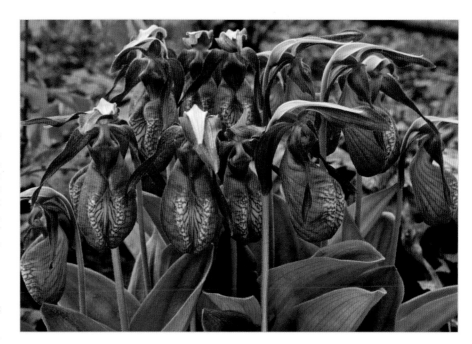

top

Pink lady's slipper, or moccasin flower, *Cypripedium acaule*, is probably our most recognizable native orchid, blooming during May in acidic soils throughout Pennsylvania. It should never be picked, as the blossoms must complete their cycle for the plant to regenerate.

bottom right

Pink lady's slipper has a white variety, *var.alba,* which is extremely rare. For this orchid to grow and survive, it must do so in association with a particular underground fungus. Because of this, any attempts to transplant it to a garden will probably result in the plant's death.

bottom left

On the ecologically fragile shale barren ledges above Raystown Lake in Huntingdon County, many eastern redcedars, *Juniperus virginiana*, growing in this harsh environment acquire contorted bonsai-like forms. Only a few feet in height, these slow-growing trees may be well over 200 years old and recognized as old growth.

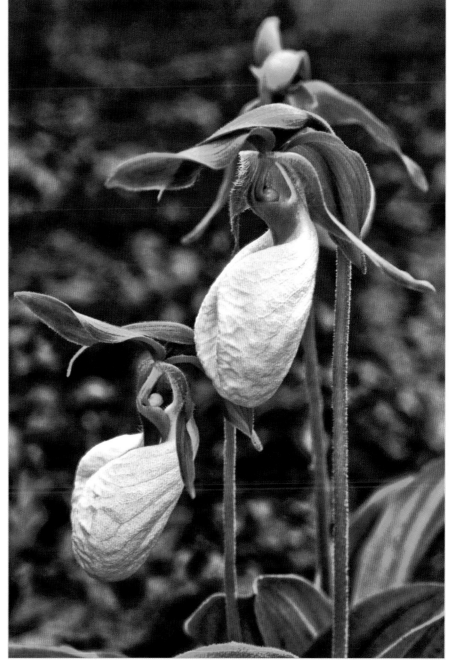

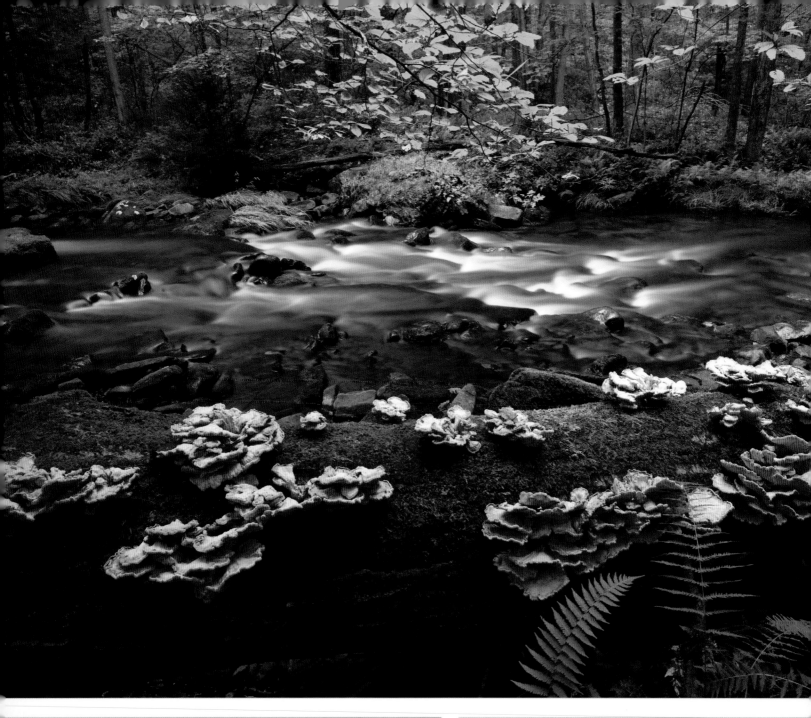

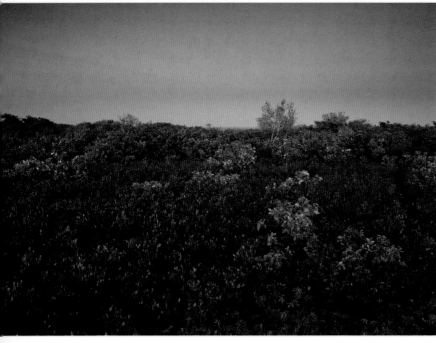

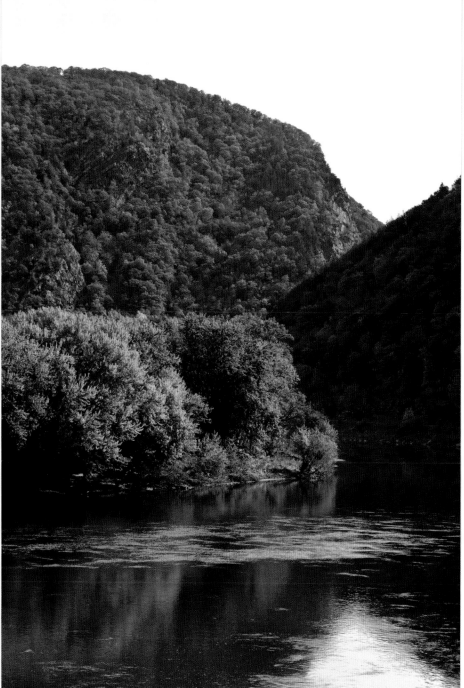

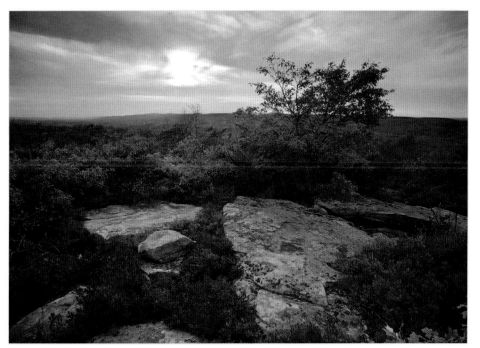

top left

Sulfur shelf fungus, *Laetiporus sulphureus,* grows on a decaying log along Swift Run in the Bald Eagle State Forest. It is also known as sulphur polypore, chicken-of-the-woods, and chicken mushroom. Young specimens are edible and taste similar to chicken or even crab and lobster.

top right

The most recognizable geological icon in Pennsylvania, the Delaware Water Gap, has been attracting visitors since 1856, when a railroad built to the gap enabled rail passengers to make the trip from New York City within 6 hours. Today, thousands living in the area commute to work in New York City daily.

bottom left

An autumn sunset colors the sky above the Moosic Mountain heath barrens in Lackawanna County. Despite the name, these lands are anything but barren and contain a healthy shrub forest of oak and pitch pine dominated by huckleberry, blueberry, sheep laurel, the uncommon rhodora, and other low-lying shrubs.

bottom center

A twisted, lone gray birch, *Betula populifolia,* grows among the heath barrens on the summit of Moosic Mountain on State Game Lands 300. Located more than 2,300 feet above sea level, the ridge summit is constantly exposed to the prevailing northwest winds and frequent winter ice storms.

bottom right

The Pocono Formation bedrock on Moosic Mountain is composed of quartzite, conglomerate, and medium to coarse grain sandstone formed during the Mississippian Period 330–365 million years ago. It is also one of the few locations in the Ridge and Valley Province that was glaciated during the last Ice Age.

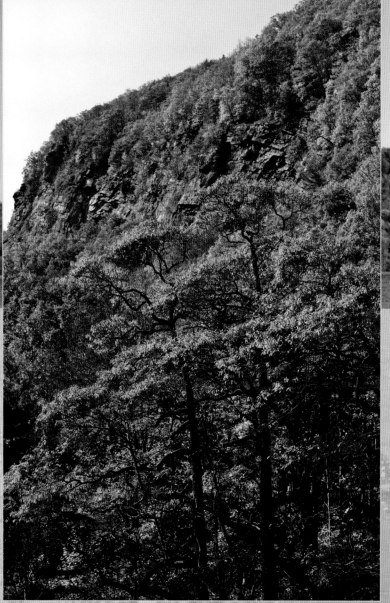

top

Rising 1,463 feet above the Delaware River, Mt. Minsi, and the Delaware Water Gap, was the second largest inland resort area in the United States after the Civil War. Mt. Minsi is also one of the very few locations that peregrine falcons are nesting on natural rock ledges in Pennsylvania.

bottom

An old open-growth form of white oak, *Quercus alba*, grows on an abandoned field at Beltzville State Park. White oak trees can live up to 400 years and open-growth specimens like the one seen here can reach 115 feet in height and have a crown spread of 122 ft.

background

The 952-acre Beltzville Lake was created by the U.S. Army Corps of Engineers as a flood control project and opened for public recreation as part of Beltzville State Park in 1972. In addition to recreation, the park is renowned as an excellent birding site that has had several rare bird sightings.

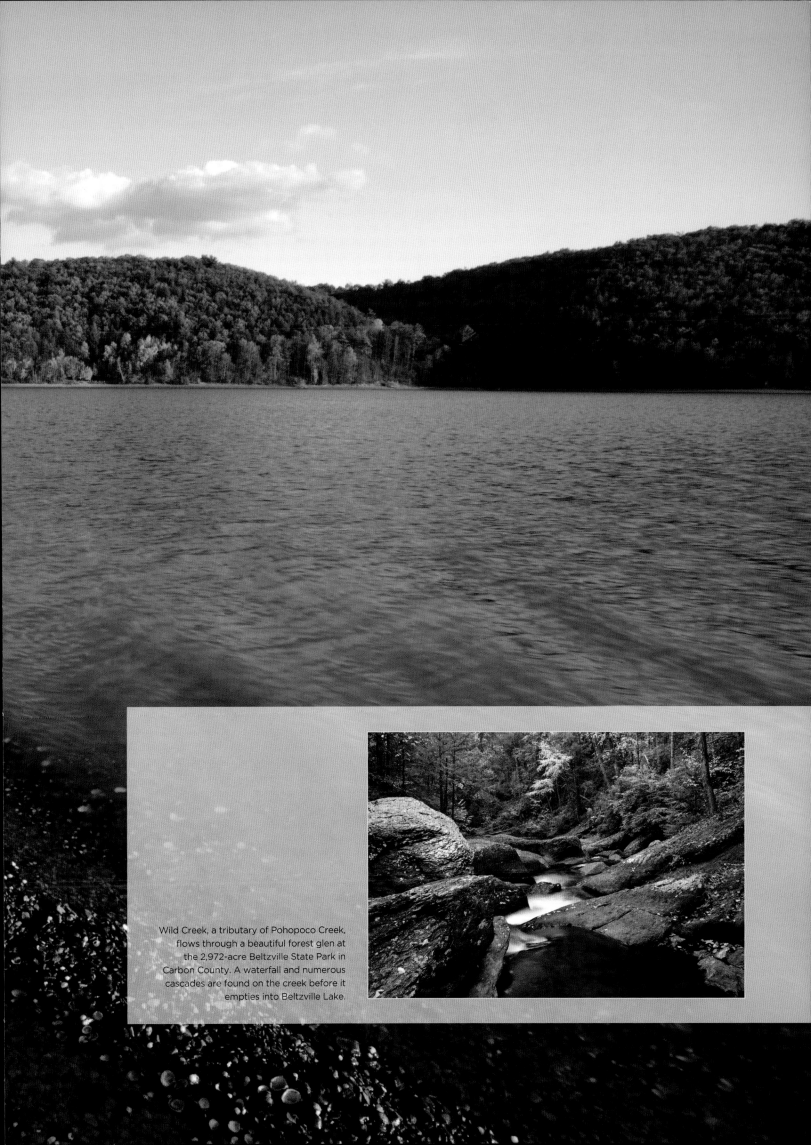

Wild Creek, a tributary of Pohopoco Creek, flows through a beautiful forest glen at the 2,972-acre Beltzville State Park in Carbon County. A waterfall and numerous cascades are found on the creek before it empties into Beltzville Lake.

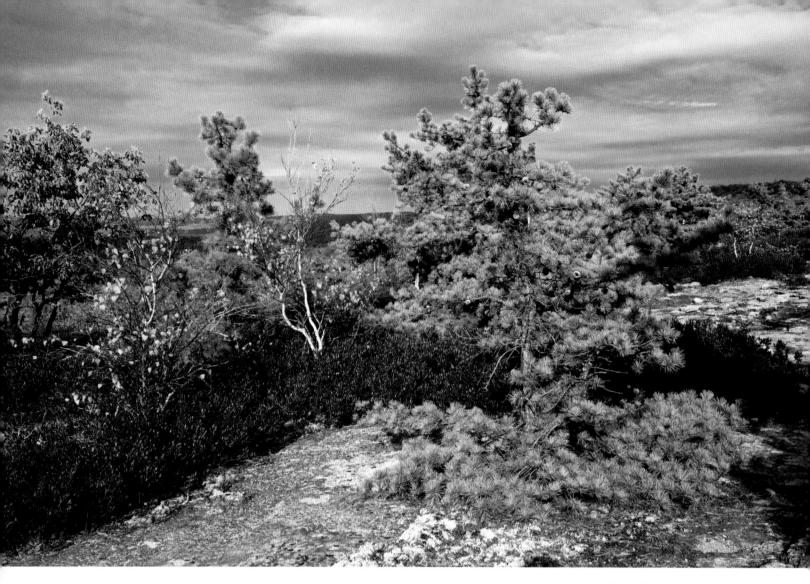

top center

One of the threats to The Nature Conservancy's Preserve at Moosic Mountain is fire suppression. The pitch pine, scrub oak, and various heaths that grow on the mountain need periodic fires to compete and reproduce. In 2008, The Nature Conservancy introduced prescribed burns to maintain this fire-dependent natural community.

bottom left

In 2001, through cooperative efforts of the Commonwealth and several private organizations, a business park that was slated to be built on the ecologically unique Moosic Mountain was relocated to a former industrial site and The Nature Conservancy began purchasing lands in the heart of the future preserve.

bottom right

Named the Dick & Nancy Eales Preserve at Moosic Mountain, this Nature Conservancy project represents one of the most extensive ridge-top heath barrens in the northeastern United States. Totaling 2,250 acres, the preserve protects a diversity of birds, butterflies, and moths, including the globally rare sallow moth and barrens buckmoth.

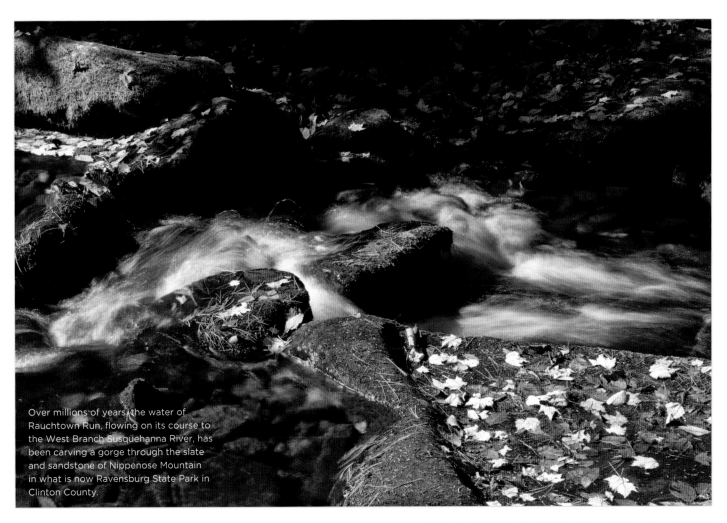

Over millions of years, the water of Rauchtown Run, flowing on its course to the West Branch Susquehanna River, has been carving a gorge through the slate and sandstone of Nippenose Mountain in what is now Ravensburg State Park in Clinton County.

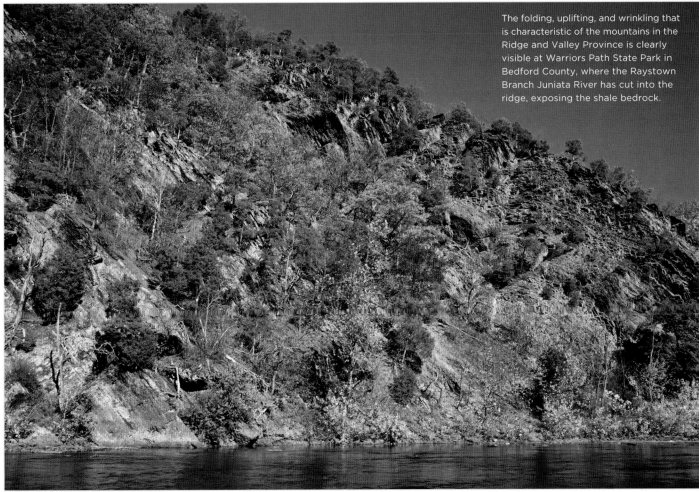

The folding, uplifting, and wrinkling that is characteristic of the mountains in the Ridge and Valley Province is clearly visible at Warriors Path State Park in Bedford County, where the Raystown Branch Juniata River has cut into the ridge, exposing the shale bedrock.

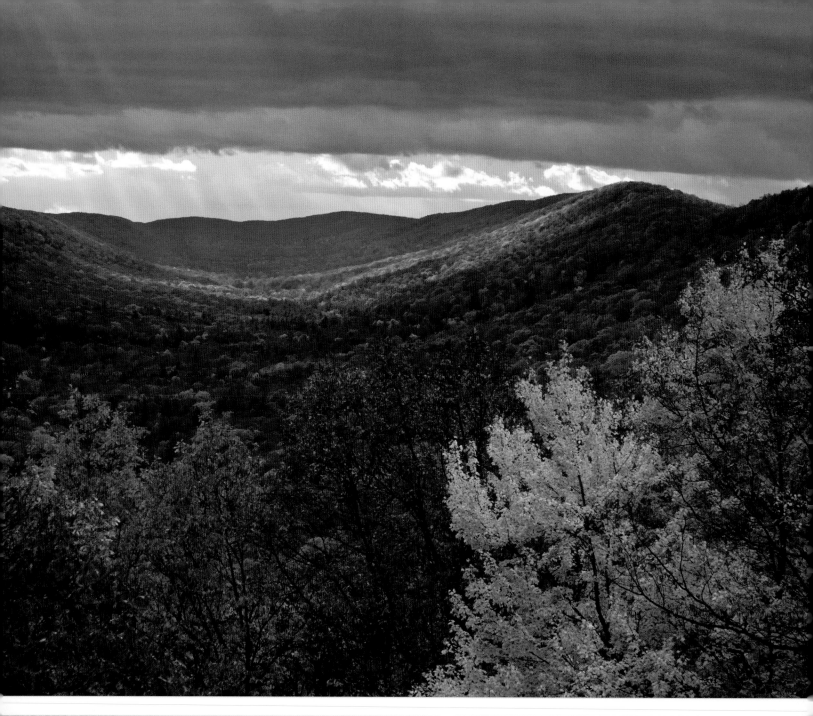

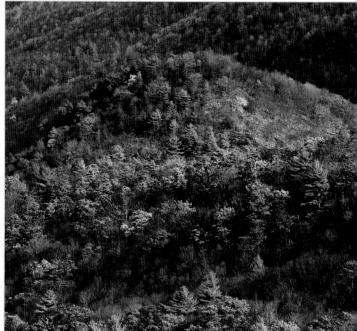

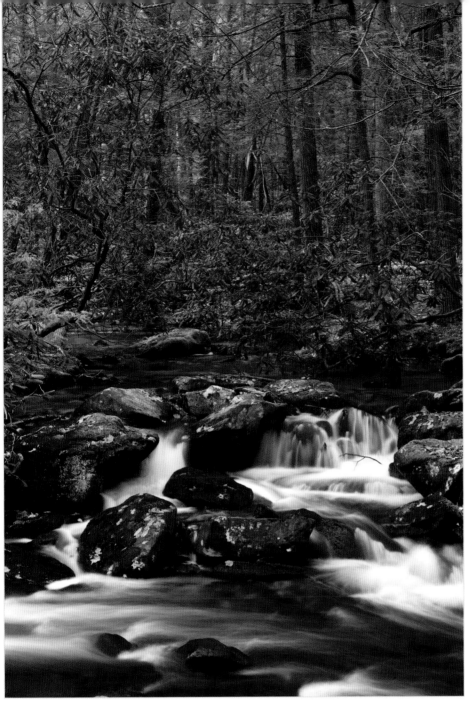

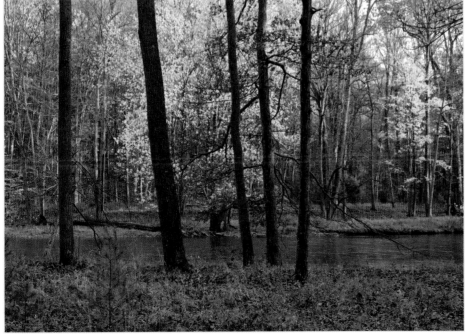

top left

From a vista off Poe Paddy Drive, a 4-wheel drive only road, one can look down the sides of Long Mountain and Poe Mountain into Poe Creek Valley, a virtual wilderness in the Bald Eagle State Forest in Centre County.

top right

Before joining Poe Creek, the smaller, yet very scenic, Pine Swamp Run finds its source as a high mountain hardwood wetland on Poe Mountain in Bald Eagle State Forest.

bottom left

Penns Creek cuts its course through a gap between Poe Mountain and Sawmill Mountain as seen from Penns View Vista in the Bald Eagle State Forest.

bottom center

The 3,581-acre White Mountain Wild Area in Bald Eagle State Forest is only accessible by hiking trails. The area has experienced little human activity since the late-nineteenth-century logging boom and will be kept in this undeveloped state for future generations to experience a sense of wilderness in Pennsylvania.

bottom right

Looking at the healthy floodplain forest along Penns Creek in Poe Paddy State Park, it is hard to imagine that in the late 1800s this was the site of a short-lived, but prosperous, lumbering center named Poe Mills. A railroad spur served the area, which had a population of more than 300 residents.

top

In autumn, leaves of silver maples and tulip trees along Penns Creek put on a spectacular show before dying and falling into the creek. Decaying leaves in the water feed mayfly larva, which in turn feed the creek's trout, which then feed mink, otters, and eagles inhabiting the area.

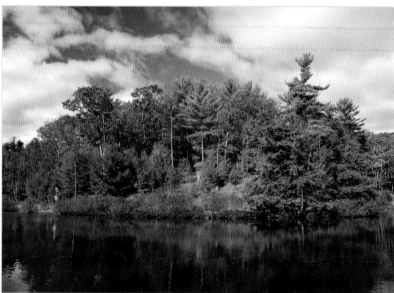

center

Once the site of a nineteenth-century dam and sawmill, the present dam for Whipple Lake was constructed by the Civilian Conservation Corps in 1935. Part of the 256-acre state park was designated a National Historic District recognizing the Corps as one of the Depression-era's most important relief programs.

bottom

Flowing through a magnificent forest composed primarily of mature eastern hemlock and white pine, Honey Creek, at Reeds Gap State Park in Mifflin County, supports a healthy population of native brook trout and trout stocked by the Pennsylvania Fish and Boat Commission.

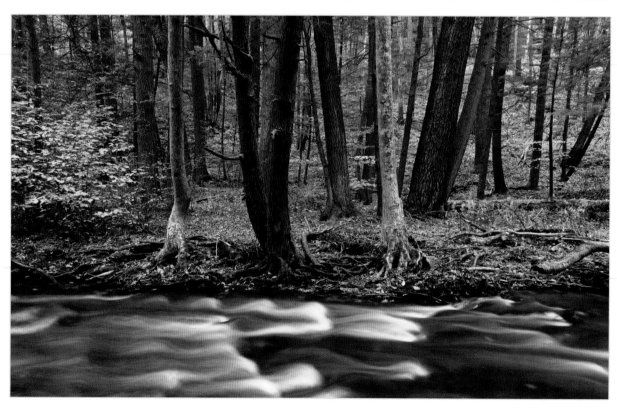

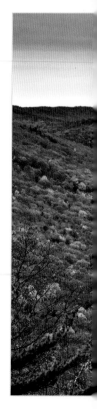

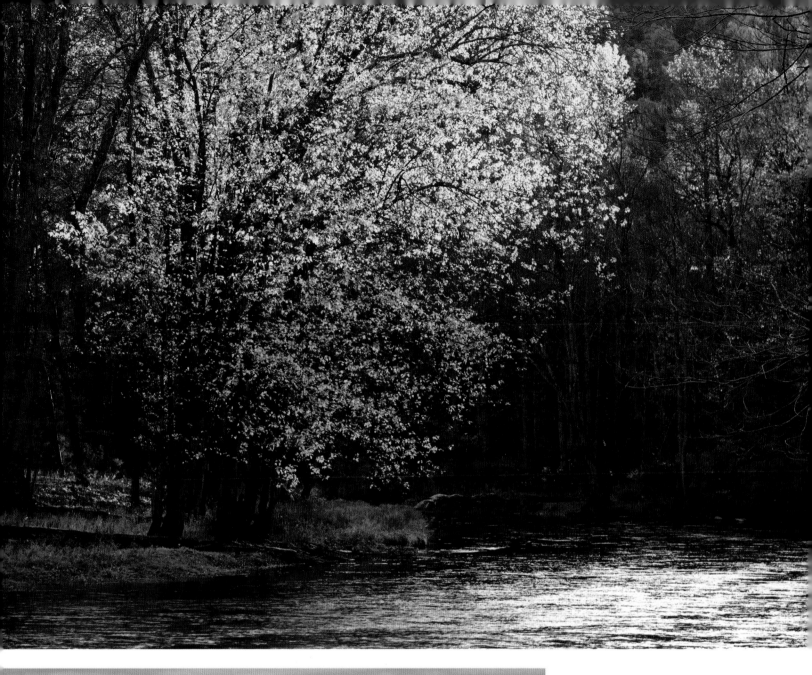

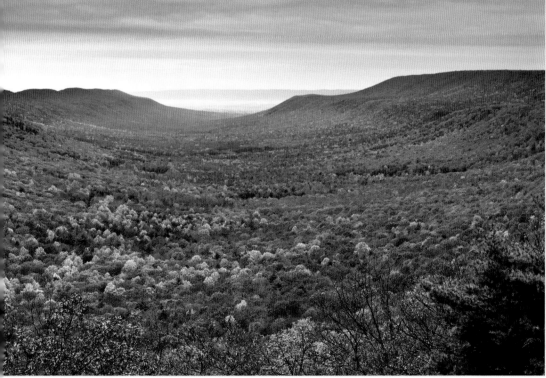

top

Autumn is a quiet time along Penns Creek, but in late May and early June, during the stream's world-famous green drake mayfly, *Ephemera guttulata,* hatches. Pennsylvania's longest limestone stream is a fly-fishing dream as hundreds of anglers flock to its waters, casting for its abundant, wild, brown trout population.

bottom

The Ridge and Valley Province is clearly defined from New Lancaster Valley Vista, located in Bald Eagle State Forest, Snyder County. Looking southwest, Thick Mountain, on the right, and Jacks Mountain, on the left, rise approximately 2,000 ft. above sea level while the valley floor is around 720 feet.

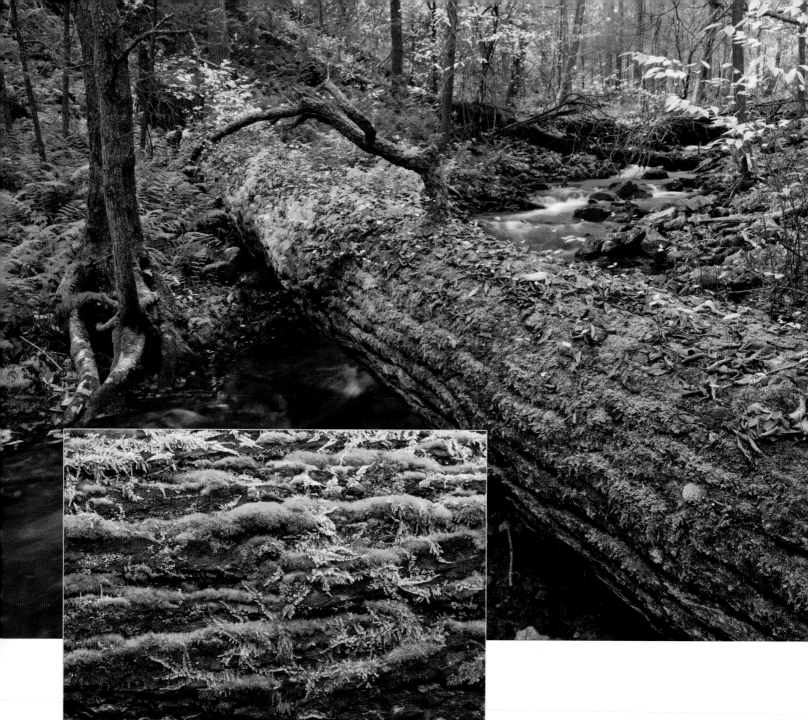

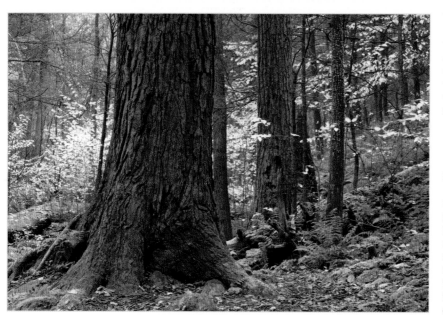

top

When a tree falls in an old-growth forest, recycling immediately begins. Here in the Snyder-Middleswarth Natural Area, mosses, lichens, and fungi have found a new home on a fallen hemlock trunk. As these plants continue to break down the wood, seedlings of birch and hemlock will start to sprout.

bottom

In a narrow Snyder County valley, between Jacks Mountain and Thick Mountain, sits one of Pennsylvania's most beautiful primeval forests: the 500-acre Snyder-Middleswarth State Forest Natural Area. Two-hundred and fifty acres are virgin forest similar to the forests that met the early settlers in the eighteenth century.

opposite

An ancient hemlock has fallen, spanning Swift Run in the Snyder-Middleswarth Natural Area. People unfamiliar with old-growth forests are surprised how littered they are with dead and dying debris. However, this litter is essential, providing wildlife and plant habitats, making old-growth forests some of the most diverse ecosystems.

top

Some trees in the Snyder-Middleswarth Natural Area are more than 150 feet tall with trunks surpassing 40 inches in diameter. One naturally fallen tree was found to be more than 347 years old. Forests like this was once common in Pennsylvania and stimulated the great eighteenth-century clear-cut across the state.

bottom

From McCall Dam Overlook in the Bald Eagle State Forest in Union County, one can see Halfway Lake, at an elevation of 1,506 feet, in R. B. Winter State Park, nestled between Naked and Seven Notch Mountains, which rise approximately 1,850 feet above sea level.

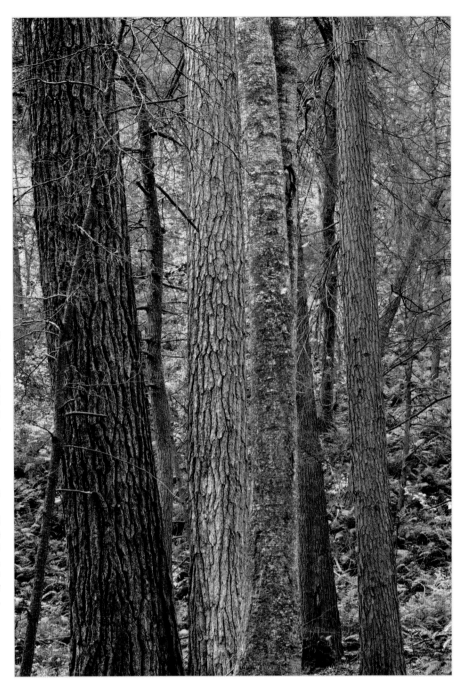

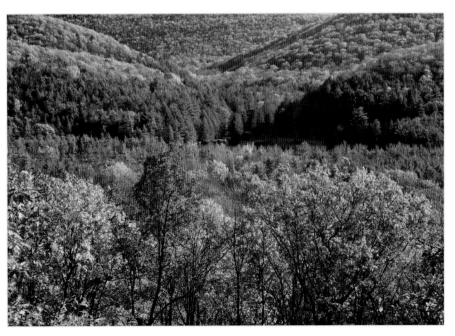

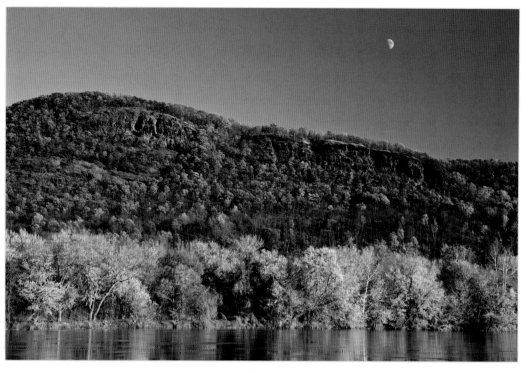

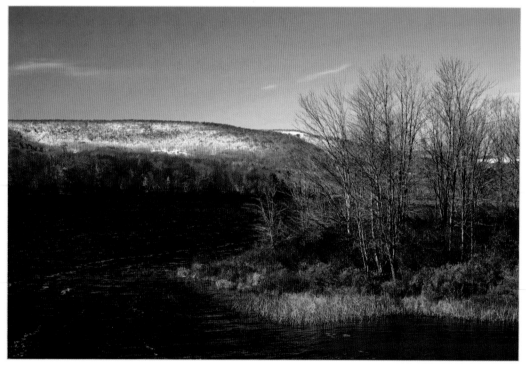

top left

A quarter moon rises over Council Cup, which ascends 720 feet above the North Branch Susquehanna as it flows through Luzerne County. Native Americans used the cliff as a lookout and meeting place. Owned by PPL Corporation, today the overlook is an important site to watch the autumn hawk migration.

bottom left

A late October snowfall blankets enduring autumn foliage on the slopes of Moosic Mountain, which rises nearly 1,000 feet above White Oak Pond in Wayne County.

top center

A snowdrift from an autumn snowstorm lingers on the heath-barren summit of Moosic Mountain on State Game Lands 300 in Lackawanna County, as Indian summer gives a short hiatus to the inevitable, approaching winter.

bottom center

An early snowfall adds contrast to the autumn foliage at an elevation of 2,411 feet on Little Flat, located on the summit of Tussey Mountain in the Rothrock State Forest, Centre County.

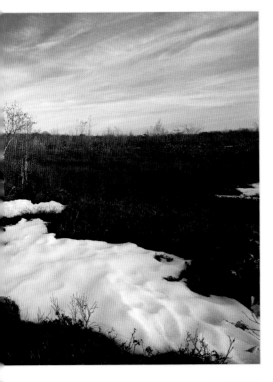

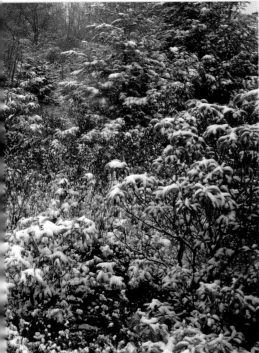

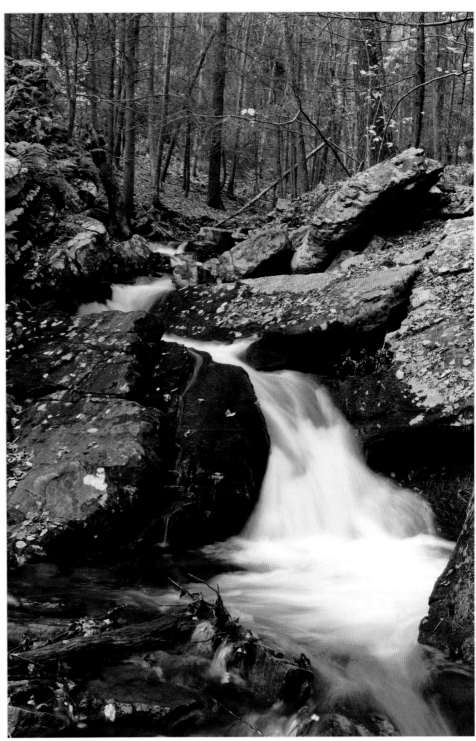

right

Bull Hollow Run creates a small
cascade as it flows down Buck
Mountain before joining with Swift
Run in Bald Eagle State Forest.

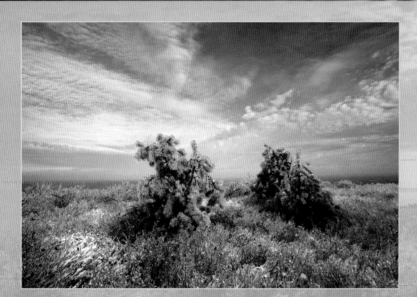

top

A pair of dwarf pitch pines, *Pinus rigida*, stand encrusted in ice after an early winter ice storm on Moosic Mountain, Lackawanna County. The thin soil of the ridge top, virtually constant winds, and frequent ice storms cause the trees to remain as dwarfs, rarely exceeding 8 feet in height.

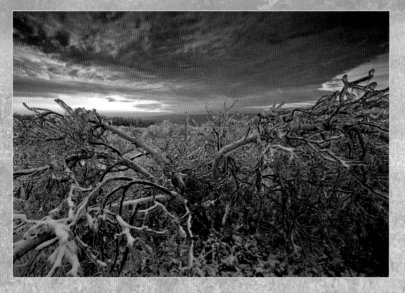

bottom

Rising more than 1,500 feet above the nearby Lackawanna Valley, the summit of Moosic Mountain is often covered in ice and snow while the valley only experiences rain. When released from the weight of ice and snow, these gray birches will straighten, but remain distorted from the frequent storms they endure.

background

Due to a high, isolated elevation and low vegetation, the views from Moosic Mountain are some of the best in Pennsylvania. From some venues there are 360-degree views to Elk Mountain in the northeast, southeast to the Pocono Escarpment, west to the Endless Mountains, and east to New York State.

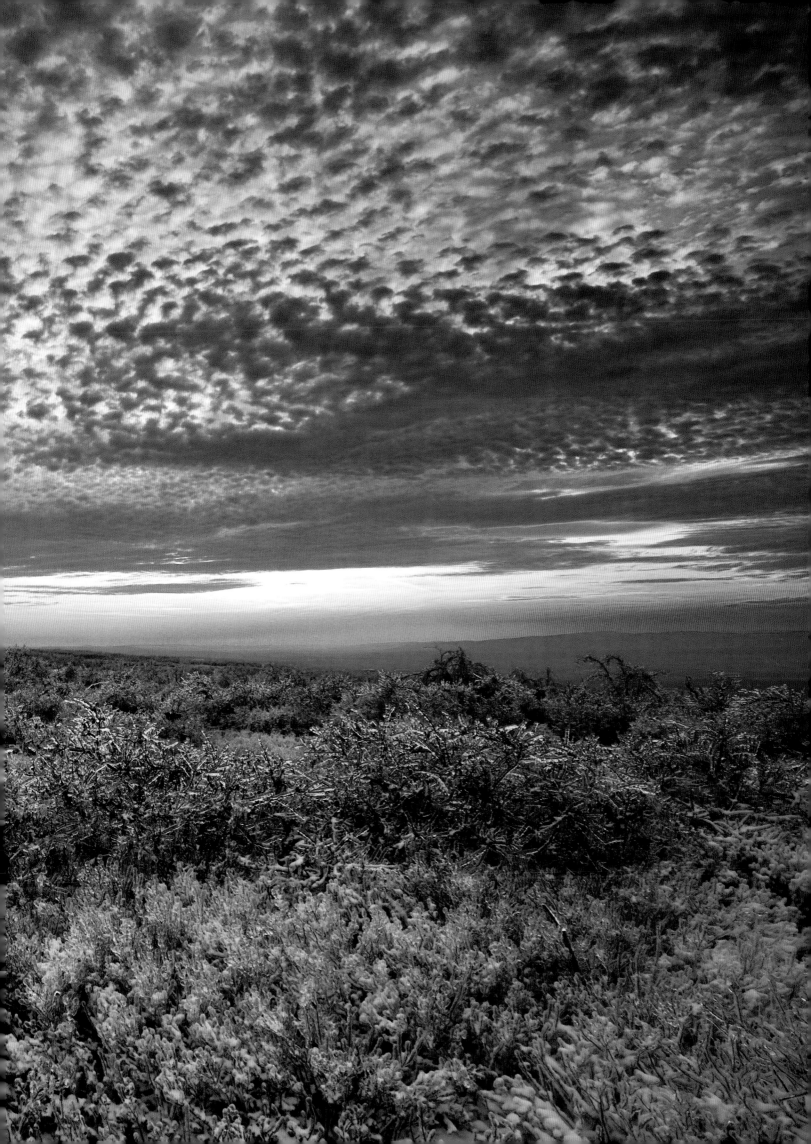

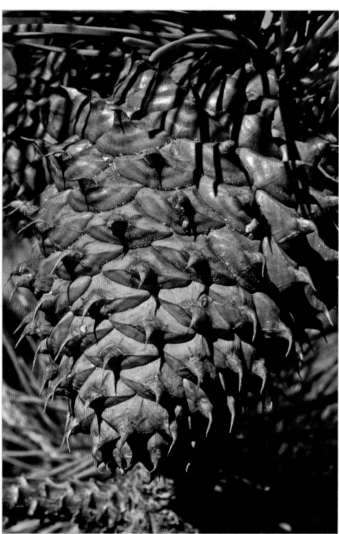

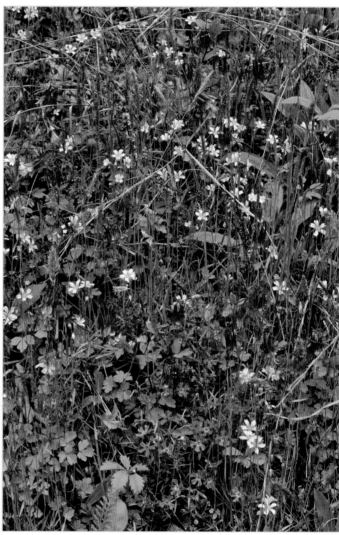

top left

A warm, afternoon sun still provides color to the bare, late autumn trees on 1,600-foot-high Locust Mountain, reflected in the calm waters of 96-acre Tuscarora Lake at Tuscarora State Park in Schuylkill County.

bottom left

In Pennsylvania, the table mountain pine, *Pinus pungens*, only grows on the dry, rocky, central Appalachian ridges. It rarely grows beyond a small scrubby tree and is not used commercially. However, its gnarly shape and very distinctive stout cones, with long curved spines, make it a picturesque sight on the ridges.

top right

Common bugle, *Ajuga reptans*, has naturalized on the shore of Hidden Lake in Delaware Water Gap National Recreation Area. The recreation area was developed from lands formerly used as farms and vacation home sites. Many plants grown at these sites became naturalized and may remain until natural succession replaces them.

bottom right

While hiking the hundreds of miles of trails in Pennsylvania, we are at times rewarded with some stunning wildflower displays like this group of wild columbine, *Aquilegia Canadensis*, moss-pink, *Phlox subulata*, and field chickweed, *Cerastium arvense*, found growing in the Delaware Water Gap National Recreation Area.

It is 14,000 B.C. The climate has been cold, but warming. The high mountains to the east are snow-free for a month or two in summer. A small hunting party of Paleo-Indians crosses the tundra. Scattered across the seemingly endless grasslands of this gently rolling landscape, stunted black spruce and tamarack trees grow. The hunting party has been following a small heard of woolly mammoths, moving north, waiting for one to become trapped in a peat bog before dispatching it with their primitive flint spears. The women and children from their extended family, making up a nomadic band of 30 individuals, have been held up under a nearby sandstone rock shelter for several weeks, feeding only on plants and berries. They desperately need protein to survive and the mammoth would provide it. They hadn't seen other humans in two years, and for all they knew they could have been the only humans on earth at the time.

This was the scene in southwestern Pennsylvania at the end of the last Ice Age, as evidence from the Meadowcroft Rockshelter archaeological site in Washington County suggests. Today, some 35 miles away, sits Pittsburgh, the second largest city in Pennsylvania, a seven-county metropolitan area with 2,356,200 people and restaurants serving every kind of food imaginable.

The tundra and woolly mammoths are long gone, replaced by an Appalachian oak forest and white-tailed deer. Yet many natural and wild areas still remain and are being protected by government agencies and private groups, such as the Western Pennsylvania Conservancy.

The area is defined by hills, from the gentle rolling Waynesburg Hills to the Allegheny Mountains in the east, where Pennsylvania's two highest peaks are found: Mt. Davis at 3,213 feet and Blue Knob at 3,146 feet. The area is also rich in coal, oil, and natural gas deposits. These fossil fuels helped the region become the largest and richest steel-producing and industrial center in the country, but not without its downfalls. In the mid-twentieth century, Pittsburgh and its surrounding cities became notorious for days when the sun could not penetrate the industrial smog and air pollution. Rivers were actually on fire or were poisoned with acid mine drainage. The land was stripped bare to get at the rich coal deposits. The situation was very grim and depressing.

Eighteen miles northeast of Pittsburgh, along the Allegheny River, Rachel Louise Carson was born on her family's small farm in Springdale, on May 27, 1907. And on that day, the seeds of the modern environmental movement were planted. Employed as a biologist for U.S. Fish & Wildlife Service, Ms. Carson was also an author who wrote several award-winning books in the 1950s about her love for the sea. Becoming aware of problems associated with the widespread use of synthetic pesticides, especially DDT, in 1962 she wrote the now-classic book *Silent Spring*. Fierce criticism from the chemical industry and personal attacks on her character immediately began, even as she was fighting cancer, from which she soon died. Further scientific studies soon validated her claims and started a grassroots environmental movement leading to our modern environmental thinking.

When Ms. Carson wrote *Silent Spring,* the bald eagle was on the verge of extinction due to the thinning of its eggshell, a result related to DDT exposure. Today, the bald eagle is becoming a common sight in Pennsylvania's skies and Pittsburgh is now one of the cleanest and most beautiful cities in the United States. We owe Ms. Carson some thanks.

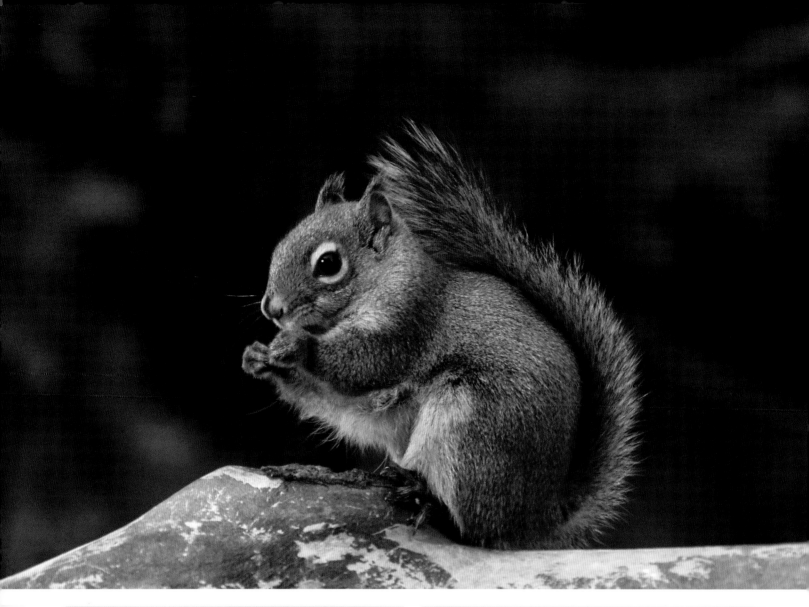

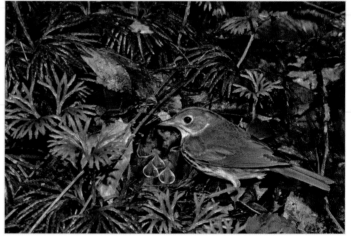

top center

While the familiar gray squirrel favors a deciduous forest, the red squirrel, *Tamiasciurus hudsonicus*, favors coniferous or mixed forests. A specialist at storing food, it has even learned that by placing mushrooms on twigs to dry, they will store longer in their underground middens, which often contain several bushels of provisions.

bottom left

The harmless, 6 1/2-inch-long, five-lined skink, *Eumeces fasciatus*, is a lizard found in the southern two-thirds of the state. The young can be identified by their blue tail, which later turns gray. To distract predators, it breaks off its tail while escaping and grows a new, shorter, tail later.

bottom right

Found during the warmer months in the forest regions throughout the state, the ovenbird, *Seiurus aurocapillus*, gets its name from the partly dome-shaped nest, resembling an old Dutch oven, that the bird builds on the forest floor. This warbler's song, "teacher-Teacher-TEACHER," inspired a poem by Robert Frost.

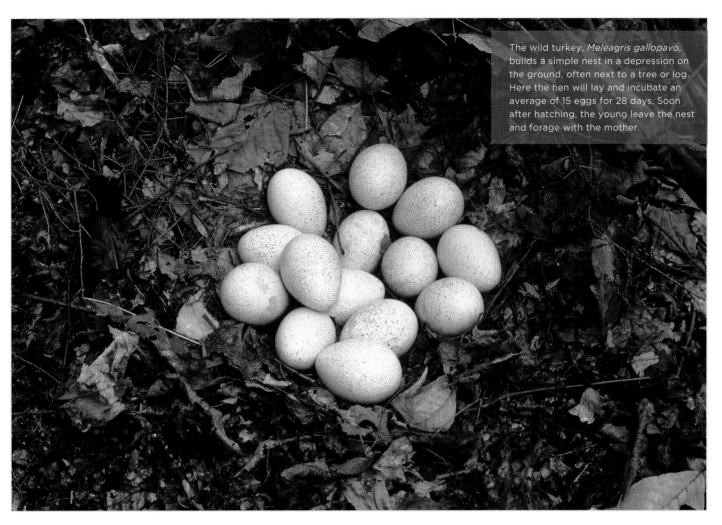

The wild turkey, *Meleagris gallopavo*, builds a simple nest in a depression on the ground, often next to a tree or log. Here the hen will lay and incubate an average of 15 eggs for 28 days. Soon after hatching, the young leave the nest and forage with the mother.

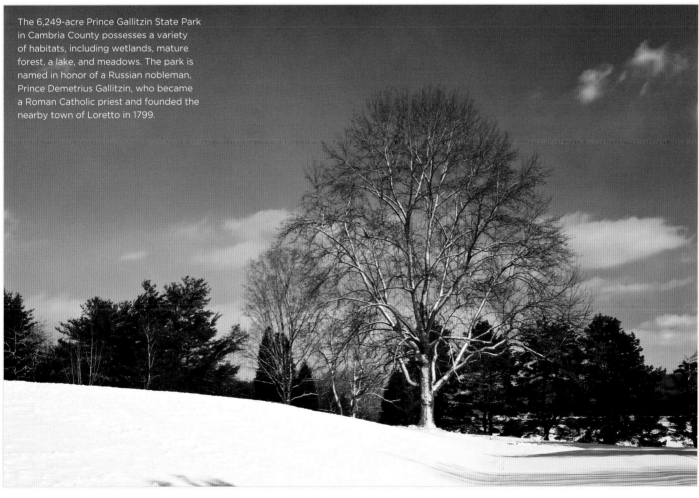

The 6,249-acre Prince Gallitzin State Park in Cambria County possesses a variety of habitats, including wetlands, mature forest, a lake, and meadows. The park is named in honor of a Russian nobleman, Prince Demetrius Gallitzin, who became a Roman Catholic priest and founded the nearby town of Loretto in 1799.

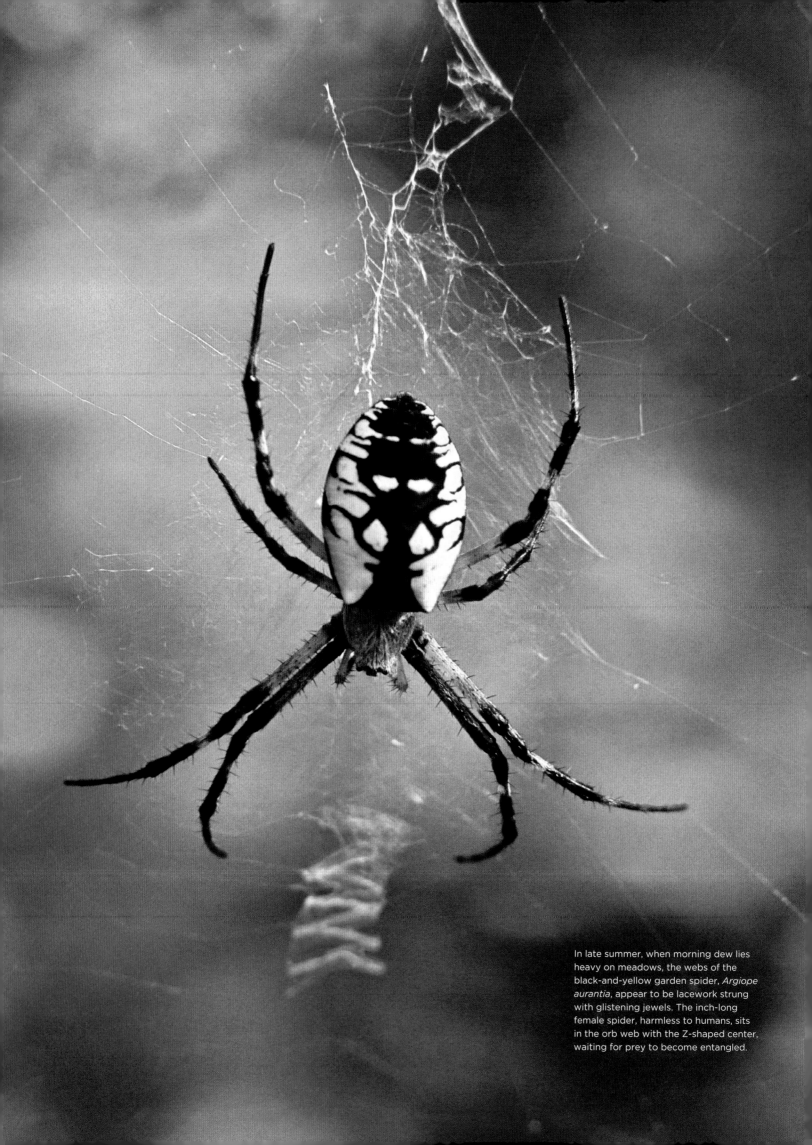

In late summer, when morning dew lies heavy on meadows, the webs of the black-and-yellow garden spider, *Argiope aurantia*, appear to be lacework strung with glistening jewels. The inch-long female spider, harmless to humans, sits in the orb web with the Z-shaped center, waiting for prey to become entangled.

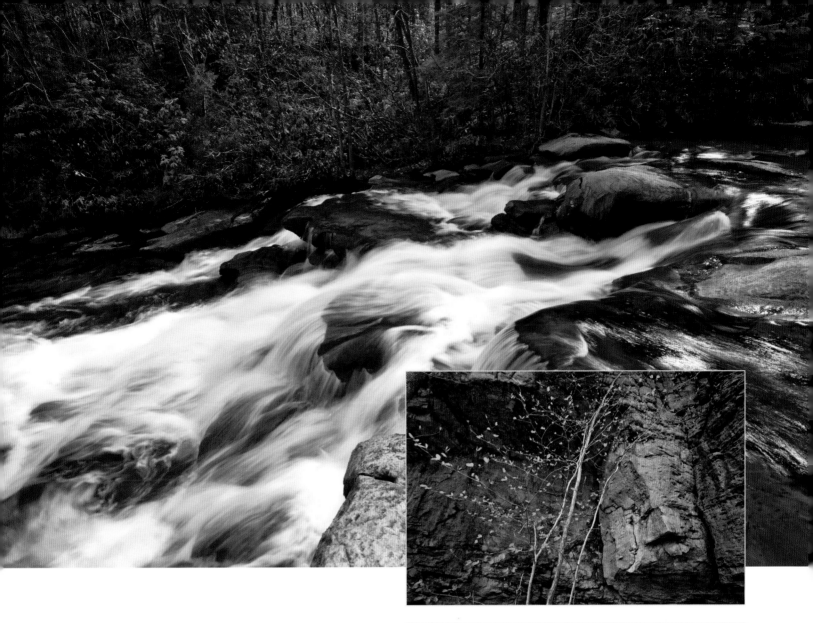

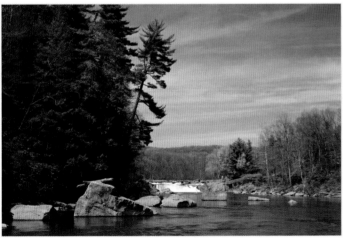

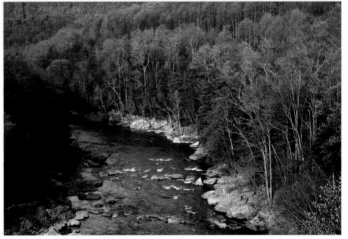

clockwise

Although dropping only about 10 feet, the series of cascades along Meadow Run at Ohiopyle State Park are highly scenic, especially during periods of heavy runoff. The cascades can be reached after a moderate 1.5-mile hike.

The scenic, 3-mile Meadow Run Trail at Ohiopyle State Park passes through a section of impressive geological formations containing sandstone and blue limestone cliffs, overhangs, and ledges, some several stories high. These formations are used for rock climbing and bouldering by those experienced in the sport.

The 134-mile-long Youghiogheny (pronounced "yaw-ki-gay-ne") River is a tributary of the Monongahela River. Approximately 15 miles of the river flow through Ohiopyle State Park, where Class 1 to Class 5 rapids are found, making this section one of the most popular whitewater rafting and kayaking destinations east of the Mississippi River

In Fayette County, 20-foot-high Ohiopyle Falls spans the Youghiogheny River at Ohiopyle State Park. Leading up to the French and Indian War, General George Washington attempted to use this river as a route to Fort Duquesne (present day Pittsburgh), but abandoned the river passage due to the waterfalls.

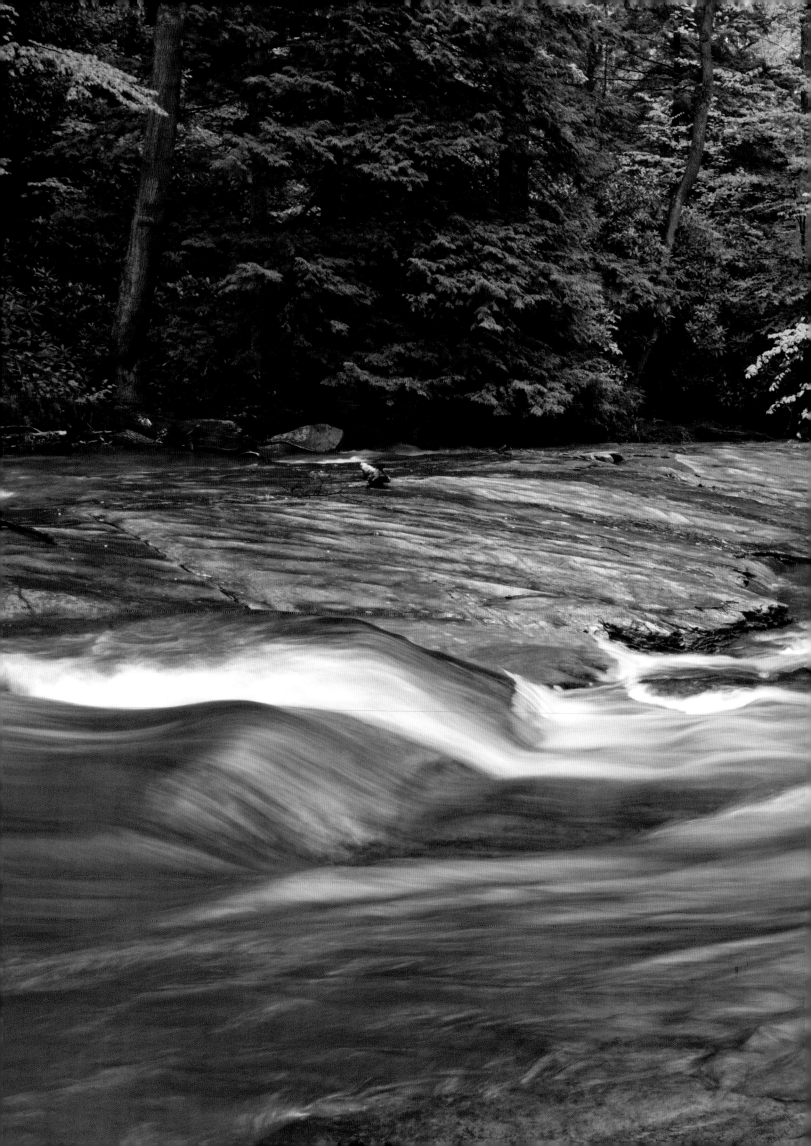

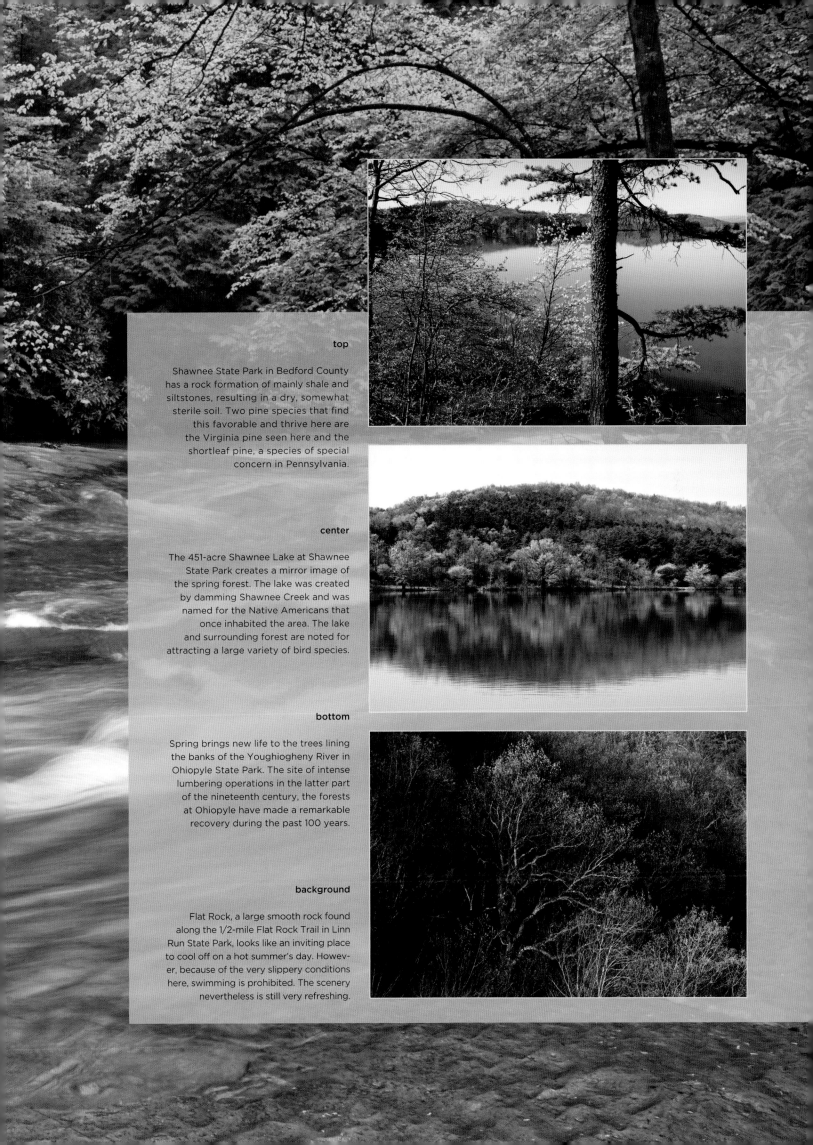

top

Shawnee State Park in Bedford County has a rock formation of mainly shale and siltstones, resulting in a dry, somewhat sterile soil. Two pine species that find this favorable and thrive here are the Virginia pine seen here and the shortleaf pine, a species of special concern in Pennsylvania.

center

The 451-acre Shawnee Lake at Shawnee State Park creates a mirror image of the spring forest. The lake was created by damming Shawnee Creek and was named for the Native Americans that once inhabited the area. The lake and surrounding forest are noted for attracting a large variety of bird species.

bottom

Spring brings new life to the trees lining the banks of the Youghiogheny River in Ohiopyle State Park. The site of intense lumbering operations in the latter part of the nineteenth century, the forests at Ohiopyle have made a remarkable recovery during the past 100 years.

background

Flat Rock, a large smooth rock found along the 1/2-mile Flat Rock Trail in Linn Run State Park, looks like an inviting place to cool off on a hot summer's day. However, because of the very slippery conditions here, swimming is prohibited. The scenery nevertheless is still very refreshing.

top

Morning dew clinging to the delicate fibers reveals the intricate detail of an orb-web spider web in a misty meadow at Prince Gallitzin State Park. They are usually camouflaged in vegetation, however when dew discloses their presence we are often amazed just how many webs may be in a meadow.

center

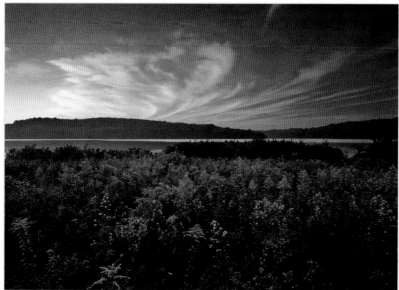

The sun sets over a summer wildflower meadow on the shore of Glendale Lake at Prince Gallitzin State Park. The 1,635-acre lake, with a 26-mile shoreline, is a warm-water fishery that attracts numerous species of water birds, including migrating and wintering bald eagles. The wildflower meadows are a butterfly's paradise.

bottom

This beautiful forest at Linn Run State Park, Westmoreland County, did not always look this healthy. During the late nineteenth and early twentieth centuries, the old-growth forest that stood here was clear cut, and the remaining slash-burned in massive brush fires. The area was described as a "waste land."

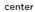

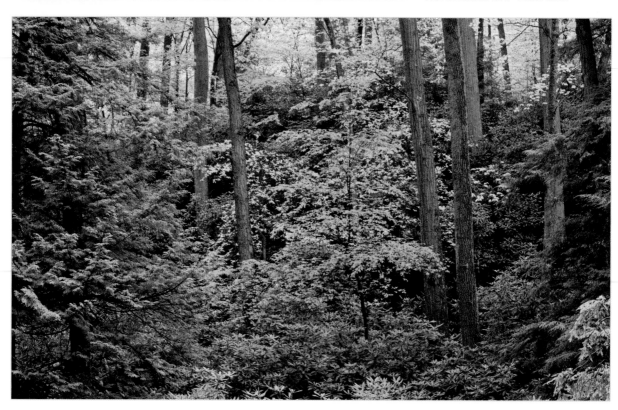

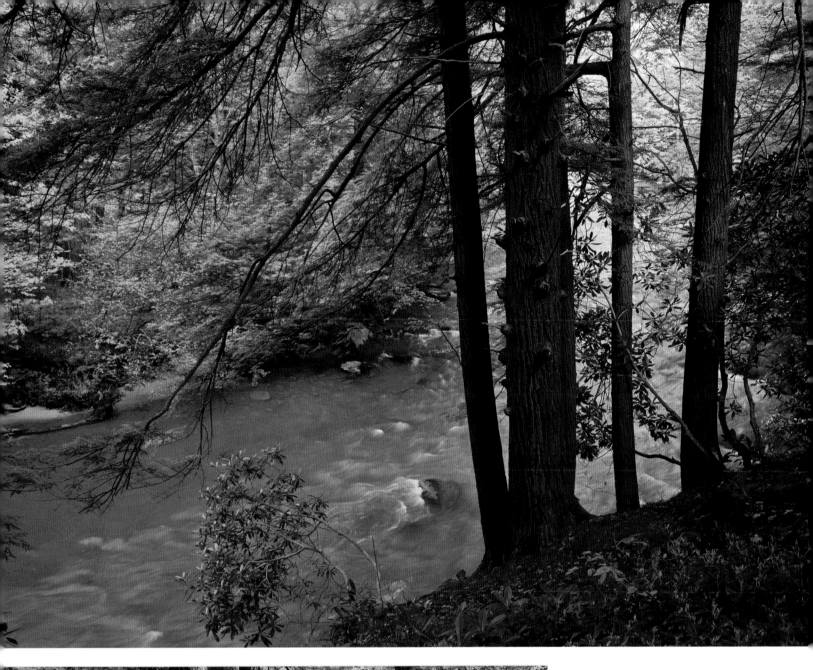

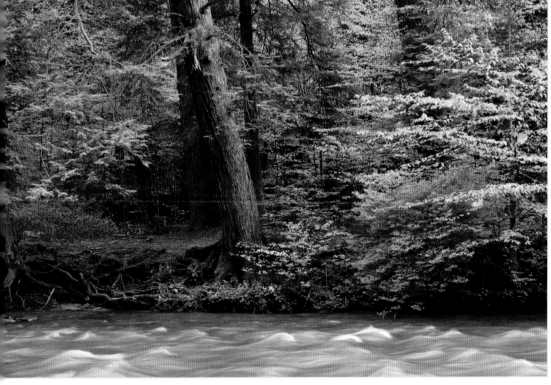

top

Draining a watershed of approximately 125 square miles, Laurel Hill Creek was dammed during the Great Depression by the Civilian Conservation Corps to form the 63-acre lake at Laurel Hill State Park in Somerset County. The 2.2-mile section above the lake is an excellent trout stream with special fishing regulations.

bottom

The nineteenth-century lumbering boom reached what is now Laurel Hill State Park in 1886. Old-growth pine and hemlock were clear-cut and wildfires swept the area. However, this 7-acre area, with 200- to 300-year-old trees, was too difficult for the lumbermen to reach and spared the logger's ax.

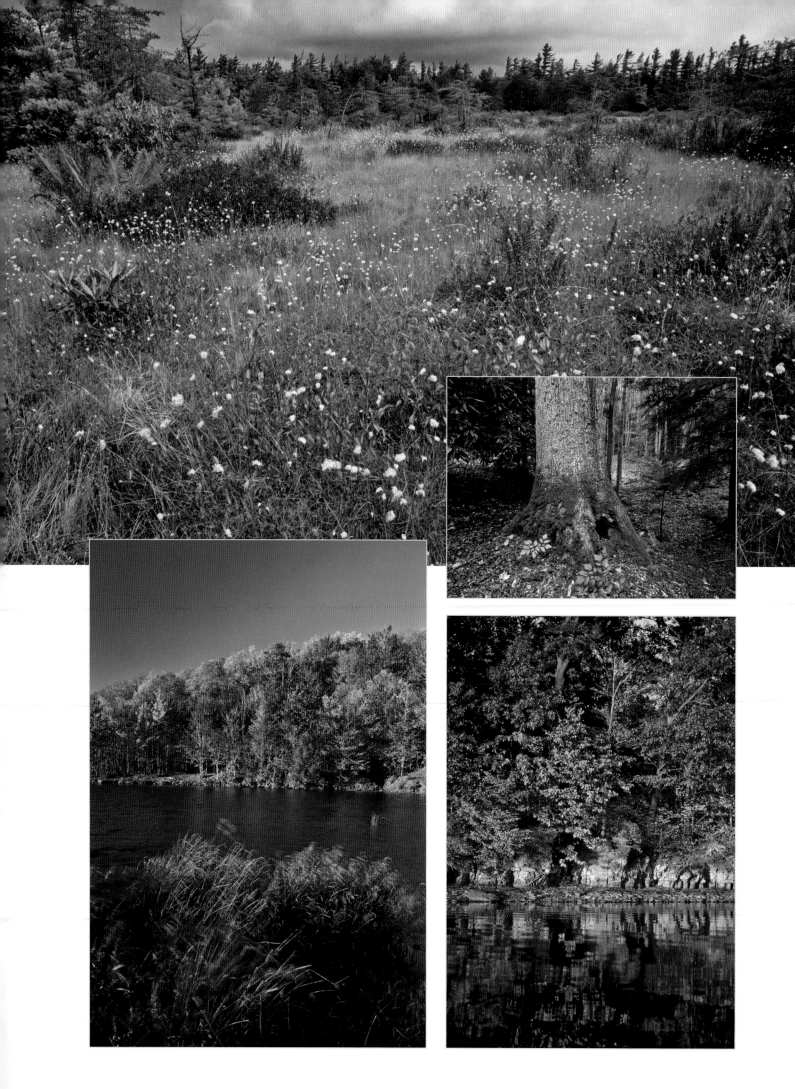

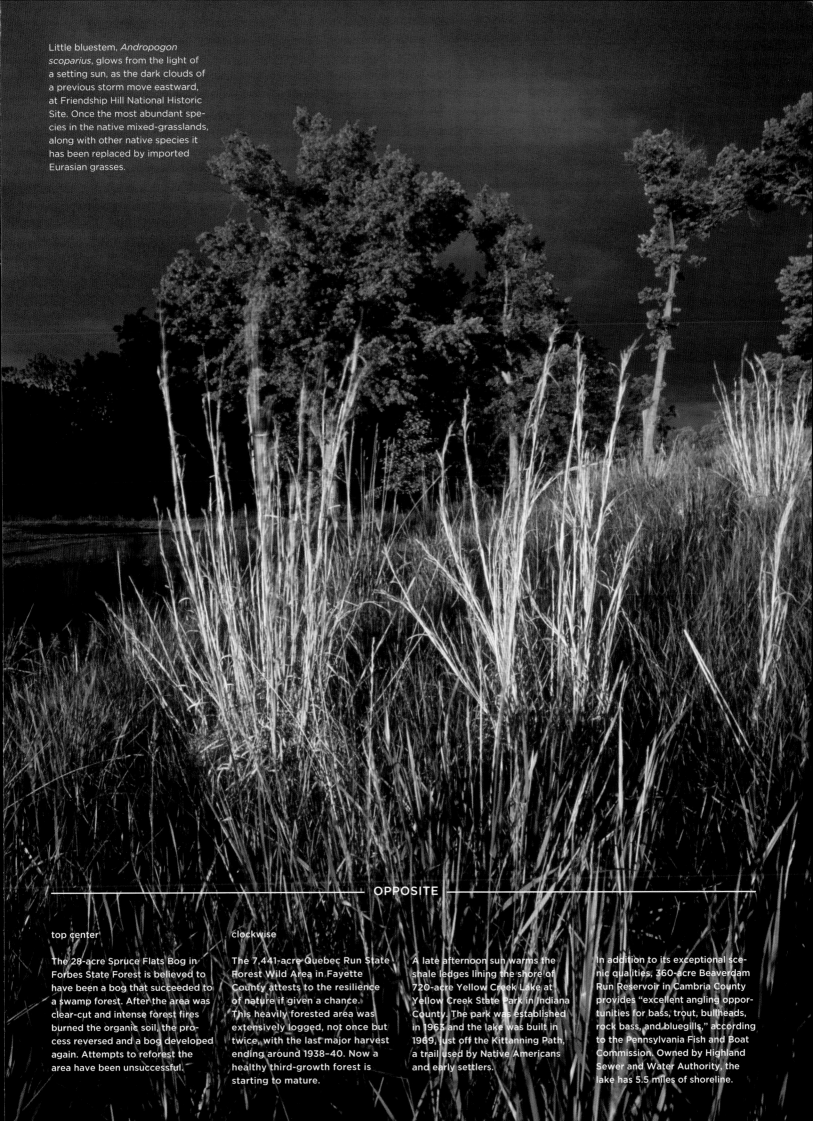

Little bluestem, *Andropogon scoparius*, glows from the light of a setting sun, as the dark clouds of a previous storm move eastward, at Friendship Hill National Historic Site. Once the most abundant species in the native mixed-grasslands, along with other native species it has been replaced by imported Eurasian grasses.

OPPOSITE

top center

The 28-acre Spruce Flats Bog in Forbes State Forest is believed to have been a bog that succeeded to a swamp forest. After the area was clear-cut and intense forest fires burned the organic soil, the process reversed and a bog developed again. Attempts to reforest the area have been unsuccessful.

clockwise

The 7,441-acre Quebec Run State Forest Wild Area in Fayette County attests to the resilience of nature if given a chance. This heavily forested area was extensively logged, not once but twice, with the last major harvest ending around 1938–40. Now a healthy third-growth forest is starting to mature.

A late afternoon sun warms the shale ledges lining the shore of 720-acre Yellow Creek Lake at Yellow Creek State Park in Indiana County. The park was established in 1965 and the lake was built in 1969, just off the Kittanning Path, a trail used by Native Americans and early settlers.

In addition to its exceptional scenic qualities, 360-acre Beaverdam Run Reservoir in Cambria County provides "excellent angling opportunities for bass, trout, bullheads, rock bass, and bluegills," according to the Pennsylvania Fish and Boat Commission. Owned by Highland Sewer and Water Authority, the lake has 5.5 miles of shoreline.

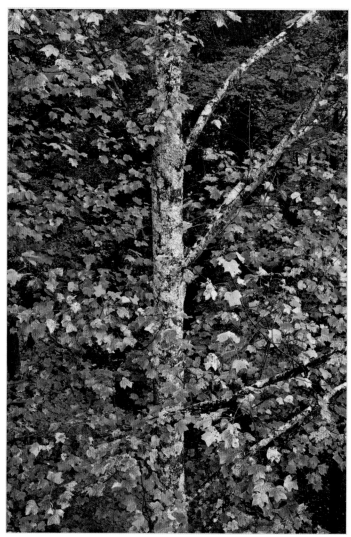

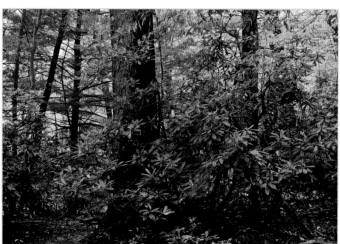

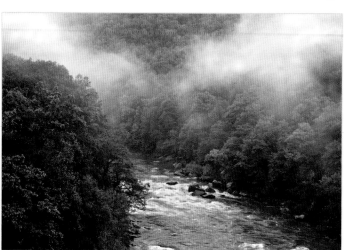

top left

Dew blankets a meadow on a foggy morning at Prince Gallitzin State Park. Dew forms overnight as surface objects cool and atmospheric moisture condenses faster than it can evaporate, forming tiny droplets on plants. The temperature at which these droplets form is called the dew point. Fog is oversaturated air.

bottom left

In addition to the 15-acre old-growth forest found preserved on the Ferncliff Peninsula at Ohiopyle State Park, several species of trees normally found south of the state grow here as their seeds are deposited by the north flowing Youghiogheny River as it makes a U-turn around the peninsula.

top right

A tuliptree, *Liriodendron tulipifera*, showing the first hint of autumn during a light rain on the Ferncliff Peninsula at Ohiopyle State Park. Due to the unique natural features of the peninsula, it was declared a National Natural Landmark in November 1973 and was named a State Park Natural Area in 1992.

bottom right

Fog forms above the Youghiogheny River at Ohiopyle State Park after the cool water from an autumn rain shower meets the still relatively warm waters of the river and becomes trapped in the deep gorge.

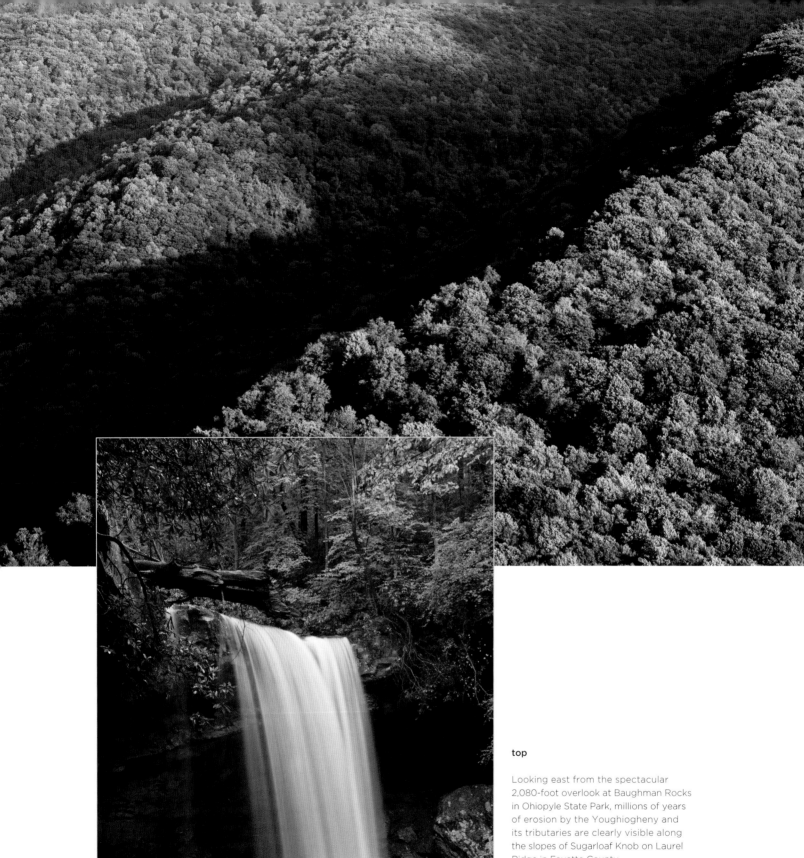

top

Looking east from the spectacular 2,080-foot overlook at Baughman Rocks in Ohiopyle State Park, millions of years of erosion by the Youghiogheny and its tributaries are clearly visible along the slopes of Sugarloaf Knob on Laurel Ridge in Fayette County.

bottom

Second only to the great Ohiopyle Falls, the 30-foot-high bridal veil Cucumber Falls, along Cucumber Run, is the most visited of the five major waterfalls found at Ohiopyle State Park. Some people also consider it to be the most photogenic waterfall in western Pennsylvania.

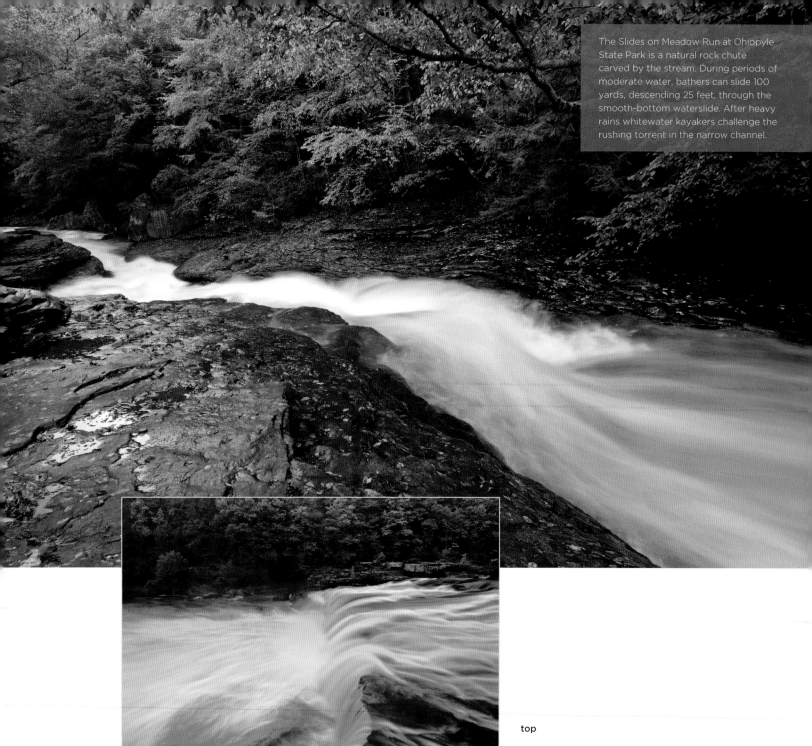

top

When viewed from above, the 20-foot-high Ohiopyle Falls on the Youghiogheny River may lose its perspective of height, but not its velocity and force. *Youghiogheny* is believed to be an Algonquin word meaning "contrary stream," while Ohiopyle is believed to be a Lenape phrase, "*ahi opihale*," meaning, "it turns white."

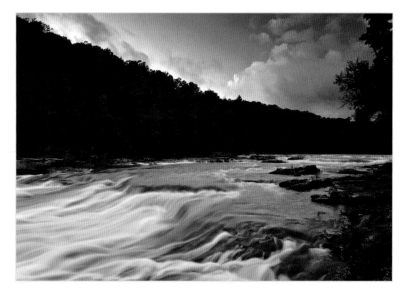

bottom

In addition to being one of the most popular whitewater boating rivers east of the Mississippi, the Youghiogheny is also a popular fishing destination. One weekend a year, experienced paddlers only can run the Class IV falls, under special regulations, during the Annual Ohiopyle Over the Falls Festival.

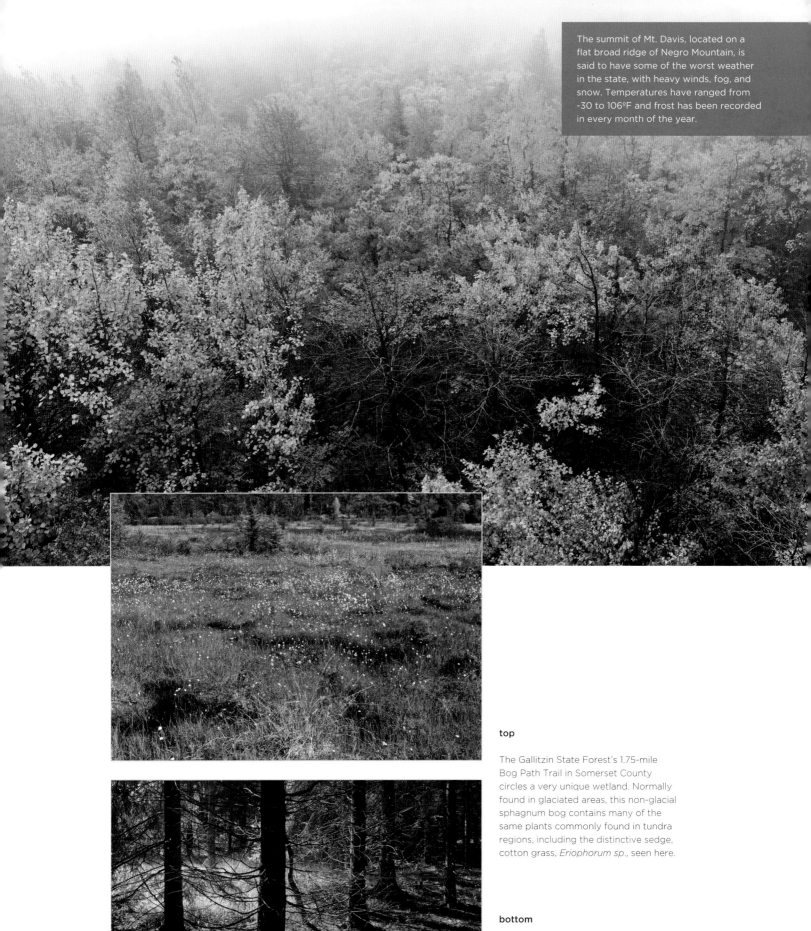

top

The Gallitzin State Forest's 1.75-mile Bog Path Trail in Somerset County circles a very unique wetland. Normally found in glaciated areas, this non-glacial sphagnum bog contains many of the same plants commonly found in tundra regions, including the distinctive sedge, cotton grass, *Eriophorum sp.*, seen here.

bottom

Most of what is now Gallitzin State Forest was clear-cut during the late nineteenth and early twentieth centuries for timber and charcoal production for the steel industry. The environmental scars are still seen today. In some locations, Norway spruce, *Picea abies*, a European tree, was planted to reforest the denuded land.

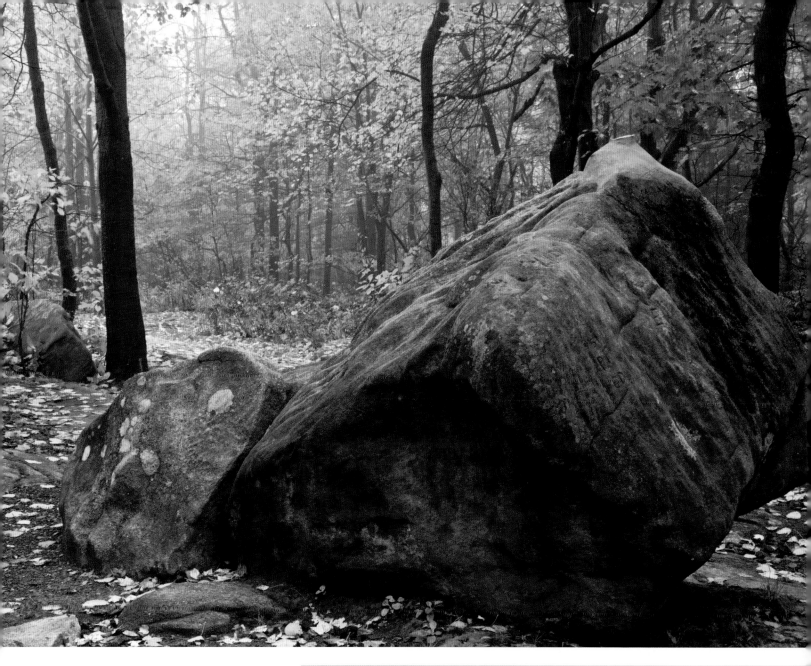

top

The tip of this boulder, on top of Mt. Davis, Somerset County, has the distinction of being the highest point in Pennsylvania at 3,213 feet, established by the U.S. Geological Survey in 1921. On June 18, 1921, at least a thousand people trekked up the mountain to commemorate the official designation.

bottom

The 720-acre Yellow Creek Lake lies at the heart of Yellow Creek State Park. Under a plan by Secretary Maurice K. Goddard to have a state park within 25 miles of every resident of the Commonwealth, the former Department of Forests and Waters began acquiring land for the park in 1963.

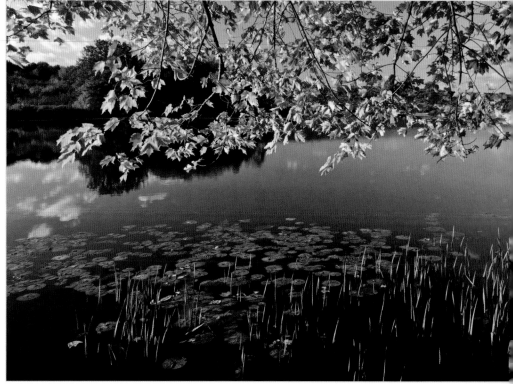

top

Sassafras shows its autumn colors on Mt. Davis. The tree's bark, believed to have medicinal properties, became one of the first exports from the New World after European exploration. Although its medical properties were exaggerated, it was still popular with the colonist as a tea and orange dye for wool.

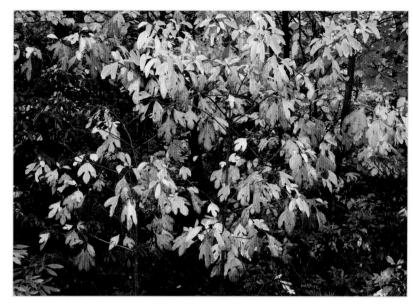

center

Autumn marks the end of another growing season for water lilies and bur-reeds growing in Yellow Creek Lake. Rooted in the shallow waters of lakes and ponds, these and other plants form the littoral habitat. It is here that the greatest number of both plant and animal species are found.

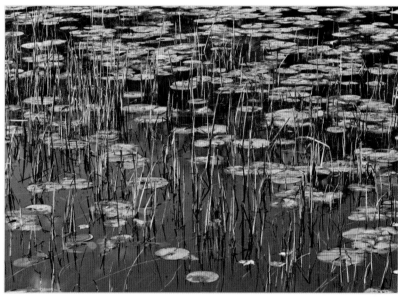

bottom

About 18 miles from Pittsburgh, the Allegheny River flows through the borough of Springdale. Although a highly industrial area, there are some wild sections along the river. A few blocks away is the birthplace and childhood home of Rachel Carson who often visited, studied, and swam in this very spot.

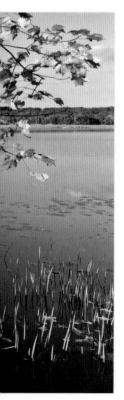

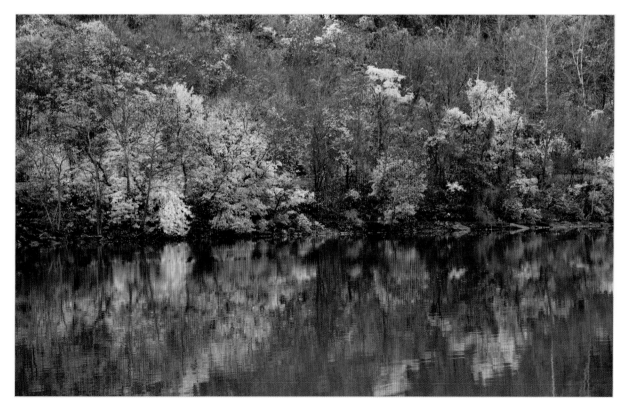

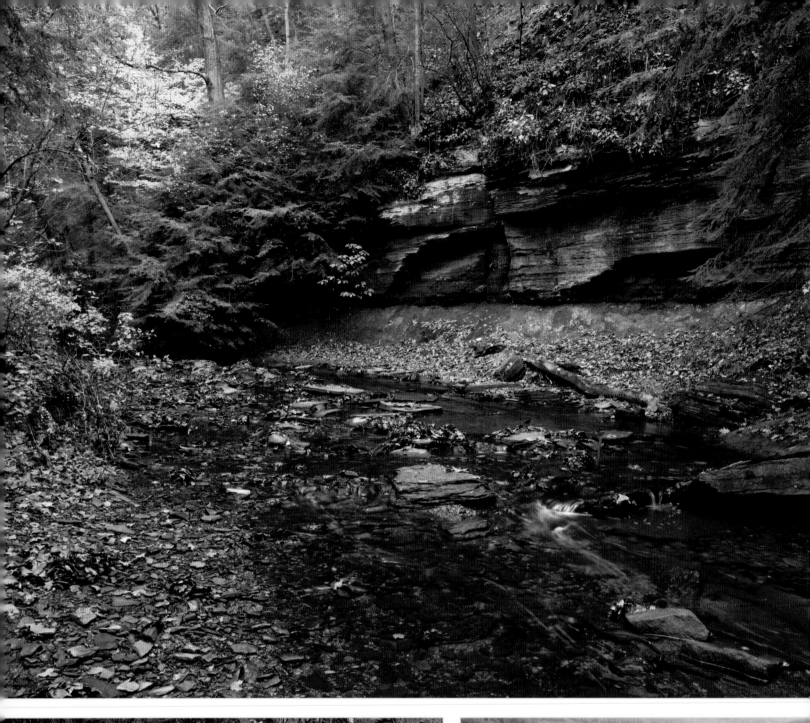

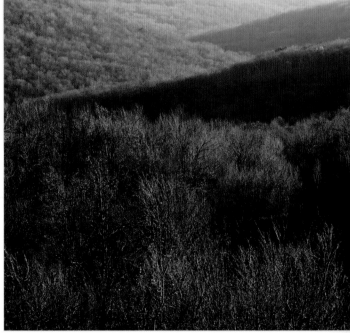

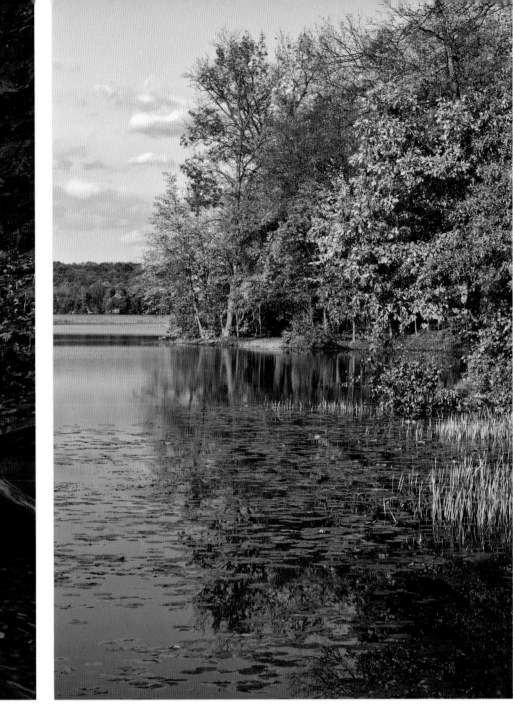

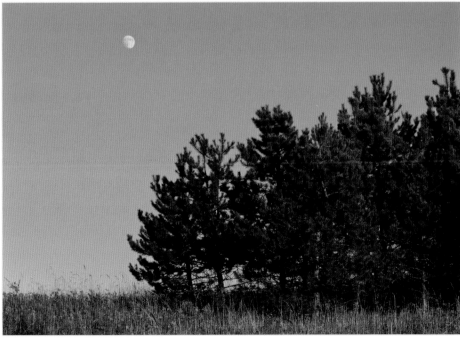

top left

It might be said that Crouse Run was the impetus for the modern-day environmental movement, for it was here in the 1920s that as a young college student, Rachel Carson, who later in life wrote the groundbreaking book *Silent Spring*, would often visit to study and be inspired by nature.

top right

Grammas Cove at Yellow Creek State Park in Indiana County is a noted birding location, especially for kinglets and warblers during migration and wintering hermit thrush, gray catbirds, and fox sparrow. The Pennsylvania Society of Ornithology lists Yellow Creek as one of the top ten birding locations in the state.

bottom left

In 1996, Hampton Township and the Pine Creek Conservation Trust set aside Crouse Run Valley as a nature preserve in Allegheny County. Shaded by giant sycamores and hemlocks, a profusion of ferns and wildflowers grows on the valley walls. A section of the Rachel Carson Trail passes through the valley.

bottom center

Standing at 2,400 feet above sea level on State Game Lands 158 in Blair County, hikers and hunters are rewarded with a view into Bells Gap Run. The watershed is the only public water source for Bellwood Borough and is protected from coal mining, which is common in the area.

bottom right

A nearly full moon rises behind a grove of planted red pine trees on State Game Lands 158. Many reclaimed strip mines, after suffering decades of abuse and neglect, are now managed by the Pennsylvania Game Commission and provide vital food and cover habitat for a diversity of wildlife species.

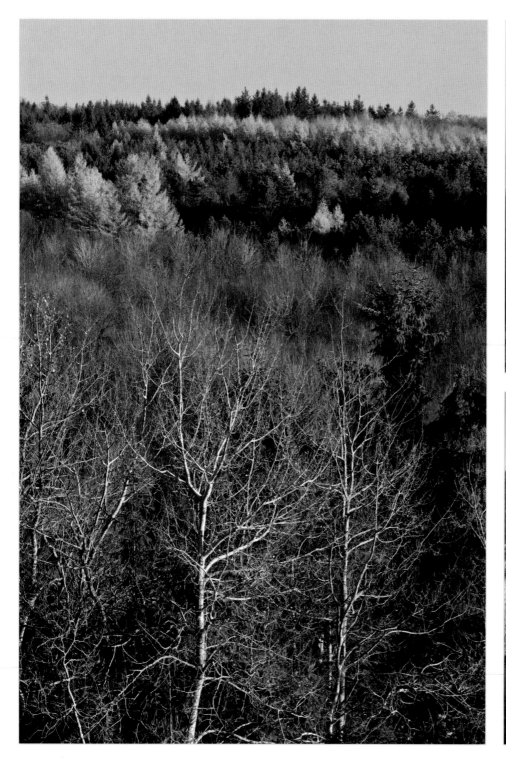

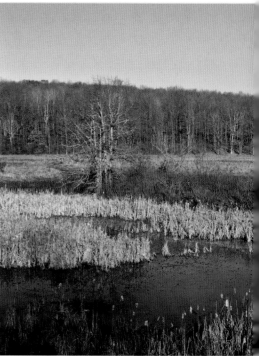

left

In early November, after most trees have lost their autumn color, Japanese larch, *Larix kaempferi*, planted on reclaimed strip mines on State Game Lands 158, just come into their glory. Unlike most conifers, which are "evergreen," larches are deciduous, shedding their needles each fall and growing new needles every spring.

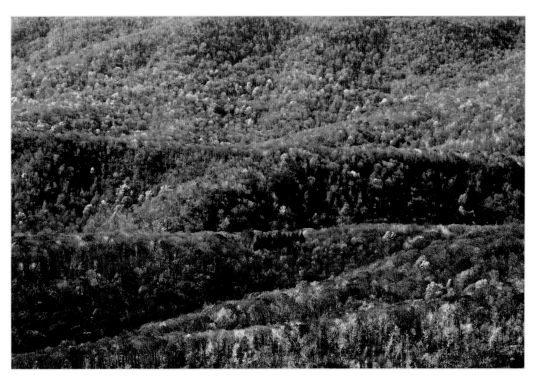

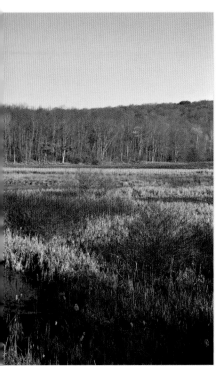

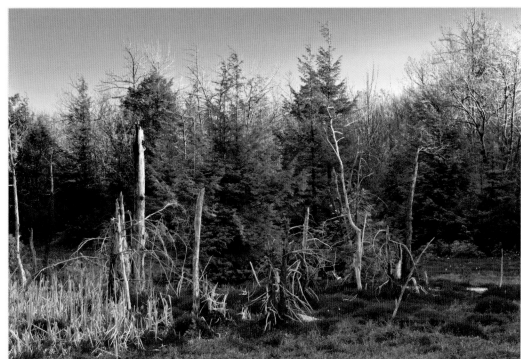

top center

The diverse human-made savannahs on the reclaimed strip-mines of State Game Lands 158 harbor bird species that are less common in natural habitats in Pennsylvania, including northern harrier, horned lark, and prairie warbler. These lands are excellent examples that environmental restoration, following prior reckless land practices, can be highly beneficial.

bottom center

High quality marshes, such as Slate Lick Run, a cove of Glendale Lake, in Prince Gallitzin State Park, are not common in Pennsylvania. This marsh provides excellent habitat for muskrats and mink in addition to migrating waterfowl. Some species recorded here are tundra swan, canvasback, northern pintail, and ruddy duck.

top right

Pavia Overlook, which sits at an elevation of 2,891 feet along Mountain View Trail in Blue Knob State Park, rewards hikers with this spectacular view of Laurel Hill and the Allegheny Front. At 3,213 feet, Blue Knob has the distinction of having the state's highest recorded snowfall of 225 inches during the winter of 1890–91.

bottom right

While common in many glacial areas, sphagnum bogs, like the one seen here along Rachel Run in the Gallitzin State Forest in Cambria County, are unique. Sedges, cotton grass, and leatherleaf are more reminiscent of Canada and New England than southern Pennsylvania. Leatherleaf, an evergreen shrub, turns red-brown in winter.

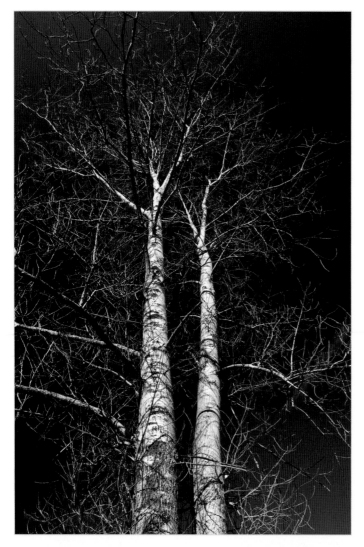

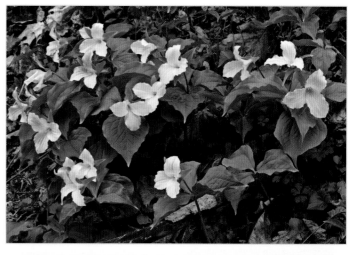

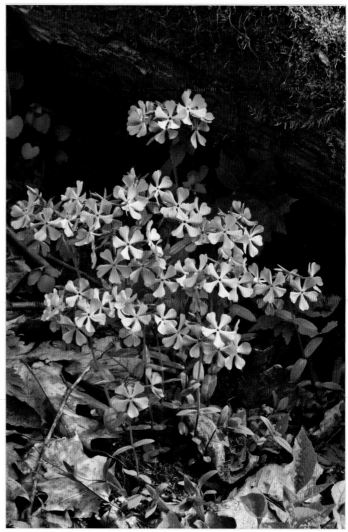

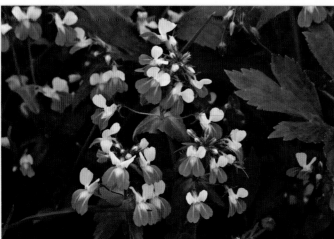

top left

A pair of mature, big-tooth aspen trees, *Populus grandidentata*, grow in Prince Gallitzin State Park. Similar to trembling or quaking aspen, it is a tree of early successional forests. Many species of wildlife depend on the tree for food: ruffed grouse for the winter buds and beaver for inner bark.

bottom left

Listed as a plant of special concern in Pennsylvania, blue-eyed Mary, *Collinsia verna*, grows in only a few locations along stream banks in southwestern Pennsylvania. One of the most visited places to see the plant in bloom, in April, is at Enlow Fork Natural Area on State Game Lands 302.

top right

Found mainly in western Pennsylvania, large-flowered trillium, *Trillium grandiflorum*, has flowers up to four inches wide. In several locations, large-flowered trillium covers the forest floor in a stunning display during April. Picking the flowers will kill the plant, but the fallen dead leaves provide necessary food for next year's flowers.

bottom right

Blue phlox, *Phlox divaricata*, bloom at Enlow Fork Natural Area on State Games Lands 302 and numerous other locations across western Pennsylvania. Also called wild sweet William, it is one of the earliest blooming wildflowers in rich, moist woods and field margins.

top center

Besides blue-eyed Mary, visitors to Enlow Fork Natural Area, on the Washington and Greene County border, witness a natural spectacle of wildflowers in bloom, including several species of violets, bluebells, red and large-flowered trilliums, blue phlox, and others. This unique area is a mecca for Pennsylvania wildflower enthusiasts.

bottom left

Spring sunlight streaks through the 8-acre remnant old-growth deciduous forest in Sophia's Woods at Friendship Hill National Historic Site in Fayette County. Comprised mainly of tulip tree, American beech, and various oaks, the forest is situated on a bluff nearly 200 feet above the Monongahela River.

bottom right

Spring comes to the forest at Hillman State Park in Washington County. This unique undeveloped 3,600-acre state park was opened in the late 1960s and has been managed for hunting by the Pennsylvania Game Commission since the early 1980s. Hiking, cross-country skiing, and mountain biking are also available.

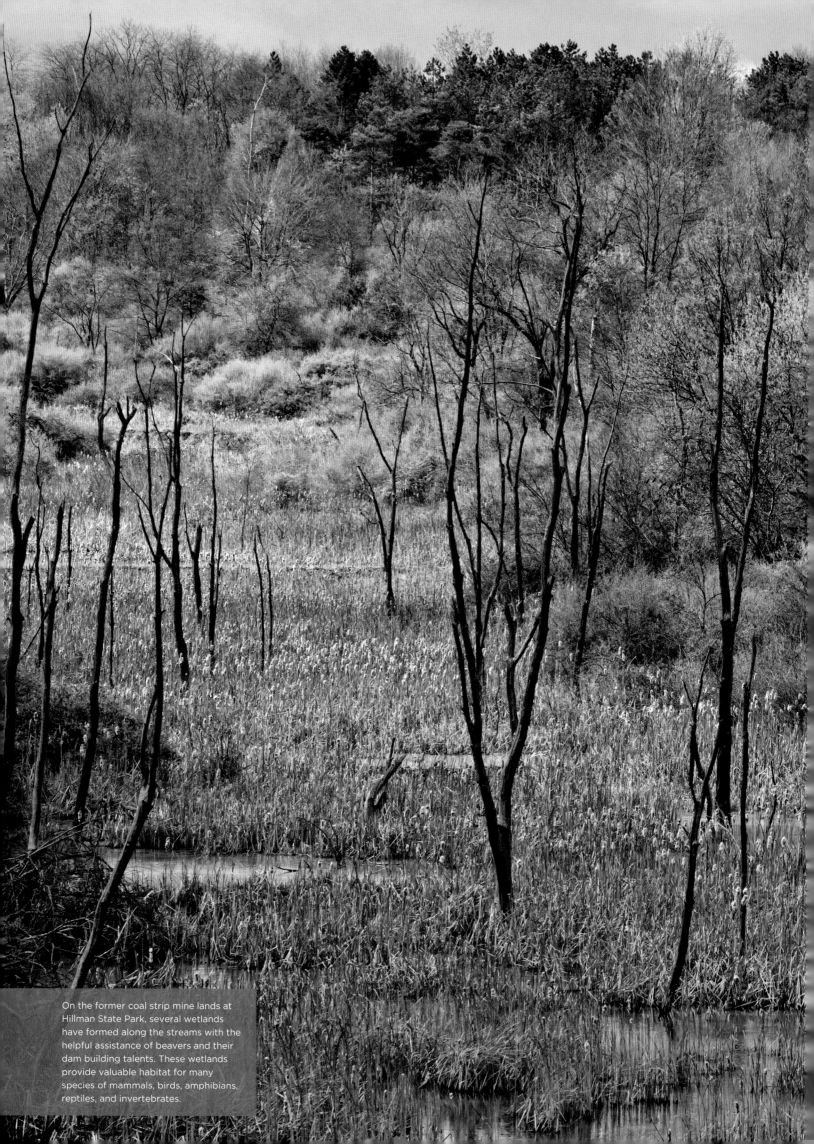

On the former coal strip mine lands at Hillman State Park, several wetlands have formed along the streams with the helpful assistance of beavers and their dam building talents. These wetlands provide valuable habitat for many species of mammals, birds, amphibians, reptiles, and invertebrates.

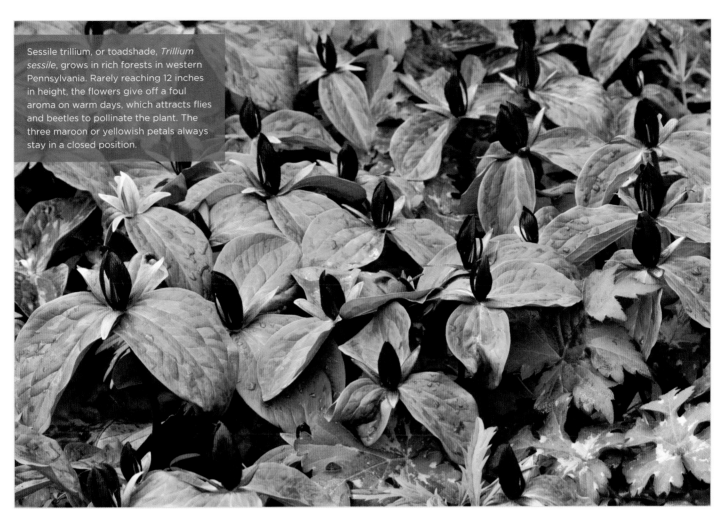

Sessile trillium, or toadshade, *Trillium sessile*, grows in rich forests in western Pennsylvania. Rarely reaching 12 inches in height, the flowers give off a foul aroma on warm days, which attracts flies and beetles to pollinate the plant. The three maroon or yellowish petals always stay in a closed position.

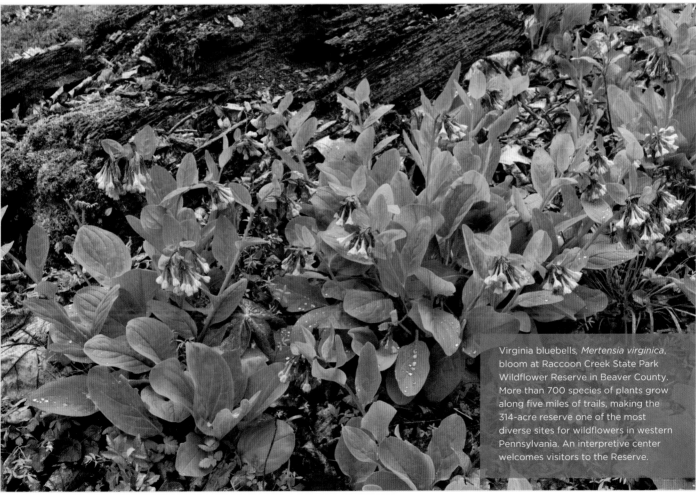

Virginia bluebells, *Mertensia virginica*, bloom at Raccoon Creek State Park Wildflower Reserve in Beaver County. More than 700 species of plants grow along five miles of trails, making the 314-acre reserve one of the most diverse sites for wildflowers in western Pennsylvania. An interpretive center welcomes visitors to the Reserve.

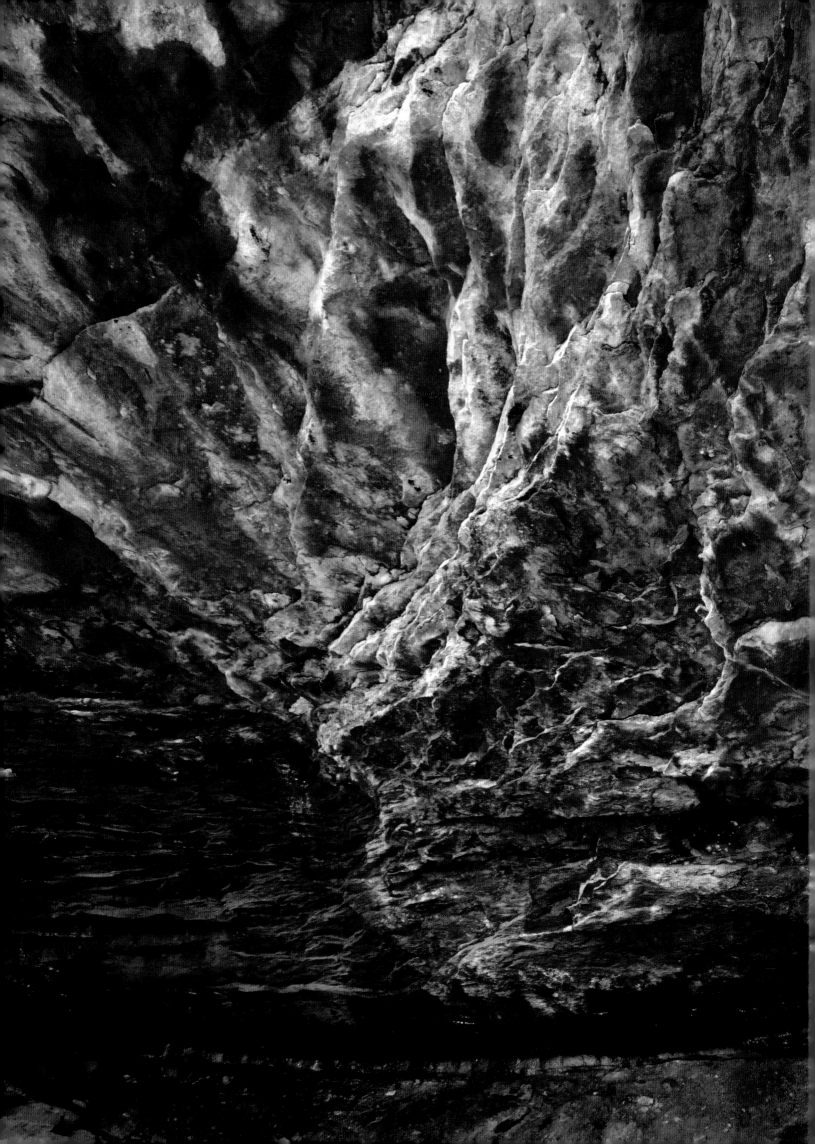

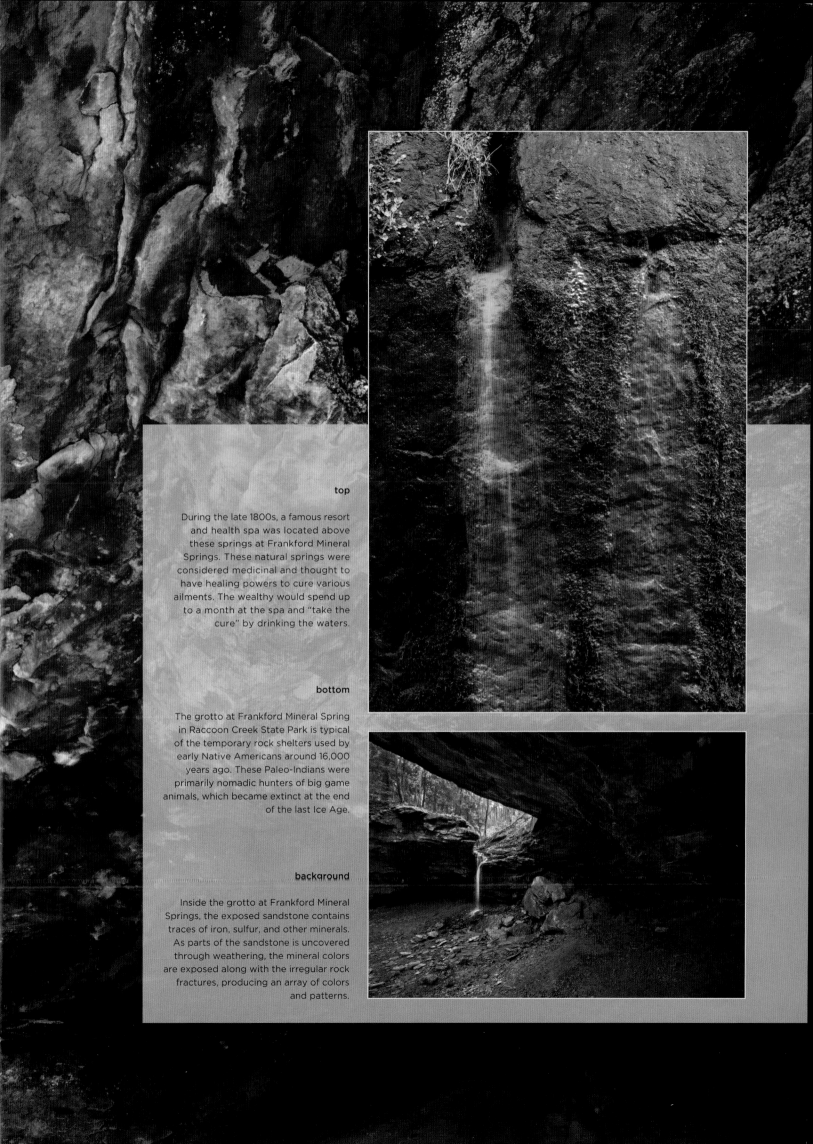

top

During the late 1800s, a famous resort and health spa was located above these springs at Frankford Mineral Springs. These natural springs were considered medicinal and thought to have healing powers to cure various ailments. The wealthy would spend up to a month at the spa and "take the cure" by drinking the waters.

bottom

The grotto at Frankford Mineral Spring in Raccoon Creek State Park is typical of the temporary rock shelters used by early Native Americans around 16,000 years ago. These Paleo-Indians were primarily nomadic hunters of big game animals, which became extinct at the end of the last Ice Age.

background

Inside the grotto at Frankford Mineral Springs, the exposed sandstone contains traces of iron, sulfur, and other minerals. As parts of the sandstone is uncovered through weathering, the mineral colors are exposed along with the irregular rock fractures, producing an array of colors and patterns.

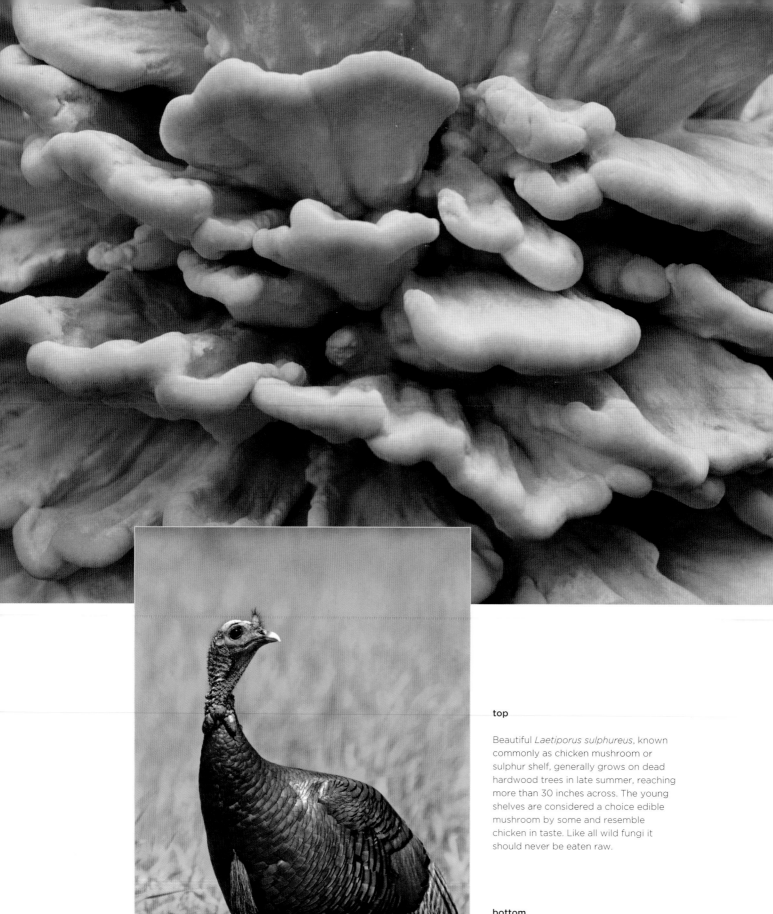

top

Beautiful *Laetiporus sulphureus*, known commonly as chicken mushroom or sulphur shelf, generally grows on dead hardwood trees in late summer, reaching more than 30 inches across. The young shelves are considered a choice edible mushroom by some and resemble chicken in taste. Like all wild fungi it should never be eaten raw.

bottom

At the beginning of the twentieth century, wild turkeys were rare due to habitat loss, market hunting, and repeated forest fires. However, under the wise management of the Pennsylvania Game Commission, it has recovered to become a common bird in the state. Here a gobbler displays its prime breeding plumage.

Conclusion

"One way to open your eyes is to ask yourself, 'What if I had never seen this before? What if I knew I would never see it again?'"

–Rachel Carson

On a spring day in the late 1990s, while working as a state park ranger at Promised Land State Park, I was on a routine park patrol and drove over to the Bear Wallow Boat Launch Area on Lower Lake. As I drove up to the boat ramp I noticed a middle-aged woman standing on the nearby shore, looking across the lake. She seemed to be mesmerized—on the far side of the lake a pair of bald eagles had built a nest in a tall white pine tree. As I got closer to the woman I could see tears streaming down her face. Before I was able to ask if she was all right, she turned to me and said, "I thought I would never see a bald eagle in my entire life and here I just saw one dive and catch a fish." More tears started to flow, as she was overwhelmed with joy.

I never got to meet or see every person who came to the park and stood on the same shore and for the first time in their lives watched a pair of eagles raise their young or catch a fish. But I'm confident that many other people felt the same overwhelming joy and excitement experienced by that one particular woman. How can you put a price on something like that? How can you measure its value?

Other times at the park I would come upon someone staring up into the night sky and it was clear that they were seeing the cosmos unobstructed by artificial light for the very first time. At that moment their lives changed as they realized the vastness of the universe, the multitude of heavenly bodies, and just how insignificant we are as individuals in the whole order of the universe. And with that realization they were connected to the thousands of generations of humankind before them: writers, artists, philosophers, and religious leaders who were moved and found inspiration beyond their immediate surroundings and were able to extend their being into infinity.

Studies have shown that for every dollar spent on state parks, approximately nine dollars comes back to the local economy. This is something quantifiable that we can count and calculate. But how can you put a dollar value on a once-in-a-lifetime experience with nature and the wild earth?

Many people find it not only easy, but also seemingly "natural" to place a monetary value on everything. Seeing an area of meadows and forest without any kind of development, they might think there is nothing there, the land is being wasted, and should be "used" for something.

Near where I live in the Poconos, developers were proposing building an industrial park on several hundred acres of century-old farms with fields, wetlands, and woodlots. To counter local opposition to the industrial park, proponents would argue with the question, "well, what's there now?" Yet at the same time, when trying to attract business to locate to the park, the developers describe the area on their website

using phrases like, "...wooded countryside," "...one of the premier freshwater fishing spots in the country," "...many lakes and streams," "...some of the best trout fishing in the state," "...large variety of trees create spectacular scenery," "...paradise for hunters, hikers, mountain bikers and outdoor enthusiasts," "...major nesting site for the Bald Eagle," and "....unpolluted glacial lake is designated as National Natural Landmark." Strange how the rationale for destroying the natural diversity and splendor of an area is by advertising and bragging about the very thing you are destroying. Yet it also proves that economic growth is dependent on a clean unpolluted environment where many natural areas have been set aside and left in a wild state.

I live about three miles south of this developing industrial park. Many nights I've enjoyed watching the northern lights wave across the winter sky from my yard. On moonless nights I've gazed and wondered at the billions of stars in the Milky Way. The artificial light from the industrial park will forever pollute the night sky and I will probably never again see the northern lights and the Milky Way from my home.

There are many things all of us will never see again. We will never again see the sky darkened for hours with millions of passenger pigeons in migration. We will never again see endless herds of bison grazing on the American prairie. We will never again see an expansive eastern old-growth forest, with all its diversity, covering many thousands of acres, as it existed in pre-Columbian times.

But what if we could never see some of the "common" things anymore? What if we could never see a robin searching for a worm on a spring morning, a displaying wild turkey, or the magnificence of an autumn forest? What if there were no more fireflies to bring us joy and amazement on a summer's evening? What if the sky was silenced from the haunting, wild call of migrating geese? What if we could never experience true silence again? Yet already there are many people who have never seen or experienced these things.

According to the 2010 census, 80.7% of the United States population now lives in urban areas with the trend toward urban living increasing. This means that less than 1/5 of the people in the United States are exposed to, or experience, nature on a daily basis. For many people their only "exposure" to nature is on television, which is generally composed of unrealistic film editing necessary to present a dramatic story line to hold the viewers' attention. Only a small percentage of people today have direct and personal contact with nature.

Generations ago, when we were a more agrarian society of small family farms, we were more in tune with *the repeated refrains of nature* as our basic survival and well being depended on them. We felt not only dependent, but also

very much a part of the dynamisms of nature. For many of us today, a summer rainstorm does not mean our crops will be able to grow, but rather our golf game, or some other event, must be cancelled.

To make matters even worse, consider our increasing dependence and interaction with technology. If we are not glued to our television sets, then it's our computers, smartphones, or tablets. How many of us cannot get through the day without using at least one of these devices? And if we do get out in nature, how many of us feel that we cannot navigate on a hike without a GPS unit instead of learning the natural patterns and lay of the land?

What is more alarming are the perceptions of nature by people who are unconnected with the natural world. Some people see nature as something that is only pretty, charming, cute, funny, or worse yet, dangerous or dirty. It is essentially of little importance because it has nothing to do with them. Again, they feel they are not a part of nature.

Yet numerous scientific studies around the world have been showing the positive effects for humans when we interact with nature. The studies show that this interaction improves memory, cognitive thinking, and learning in children, which often results in better school grades. With the elderly, contact with nature appears to help lessen the symptoms of Alzheimer's disease. Contact with nature improves productivity and creativity, which explains why people seem more energetic at3 their jobs after returning from a vacation involving the outdoors. Many creative people who are seeking inspiration look to nature for inspiration even if their creative work is not directly related to nature.

Anyone who has studied the world's great religions knows that their prophets were often inspired with transcendental experiences after a contact with nature. The scientific evidence is overwhelming on the positive effects to our physical well-being, health, and healing, and this evidence is starting to be taken very seriously by the medical community. The beneficial effects of clean air, water, and outdoor exercise goes without saying, but contact with nature has also shown to have positive effects on blood pressure, diabetes, and cardiovascular disease, all of which are aggravated by the stress of urban life.

Our parks, forestlands, and nature reserves not only protect and conserve our natural resources, but are also considered a fundamental health resource in disease prevention and for restorative capabilities. They are *reserves of strength* for our own wellbeing. We do not exist independent of nature. Rather we are part of a very complex interconnected worldwide natural ecosystem that we must protect and preserve at all costs to protect and preserve ourselves.

Do not be satisfied with the words and photographs in this book. Put the book down, open your door and venture out into Pennsylvania's wild nature. Hear a wapiti bugling on a misty autumn morning, see a duck walk on the backs of fish, watch the monarch butterflies in a summer meadow and marvel at their great migration, and on some moonless night find the darkest sky you can locate and gaze up into the heavens and wonder. Look for things you have never seen before.

Imagine to yourself, *What if I knew I would never see it again?*

Bibliography

Abramson, Ruby, and Jean Haskell. *Encyclopedia of Appalachia*. (Knoxville, TN: The University of Tennessee Press, 2006).

Allen, Peter, and Brian Cassie. *The Audubon Society Field Guide to The Mid-Atlantic States*. (New York, NY: Alfred A. Knopf, Inc., 1991).

Barnes, John H., and W.D. Sevon. *The Geological Story of Pennsylvania*. (Harrisburg, PA: PA Bureau of Topographic and Geologic Survey, 2002).

Behler, John L. *The Audubon Society Field Guide to North American Reptiles and Amphibians*. (New York, NY: Alfred A. Knopf, Inc., 1979).

Bernik, Ed, and Lisa Gensheimer. *Pennsylvania Wild: Images from the Allegheny National Forest*. (Bradford, PA: Forest Press, 2006).

Bent, Arthur Cleveland. *Life Histories of North American Wild Fowl, Part One*. (New York, NY: Dover Publications, 1962)
———. *Life Histories of North American Gallinaceous Birds*. (New York, NY: Dover Publications, 1963).

Bonta, Marcia. *Outbound Journeys in Pennsylvania: A Guide to Natural Places for Individual and Group Outings*. (University Park, PA: The Pennsylvania State University Press, 1987).
———. *More Outbound Journeys in Pennsylvania: A Guide to Natural Places for Individual and Group Outings*. (University Park, PA: The Pennsylvania State University Press, 1995).

Brock, F., S. Fordyce, D. Kunkle, and T. Fenchel. *Eastern Pennsylvania Birding and Wildlife Guide*. (Harrisburg, PA: Pennsylvania Department of Conservation and Natural Resources, 2009).

Broun, Maurice. *Hawks Aloft: The Story of Hawk Mountain*. (Kutztown, PA: Kutztown Publishing Co., 1948).

Brown, Scott E. *Pennsylvania Waterfalls: A guide for Hikers and Photographers*. (Mechanicsburg, PA: Stackpole Books, 2004).
———. *Pennsylvania Mountain Vistas: A guide for Hikers and Photographers*. (Mechanicsburg, PA: Stackpole Books, 2007).

Cramer, Ben. *Pennsylvania Hiking Trails: 13th Edition*. (Mechanicsburg, PA: Stackpole Books, 2008).

DeCoster, Lester A. *The Legacy of Penn's Woods: A History of the Pennsylvania Bureau of Forestry*. (Harrisburg, PA: Pennsylvania Historical and Museum Commission, 1995).

Felbaum, Frank, et al. *Endangered and Threatened Species of Pennsylvania*. (Harrisburg, PA. Wild Resource Conservation Fund, 1995).

Fergus, Charles. *Natural Pennsylvania: Exploring the State Forest Natural Areas*. (Mechanicsburg, PA: Stackpole Books, 2002).

Fike, Jean. *Terrestrial & Palustrine Plant Communities of Pennsylvania*. (Harrisburg, PA: Pennsylvania Natural Diversity Inventory, 1999).

Foster, Steven, and James A. Duke. *The Peterson Field Guide Series: A Field Guide to Medicinal Plants*. (Boston, MA: Houghton Mifflin Co., 1990).

Frye, Bob. *Best Hikes Near Pittsburgh*. (Guilford, CT: The Globe Pequot Press, 2009).

Geyer, Alan R., and William H. Bolles. *Outstanding Scenic Geological Features of Pennsylvania*. (Harrisburg, PA: PA Bureau of Topographic and Geologic Survey, 1987).

Grimm, William C. *Birds of the Pymatuning Region*. (Harrisburg, PA: The Pennsylvania Game Commission. 1952).

Harrison, Hal H. *Peterson Field Guide Series: A Field Guide to Birds' Nests in the United States East of the Mississippi River*. (Boston, MA: Houghton Mifflin Co., 1975).

Haywood, Mary Joy, and Phyllis Monk Testal. *Wildflowers of Pennsylvania*. (Pittsburgh, PA: Botanical Society of Western Pennsylvania, 2001).

Illick, Joseph S. *Pennsylvania Trees*. (Harrisburg, PA: Pennsylvania Department of Forestry, 1919).

Kershner, Bruce, and Robert T. Leverett. *The Sierra Club Guide to the Ancient Forest of the Northeast*. (San Francisco, CA: Sierra Club Books, 2004).

Kopczynski, Susan A. *Exploring Delaware Water Gap History: A Field Guide to the Historic Structures and Cultural Landscapes of the Delaware Water Gap National Recreation Area*. (Fort Washington, PA: Eastern National, 2000).

Korber, Kathy, and Hal Korber. *Pennsylvania Wildlife: A Viewer's Guide*. (Lemoyne, PA: Northwoods Publications, 1994).

Letcher, Gary. *Waterfalls of the Mid-Atlantic States*. (Woodstock, VT: The Countryman Press, 2004).

Lincoff, Gary H. *The Audubon Society Field Guide to North American Mushrooms*. (New York, NY: Alfred A. Knopf, Inc., 1981).

McCabe, Charlotte. *Down the Delaware: A River User's Guide*. (Fort Washington, PA: Eastern National, 2003).

McKnight, Kent H., and Vera B. McKnight. *The Peterson Field Guide Series: A Field Guide to Mushrooms*. (Boston, MA: Houghton Mifflin Co., 1987).

Merritt, Joseph F. *Guide to the Mammals of Pennsylvania*. (Pittsburgh, PA: University of Pittsburgh Press, 1987).

Michael, Art. *Pennsylvania Overlooks: A Guide for Sightseers and Outdoor People*. (University Park, PA: The Pennsylvania State University Press, 2003).

Miller, Randall M., and William Pencak. *Pennsylvania: A History of the Commonwealth*. (University Park, PA: The Pennsylvania State University Press, 2002).

Mitchell, Jeff. *Hiking the Endless Mountains: Exploring the Wilderness of Northeastern Pennsylvania*. (Mechanicsburg, PA: Stackpole Books, 2003).
———. *Backpacking Pennsylvania: 37 Great Trails*. (Mechanicsburg, PA: Stackpole Books, 2005).
———. *Hiking the Allegheny National Forest: Exploring the Wilderness of Northwest Pennsylvania*. (Mechanicsburg, PA: Stackpole Books, 2007).
———. *Paddling Pennsylvania: Canoeing and Kayaking the Keystone State's Rivers and Lakes*. (Mechanicsburg, PA: Stackpole Books, 2010).
———. *Hiking the Endless Mountains: Exploring the Wilderness of Northeastern Pennsylvania 2nd Edition*.

(Mechanicsburg, PA: Stackpole Books, 2011).

Mowery, Marci J., and Audubon Pennsylvania. *Susquehanna River Birding and Wildlife Trail*. (Harrisburg, PA: Pennsylvania Department of Conservation and Natural Resources, 2004).

Newman, Boyd, and Linda Newman. *Great Hikes in the Poconos and Northeast Pennsylvania*. (Mechanicsburg, PA: Stackpole Books, 2000).

Oplinger, Carl S., and Robert Halma. *The Poconos: An Illustrated Natural History Guide*. (New Brunswick, NJ: Rutgers University Press, 1988).

———. *The Lehigh Valley: A Natural and Environmental History*. (University Park, PA: The Pennsylvania State University Press, 2001).

Ostertag, Rhonda, and George Ostertag. *Hiking Pennsylvania*. (Helena, MT: Falcon Publishing, 1998).

Ostrander, Stephen J. *Great Natural Areas in Eastern Pennsylvania*. (Mechanicsburg, PA: Stackpole Books, 1996).

———. *Great Natural Areas in Western Pennsylvania*. (Mechanicsburg, PA: Stackpole Books, 2000).

Peterson, Lee. *The Peterson Field Guide Series: A Field Guide to Edible Wild Plants*. (Boston, MA: Houghton Mifflin Co., 1978).

Peterson, Rodger Tory. *Peterson Field Guide to Birds of Eastern and Central North America*. (New York, NY: Houghton Mifflin Harcourt Publishing Co., 2010).

Poole, Earl L. *Pennsylvania Birds: An Annotated List*. (Narbert, PA: Livingston Publishing Co., 1964).

Rhoads, Ann Flower, and Timothy A. Block. *Trees of Pennsylvania: A Complete Reference Guide*. (Philadelphia, PA: University of Pennsylvania Press, 2005).

Scherer, Glen, and Don Hopey. *Exploring the Appalachian: Hikes in the Mid-Atlantic States*. (Mechanicsburg, PA: Stackpole Books, 1998).

Schneck, Marcus, and Glenn Davis. *Backroads of Pennsylvania: Your Guide to Pennsylvania's Most Scenic Backroad Adventures*. (St. Paul, MN: Voyageur Press, 2003).

Sevon, W.D., and Gary M. Fleeger. *Pennsylvania and the Ice Age*. (Harrisburg, PA. Pennsylvania Geological Survey, 1999).

Sutton, George Miksch. *An Introduction to the Birds of Pennsylvania*. (Harrisburg, PA: J. Horace McFarland Co., 1928).

Thieret, John W., and William A. Niering. *The Audubon Society Field Guide to North American Mushrooms*. (New York, NY: Alfred A. Knopf, Inc., 1981).

Whiteford, Richard D., and Michael P. Gadomski. *Wild Pennsylvania: A Celebration of Our State's Natural Beauty*. (St. Paul, MN: Voyageur Press, 2006).

Wilshusen, Peter J. *Geology of the Appalachian Trail in Pennsylvania*. (Harrisburg, PA: PA Bureau of Topographic and Geologic Survey, 1983).

Websites

Audubon Pennsylvania. http://pa.audubon.org (accessed January 6, 2013).

Department of Conservation and Natural Resources: Commonwealth of Pennsylvania. www.dcnr.state.pa.us/index.aspx (accessed January 6, 2013).

Pennsylvania Fish and Boat Commission: Commonwealth of Pennsylvania. www.portal.state.pa.us/portal/server.pt/community/pgc/9106 (accessed January 6, 2013).

Pennsylvania Game Commission: Commonwealth of Pennsylvania. www.portal.state.pa.us/portal/server.pt/community/pgc/9106 (accessed January 6, 2013).

Pennsylvania Historical and Museum Commission: Commonwealth of Pennsylvania. www.portal.state.pa.us/portal/server.pt?open=512&mode=2&objID=1426 (accessed January 6, 2013).

Pennsylvania Land Trust Association: http://conserveland.org (accessed January 6, 2012).

The Nature Conservancy: Pennsylvania Chapter, www.nature.org/ourinitiatives/regions/northamerica/unitedstates/pennsylvania/index.htm (accessed January 6, 2012).